$14.95

AFRO-AMERICAN ARTS OF THE SURINAME RAIN FOREST

Published in collaboration with the
Museum of Cultural History,
University of California, Los Angeles

AFRO-AMERICAN ARTS OF THE SURINAME RAIN FOREST

By Sally and Richard Price

UNIVERSITY OF CALIFORNIA PRESS
Berkeley • Los Angeles • London

University of California Press
Berkeley and Los Angeles, California

University of California Press, Ltd.
London, England

This book and the exhibition associated with it were sup-
ported by a grant from the National Endowment for the
Humanities, Washington, D.C., a Federal Agency created by
Act of Congress, 1965.

Exhibition presented at:

 The Frederick S. Wight Art Gallery,
 University of California, Los Angeles
 October 14–December 7, 1980

 Dallas Museum of Fine Arts,
 Dallas

 The Walters Art Gallery,
 Baltimore

 American Museum of Natural History,
 New York

FRONT COVER. Detail of cape in Color Plate IX

BACK COVER. Saramaka boys enjoy the aesthetic by-products
of an orange snack. Photo by Richard Price (Dangogo, 1968).

Library of Congress Cataloging in Publication Data

Price, Sally. 1943–
 Afro-American arts of the Suriname Rain Forest.

 The exhibition associated with this book was organized by
the Museum of Cultural History, UCLA, and held Oct. 14–Dec.
7, 1980 at the Frederick S. Wight Art Gallery, UCLA, and at
other museums.
 Bibliography: p.225
 Includes index.
 1. Arts, Maroon—Exhibitions. 2. Maroons—Surinam—
Exhibitions. I. Price, Richard, 1941– joint author. II. Cali-
fornia. University. University at Los Angeles. Museum of Cul-
tural History. III. Frederick S. Wight Art Gallery. IV. Title.

NX537.2.A1P75 700′.89969883′074013 80-22123

Printed and bound in the United States of America.

TABLE OF CONTENTS

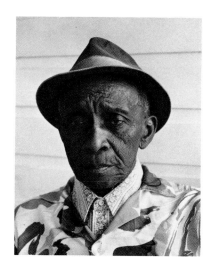

For Gaamá Aboikoni (Agbago),
Chief of the Saramakas,

for his late sister, Naai, and
their brother Kabitêni Dangasi (Kala),

and for the young Republic of Suriname,
in the hope that greater understanding
of the remarkable achievements of its
Maroon peoples may enrich the cultural
heritage of the nation as a whole.

PREFACE

This book combines two approaches to the study of art, neither of which is as yet widely accepted among specialists and connoisseurs of what most art historians continue to call "primitive art." The first is an attempt to interpret the artistry and aesthetics of a particular people from an ethnographic and ethnoaesthetic ("inside") perspective, rather than allowing *objets d'art* to speak largely for themselves. The second is an effort to trace the development of aesthetic ideas and artistic forms over time, to view from an historical perspective arts that have often been assumed to be relatively static and unchanging. It may be useful to elaborate briefly on the importance of each of these approaches.

Today, there is a widespread and respectable scholarly belief that Euroamerican audiences have become sufficiently sophisticated about the arts of the rest of the world so that "primitive art" is best presented with minimal interpretation. This view advocates an "osmotic approach" to the presentation of works of art, holding that "explanatory devices...[are] more properly handled by the ethnographic museums" (Newton 1978:45–46). In contrast, the present book is guided by the view that learning how to look at, understand, and fully appreciate an artistic creation depends on knowing something of how its creators (and those for whom it was created) *themselves* viewed, understood, and used it. For us, interpretation and aesthetic appreciation go hand in hand.

Once we adopt this perspective, we immediately take on a special set of responsibilities. One of these is the rejection of Western stereotypes of culturally-foreign arts, many of which are firmly embedded in our society's intellectual heritage. Edmund Carpenter, commenting on our own civilization's propensity to see (and, ultimately, to transform) other peoples' cultures in the light of our own special needs, claimed that "We have called primitive man forth from his retreat, reclothed him as a noble savage, taught him to carve the sort of art we like, and hired him to dance for us at lunch" (1973:4). And in planning this book and the accompanying exhibition, we have often been struck by the strength of stereotypic Euroamerican notions about the arts of darkskinned, non-literate, scantily-clothed inhabitants of a tropical rain forest. In spite of growing sophistication about the arts, for example, of Africa or Oceania, many people have expressed surprise that Maroon woodcarving is not dominated by masks or fetish figures and that Maroon patchwork textiles (because of their geometric patterns and contrastive primary colors) remind them more of Mondrian than of Abidjan.

If, however, we set aside such preconceptions and direct our attention instead to the ideas and values held in the villages of the artists themselves, the task of presenting the arts of another people becomes newly defined. In becoming spokesmen for people who have not yet had an opportunity to speak for themselves, we must become listeners (in the native language) before we become lecturers, and we must make every effort to assure that the sense of our analysis does not violate the sense which the people themselves make of their own artistic life.

Given our express intent to present an "inside" view of Maroon arts, one might expect considerable discussion of native terms and categories. But because we are hoping that this book will be read by people whose interest in Maroons is widely varied—rather than just by academics—we have chosen not to burden the text with Maroon terminology but rather, through our implicit organization of ideas, to try to remain faithful to their particular understandings about art and life. (A detailed analysis of Maroon terms relating to the arts is included in S. Price n.d.)

The attempt to present Maroon arts within the framework of Maroon life and aesthetic values has strongly influenced not only what we have written, but also the range of objects that we have illustrated in this book and included in the accompanying exhibition. Because Maroons do not, for example, view shrines and masks in terms of aesthetic criteria, these have not been shown in the

exhibition, and are illustrated in the book only in the course of ethnographic discussion of Maroon village environments and the rites within which music and dance are performed. But because Maroons *do* view manioc cakes and imported kerosene lanterns from an aesthetic perspective, we have shown these objects in both book and exhibit. Ethical considerations have combined—sometimes in complex ways—with these kinds of criteria for defining the scope of the book and exhibition. For example, women's "wrestling belts" do not appear in the exhibit because of the private, sexual associations which these objects hold for their owners (see Chapters 3 and 8), though photographs of them were said by Maroons to pose no threat of indiscretion. The status of village shrines as community possessions (which exist in many museums, but could have been "collected"—ripped out of the ground—only through clandestine bribes to self-interested individuals) has reinforced our decision to exclude them from the exhibit. As part of our ethnographic discussions in the book, however, we do show several photographs of such shrines, taken by anthropologists, with permission, during the course of their fieldwork. And several examples of ritual jewelry (which Maroons feel is acceptable for the individual owner to sell if he or she wishes, and which they view in part in aesthetic terms) are included in both book and exhibit.

The detailed attention we give to historical development represents a second departure from traditional scholarship in this field. For it has long been a canon of Western thought that small-scale, non-literate societies exist somehow suspended in time and are extremely slow to change (unless impinged upon from the outside). In studies of Maroon art, such ahistorical assumptions have been reinforced by the common belief that what is at question is simply "an African art in the Americas," that the arts of the Maroons have been passed down from one generation to the next since Africa, essentially unchanged. But we believe that such views profoundly underestimate the creativity of Afro-Americans, their ability to adapt and reshape their collective pasts, and that in denying them a real history, such views ultimately serve to dehumanize them.

By research in archives, in museums, and most important with Maroons themselves, we have at least begun to trace the outlines of a real art history—one that in no way denies the importance of the African contribution, but that places it firmly within the context of Maroon cultural history. An examination of the processes by which Maroons developed their arts reveals an immense dynamism and creativity; it shows people building upon their collective cultural pasts by adapting, reshaping and playing with ideas to create and elaborate arts that are strikingly new, yet still organically related to those pasts. As we write below, in our final section on the legacy of Africa: "The arts of the Maroons, forged in an inhospitable rain forest by people under constant threat of annihilation, stand as an enduring testimony to Afro-American resilience and creativity and to the remarkable exuberance of the Maroon artistic imagination working itself out within the rich broad framework of African cultural ideas."

And finally, we would like to join Sidney Mintz in asserting that the study of the Afro-American past perforce involves a special moral and political commitment and responsibility. As he has written,

> That past—or better, those pasts—live in the present; their careful documentation is in the service of millions of people, now dead, who had to build their new world under the harshest conditions in recorded history, and even more in the service of their descendants [1974:60].

ACKNOWLEDGMENTS

Our study of the arts of the Maroons forms one part of a more comprehensive study of Maroon life and history, which began with a two-year stay in Saramaka in the mid-1960s, and has included five return field trips to Suriname, the last in 1979. During this period, we have also spent two years in the Netherlands conducting related museum and archival research. During one or another phase of our research and writing on the arts, generous financial support has been provided by several organizations, to which we would like to express our sincere gratitude: for support of S.P.'s work, to the Fulbright-Hays Doctoral Dissertation Research Abroad Program, the Tropical South American Program of the University of Florida, the National Science Foundation (for a pre-doctoral fellowship), and the Johns Hopkins Program in Atlantic History and Culture; and for support of R.P.'s work, to the American Council of Learned Societies, the National Science Foundation (Grant BNS 76–02848), and the Netherlands Institute for Advanced Study. We would like especially to thank N.I.A.S., where R.P. was a residential fellow during 1977–78, for providing us with extra office space to work on this project. Finally, the Museums and Historical Organizations Program of the National Endowment for the Humanities, through three related grants to the UCLA Museum of Cultural History, funded much of the international museum research on which this book is based and subsidized the publication itself; we are particularly grateful to Cheryl McClenney and Nancy Worssam for their support of the project.

Sitting down on a given day, at the end of a project that has stretched over many years, it is not easy to draw up an appropriate list of the countless people who have at one time or another lent their assistance. Our memories are far from perfect, and individuals have contributed in vastly different ways and with very different commitments of time and effort. We apologize in advance for any inadvertent omissions.

The staff of the UCLA Museum of Cultural History, which first suggested in 1975 that we write a brief catalogue of their Maroon holdings, has responded over the years to the repeated expansion of the project with enthusiasm, creativity, and supportiveness; of the many members of the Museum staff who have contributed their time and energy to this project, we would like especially to thank Anne Bomeisler, Christopher B. Donnan, Benita L. Dumpis, Larry duPont, Nancy Ellis, Margaret Falk, Antonia Graeber, Suzanne Jurmain, Barbara Underwood, Emily M. Woodward, and Kathleen A. Zernicke. We would like to express our special gratitude to three people at the Museum: Robert Woolard, Director of Publications, who with professionalism and imagination has overseen the production of this book, and who has been consistently responsive to our own ideas; Jack Carter, whose rare combination of technical expertise and artistic creativity has produced an ethnographically sensitive and visually exciting design for the exhibition; and especially, George R. Ellis, who initially conceived of this project and who has worked closely with us throughout, guiding with remarkable skill the complex administrative apparatus necessary for its realization.

The staffs of the museums where we conducted research were consistently helpful in supplying photographs, responding to our inquiries on particular pieces, and allowing us access to their collections and documentation. Those who have assisted our research particularly frequently over the past years include J. Douglas, R. Van Horenbeeck, and Henna Malmberg at the Surinaams Museum; Wolfgang Haberland at the Hamburgisches Museum für Völkerkunde; P. H. Pott at the Rijksmuseum voor Volkenkunde in Leiden; Jacques J. Buffart at the Museum voor Land- en Volkenkunde in Rotterdam; A. Fluyter at the Tropenmuseum in Amsterdam; and Mireille Simoni-Abbat at the Musée de l'Homme in Paris. M. van Opstall graciously assisted R.P.'s documentary research at the Algemeen Rijksarchief in The Hague.

The lenders to the exhibition, whose collections are represented in illustrations throughout this book, deserve special thanks. We would like to single out the extraordinary contribution of the Surinaams Museum, which is the

largest institutional lender; over a period of many years, J. Douglas, Director of the Museum, has worked with us tirelessly to permit its unique resources to be appropriately represented. We are indebted also to the other lending museums: the American Museum of Natural History, New York; the Hamburgisches Museum für Völkerkunde, Hamburg; the Indiana University Museum, Bloomington; the Musée de l'Homme, Paris; the Museum of African Art, Smithsonian Institution, Washington, D.C.; the Museum voor Land- en Volkenkunde, Rotterdam; the Rijksmuseum voor Volkenkunde, Leiden; the Royal Museum for Central Africa, Tervuren; the Tropenmuseum, Amsterdam; the UCLA Museum of Cultural History, Los Angeles; and the University Museum of Archaeology and Anthropology, Cambridge, England.

All loans from individuals consist of objects collected by the lender in Maroon villages. More than 95% of these objects were collected by anthropologists during the course of long-term ethnographic field research; the remainder were collected by individuals who had extended relationships with Maroons during the course of professional work in the interior of Suriname. For their willingness to loan objects from their personal collections, we are very grateful to: Silvia W. de Groot, Jean Hurault, John D. Lenoir, Jan Michels, Robin Ravales, Bonno Thoden van Velzen, John C. Walsh, and Wilhelmina van Wetering. The anonymity of certain loans has been maintained at the specific request of the National Endowment for the Humanities.

The captions in this book reflect the unevenness of the documentation available on the several hundred objects which are illustrated. For each object, we have made an effort to establish the village where it was made, the date when it was made, and the artist who made it. It has often been necessary, however, to settle for information on owner (rather than artist) and for indications about where and when it was collected (rather than made) or, in many cases, simply for the date when it was acquired (without documentation) by a museum. In a few cases, Maroons who kindly permitted us to photograph art which they owned expressed the wish to remain anonymous, which we have respected. Because Melville J. Herskovits' collection and private papers were in the midst of being transferred from Chicago to the Museum of African Art in Washington, D.C., we did not have access to documentary materials on the objects from that collection during the writing of this book; judging from the detailed notes Herskovits supplied for the Hamburg portion of his collection, however, we would expect useful information on provenance to become available for the Museum of African Art collection, once his papers are sorted out and catalogued.

During our stays in Paramaribo, we have benefitted from the hospitality and countless small kindnesses of, among others, Terry Agerkop, D. F. Ajaiso, Anikel Awagi, Naomi Glock, James Healy, I. Henar-Hewitt, Jan Michels, Komisasie Ngwete, Robin Ravales, Catherine Rountree, and Betty Sedoc-Dahlberg. For special help with medical problems and emergency transportation in Suriname, we wish to thank the members of the E.B.G. mission at Djumu, particularly L. Bom, and their colleagues at the Diakonessenhuis in Paramaribo.

During the years when this book was in preparation, Gertrude Price and George Price have each contributed in countless and varied ways, not the least of which was parenting our children during several of our summer field trips to Suriname.

Moses Asch, President of Folkways Records, kindly arranged for our record, "Music from Saramaka," to be made available at reduced cost at the museums which are exhibiting "Afro-American Arts from the Suriname Rain Forest." Jean Hurault allowed us to include a view of the performing arts in the exhibition by offering his excellent film of an Aluku funeral.

Ethnographic materials on the Kwinti were kindly provided by Dirk van der Elst. Chris de Beet and Miriam Sterman have generously shared their extensive knowledge of Matawai life over the past four years. Bonno Thoden van Velzen and Wilhelmina van Wetering truly gave of themselves and their intimate acquaintance with Djuka culture in ways too numerous to mention; although

11

major Dutch museums repeatedly rejected the idea of presenting arts from their former colony as "art" rather than as ethnographica or political statement, Bonno never tired in his efforts to bring the exhibition to the Netherlands, in the hope of making it more accessible to the tens of thousands of Surinamers who live there. (The stringent requirements of lending institutions—especially in terms of security and climate controls—did not allow the possibility of taking the exhibition to Suriname.)

Various drafts of the manuscript have been typed by Barbara Curtin, Marilyn Heckrotte, Katherine Murphy, and Karen Rubinson. We are particularly grateful to Barbara Curtin who often extended her work day to do extra typing, make photocopies, pick up photographs, and make special trips to the post office when deadlines became tight. Adiante Franszoon's transcriptions of a large corpus of field recordings considerably facilitated our work on songs and tales in Chapter 6.

Niko and Leah Price have enthusiastically shared with us the experience of writing this book—in Paramaribo and Saramaka, in museums in Europe and the United States, and in our home study during week-end caption-writing and proofreading marathons.

William C. Sturtevant offered detailed and very helpful commentary on a near-final draft of the manuscript. The book benefitted also from the comments of Chris de Beet, David W. Cohen, Philip Dark, Silvia de Groot, Deborah Heath, Miriam Sterman, Bonno Thoden van Velzen, Patricia Torres, Rolph Trouillot, and Wilhelmina van Wetering, as well as members of R.P.'s 1979 undergraduate class on anthropological approaches to art and aesthetics, at The Johns Hopkins University.

Finally, Sidney Mintz, who has long been our mentor in matters Caribbean, first suggested to us the special importance of the initial contact situation in Afro-America as the crucible for a new kind of individualism and creativity; his insights on the development of Afro-American cultures in the Caribbean have consistently enriched our understandings of the ways in which Maroons, working with extremely limited material resources, created some of the richest and most innovative cultural complexes in the Western hemisphere.

Our greatest debt, of course, is to the many Saramakas who, over the course of a decade and a half, have offered their hospitality, shared their wisdom, and tolerated our curiosity. In composing these acknowledgments, we began to draw up a list of individuals who have made special contributions to our understanding of Maroon arts. But as the list grew toward a hundred and was still clearly incomplete, and as we realized the inadequacy of our records regarding the often-strong feelings of individuals about having their names set in print, we decided instead to express our gratitude to them collectively. We hope that we have not disappointed any of our teachers in Saramaka, nor violated any of their trusts. This book was written with them constantly in mind and, ultimately, is dedicated to them, and to their children.

Sally and Richard Price
Baltimore
June 1980

1 AN INTRODUCTION TO THE SURINAME MAROONS

Maroon societies—communities created by escaped slaves—have been a widespread concomitant of plantation life in the Americas for more than four centuries. Ranging from tiny bands that survived for less than a year to powerful states encompassing thousands of members and surviving for generations or even centuries, these communities still form semi-independent enclaves in several parts of the hemisphere. They remain fiercely proud of their maroon origins and, in some cases at least, continue to carry forward unique cultural traditions that were forged during the earliest days of Afro-American history (see R. Price 1979b).

For some three hundred years, the classic setting for maroon communities has been the heavily forested interior of Suriname, a Dutch colony in north-eastern South America that gained its independence in 1975.[1] The Suriname Maroons (known also as "Bush Negroes") have long been the hemisphere's largest maroon population, representing one extreme in the range of cultural adaptations that Afro-Americans have made in the New World.[2] Between the mid-seventeenth and late eighteenth centuries, the ancestors of the present-day Maroons escaped from the plantations on which they were enslaved, in many cases soon after their arrival from Africa, and fled far into the forested interior of the country where they re-grouped into small bands. Their hardships in forging an existence in a new and inhospitable physical environment were compounded by the persistent and massive efforts of the colonial government to eliminate this threat to the plantation colony.

The colonists reserved special punishments for recaptured slaves—hamstringing, amputation of limbs, and a variety of deaths by torture. For example, one recaptured town slave, "whose punishment shall serve as an example to others," was sentenced

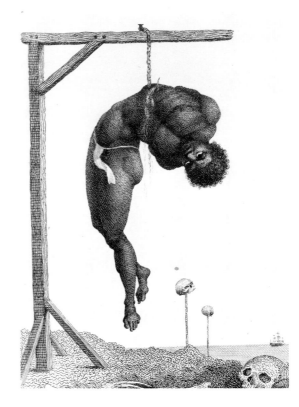

1. "A Negro hung alive by the Ribs to a Gallows" (1770s)

> to be quartered alive, and the pieces thrown in the River. He was laid on the ground, his head on a long beam. The first blow he was given, on the abdomen, burst his bladder open, yet he uttered not the least sound; the second blow with the axe he tried to deflect with his hand, but it gashed the hand and upper belly, again without his uttering a sound. The slave men and women laughed at this, saying to one another, 'That is a man!' Finally, the third blow, on the chest, killed him. His head was cut off and the body cut in four pieces and dumped in the river [Herlein 1718:117].[3]

Several years later, the following sentence was meted out by the criminal court to eleven Maroons captured on a punitive expedition in 1730:

> The Negro Joosje shall be hanged from the gibbet by an Iron Hook through his ribs, until dead; his head shall then be severed and displayed on a stake by the riverbank, remaining to be picked over by birds of prey. As for the Negroes Wierai and Manbote, they shall be bound to a stake and roasted alive over a slow fire, while being tortured with glowing Tongs. The Negro girls, Lucretia, Ambia, Aga, Gomba, Marie and Victoria will be tied to a Cross, to be broken alive, and then their heads severed, to be exposed by the riverbank on stakes. The Negro girls Diana and Christina shall be beheaded with an axe, and their heads exposed on poles by the riverbank. [Hartsinck 1770:763–65; see Figures 1 and 2.]

The organized pursuit of Maroons and expeditions to destroy Maroon settlements date at least from the 1670s, when a citizens' militia was established for this purpose. During the late seventeenth and early eighteenth centuries, numerous small-scale military expeditions were mounted, sometimes at the personal expense of particular planters; but these rarely met with success, for the Maroons had established and protected their settlements with great ingenuity and had become expert at all aspects of guerrilla warfare (see R. Price 1976). It was during the 1730s and 1740s, when "the colony had become the

theater of a perpetual war" (Nassy 1788, I:87), that such expeditions reached their maximum size and frequency. Among the several sent out in 1730, for example, was one that included fifty citizens and two hundred slaves. In addition to killing sixteen Maroons, this force captured four men, twelve women, and ten children (including those whose execution is described above—Hartsinck 1770:759–65). Other expeditions on the same scale were mounted throughout this period; a force sent out in 1743, for example, was composed of 27 civilians, 12 soldiers, 15 Indians, 165 slaves, and 60 canoes (Nassy 1788, I:93). Though the most successful military expeditions during the 1730s and 1740s returned with as many as "47 prisoners and 6 hands of those whom they had killed" (Nassy 1788, I:92), most such expeditions were fruitless. Indeed, by the 1740s the colonists found the costs overwhelming, as typical expeditions required "more than 100,000 guilders each" and had to traverse "forty mountains and sixty creeks" before reaching a Maroon hideaway (Hartsinck 1770:766–68). By this time, it had also become clear to the colonists that the expeditions themselves were contributing to increased *marronage*, by making known to the slaves both the escape routes from the plantations and the locations of Maroon villages (*Ibid.*). The increasingly costly guerrilla warfare beween Maroons and colonists, which by the mid-eighteenth century had lasted nearly one hundred years, culminated in a decision by the whites, during the late 1740s, to sue their former slaves for permanent peace. In 1760 and 1762 peace treaties were finally concluded with the two largest groups, the Djuka and the Saramaka, and were confirmed in 1767 with the Matawai. New revolts and the large-scale war of subsequent decades, for which an army of mercenaries was imported from Europe, eventually led to the official recognition of the Aluku (or Boni), as well as of the smaller Paramaka and Kwinti groups.[4]

There are six Maroon tribes in Suriname (and along the border river, in French Guiana): the Djuka (Aucaners) and Saramaka each have a population of about 20,000; the Matawai, Aluku (Boni), and Paramaka are each closer to 2,000; and the Kwinti fewer than 500.[5] Tribal territories are shown in the sketch map (Figures 3 and 4), though it should be noted that increasingly large numbers of Maroons are now living in and around Paramaribo. Although formed under broadly similar historical and ecological conditions, these societies display significant variation in everything from language, diet, and dress to patterns of marriage, residence, and migratory wage labor. From a cultural point of view, the greatest differences have traditionally been between the tribes of central Suriname (Saramaka, Matawai, and Kwinti) on the one hand, and those of eastern Suriname and western French Guiana (Djuka, Aluku, and Paramaka) on the other.[6] The differential development of Suriname's interior by government and mining interests is, however, complicating this picture today.

Since the colonial government signed treaties with the Djuka, Saramaka, and Matawai in the mid-eighteenth century and later recognized the Aluku, Paramaka, and Kwinti, a loose framework of indirect rule has obtained. Each tribe except the Kwinti has a government-approved Tribal [Paramount] Chief (who from an internal perspective might better be described as a "king"), a series of headmen, and other public officials. Traditionally, the role of these officials in political and social control has been exercised in a context replete with oracles, spirit possession, and other forms of divination, though today the national government is intervening more frequently in the affairs of the tribes, and the sacred base of the tribal officials' power is gradually being eroded.

Villages, which average one hundred to two hundred residents, consist of a core of matrilineal kinsmen (people related through the female line) plus some wives and children of lineage men. Although matrilineal relationships are important in determining everything from residence patterns to marriage prohibitions and succession to political office, men are generally very close to their children, passing on ritual knowledge to their sons, playing an active role

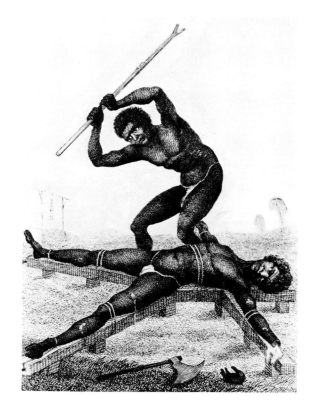

2. "The Execution of Breaking on the Rack" (1770s)

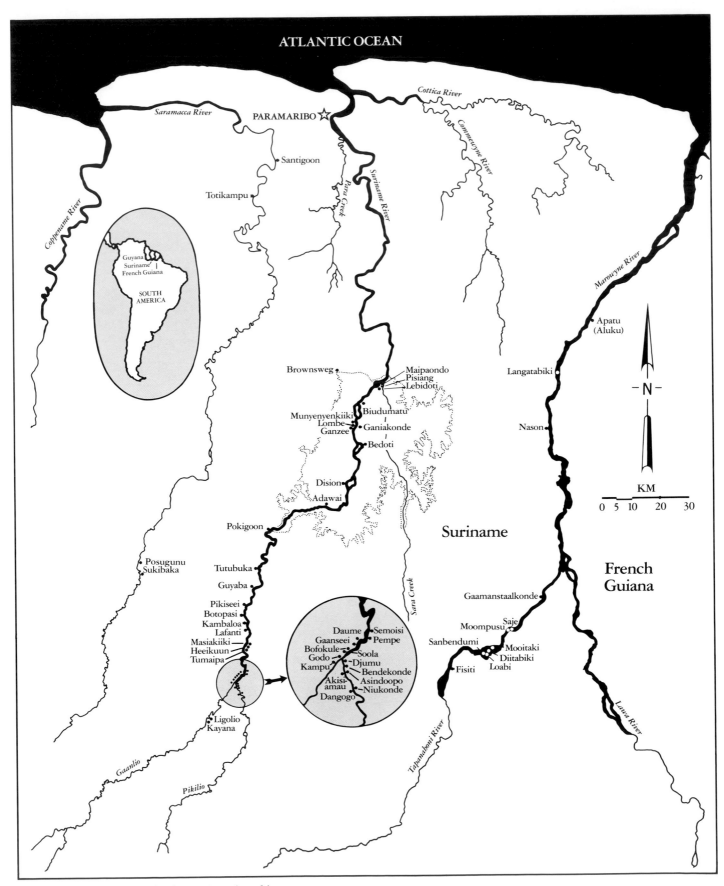

3. Maroon villages mentioned in the text. A number of these are no longer inhabited, including those destroyed in the 1960s by the hydroelectric project.

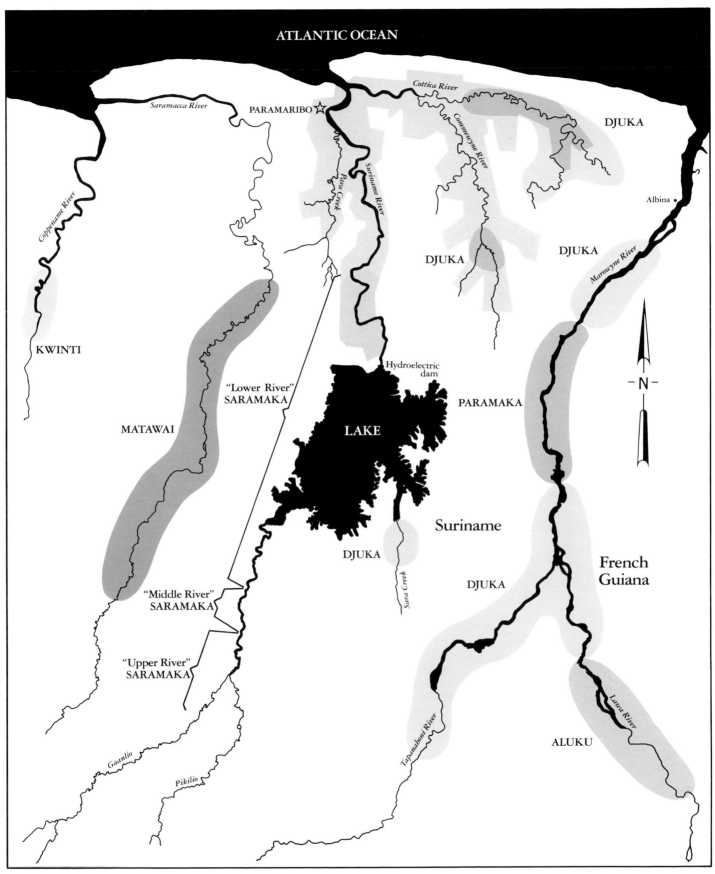

ATLANTIC OCEAN

Saramacca River

PARAMARIBO

Coppename River

Cottica River

DJUKA

Commewyne River

Albina

Para Creek

Suriname River

DJUKA

DJUKA

Marowyne River

KWINTI

-N-

"Lower River"
SARAMAKA

Hydroelectric
dam

PARAMAKA

MATAWAI

LAKE

DJUKA

Suriname

French
Guiana

DJUKA

Sara Creek

"Middle River"
SARAMAKA

"Upper River"
SARAMAKA

Lawa River

Gaanlio

ALUKU

Tdpanahoni River

Pikilio

4. General distribution of Maroons. This map is schematic only; among the details not shown are a Kwinti enclave in Matawai territory, several mixed villages of Matawais, Saramakas, and Djukas on the Lower Saramacca River, and villages of Sara Creek Djukas, displaced by the artificial lake just north of the dam. The shaded area at the top indicates the former plantation area from which the ancestors of the Maroons escaped.

17

in the raising of their children, and so on. Many men have more than one wife, though few have more than three at one time. The care of children is entrusted to one adult rather than to a couple. Although most children spend their first four to six years with their mother, many are then given to their father or another relative, and there may be further shifts at later ages in order to accommodate the child's developing needs, changes in the parents' marital status or residence patterns, and so on.

Rituals of many kinds form a central part of Maroon daily life. Such decisions as where to clear a garden or build a house, whether to make a trip, or how to deal with theft or adultery are made in consultation with village deities, ancestors, forest spirits, snake gods, and other such powers. The means of communicating with these entities vary from spirit possession and the consultation of oracle bundles to the interpretation of dreams. Gods and spirits, who are a constant presence in daily life, are also honored through frequent prayers, libations, feasts, and dances. The rituals surrounding birth, death, and other life crises are extensive, as are those relating to more mundane activities, from hunting a tapir to planting a rice field.

Because of both subsistence and marriage patterns, Maroon life is characterized by great individual mobility and personal independence. All able-bodied adults have a canoe of their own which supplies a ready means of travel for trips to and from horticultural camps, visits to spouses and kinsmen, medical consultations at mission clinics, attendance at funerals and other village rituals, and so on (Figure 5). Each person's network of kinsmen and affines is unique and extends over many different villages (often as much as a full day away by canoe), and the ability to come and go independently is crucial to the fulfillment of a whole range of social obligations. Because of the high divorce rate and the practice of having children live for extended periods with foster parents, even young children have very individualized social networks and are involved in the unique visiting patterns these entail.

Related to this feature of social life is a residence pattern in which houses are owned by individual adults rather than family groups, and in which many adults have more than one house. Most women on the Upper Suriname River, for example, have a house in their own village (in an area inhabited largely by their matrilineal kinsmen), a house in their horticultural camp (which may be as much as a full day away by canoe), and a house built for them by their current husband in his village. In their own villages, men often divide their time among three or four houses, built at various times for themselves and for past or current wives.

Maroon economic life has always displayed a balance between exploitation of the forest environment and dependence on the world outside. For their food, Maroons have always relied on shifting horticulture, hunting, and fishing, supplemented by various wild forest products and a few key imports such as salt. Production activities tend to be individualized; each adult works largely

5. Saramaka canoe made in 1978 by Fotobakaa, Asindoopo. For a detail of the carving on this canoe and a discussion of regional variation in the decoration of canoes, see Chapter 4.

Generaale Lijst van de Verdeeling der Present Goederen aan de bevredigde Sarameecaanse Boschnegers in't Camp vlak over Sara Creecq door my onder geschreve aan haar lieden in tien Dorpen verdeelt op den 16 September 1763.

Naamen der Dorpen	Naamen der Opperhoofden																														
Coujo Baija	Darie	70	70	70	VI	9	5	70	5	7	7	8	5	2½	5	5	5	3	200	7	4	5	4	3	—	7	47	160	70	—	
Cabriata	Foula	60	60	60	9	9	4	60	5	7	7	4	5	2½	5	5	5	3	200	7	7	2	—	3	5	—	5	9	300	60	—
Cabriata	Attama	70	70	70	VI	9	4	70	5	7	7	8	5	2½	5	5	5	3	200	7	7	4	5	4	3	—	6	47	160	70	—
Coffij Sombo	Samsam	90	90	90	19	14	7	90	5	12	14	9	2	5	10	10	2	6	300	9½	9½	5	5	5	3	5	10	49	190	90	2
Serfoe Creecq	Quacoe	86	86	86	VI	9	5	86	5	7	7	8	5	2½	5	5	2	4	200	7	7	4	5	4	3	5	7	47	180	86	—
Canga Creecq	Primo	78	78	78	VI	9	5	78	5	7	7	8	2	2½	5	5	2	4	200	7	7	4	5	4	3	5	9	47	140	78	—
Matyperie	Avanje	90	90	90	19	14	7	90	5	12	10	9	2	5	10	10	2	6	300	9½	9½	5	5	5	3	5	10	49	190	90	2
Jaro Creecque	Abraham	60	60	60	10	9	4	60	5	7	7	7	5	2½	5	5	5	3	200	7	7	3	5	3	3	5	7	10	146	60	—
Oebro Creecq	Aram	60	60	60	8	9	4	60	—	7	7	3	5	2½	5	5	5	3	200	7	7	2	5	3	5	—	5	8	100	60	—
Mattuarie	Coffij Sico	86	86	86	VI	9	5	86	5	7	7	8	2	2½	5	5	2	4	200	7	7	4	5	4	3	5	9	47	180	86	2
Inde tien Dorpen	Totaal	750	750	750	150	50	50	750	9	80	77	75	30	66	60	60	15	39	2200	75	75	37	9	39	26	6	76	150	1500	6	

6. "General list of the distribution of the tribute goods to the free Saramaka Bush Negroes in the camp just across from the Sara Creek by me, the undersigned [J. C. Dorig], to the people of ten villages on the 16th of September, 1763." For each village, this document lists the name of the headman and the amount of axes, knives, muskets, cloth, needles, etc. received. (For a detailed discussion of such tribute lists, see R. Price n.d. 1.)

independently and there is little specialization, except by sex. Horticulture is mainly women's work, though men cut the underbrush and fell trees prior to burning. Gardens are cut in both virgin and secondary forest, and are planted most heavily in rice or manioc (depending on region). They include many other crops as well—sweet potatoes and a variety of other root crops, plantains, bananas, peanuts, okra, maize, sugar cane, tobacco, and others. Hunting is the responsibility of men, and the best hunters enjoy high prestige. Maroons rely primarily on shotguns, but also use traps to hunt a wide variety of game animals, and shoot fish with bow and arrow. Fish, which are also taken with hand-lines, poles, traps, and several kinds of vegetable drugs, contribute at least as much to the diet as does meat, and some kinds of fishing are practiced by women and children as well as men.

Maroons have always been dependent on coastal society for selected manufactured goods. The original escaped slaves often took with them a gun, an axe, a pot, or some other object that would contribute to their chances for survival in the forest. All Maroon groups, including those based as far away as two weeks' travel from the plantation area, sent out periodic raiding parties to recruit new personnel (especially women), and to replenish their supplies of guns, gunpowder, tools, pots, cloth, salt, and so forth. Indeed, a major incentive for the Maroons to accept the peace treaties was the guarantee of regular access to such goods from the coast, and Maroon concerns during the complex negotiations that surrounded these treaties focused sharply on the details of the "tribute" to be provided by the government and its distribution among and within the villages (Figure 6). Since the treaties, the means by which Maroons have acquired such necessary manufactured goods have changed—from dependence on tribute and brief trading trips, to money-earning through logging, the bleeding of balata (wild rubber) trees, and the provision of river transport services and, more recently, through construction work and regular employment in industry (see R. Price 1975b).

Changes in Maroon relations with the society of coastal Suriname have accelerated significantly since the early 1960s. First, the widespread use of outboard motors and the development of air service to the interior have encouraged an increase in traffic of people and goods between Maroon villages and the coast. In addition, the construction, by Alcoa and the Suriname government, of a giant hydroelectric project in the 1960s brought a particularly dramatic migration toward the coast; some six thousand Saramakas were forced to abandon their homes as the artificial lake gradually flooded almost half of Saramaka

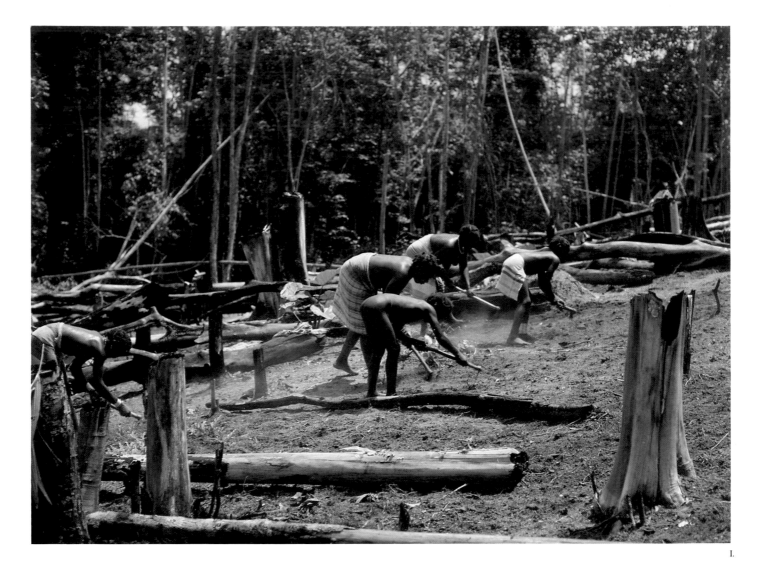

tribal territory. Two-thirds of these people were relocated in large, government-constructed towns in the area between the lake and Paramaribo, where stand-pipes replaced the river water supply, standardized houses stood shoulder-to-shoulder in relentless rows, and many of their traditional subsistence resources (e.g., many kinds of fish and game, as well as a variety of forest products) were unavailable (Figure 7). For Maroons more generally, there has been a significant increase in permanent migration to the capital. Several decades ago, most Maroon men spent only brief periods in Paramaribo at the end of coastal wage-labor trips, buying supplies to take back to their families in the interior; but today, while the squalid barracks maintained by the government for Maroon visitors to the city are still fully utilized, there are also many Maroon men who are bringing their wives and children to settle in various areas of the city (Figures 8 and 9). Both in the interior and on the coast, then, the Maroons' traditional dependence on non-Maroon society for a highly selective set of manufactured products is beginning to be transformed into a more generalized participation in the modern consumer economy.

Maroons conceptualize villages and horticultural camps as contrasting environments. Life in the horticultural camps is viewed romantically, especially by women. Despite the fact that days in the camp are dominated by long hours

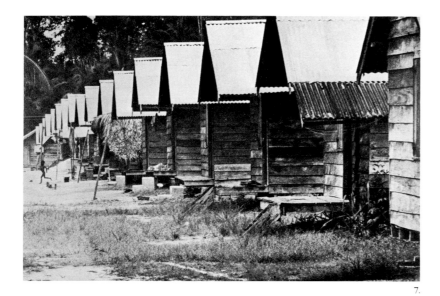

7.

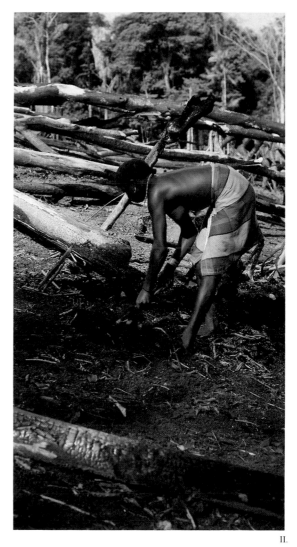

II.

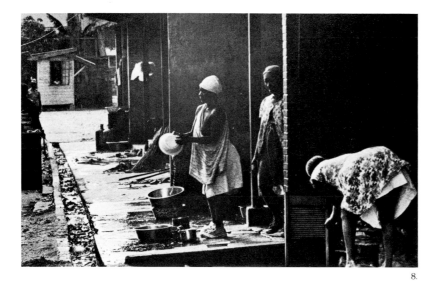

8.

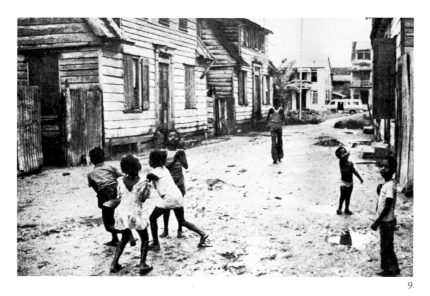

9.

I. Saramaka women and girls hoe the ground in preparation for rice planting.

II. A young Saramaka working in her mother-in-law's garden

7. A row of houses in the Saramaka "transmigration village" of Brownsweg

8. Njoeng Combe, the former slaughterhouse maintained as a barracks by the government for Maroons and Amerindians visiting the capital.

9. Typical lower class housing in Paramaribo, like that in which many Maroons now live.

21

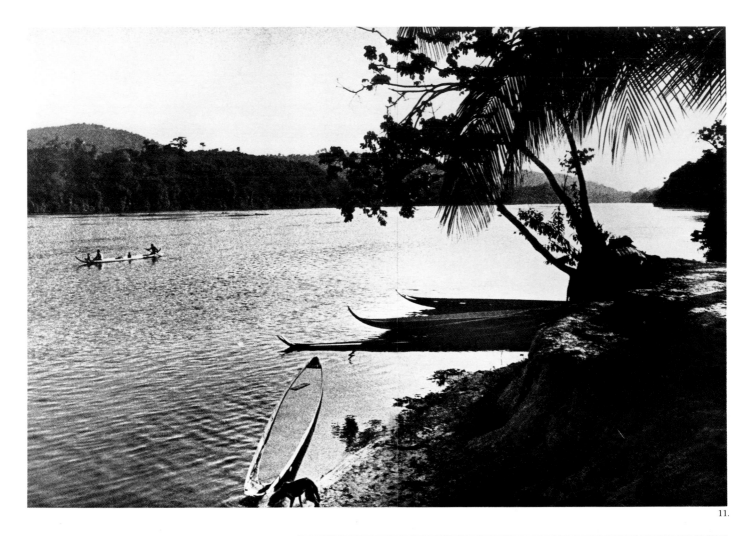

11.

10. Saramaka boys paddling a canoe
11. The Tapanahoni River

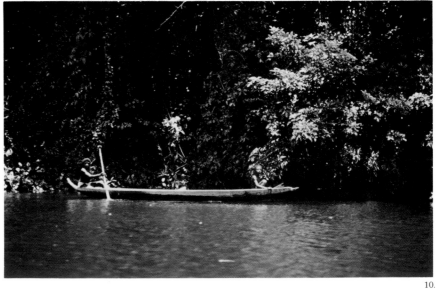

10.

of hard physical work (as opposed to a generally less intense pace in the villages), the atmosphere there is distinctly relaxed. Torn and faded clothes, considered improper in the village, are acceptable; meals are less formally served and may even be eaten by men and women together; folk tales, which are forbidden in the village except during funeral rites, may be told in the evenings; and, most important according to Maroons, there is a relative absence of the interpersonal conflicts and tensions viewed as inherent in village life. In addition, food is more varied and abundant in the camps; both forest and garden products are readily accessible, and it is during stays in the camps that women drug streams for fish and men do their most intensive and productive hunting and fishing. Without doubt the most trying aspect of old age for both men and women is confinement to village life, the forced retirement from camp and forest (Color Plates I–II).

For men, the forest itself is the focus of romantic associations. Days devoted to hunting—with shotgun or any of a number of special traps—are filled with the beauty, excitement, and dangers of lone forays into an environment populated not only by a wide variety of animals, from jaguars and peccary to scorpions and parrots, but also by a multitude of spirits who jealously guard their territories and may either aid or punish the human trespassers. The most animated stories told among men of an evening concern their adventures in the forest—being seduced by a forest spirit who had assumed the form of a woman, being lost overnight after frantically chasing an animal, rescuing a prized hunting dog from an anaconda, and so forth.

In the villages, much of a person's time is devoted to social and ritual obligations. People come back to the village from the forest or their camp for funeral rites, for oracle sessions, and for rites for possession gods; they come to greet a kinsman who has returned from a trip to the coast, to attend a ceremony for a newborn baby, to visit a sick relative, or to bring food or firewood to a kinsman who is too old to leave the village. In addition, there are subsistence tasks: houses require periodic maintenance and rebuilding, grounds must be cared for, and food processing (e.g., making palm nut oil) is sometimes carried out in the village. There is a great deal of both individual and seasonal variation in the pattern of alternation between village and camp; however, we found that in Upper River Saramaka women spend on the average about half of their days in camps, and men (aside from time spent on the coast) about 20% (R. Price 1975b:82–83).

The river not only provides the connecting link between villages, camps, and hunting grounds, but also constitutes a special environment of its own (Color Plate III, Figures 10–14). All Maroons spend a great deal of time in canoes and at the water's edge, where they enjoy a relaxation of some of the constraints of village life; it is only there, for example, that Saramakas are free to whistle. In each village there are several landing places that serve as areas for tying canoes, bathing, laundering clothes, washing dishes, preparing fish and game, pounding and winnowing rice, fishing, building canoes, and catching up on local gossip. Women who are in menstrual seclusion, and therefore banned from all but one of the houses in the village, spend considerable time at the river, and children use it as a versatile playground.

A typical Maroon village is an irregular arrangement of small houses, open-sided structures, domesticated trees, an occasional chicken house, various shrines, and scattered patches of bushes. There are usually several paths leading into the village from the river, and other tiny paths lead out to gardens, to areas used as toilets, and sometimes to nearby streams or villages. Most of the ground is scraped clear of vegetation; all the trees have been planted by individual villagers and bear some usable fruit—oranges, mangos, bananas, coconuts, and palm nuts, as well as calabashes, limes (used for washing woodcarvings and calabashes), and many others. The bushes that interrupt the cleared ground mark divisions within the village, most frequently between areas inhabited by different groups of matrilineal kinsmen (Figures 15–16).

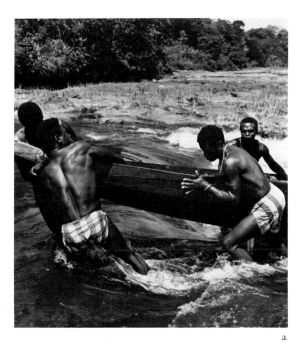

a.

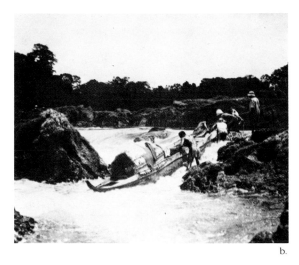

b.

12. Ascending the rapids: a) Alukus on the Marowyne River during the dry season (Jean Hurault, *Africains de Guyane*); b) the Gran Soela rapids on the Lawa River.

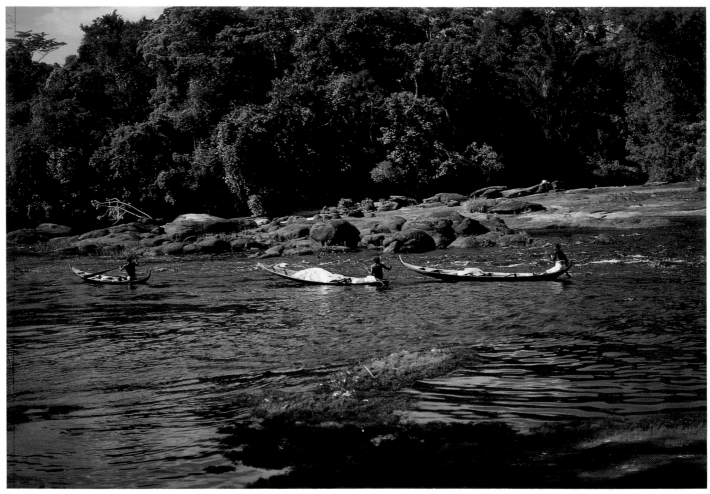

III.

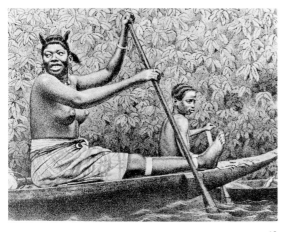

13.

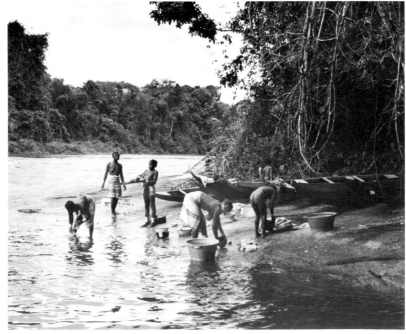

14.

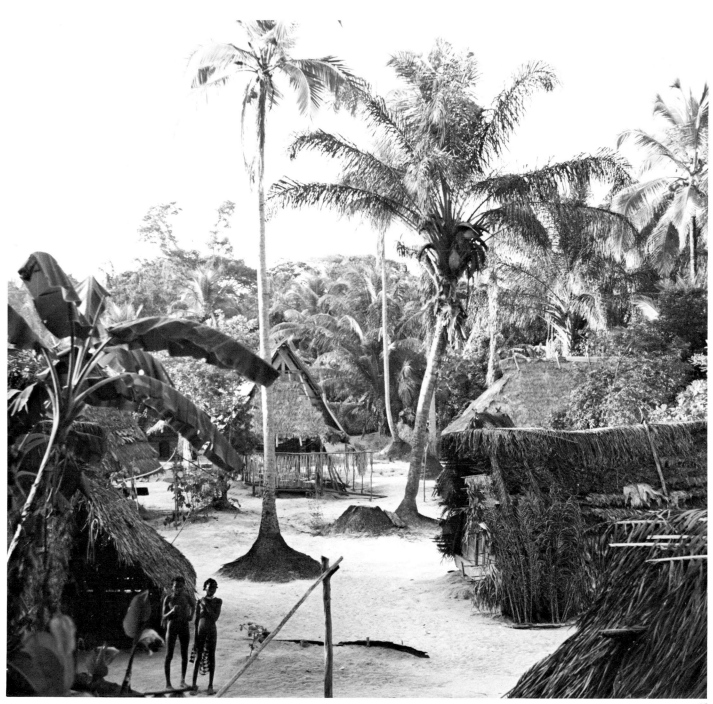

III. Saramakas descending a rapids in the Pikilio

13. A late nineteenth-century woman paddling a canoe on the upper Marowyne River. This posture, with legs outstretched, is used by Maroon women for many activities, from sewing to cracking palm nuts. The young girl is paddling at the rear of another canoe.

14 Saramakas washing clothing and dishes at a village landing place

15. Part of the Djuka village of Diitabiki. In the center (rear) is the shrine of the deity *Gaan Gadu* (also called *Gaan Tata*), built c. 1905 by Da Labi Agumasaka.

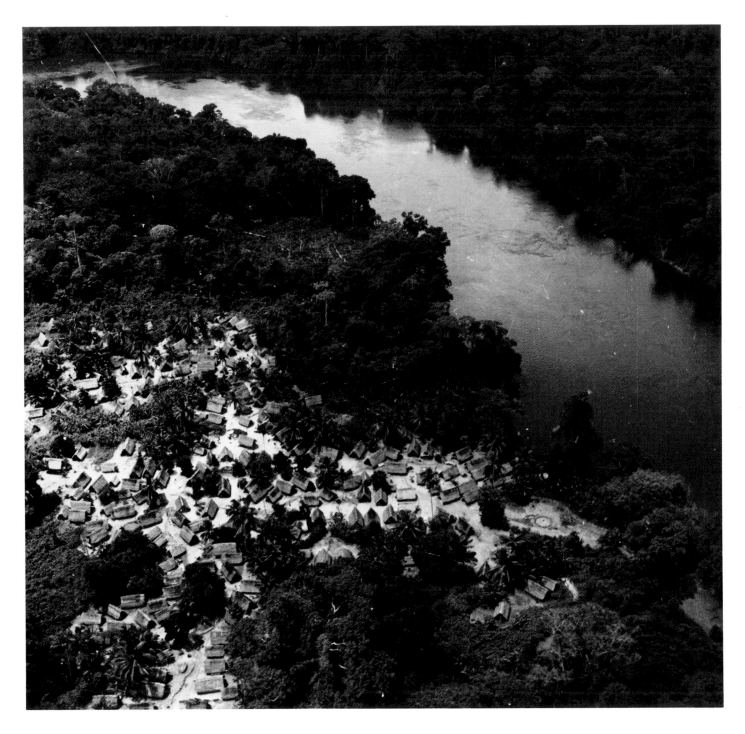

16. A Djuka village near the confluence of the Tapanahoni and Lawa Rivers.

Horticultural camps are generally set farther back from the river than villages; some are several hours' walk into the forest, but are always located near a stream. In Saramaka, camps range in size from one or two to as many as a few dozen different structures, and in Djuka they may be several times as large. Camps differ from villages in that they include more open-sided houses, more structures built by women, more one-room houses, and fewer made with wooden planks (Figure 17). The living area of a camp may be maintained for decades, serving as a base for work in gardens which are cut in new sites in the surrounding forest each year or two.

The entrances to both villages and camps are marked by palm-leaf gateways, through which everyone (with the exception of menstruating women) must pass. Although most major shrines are located in villages (Figure 18), both villages and camps have smaller ritual structures which mark the sites of specific ceremonies conducted in the past—a bottle containing a special mixture which has been buried in front of a house to appease a local god, a calabash set into a forked stick in the ground which was once used for ritual ablutions, and so on.

The small size of most houses in a Maroon village (just wide enough to tie a hammock across, and not much longer from front to back) and the absence of windows encourage a very selective use of their interiors. Women take all their dishwashing and laundry to the river and prepare fish and game for cooking there; they bake manioc cakes and pound and winnow their rice outdoors or in open-sided sheds; and informal visiting is conducted under the front overhang of the house rather than inside. Many women also prefer to cook meals in a small open-sided structure rather than in their house (Figure 19). Men's activities are similarly oriented toward outdoor settings. House interiors, then, are reserved chiefly for sleeping, eating, some meal preparation, and visits of a private nature. (During a village festivity, for example, guests from other villages are sometimes invited to sit inside, as a special gesture of hospitality and gratitude for their participation.)

In Saramaka, a typical woman's house with a divided interior is built with the doors to one side, creating a "large side" and a "small side"; there is a belief that people should always sleep with their heads to the "large side" of the house, and a number of ritual procedures require attention to this distinction as well (Figure 20). (Even in houses with a centered front door, the doorway of the interior partition determines this crucial division.) The fire area, kept as immaculately swept as the rest of the house, contains three hearthstones, which are made from clay by local specialists and must never be moved from their original site (Figure 25). Above the fire area, supported by house beams, there is often a triangular shelf of wooden slats; baskets, fire fans, brooms, salt barrels, bottles of fat, and so forth may be kept here. Firewood, gathered from the gardens and split into two- to three-foot lengths, is carefully stacked behind the front door, along with one or two "dustpans" cut from a local palm tree (*Maximiliana maripa* Drude). The floor space in the third corner of the room is used for storing water in covered buckets or gourd vessels. Utensils are stuck into the woven palm walls, hung from nails hammered into wooden planks, or placed in a wooden crate or specially made storage cabinet (Figure 21).

Figure 22 diagrams the interior of one Saramaka woman's house. Along the right wall, wooden crates (which originally contained long bars of imported laundry soap) are used for miscellaneous storage, and a brightly painted metal trunk (bought in Paramaribo) holds dozens of skirts and capes, each one folded into a small, neat packet. Along the back partition (which does not reach to the top of the house) a wooden crate serving as a table holds a tin lantern, a bowl, and other miscellaneous household items; the partition serves also to hold calabashes, pots, a tray, and a manioc press. The doorway leading into the back

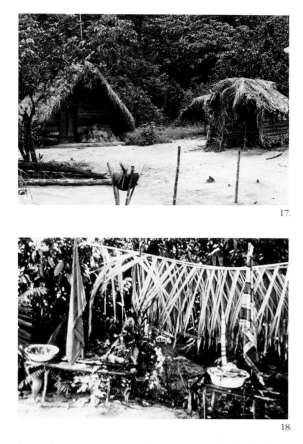

17.

18.

17. A Saramaka horticultural camp. The calabash in the foreground marks the site of an earlier ritual. The house on the left has a carved door frame and is embellished on its lower facade with contrastive woods. Newly harvested rice is stored under the roof overhang, and calabash utensils have been stuck into the woven palm-leaf wall. The hut on the right is for menstruating women; behind it stands an open-sided shelter used for cooking. There are two other houses and three other open-sided structures in this camp, which is used by four women.

18. A Djuka shrine. The banners honor a particular spirit, the basins are used for purificatory ablutions and the palm-leaf structure wards off evil (just as others do at the entrances to all Maroon villages).

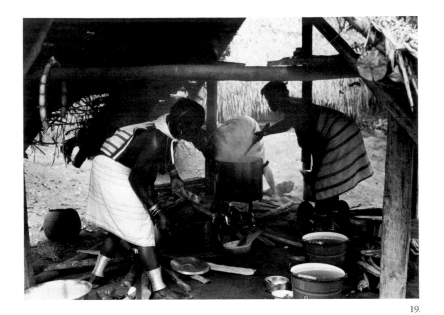

19.

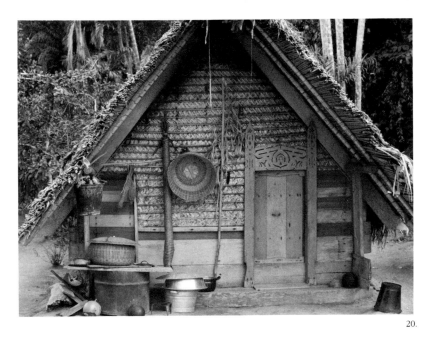

20.

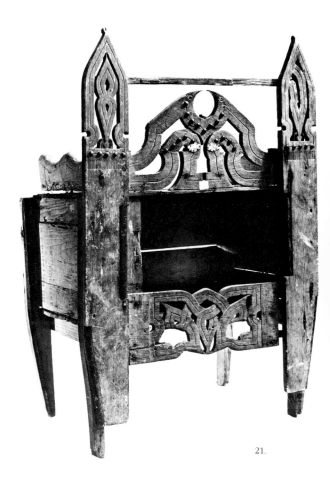

21.

room is covered by a decoratively embroidered cloth hanging from the top. The back room is largely taken up by the hammock, which is left open during the day. There is a chamber pot on the floor; more folded skirts are packed in suitcases and a wooden crate in the corner; and a manioc sieve has been hung on the wall.

This particular house is in many ways a Saramaka woman's ideal. It not only is somewhat larger than most and divided into two separate rooms, but, unlike about half the houses in the village, it has a "doorstep"—a massive wooden beam, extending across the whole front of the house and used as a bench during informal visiting. Furthermore, the woven-palm walls provide a convenient storage area for calabash and enamel utensils and dishes. Most women (unlike men) prefer palm to the costlier plank construction; as we once overheard a woman remark to a friend, "I wouldn't ever want a plank house; I'm not going to be put in a coffin more than once in my life!" The storage cabinet

19. Saramakas prepare food for a feast in honor of an ancestor; the large pot contains rice.

20. A Saramaka woman's house. A basket, a manioc press, brooms, and protective medicines hang on the front wall; horticultural products are stored in a bucket, a basket, a washtub, and a sawed-off gasoline drum under the roof overhang.

21. A carved storage cabinet, collected 1960s (apparently in Saramaka), made from an imported wooden crate and local woods. Porcelain, glass, and calabash bowls would be kept inside and spoons inserted between strips of wood at the top. For a Djuka equivalent decorated with painted designs, see Color Plate IV.

22. Interior of a Saramaka woman's house

IV. Interior of a Djuka woman's house

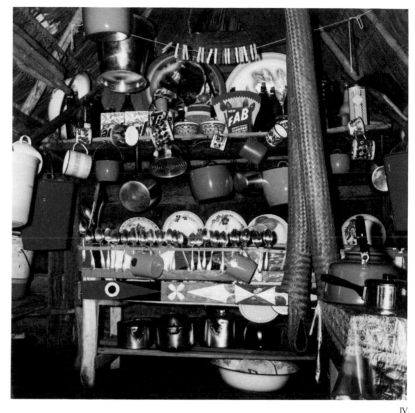

IV.

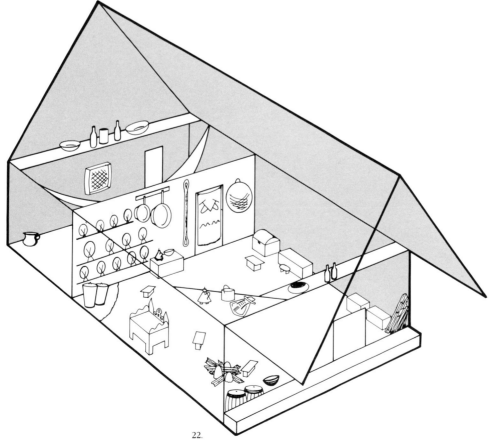

22.

in this house is an elegant alternative to the plain wooden crates in which many women store their dishes, and the floor area used for water buckets has been covered with a layer of fine white sand from a creek (considered more attractive than that from the river)—a practice which Saramaka women explain as purely aesthetic. In a house without a separate back room, the arrangement is basically the same, though there are one or more hammocks, bundled up with their mosquito covering, hanging from ropes on the side crossbeams. These hammocks are opened at night and tied across the room by the woman and any children who are sleeping with her. (See Hurault 1970:46 for a diagram of the interior of an Aluku house.)

One of the most variable features of the interiors of women's houses are the calabash, enamel, and aluminum wares which are stored and displayed along the walls. Figure 23 illustrates how one well-supplied woman from the Lower Suriname River "dressed up" her house in her husband's village on the Upper River. Color Plate IV shows an equally lavish Djuka woman's house interior from the Tapanahoni River. (See also Figure 24.) These displays, while more extensive than many, illustrate the standard methods by which dishes and utensils are stored—stuck directly into the palm walls, wedged behind sticks stuck into the wall, and hung by ties from nails in wooden slats bordering the woven-palm area. Figure 25, the back wall of an otherwise open-sided cooking house, is more typical in the number of utensils in wall storage. Because items on display should be immaculate, many women keep only a small proportion of their calabashes on the walls, while many dozens of extras are stored in burlap sacks in the back room or in crates. Pots and pans must likewise be kept sparkling clean, and the black covering which pots acquire from sitting on a wood fire is meticulously removed after each use. The sponge-like interior of a local fruit (*Luffa* spp.), together with bar soap imported from the coast and fine sand gathered from special spots at the river or creek, is used to scour each pot until it gleams, and a tiny rag and fine sand may be used to remove the last small traces of black which lie behind handle joinings and in other inaccessible crevices.

A man's house is usually smaller than a woman's, is more likely to have a plank floor, and is furnished very differently (Figure 26). As with women's houses, the ideal is to divide the back sleeping area from the front, even in a very tiny house. The hammock (or now, occasionally, a double bed imported from the coast) fills the entire back space, and a cloth hangs in the doorway between the two. The front room, which serves as a parlor, is used for visiting, communal meals, and the storage and display of personal wealth. Trunks filled with cloth and other coastal goods may be stacked high along the walls; a table and carved stools, or perhaps one or two imported folding chairs, are the main items of furniture. The table and walls are usually cluttered with such items as the owner's shotgun and hunting sack, a fishing bow and arrows, a flashlight, an umbrella, hats, a bottle of liquor, a few small empty bottles, an alarm clock, some photographs, a jar of hair fat, a calendar, an assortment of machetes, knives, and shotgun cartridges, a tape recorder, and tapes or cassettes. Some men assemble collections of objects that rival the women's displays of plates illustrated above; for example, up to several dozen differently shaped machetes are often displayed at a time (Figure 27).[7]

The several men who are in a neighborhood on a given day usually eat meals together in one of their houses. Each wife (or another kinswoman if a man's wives are all absent) brings a complete meal and set of dishes to the house and arranges them carefully on the floor. The bowls of rice have been mounded and smoothed with a wide calabash utensil (see Chapter 5), and are accompanied by a plate containing carefully selected pieces of manioc cake and by small china or enamel dishes with several pieces of meat or fish in each; vegetable sauces made from okra, taro leaves, or other greens may be served, but meat and fish are very much preferred whenever available. In addition, a shiny aluminum teapot with cold water, a calabash or a small aluminum pot

23. Storage of dishes and utensils in a Saramaka woman's house. Plates and calabash bowls are supported by sticks inserted in the wall; porcelain bowls hang by strings tied around the base; calabash ladles, stirring sticks, and aluminum spoons are stuck into the wall; and pots are hung from nails by their handles.

24. A display of calabash bowls and an openwork doorway carving decorate the interior partition of this house.

25. Interior of a Saramaka cooking house. Horticultural products are kept in the wooden crate, and water in the aluminum bucket and Amerindian-made earthenware jug on the right.

26. A Saramaka "raised house." Only a small proportion of men live in this type of house, which for over a century has been associated with age and seniority.

27. Machete display above the center partition in a man's house. Like women' spoons (see Color Plate IV), machetes are hung between a pair of wooden slats; like many other commercial imports, each type is named according to its form, color, and materials.

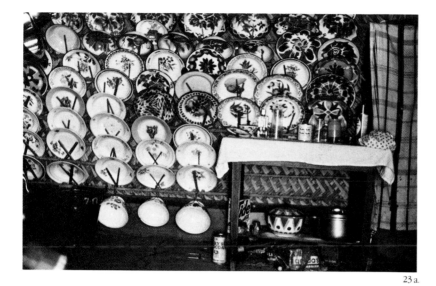

23 a.

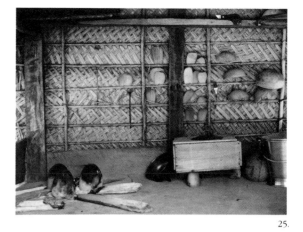

25.

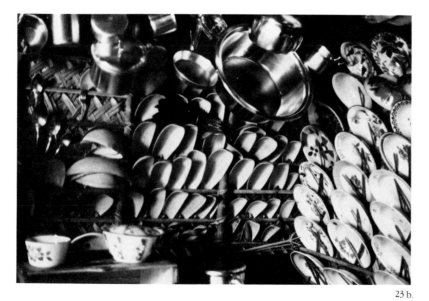

23 b.

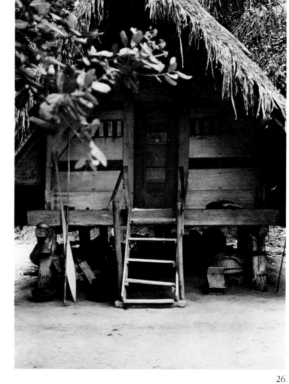

26.

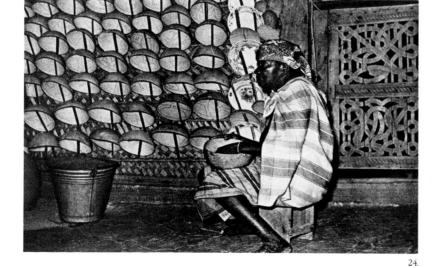

24.

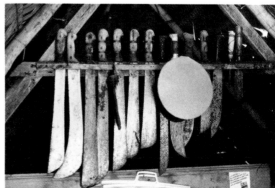

27.

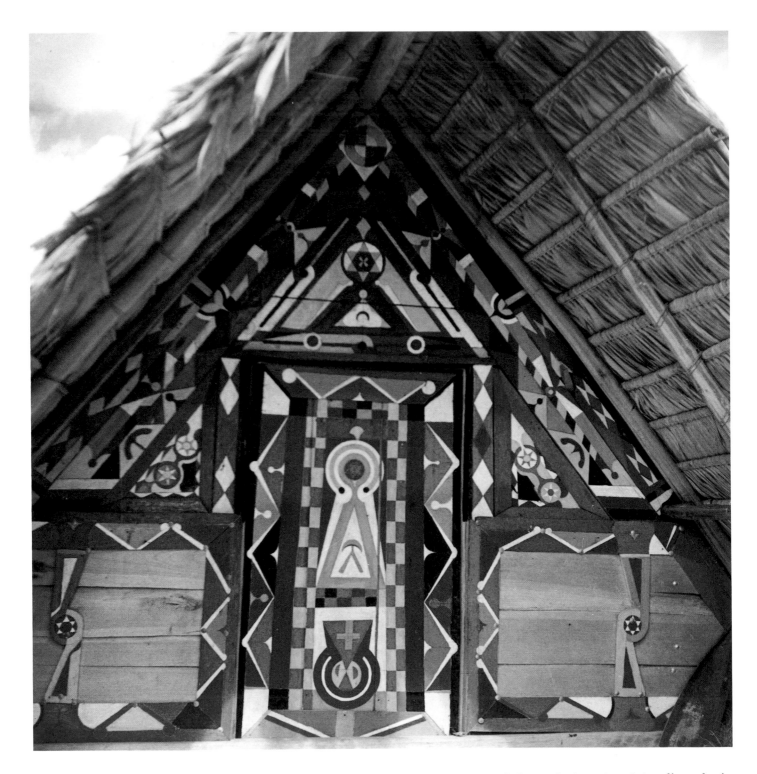

V. A Djuka house. The decorative painting of house facades was in sharp decline by 1970.

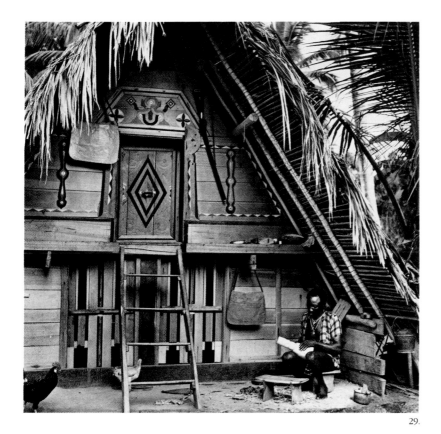

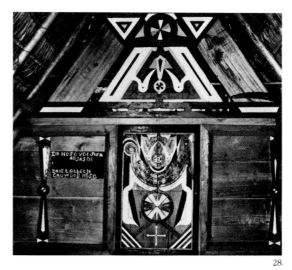

28.

28. A Djuka house. The sign gives the name of the owner and the village, and proclaims that it is a "cowboy house"—alluding to the special flair or bravado that young Maroon men admire in Hollywood westerns.

29. Two-story Djuka man's house (Jean Hurault, *Les Noirs Réfugiés Boni de la Guyane Française*).

29.

for drinking it, another calabash for rinsing hands, a glass or enamel plate, and a metal eating spoon are provided by each woman.[8] The men share all the dishes, spitting bones onto the floor, and the youngest one sweeps the area clean after the meal. Women eat more informally in their own houses, with children and perhaps another kinswoman. Their rice is not mounded, and the accompanying foods (which are more frequently vegetable sauces than in men's meals) are often eaten directly from the cooking pot. The crusty rice which sticks to the pot is softened with water and scraped out for children and sometimes women.

The layout, use, and mode of construction of houses are basically similar among the various Maroon groups, but there are also recognizable differences in architectural detail and in the frequency of different types of housing. Hurault has presented detailed descriptions of the construction and layouts of various house types in Aluku villages (1970:40–54), as well as photographs and line drawings which give an excellent sense of the range of aesthetic treatments applied to individual dwellings. Some of the features that distinguish the houses of eastern Maroons from those in Saramaka are their elaborately painted facades, their larger doors, the triangular facades of some houses (formed by a lower roof extension on the sides and a filling of the lower side areas with planks), the absence of a "doorstep" beam across the front, and the optional use of vertical decorative posts placed at the very front of the roof overhang (Figures 28–30, Color Plate V; Color Plate XIV illustrates the related eastern Maroon technique of painting carved wooden paddles). During the 1970s, many of the new houses built by Maroons were based on a model seen in coastal Suriname, with shuttered windows, flatter roofs, full-size doors, cement floors, and complete plank (or sometimes cement) construction. In addition, corrugated zinc, which had been introduced as roofing on the houses of particularly wealthy men ten to twenty years earlier, became extremely common.

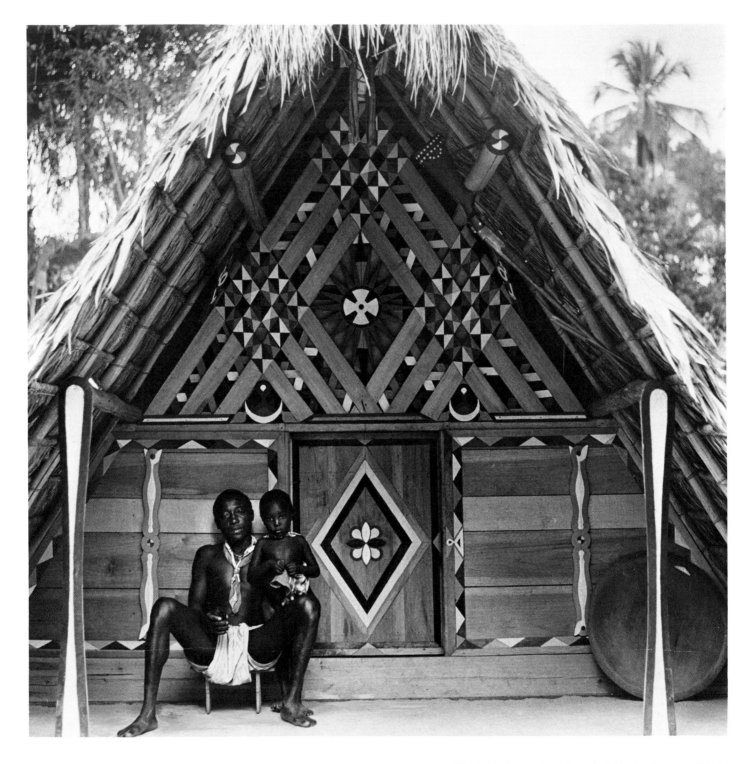

30. Djuka house (Jean Hurault, *Africains de Guyane*). Note the painting on the ends of the upper roof beams and the decorative application of tacks to the shotgun hanging under the roof.

2 ART AND AESTHETICS IN MAROON LIFE

The Pervasiveness of Art and Aesthetics

One morning in 1976, in a village on the Pikilio, we came upon three women who were working and talking in an open-sided house. Among them, they were engaged in the production of designed manioc cakes, an elaborate hairdo, carved calabash bowls, and decorative calfbands, casually combining individual artistry, mutual cooperation, and lively aesthetic discussion. One woman had brought a supply of manioc flour and set up a large round griddle over a barely smoldering fire, and was baking the large, dry cakes which would eventually be broken in pieces, dipped in water or broth, and eaten. The second woman sat on a small carved stool with a clean, wet, hemispheric calabash shell on her lap and a collection of broken bottle pieces in a scrap of cloth on the ground. Next to her, the third woman sat on an old cloth on the earthen floor, legs outstretched and a bottle on her lap; with a sharpened umbrella rib she was fashioning a pair of cotton calfbands for her husband, using the bottle as a form to create an evenly circular band. The first woman spread her manioc flour deftly over the dry griddle, drew her fingers over the entire surface to form particular decorative patterns, and carefully sifted a thin layer of flour over the top (Figures 31 and 264c). While each cake was baking, she worked on a hairdo for the woman with the calabash, standing behind her to part the hair into sections and to braid each one as part of an overall design. Those around the face protruded forward and were secured with hairpins shaped out of aluminum wire; those in the back were linked in a pattern known as "insertions"; and a long tightly braided line of "ground hair" ran between (Figure 32). The woman with the calabash, well known in the village for her sense of design in this decorative art, was marking several designs as a favor to the woman sitting next to her, who would later finish executing the bowl carvings herself. As she worked, she constantly rotated the prepared shell between her hands, trying to remember just how a particular design went, and adjusting the calabash to the proper position for each curved line. She discussed with the woman sitting at her side the design they wanted to replicate, and finally, when neither could recapture the exact way the appendages were curved, she settled on a new version which, she later concluded, came out even better than the original (Figure 33). The third woman, working steadily around the calfband, enlisted the advice of her friends concerning the width of the red and yellow stripes that formed its center. As the three of them worked, their conversation alternated between village gossip and discussion of their artistry.

This gathering, typical of many others, reflects several generalizable features of artistry in Maroon life: the pervasive influence of aesthetic considerations in all areas of life (from food preparation and service to clothing and grooming), the active participation of all adults in a wide range of artistic endeavors, and the enjoyment of discussions devoted to all aspects of artistry and aesthetic evaluation. The degree to which "art" permeates Maroon life has consistently been remarked upon by outside observers. As Herskovits noted, "Bush Negro art in all its ramifications is, in the final analysis, Bush Negro life" (1930:167).

Both graphic and performing arts have been elaborately developed by the Suriname Maroons. Visual media include, for example, woodcarving and painting, different techniques of calabash carving, designs baked into manioc cakes, narrow-strip textiles, embroidery of many kinds, appliqué, body cicatrization, hairdos, the carving of designs on imported metal spoons, the manufacture of carved aluminum combs, decorative beadwork, colorful yarn tassels, "crocheted" calfbands, a kind of "knitted" multicolor ribbon, and so on, all of which display significant ranges of both technique and style.

The performing arts, discussed in greater detail in Chapter 6, are equally extensive. Specialized dance forms are performed by the mediums of each type of possession god, and there are many secular dances, each of which is enjoyed in a particular social context. Highly distinctive song styles are used in the whole range of Maroon ritual events (from complex funerary rites to the domestication of a new possession god), in communal labor (e.g., felling trees

31. Designs baked by Saramakas into manioc cakes: a) "Dog's paws [in the sand];" b) "parallel stripes;" c) "sieve;" d) "curved fingers;" and e) an unnamed pattern. (Here, and throughout this book, order of images—as indicated by a, b, c, etc.—is left to right or top to bottom, unless otherwise indicated.)

or hauling logs) and in many casual and even solitary settings; it is rare to walk through a Maroon village without hearing someone singing. Drums are used singly or in various combinations to accompany different secular dance forms; to announce, supervise, and comment on the proceedings of large public council meetings; to communicate with each kind of possession god, with other deities, spirits, and ancestors; and so on. There are other musical instruments as well—from bells and wooden trumpets to a gourd stringed instrument and a "finger piano." Finally, the verbal arts—folk tales, play languages, proverbs, oratory, possession speech, and prayer—embody a wide range of stylistic modes in the tribal languages and keep alive a large number of completely distinctive esoteric languages.

In addition to being extremely rich and varied in form, the arts of the Suriname Maroons are unusual in the extent to which they have traditionally been practiced by the entire population. In contrast, for example, to many African societies in which certain individuals trained as "artists" produce sculpture, carving, etc. and sell it to others (and in some of which even the role of "critic" is a recognized specialization—see, for example, Thompson 1973), Suriname Maroon expectations include the assumption that *all* adults will be active artists and assertive critics.

Within this pattern of highly generalized artistic production, some kinds of specialization are nonetheless present. The most obvious and important of these is artistic specialization according to sex. In terms of media, for example, only men carve in wood, and only women compose narrow-strip textiles. There are also important stylistic differences in media exploited by both men and women. In embroidery (which is always sewn by women, but may be designed or "marked" by either sex), men's designs are geometric, angular, and rigorously symmetrical, while women's tend to be more free-form and curvilinear (Figures 34–35). Calabashes—which may be designed either by men or by women—follow the same stylistic division (Figure 36).

Furthermore, some specialization of artistic production grows out of the recognition of differential talent and enjoyment of artistry; in all media, the work of certain individuals is generally considered especially beautiful. These individuals have not traditionally taken on a special role as "artists" in their community and there has not, until recently, been a local "market" for their work. They have always, however, been rewarded by the admiration of their fellows, and occasionally asked to help design an object which a friend or kinsman is preparing to execute. Thus, a woman may ask a man to pencil a geometric design onto a neckerchief and to specify the colors she should use to embroider each line segment. Or, as we saw earlier, one woman may ask another to carve a calabash for her or to mark the outline of a calabash design. The enlisting of artistic talent has, however, most often been confined to an advisory level; it has tended to supplement and enhance, but not to substitute for, the active production by every adult of objects in a wide range of media. Likewise, in the performing arts, the recognition of special talent in no way diminishes the importance of generalized participation by all adults (and children) in the various forms of song, dance, and drumming appropriate to their sex. The performances of a well-known singer or dancer are accorded special attention at any communal event, but *everyone* is expected to dance and sing; these activities are considered part of being an able-bodied human being.

The breadth of Suriname Maroon "art" is, however, due to more than the very generalized development of productive and performing skills; not only their own wide variety of formal arts, but the entire environment—from gardens and postures to tin lanterns and outboard motors—tends to be viewed from an aesthetic perspective. Manufactured items imported via the coast from China, Japan, the Netherlands, the United States, and elsewhere—including guns, buckets, trade cotton, bottles, lanterns, and so on—have formed a substantial contribution to the material culture of Suriname Maroon societies since the very earliest days of their formation.

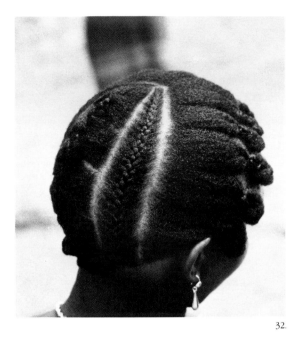

32.

33.

32. Three named hairbraiding patterns

33. Saramaka calabash drinking bowl, carved by Keekete, Asindoopo, 1970s.

36

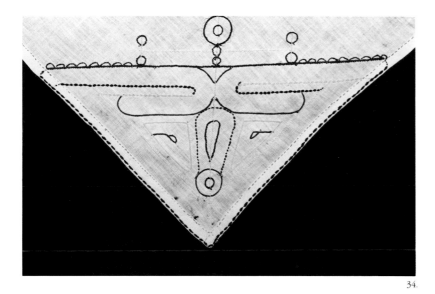

34.

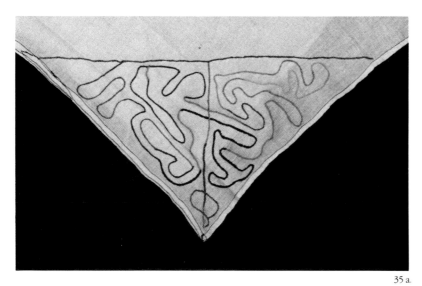

35 a.

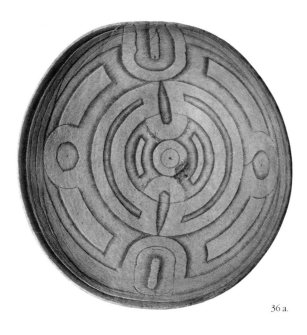

36 a.

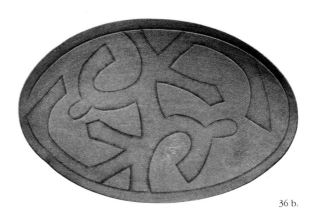

36 b.

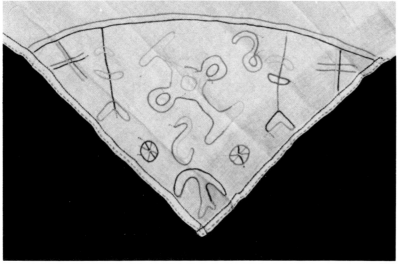

35 b.

34. Saramaka man's neckerchief sewn in the 1960s. The design was marked in pencil by a man, then embroidered by a woman. Colors include black, blue, yellow, pink, red, green, and orange.

35. Saramaka man's neckerchiefs sewn c. 1950. The designs were marked and embroidered by women. Colors include yellow, red, and blue.

36. Two Saramaka calabashes: a) unusual drinking bowl with design marked (with compasses) by a man, then carved by a woman—Finuwomi and Keekete, Asindoopo c. 1960; it is rare for a man to design the interior of a calabash; b) hand-washing bowl designed and carved by a woman of the Pikilio in the 1950s.

The men who have usually bought these objects at the end of lengthy wage-labor expeditions outside tribal territories (in coastal Suriname, French Guiana, and elsewhere) select their purchases very carefully from the full range of products available. In addition to basic utilitarian features, the different perfumes of soaps, the slightly varying proportions and finishes of tin lanterns, the colors of different cloths, the fringed edgings on cotton hammocks, and the curve of the handles on aluminum pots are all subjected to scrutiny. Once brought back to the home villages and distributed to wives and kinsmen, the chosen articles are resubmitted to the same kind of exacting evaluative examination. The most successful purchases are displayed with pride, serve as the inspiration for songs of admiration, and are understood to reflect the care and aesthetic sense of the man who bought them; many are also given names reflecting their own physical features, the circumstances of their first introduction into the region, or unrelated events that were contemporaneous with their arrival (see Chapters 3 and 7). These objects are often further embellished in the villages; for example, metal spoons from French Guiana may be elaborately incised with designs found also in local woodcarvings, and pots are marked with simple carvings or red tape, both for identification and embellishment (Figure 37).

Children are included in this world of artistic production, performance and connoisseurship from a very early age, reflecting the firm expectation that they will, regardless of individual temperament, need the skills and aesthetic frameworks that will enable them both to participate actively in the whole range of artistry appropriate to members of their sex and to contribute to the aesthetic standards expected in *all* aspects of life. From the time children can stand, they are frequently and enthusiastically encouraged to "dance" to the rhythm of handclapping or thigh-slapping (Figure 38; see also Figure 39); six-year-old girls begin to learn the principles of narrow-strip textiles by fashioning three-piece aprons out of scraps of cloth too small for other uses; boys carve crude wooden objects such as combs and small paddles at an equally early age; and so on.

The early learning of artistic skills and aesthetic judgments is achieved without systematic formal instruction, as an unstructured by-product of the communal settings in which adults engage in artistry. As the scene described at the beginning of this chapter illustrates, artistic production is generally a highly sociable affair, with advice and commentary flowing freely around it. Because children are never excluded from adult activities, they overhear such discussions, and their own artistic attempts are greeted with the same kind of evaluative discussion, combined with selective ridiculing and reprimands. For example, a nine-year-old girl, sewing diligently on her fourth apron in two days, was once asked by her great-grandmother, "What on earth do we have here?!" and playfully addressed with a new name translatable as "Terrible Sewing." Her ten-year-old cousin, sewing with her, was then told that *her* apron was quite nice, though she should have known to turn all the seams toward the wrong side of the cloth. The younger child apparently did not take her derogatory play name lightly; five months later our field notes record that while sewing a blue border onto a white apron, she defiantly showed her work to her great-grandmother and announced that with *this* one, she was *not* "Terrible Sewing." The old woman then examined it critically, pointed out that the strips were slightly crooked, and asked the child why she hadn't asked for help in aligning them. The girl, looking hurt, said nothing, but returned with determination to her work. Five years later, when she was ready to marry for the first time, she would need to be an accomplished seamstress and to know the principles of narrow-strip textile composition; a narrow-strip cape of the bride's own making would be just one of the many gifts required to conclude her marriage. The Maroon child's introduction to artistic life is thus accomplished through casual conversation in the course of everyday play and social interaction. Although woodcarving skills are envisioned as being passed from father

37. Maroon men sometimes buy metal spoons in French Guiana and decorate them with woodcarving tools. The illustrated spoons were made in 1961 by Ti Asakon, Ba Adan, and Ba Yesyintu, all of Diitabiki.

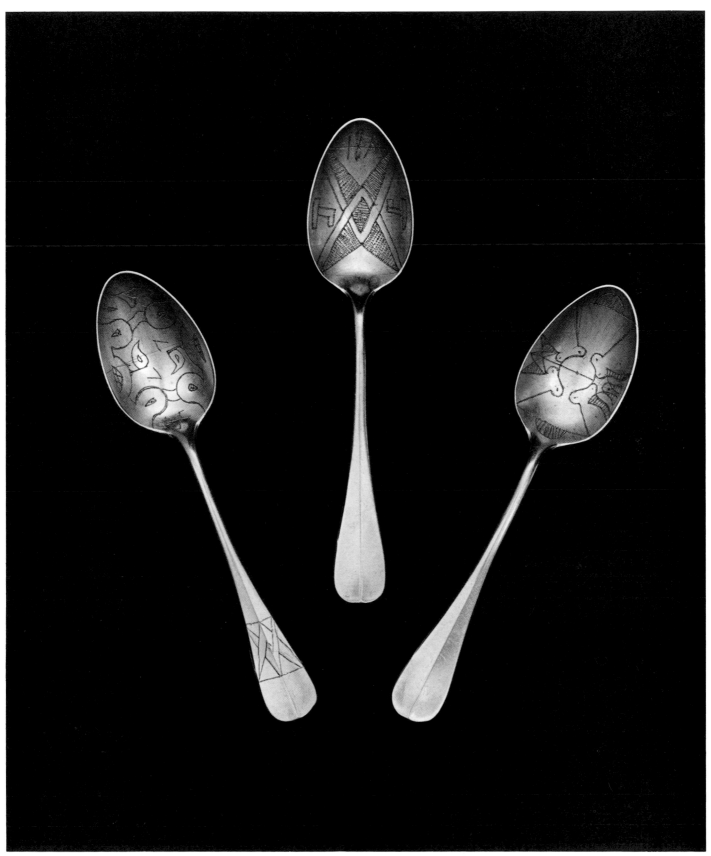

to son, there are no formal "apprenticeships" under chosen experts, and much of a child's understanding of aesthetic ideals is derived from listening to adult conversations.

The same openness of artistic life and pervasiveness of aesthetic discussion which characterizes the education of Maroon children also shaped our own understandings of Maroon art. The frequency of casual visiting within the Saramaka village where we lived and the amount of artistic production and discussion that took place in those settings combined to form an inexhaustible source of natural exegesis, spontaneous evaluative remarks, and unsolicited commentary on aesthetic principles and technical details. These settings provided the basic framework for our introduction to Saramaka aesthetic life—which was then supplemented through work with individual Saramakas and extended to other Suriname Maroon tribes through further field interviews, museum work, and reading of the comparative literature. Within the context of anthropological studies of art, this field situation would seem to lie at one extreme in terms of the degree to which it allowed observed artistic activity and overheard aesthetic discussion (rather than formal analysis of the finished artifacts or discussions structured by the anthropologists' questions) to determine the shape of our understandings.

It might be noted that this kind of casual but detailed commentary characterizes many other areas of Maroon life as well, affecting both our fieldwork methodology and our view of cultural process in these societies on a daily level. Likewise, the expectation that everyone achieves a basic competence but that individuals are not equally "gifted," that we noted in the sketch of the three women, is common to many different areas of life. In rituals, the recognition of "masters" of particular kinds of rites in no way tempers the fact that everyone joins in during the frequent and highly animated debates concerning the proper way to carry out each detail. A similarly lively tone marks discussions surrounding almost any "traditional" activity. For example, in the filling of the Amerindian-made basket that is presented to a woman at a particular stage in the establishment of a new marriage, the groom's own plans for its contents are subject to the unrestrained commentary of others who gather to observe the packing of gifts. Through extensive discussion which alternates between praise and ridicule, jokes and earnest comparative discussion, kinsmen (and sometimes others) are able to exercise a significant influence on the details of this important gift of marriage which Maroons believe, at least in principle, should be determined by "tradition."

These kinds of informal exchanges form the lowest level, the "mechanics," of the very important process of cultural perpetuation and change—a process that, as we will see, is crucial to the understanding of the nature of Suriname Maroon art, and life in general. Such scenes embody the subtle confrontation between individual and community-wide notions of propriety and aesthetics, between innovation and tradition, and between the diverse cultural ideas of men and women, young and old, and the inhabitants of different villages, regions, and sometimes tribes. The result is inevitably a compromise of some sort, an opportunity for the participants both to confirm and modify established cultural patterns.

In matters of decorative artistry, such discussions are often phrased in terms of the aesthetic and artistic differences among individual artists, among different villages, and among tribes. Rather than noting how a given object fulfills general "classical" standards for its type, Maroons tend to devote their attention to the features that mark its particular position in time and space. Overheard discussions make clear that Maroons agree unanimously on very few details of artistry and performance, and that they are unusually tolerant of—and fascinated with—the features that mark generational, regional, and individual diversity.[9] This contrasts with discussions about rituals, in which issues tend to be conceived and presented more as matters of right and wrong, and participants aggressively defend their knowledge of the details of traditional custom by making frequent

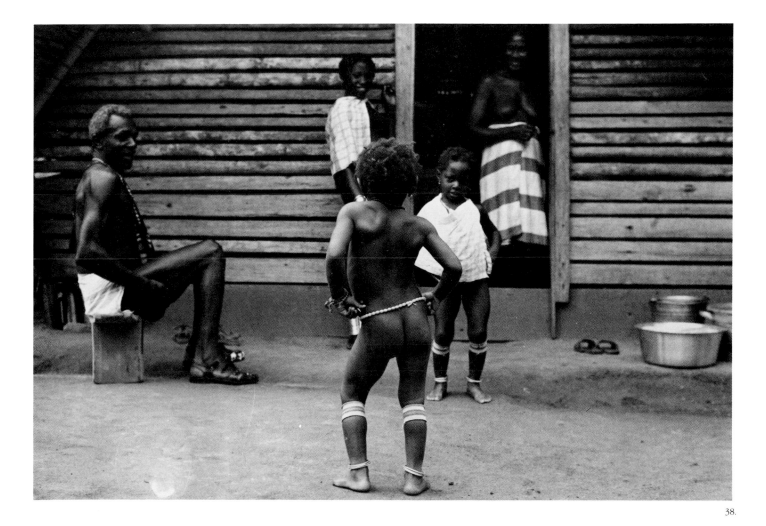

38.

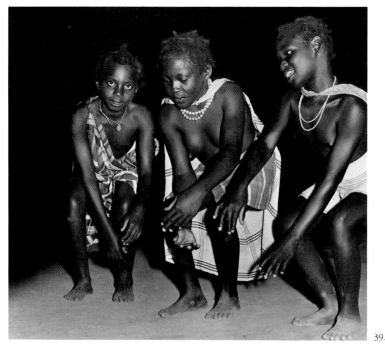

39.

reference to their sources of information—either observed precedents or the
authority of elder kinsmen.

Artistry in Social Life

The central role of artistry in Maroon social institutions—particularly mar-
riage—also contributes importantly to aesthetic ideas. In discussing art with
us, Maroons very often concluded their explanations of the formal, symbolic,
or technical features of a particular style or medium with comments on the
social uses of the objects—most frequently an enumerative list of the gift
exchanges appropriate to particular situations (life crisis rites, welcoming a
husband returning from the coast, etc.). For example, a woman who had been
asked about the components of women's formal dress interpreted the question
in terms of a particular situation for which formal dress would be required—
a woman's first visit as an affine to her husband's village—and digressed at
length on the subject of the foods, clothes, and other objects that the woman
would bring in her basket as gifts to her husband's kinsmen. Men rarely dis-
cussed particular woodcarvings without referring, not only to the artist, but
also to the woman for whom the woodcarving was made, and the details of
the couple's relationship at the moment each piece was given. Just as dance,
song, and drumming are conceptualized firmly in terms of the social events
at which they are most frequently performed, the "meaning" of a particular
artistic object is closely bound up with the social context for which it is intended
(see Chapter 7).

Together with fish and game, garden and forest products, and Western im-
ports, artistic objects contribute importantly to the fulfillment of a variety of
social relationships, from voluntary formal friendships and ritual clientage to
ties of kinship and marriage. Most important among these is the conjugal
relationship; woodcarving, calabash carving, textile arts, and bodily adornment
are generally intended to serve in the ongoing campaign of every adult to
attract spouses and lovers and maintain their affection over time. The comple-
mentary participation of men and women in subsistence tasks (including artistic
production) contributes to the solidarity of a wide variety of male-female re-
lationships; a man may carve a paddle or clear a field for his mother, a woman
may greet her brother upon his return from the coast with some rice she has
grown and winnowed or a new pair of calfbands she has made, and so on. By
far the greatest bulk of such exchanges, however, are those between spouses
or prospective spouses. Furthermore, exchanges of goods and services between
spouses (and, at certain stages of the relationship, between affines) tend to be
more formally acknowledged and more carefully reciprocated than others.
Even when a man is on the coast for a several-year period of wage labor, he
sends periodic gifts back to his wife (or, in the case of a girl's first marriage,
his wife-to-be), and she in turn works on the "thanks" that she will present
formally to him upon his return (see below). All conjugal exchanges, whether
of goods or services, are conceptualized in terms of an etiquette of direct
repayment, referred to as "giving thanks." Thus, a woman who scrapes clear
the ground around her husband's house is "given thanks," perhaps by the
presentation of a carved comb or a new cloth. Likewise, a man who carves a
food stirrer for one of his wives will receive in return a small gift, such as a
bottle of palm oil that she has made. Even in very small exchanges, the recipient
of each gift is careful to display it to many other people and to discuss at length
how "big" (generous) it is (see R. Price 1975b:58; S. Price 1978).

Something of the tone of conjugal gift exchanges may be illustrated by a
Saramaka woman's description of a husband's return from the coast—just one
of the many institutionalized contexts in which gifts, including artwork, are
presented.[10]

> The woman works on art while her husband is away on the coast.
> She does everything—gathers palm nuts [to make oil for him], makes

calfbands, sews things, and on and on until her husband finally returns. The husband and wife sleep together for three nights. On the fourth day he gives her coastal goods. [On the third day] he loads up a trunk, maybe 100 cloths, maybe 70 or 60 or 50 or 30. He and his kinsmen will load up the trunk till it's full, then put it aside. Then they pull over the soap crate and the kerosene drum—just slide it right on over. Then they take buckets, machetes, cooking tripods, and set them there. Finally they take all those enamel and metal things from the coast—dishes, pots, spoons, knives, chamber pots—and they put those there too. They get them all together. Then everyone sleeps until morning. Then the man calls the woman and he says, 'Well, wife, come look at some presents your sisters-in-law have for you.' And his sisters arrive at his house. They pick up the trunk—*kidé kidé kidé* [the rhythm of their walking with a heavy load on their heads]—and carry it to the woman's house. They come back and get the kerosene drum—*kidé kidé kidé*—over to the woman's house. Now they get all the goods and load them up in the woman's house. [Here the speaker pantomimes the wife, coyly looking at the floor, fingering the hem of her skirt, and squirming, embarrassed, on her stool.] Well, they'll load up things until they're completely finished. Then they'll say, 'Well, sister-in-law . . . well, woman, don't you see? Here's a little something for you, that we're giving you here, since your husband's gone and come back.' (Only the sisters-in-law are present; the husband is back in his own house.) The sisters-in-law will address the woman, 'Woman!' She answers shyly, 'Yes?' 'Well, woman, the things here are really nothing. But here's just a little something for you. Here's a little salt for you, so you can boil some taro leaves for us to eat. We've brought some goods to give you.' Then everyone really celebrates in that house! Then the woman says 'Listen to me!' and she jumps up. She'll load [into an enamel basin] some calfbands. She'll load some narrow-strip cloths. She'll load some cross-stitch cloths. She tells the others 'Take these to the man for me.' And they'll set everything on their heads and carry it off to the man. The woman will stay in her own house, rejoicing over her presents while all the others go off to the man's house. Then the man will say, 'Well here's something for you to take over to the woman.' This last present can be anything from the coast—any kind of dishware, maybe an aluminum water jug. . . . They bring it over and say 'Woman, don't you see? Here's something that your husband sent over for you.' The wife will jump right up—*vúúúú!* She'll grab the one thing that she hasn't yet given him and, right there, she'll give it to her husband's lineage. She'll always have one thing held back, to give him separately. It could be some cross-stitch or an embroidered neckerchief, or whatever. 'Take this thing here; go drape the man with it for me' [a way of thanking his soul]. After her gift is presented, shouts will ring out *wooooo!!* 'My goodness! The woman has really pulled the goods to the ground!' That means that she hasn't been shamed by having too little to reciprocate his gifts. That's what's known as 'pulling the goods to the ground.'

The fact that most woodcarving and sewing is intended as gifts of courtship or marriage and that handsomely carved calabashes are used principally in the presentation of meals by a woman to her husband allows these arts to carry a very generalized sexual significance. Both men and women think of many of their material possessions in terms of the relationships which they, in a sense, symbolize. Saramakas, who nearly always deny sexual symbolism on the level of particular motifs, sometimes suggest that *all* woodcarving and calabash art is alluding abstractly to the same thing; "husband-and-wife business is what they're really all about." Djukas and Alukus may be inclined to conceptualize sexual symbolism somewhat more explicitly. (See Chapter 7 for a fuller discussion of this aspect of Maroon art.)

Commercialization

During the 1970s in Upper River Saramaka, and somewhat earlier among other Maroons, the growing use of money within tribal territory has modified the place of art in social life to a limited extent. For example, there are now for the first time a few men on the upper Suriname River who carve in wood on a fairly full-time basis, selling their products to both Maroons and outsiders, and using the money for their own subsistence needs.[11] Such concentrated, commercial artistic activity in the villages not only creates a specialized role for the artist, but also allows his clients to narrow the range of their own artistic and subsistence activities. This trend toward specialization, a direct outgrowth of the recent introduction of the use of money into societies which previously had little internal money flow, is beginning to influence not only the sociology of artistic production, but also subsistence patterns and social relations much more generally. Thus, while hunting, fishing, the clearing of forest gardens, woodcarving, and so on have traditionally been performed on a regular basis by literally *all* able-bodied men (until the early 1970s in Upper River Saramaka), both opportunities and expectations are beginning to change. One man from the Pikilio, for example, has begun setting fish traps as a regular occupation; because of the new availability of cash—for men and even some women—he is able to find customers, and can use the money to buy goods and services which, ten years earlier, he provided for himself.

This development promises to lead to the most fundamental social and cultural consequences these societies have felt since the beginning of widespread emigration of men to the coast in the last century (see R. Price 1970a). In terms of the commercialization of subsistence activities such as hunting, fishing, or garden clearing, the traditionally unquestioned moral sanctions which have insured cooperation and sharing among kinsmen are beginning to compete with the temptation to sell products and services for individual profit. Women without husbands are the most acutely concerned with the potential consequences of this kind of shift in subsistence patterns; in addition to resigning themselves to a lower standard of living, many of them are attempting to make up for their lost resources by entering the incipient monetary economy as well—selling garden products to the local mission hospital, charging money for favors that were until recently exchanged more or less in kind, sending decorated calabashes to the city to be sold rather than distributing them to friends and kinswomen, and so forth—thus confirming and accelerating the process.

In terms of artistic products, the trend toward specialization and commercialization—which, it must be stressed, is as yet fairly limited in scope—is further complicated and encouraged by the growing interest of outsiders in the "available culture" of Maroons. Tourism has grown significantly in the past decade; while the arrival of an outsider in the Saramaka Tribal Chief's village was, ten years ago, an event of major local interest, visitors now come and go without a great deal of comment—one even flying his own one-engine plane for an occasional Sunday afternoon outing. Needless to say, the objects with which these visitors document their exotic adventures acquire, through the bargaining process, monetary associations which contrast with the values attached to them in their own social and cultural setting.

Maroon art has, of course, been purchased on an occasional basis by outsiders for a long time. We have no details concerning the field procedures of nineteenth-century collectors, but some idea of the bargaining which surrounded the acquisition of collections from the early twentieth century is available. The Herskovitses, in describing their efforts to persuade one woman to sell them a peanut-grinding board (Figure 40), make painfully clear the ultimate impotence of Maroon perceptions of value in the face of pressure from cash offers. Following a lively discussion with the Herskovitses of the symbolism of its motifs, and then their suggestion that they

40. A Saramaka peanut-grinding board which the Herskovitses describe buying from an Asindoopo woman in 1929. For a detail of the carving, see Figure 265b.

might care to acquire the board, the woman became apprehensive. She took up the board, and excusing herself, disappeared with it inside her hut.

'No, no,' she called from the house, when her brother went to tell her of the offer we had made for it. 'I don't want money for it. I like it. I will not sell it.'

The sum we offered was modest enough, but not inconsiderable for this deep interior. We increased it, then doubled our original offer. There was still no wavering on the woman's part, but the offer began to interest her family. Such wealth should not be refused. Bassia [Assistant Headman] Anaisi began to urge her in our behalf.

'With this money you can buy from the white man's city a hammock, and several fine cloths. You should not refuse this.'

The old woman took up the discussion, then another sister, and a brother. At last the bassia took us aside, and asked us to leave his sister alone with them.

'We will have a krutu [meeting], and tomorrow you will hear. She is foolish not to sell. But she cares for the board. It is good, too, when a woman loves what her man has carved for her. We will krutu about it, and you shall hear.'

Three days passed before the woman's permission was given to dispose of the piece.

'When they see this, your people will know our men can carve!' she exclaimed in a voice which held as much regret as pride [Herskovits and Herskovits 1934:281].

Not only is the sale of Maroon artwork generally an exploitation of the Maroons' situation, but the rhetoric with which it is conducted often transgresses fundamental Maroon codes of etiquette. For example, visitors generally insist on haggling over prices, perhaps because of stereotypes derived from such areas of the world as Mexico or the Middle East; but Maroons view bargaining as rude and offensive. In transactions among themselves, the seller calls the price on anything from a bunch of bananas to a new canoe, and differing opinions about the product's worth are discreetly avoided.

At issue in such confrontations is whose system of valuation will prevail. The outsider's insistence on imposing his own scale of value reflects an unselfconscious cultural arrogance. Many commentators willingly describe their tactics—both as a way of communicating what they consider the "childlike irrationality" of Maroons and as helpful advice to others who might wish to acquire

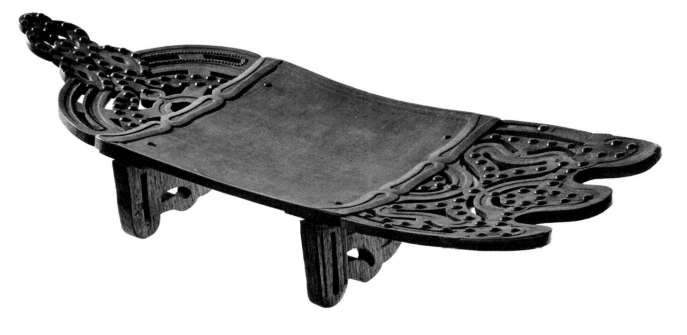

Maroon art. For example, Morton Kahn, who made the great collection now at the American Museum of Natural History in New York, characterized the women with whom he had to deal as follows:

> They laugh, giggle, put their finger coyly in their mouths, joke bashfully with bystanders, and cannot make up their minds as to the price. They never know how much to ask for a piece. Sometimes they will mention a preposterous figure, hoping like a naive child that the strange bahkra [outsider] will pay that much. But on such occasions a rebuke will make them more reasonable. Once an arrogant witch doctor intervened in a transaction with a Bush Negro woman, demanding angrily that she receive an exorbitant payment. His anger was squelched with a few sharp words, and, contrite, he sat up all night to carve an ornate implement to present to the bahkra as a peace-offering. Cunning Adjobo, the medicine man! [1931:196].

Within the context of life in their own villages, the sale of art represents one of the most unevenly balanced encounters between Maroons and outsiders. In setting minimal standards for the behavior of visitors, in maintaining the prerogative to send visitors away, and in rejecting interference in internal politics and social control, Maroons have been relatively successful in maintaining control over their own territory. However, because of the material poverty of most Maroons (from the perspective of the Western market economy) and the totally incomparable resources of outsiders, pressures to sell personal belongings are often irresistible. Women are the most frequent victims of this imbalance, both because they are the ones who own the most woodcarvings and because they have few other sources of cash. The encounters described by the Herskovitses and Kahn have been repeated innumerable times by enthusiastic visitors to the interior. Maroon women have consistently fought, not for higher prices, but for the right of possession, and the right to define the meaning and value of a particular object in their own way, and they have generally lost.

One consequence of this dreary process is that the ownership of masterpieces of Maroon art is gradually being transferred from Maroons to non-Maroons. Although Maroons participate in this transfer only because they desperately need the money it provides, it is not they, but the buyers, who reap the ultimate profits.[12]

3 PERSONAL ADORNMENT

One of the most distinctive features of Maroon life is the high value placed on individuality, the special pleasure people take in the subtle characteristics that contribute to an individual's uniqueness as a person. There is a strong, pervasive belief that past events and actions condition the present in very specific ways, for individuals as well as for the larger society, establishing a very special social identity for each baby born into the community. Furthermore, the individualization of personalities is thought of as a progressive, ongoing process which continues even after death. At birth, such considerations as which gods had been invoked to lend assistance during the pregnancy, or whether the birth was a breech delivery, establish special ritual relationships and obligations that persist for the rest of the newborn's life (Color Plate VI). During childhood, a person's social identity is further distinguished from that of full brothers and sisters, first through formal recognition of a particular ancestor as a supernatural participant in the act of conception, and later through decisions about who will have primary responsibility for the child's upbringing. Throughout a person's lifetime, there is a strong emphasis on commemorating specific events, for example through the addition of new personal names and individualized ritual prohibitions (see R. and S. Price 1972b). The events thus commemorated are not the standard life crisis rites through which everyone passes, but tend rather to be incidents more or less unique to the life of a particular individual. Even long after death, people are honored with ancestral rites which reflect their special food preferences and other personal idiosyncrasies, and they are given a continuing and active role in daily life—through various types of divination—as expressive, highly individualized personalities.

It has been argued that this special appreciation of individual distinctiveness, which is found to a variable extent in many Afro-American communities, may have originated at least in part as a reaction to a system of plantation slavery in which individual identity came under fierce attack.

> While the greatest shock of enslavement was probably the fear of physical violence and of death itself, the psychological accompaniment of this trauma was the relentless assault on personal identity, the stripping away of status and rank, the treatment of people as nameless ciphers. Yet, by a peculiar irony, this most degrading of all aspects of slavery seems to have had the effect of encouraging the slaves to cultivate an enhanced appreciation for exactly those most personal, most human characteristics which differentiate one individual from another, perhaps the principal qualities which the masters could not take away from them. Early on, then, the slaves were elaborating upon the ways in which they could be individuals—a particular sense of humor, a certain skill or type of knowledge, even a distinctive way of walking or talking, or some sartorial detail, like the cock of a hat or the use of a cane [Mintz and Price 1976:26].

But the enjoyment of body arts as an expression of individuality grew out of strong African tendencies as well. One eighteenth-century observer in Suriname, for example, described how, at the end of the nightmare of the Middle Passage

> all the slaves are led upon deck … their hair shaved in different figures of stars, half-moons, &c., which they generally do the one to the other, (having no razors) by the help of a broken bottle and without soap [Stedman 1796, I:205].

The arts centering on the human body take on a special significance among Maroons, for whom the individuality of each person is defined and confirmed at least in part by the image he allows himself to project through postures, hairdos, cicatrization, clothes, and jewelry. Though styles of adorning the human body have changed repeatedly over the years, pictorial documentation of the

See page 65 for Color Plate VI.

Maroons makes clear that the hardships of life in the Suriname interior were never able to diminish the importance and creativity of these personal arts (Figures 41–44). Indeed, Stedman claimed that the way to distinguish Maroon rebels from slaves was by the fact that they had special braided hairdos (1796, II:88 and Plate 53). German missionaries living among the Saramaka in the eighteenth century tended, because of their own prejudices, to minimize the aesthetic sensibilities of their hosts, but occasional passages in their diaries bear inadvertent witness to the Maroons' strong interest in fashion. One, for example, described his boatmen preparing for arrival at their home village after a trip to Paramaribo:

> Each of them opened his carrying case, in which was the clothing that they wear either in Paramaribo or on ceremonial occasions. They dressed themselves in the best manner they could. Our very proud commodore, Akra, was particularly odd in the manner in which he dressed. Through his bartering in Paramaribo he had acquired a magnificent nightshirt which had been made at Zitz and for which he had been charged 50 guilders. He put this on, tied on a sword and sash, and wore a hat with braid on it. With this ridiculous attire he gave his comrades orders which he repeated with solemn formality. I had a difficult time suppressing my laughter when I saw him. When our muskets were finally loaded, the Negroes set out, proud of their finery, and continued the trip in a very uncommon silence [Staehelin 1913–19, III ii: 197].

Throughout Maroon history, fashion has provided an important idiom for the expression of regional as well as individual identity. Certain differences in the clothing worn in different regions are clear indicators of tribal membership. For example, among the eastern Maroons, adolescent girls fold their aprons over the waist tie so that the upper flap is visible (Figure 43), while Saramakas tuck it in against the body (Figure 52); eastern breechcloths are significantly narrower than those in Saramaka; Djuka women have until recently tied their skirts with a red sash topped with a black (often tasseled) tie, while Saramakas use a folded kerchief with the point at the back (Figure 46); the corners of eastern capes are simply tied together rather than being attached with special yarn or cloth ties like those of the Saramaka; and eastern Maroon and Lower River Saramaka women have sometimes embellished their skirts with elaborate embroidery designs, while Upper River Saramakas have generally limited skirt embroidery to relatively simple edging stitches. Within such regionally "standardized" outfits, however, there is considerable variability according to age, social status, context, and personal style. Maroon modes of dress serve as clear statements of the special status of a person in mourning, the contrasting roles of a woman in her own and her husband's village, the different behaviors appropriate in casual settings, council meetings, and public dances, and so on.

Public events such as funerals, rites for local gods, or tribal council meetings are occasions for particular attention to personal adornment (see Chapter 6). Before leaving home, participants from other villages have their hair braided, scrape off unwanted facial hair around the neck and temples with a bare razor, and assemble clothes, jewelry, lanterns, umbrellas, and other accessories. Then, just before coming into sight of the village landing place, they stop their canoes at a rock in the river in order to bathe, apply sweet-smelling lotions, change into clean clothes, adjust jewelry and accessories, and assume the special postures and tones of speech which reflect their role as visitors to an important community event. Such elaborate personal preparation just prior to arrival in a village has apparently been practiced throughout Maroon history; the missionary account quoted just above documents it for eighteenth-century Saramaka, and de Goeje gives a similar description for Djuka in the early twentieth century (1908:1004).

41.

41. Aluku men, early 1900s

42. Djuka men from the Cottica River, 1920s

43. Djuka man and adolescent girl, early twentieth century

44. A Maroon headman and his wives, 1928

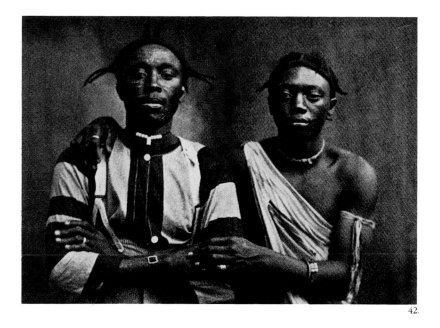

42.

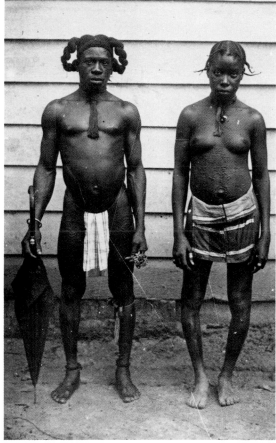

43.

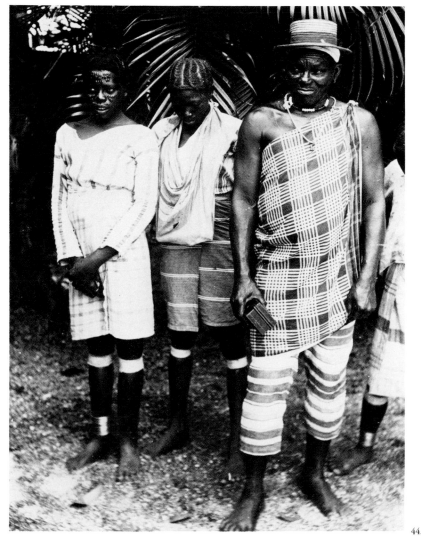

44.

The age considered most appropriate for experimentation in body ornamentation is young adulthood, beginning in the teens. This is the time when women have the largest number of cicatrization designs incised on their bodies; and young men are expected to indulge in creative and, from their elders' perspective, "outrageous" new styles, using goods that they have bought during their first extended period of wage labor on the coast.

Men's necklaces in Upper River Saramaka may serve as just one illustration of the kind of fads which characterize every aspect of dress. Stylish dress for young men at the turn of the century included bead necklaces that hung to the navel. Their sons' generation also made single strands of the same type of beads, but wore them over one shoulder and under the other arm. A decade later, it became the fashion to wear a single-stranded necklace of smaller beads that would hang all the way to the ground when the young man was standing. (If the necklace failed to reach the ground, the standard comment was that the wearer must have "picked it up off the ground"; but if it was long enough, people would compliment it as something "bought from a counter top on the coast.") Around 1930, young men began wearing white over-the-shoulder beaded jewelry of up to seven strands, accompanied by a thin silver chain around the neck. Later, gold chains replaced silver, and the all-white strands gave way to green, red, and transparent beads. During the 1960s the most popular necklace for men was a commercial gold chain with a cluster of three pendants—one of which was sometimes used to clean the ears, the other two to pick the teeth (Figure 47).

Similar successions of fads could be described for any of the Maroon groups. Among the Djuka, for example, where breechcloths have traditionally been smaller than in Saramaka or Matawai, young men in the 1960s ostentatiously flaunted breechcloths that reached to the ground. The appropriate compliment for a woman to make about such a garment was that its owner's [sexual] potency must be "forty horsepower"—referring to the most powerful outboard motors then used on the river (Figure 48).[13] At the same time, Djuka women were wearing handsewn patchwork bras and, around their waists, a red sash topped by a black cord (Figure 45). By the mid-1970s, both of these fashions had disappeared entirely and others had taken their place. Young Djuka men were experimenting with a variety of elements of Western dress, including, for example, thin plastic belts which they bought in Paramaribo and wore in clusters of three to five at a time. Djuka women had adopted commercial bras from the city and, as skirts, a double layer of colorful bath towels, tied at different sides and at staggered heights on the body. Among the Matawai in the 1970s, women were sewing patchwork capes and breechcloths composed of red, white and navy triangular bits of cloth; this style was accompanied by the same suddenness of popularity and excitement of high fashion as the contemporaneous but completely different rages in Saramaka and Djuka (Color Plate XIX).[14]

Legbands provide another example of the kind of stylistic variation Suriname Maroons enjoy in even narrowly limited artistic forms. A few Saramaka examples will illustrate.

Until the 1930s, both men and women often wore crocheted bands on calves, ankles, and even upper arms. Although the expense of imported yarns meant that most of these were made of locally grown undyed cotton, some also included red, white, and black commercial cotton crocheted into special designs that older Saramakas remembered from their childhood around the turn of the century (Figure 49a,b). Legbands were also embellished with protective charms well into the twentieth century, most commonly with a pendant made of cowrie shells and a raffia-like fiber from the Mauritius palm. By the mid-twentieth century, crocheted ankle and armbands had largely dropped out of fashion, and calfbands were no longer made in plain white, but sported a single stripe of color in the center, a set of very thin center stripes (the "chicken stitch"), or a wider pair of off-center stripes (the "rainbow") (Figure 49c,d). The edges were usually decorated with a thin line of color, added after the

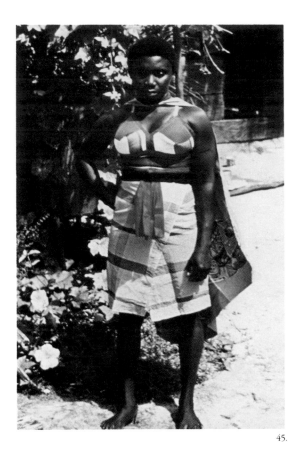

45.

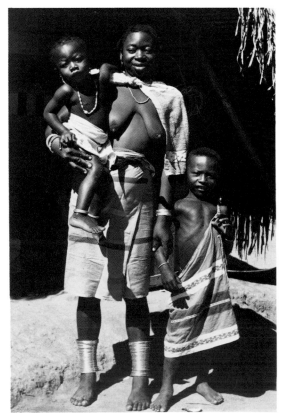

46.

band was complete, and a small braided tie made from threads that had been pulled from scraps of colorful trade cotton. After about 1940 these braided ties were replaced by fluffy pompoms, which have been gradually increasing in size since they were introduced (Figures 49e,f and 148a).

Today, most Saramaka crocheted bands are white calfbands with tassels and multiple, colored stripes, but the styles of earlier generations have been retained selectively by some villages. For example, the "rainbow" stripe is said still to be made in Guyaba; the wide stripes shown in Figure 49g are occasionally made on the upper Gaanlio; the "chicken stitch" is sometimes made in Pempe; and anklebands (Sar. *dongobá*) are still occasionally worn in the village of Botopasi (see Crevaux 1879:361 for an illustration of Aluku anklebands).[15] The occasions for which crocheted bands are worn also vary by region: Upper River Saramakas consider them most important for participation in funeral rites, while in many Lower River villages they are reserved for New Year's celebrations.

In addition to shedding light on Maroon attitudes toward personal adornment and artistic innovation, these details of fashion offer us important clues for the identification of otherwise undocumented artifacts. It is often possible, for example, to establish the approximate age of a Saramaka man's shoulder cape by noting the way it is tied. Most early twentieth-century capes were secured by tying the corners of the cloth together; either there were no ties at all on the corners, or the top of the cloth was cut with a triangular extension intended to be used for tying the cape. In the 1930s–50s, ties were made by folding strips of cotton cloth and sewing the edges together; later they consisted of braided or twisted threads of several colors that had been pulled from the edges of cotton cloth. Most recently, ties have been made with commerical yarns, twisted into a cord and ending in a large yarn tassel. Saramaka women's cape ties have also changed over time. Sewn without any ties during the early twentieth century, capes were later given short ties made from strips of cloth— a style which lasted until the late 1960s. Currently, women usually join the two upper corners of their capes with a single long strip of cloth which allows the garment to hang at the lower back rather than at the shoulders.

The strong interest that Maroons exhibit in the individuality of each person, in creative innovation and change and, more generally, in "style," have combined to produce an extremely varied range of "personal arts." The remainder of this chapter presents an overview of the more important of these—clothing, jewelry and other accessories, hairdos, and cicatrization—and explores some of the general aesthetic principles which lend them their special character.

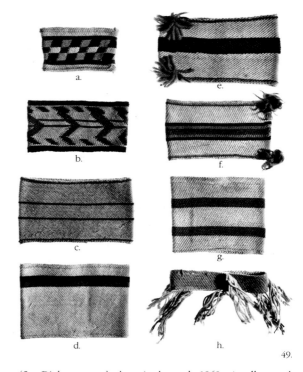

45. Djuka women's dress in the early 1960s. A yellow and blue skirt is tied with a red cotton sash, topped with a black yarn belt. The patchwork bra is sewn on a hand-cranked sewing machine imported from the coast; the cape is an aqua "calico" cloth.

46. Saramaka dress in the mid-1960s. This woman has secured a predominantly-orange skirt with a navy waistkerchief, and is using a commercial towel as a cape. Her son has borrowed her appliqué cape to dress up for the portrait.

47. An imported gold pendant popular among Saramaka men in the late 1960s.

48. Teenage boys wearing the long breechcloths which were fashionable in Djuka during the early 1960s.

49. Calfband styles: a–g) were made by Saramakas; h) was made by Carib Indians in Suriname. a) was collected 1932–38; b) in the late 1920s; c–g) in the 1960s; and h) before 1906.

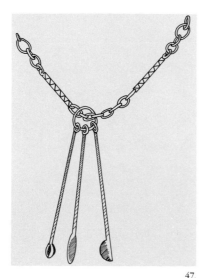

47.

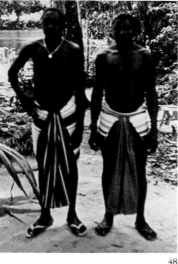

48.

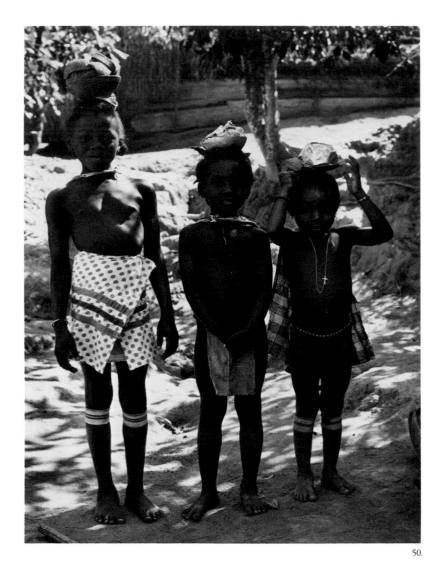

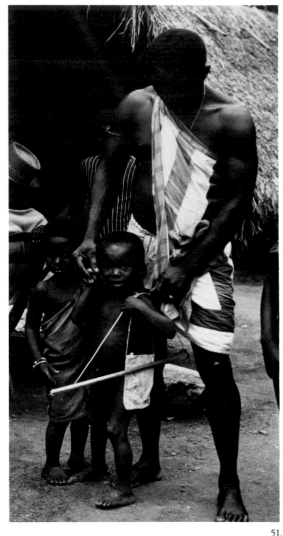

50.

51.

Clothing[16]

Stepping back, for a moment, from the details of high fashion and regional diversity, we may describe the basic elements of Maroon clothing: women wear two wrap-around cotton skirts, secured at the waist by a sash or folded kerchief, and a cloth tied over one or both shoulders; men wear a breechcloth and a cape tied over one or both shoulders.[17] Infants wear a tie of twisted cloth around the waist, and often a hand-sewn cap; girls also wear little rings in their ears, or at least a piece of string to maintain the holes pierced in early infancy. As children appear ready to begin walking, they are given their first pair of calfbands (known by a special term, and "knitted" rather than "crocheted" like other calfbands) and string anklets onto which a pair of tiny gourd rings have been threaded. Children are generally naked except for the essential waist tie and incidental accessories, but all children play at dressing up in the kinds of clothes they will later wear on a daily basis (Figures 50–51). Adolescent girls who are not yet old enough to marry wear a pubic apron tucked over their waist tie (Figures 43, 52, and 109).

Maroon men and, to a lesser extent, women have always also made selective use of "Western" attire. Shirts and trousers made from colorful trade cotton by coastal tailors, as well as a variety of imported hats, have been worn by men throughout Maroon history (Figures 41–42 and 44). The "long shirt" (similar to the eighteenth-century "nightshirt" described above) was standard formal

50. Saramaka girls dressed up for a play visit to their "husbands' village"

51. Three-year-old twins try out adult male outfits—a cape, a "gun," and a hunting sack

52. A Saramaka village headman and his wife's granddaughter

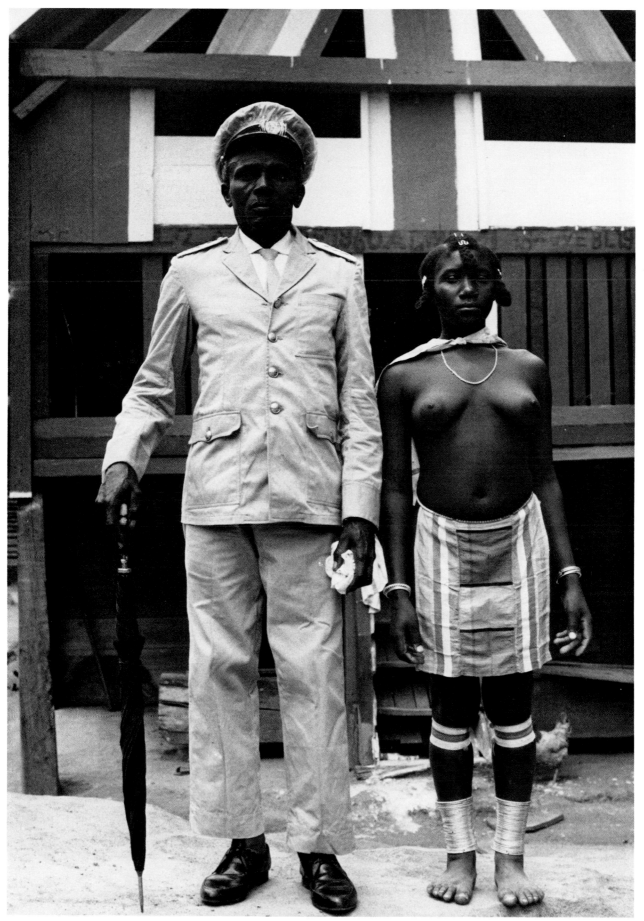

52.

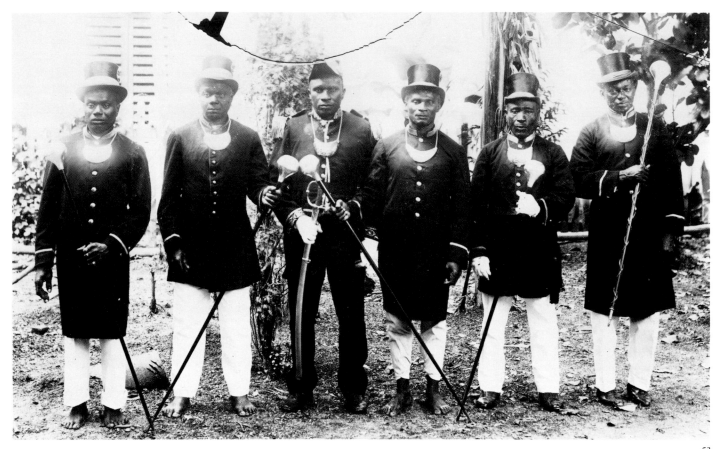

dress for Saramaka elders during the early twentieth century and for Djuka elders well into the 1960s (Figure 41 and Herskovits and Herskovits 1934: plate facing p. 24). Even today the everyday clothes of the Saramaka Tribal Chief in his own village are a modified version made, together with matching trousers, from colorfully patterned materials by Creole tailors in Paramaribo. Commercial thongs, trousers, shorts, shirts, and hats (from berets and golf caps to fedoras, Stetsons, and pith helmets) are now commonly worn, not only by men spending time on the coast, but also by those living in the villages of the interior.[18] Women's ownership of manufactured bras and city-style dresses varies considerably from region to region. Many Saramaka women of the Pikilio, for example, must borrow a dress from a kinswoman if they are taken to Paramaribo; others wear dresses in their own village only when they are feeling ill; Saramaka women in villages that are missionized or closer to the coast may own several apiece and wear them on an occasional basis in their own villages; many Djuka women now wear dresses, folded down at the waist, as a nearly standard outfit; Kwinti women wear dresses every day and Matawai women often tie a traditional wrap-around skirt over a Western-style dress (see Color Plate XIX). In addition, the several public officials in each village own government-issued uniforms which they wear at council meetings and when Suriname government officials visit the interior; chiefs, village headmen, assistant headmen, and "women assistants" are given khaki suits or dresses, hats, black leather shoes and black socks upon their installation to office in Paramaribo (Figures 52–53).

Although weaving has never been highly developed by Maroons, their textile arts form one of the richest and most varied areas of their material culture.[19] Decorative sewing, whatever its specific form, appears on every kind of cloth article made by Maroons—breechcloths, skirts, bras, caps, men's and women's

53. Maroon Tribal Chief and headmen on official visit to Paramaribo, early twentieth century

54. Man's shoulder cape. Embroidered by a woman from Totikampu who included her husband's name and her own in the design. The original cape was later enlarged by extra cloth at each side, in response to changes in men's fashion.

55. Man's appliqué shoulder cape, probably Djuka. Predominantly red, white, black, and yellow. The use of circular pieces of cloth is extremely rare.

56. Breechcloth embroidered in red, grey, and yellow. Collected 1932–38.

57. Saramaka man's apron, worn over a breechcloth during certain kinds of dancing (see Figure 62 and Color Plate XVIII). Patchwork and embroidery. Ties are braided threads taken from scraps of imported cotton cloth. Collected in Dangogo, 1968.

54.

56.

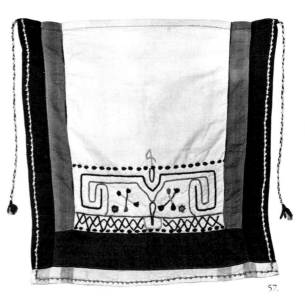

57.

55.

capes, adolescent girls' aprons, men's dance aprons, men's neckerchiefs, women's waist kerchiefs, sacks for manioc meal, sacks for shotgun cartridges, and covers for stools, meal trays, hunting sacks, and hammocks (Figures 54–62 and 65). These items may also be adorned with colorful ties, fringes, tassels, or pompoms of braided, twisted, or knitted fibers (locally processed plant fibers or spun cotton), manufactured yarn or embroidery thread, or threads unraveled from cotton cloth.

Historical accounts and drawings allow us a relatively full picture of Maroon dress during the eighteenth and nineteenth centuries. Like the clothing worn by most of the Maroons' African ancestors and that commonly used by slaves on Suriname plantations, the essential items of adult dress were a wrap-around skirt for women and a breechcloth for men.[20] In spite of the simplicity of these basics, however, Maroons had already created a well-developed art of fashion, based on subtle stylistic distinctions in clothing and on the enjoyment of both imported and locally made accessories.

Outside observers tended to view early Maroons largely as "naked savages" in their generalizing descriptions, but their passing remarks on the appearance of particular individuals offer abundant (if inadvertent) evidence of the attention Maroons lavished on their attire. German missionaries living among the Saramaka in the late eighteenth century, for example, noted that "All they [the men] have as far as clothes are concerned is a small covering below the waist" (Staehelin 1913–19, III ii:141); and sketches made in the field by one of the missionaries conform to this description (Figure 63). But the missionaries also commented that men were sometimes "hung all over" with protective amulets (Staehelin 1913–19, III iii:131); they complained that Saramakas attended church "just to show off their finery" (Staehelin 1913–19, III iii:44); and in their Saramaccan dictionary they recorded multiple styles of breechcloths, skirts, hats, and rings, as well as a variety of terms for aprons, kerchiefs, fringed cloth, necklaces, and men's accessories for formal dress such as umbrellas, hunting sacks, staffs, and walking sticks (Schumann 1778). Stedman's brief description of two Maroon warriors in the heat of battle specifies wrist and ankle ornaments, a necklace with supernatural protective powers, a braided hairdo, and a gold-laced hat (Stedman 1796, II:88–89, 108, Plate 53). And a long-term visitor to villages on the Marowyne in the 1850s who describes Maroon clothing as "very simple" (with women wearing just a single skirt and men usually only a breechcloth), nevertheless enumerates a long list of accessories such as imported hats; necklaces made of jaguar or peccary teeth; calf and anklebands hung with animal teeth, feathers, and tassels; strings of beads worn on neck, wrist, and ankles; copper and iron bracelets; and copper rings (worn up to ten at a time on fingers and thumbs). He also mentions that "colored cloths are worn over the shoulders" for festive occasions (Coster 1866:26–28; Figure 64).[21]

Hand-sewn caps have been an optional item of dress since earliest Maroon history. Mentioned by eighteenth-century observers (Schumann 1778: s.v. *kwe-fa*), they were worn by older Maroon men until quite recently, and continue to be worn by infants of both sexes and by specialized male dancers (see Chapter 6). Saramakas have traditionally favored the drawstring construction illustrated in Figure 65; eastern Maroons have made caps either in this same style or with the open "bonnet" construction illustrated in Figure 66.

During the eighteenth and nineteenth centuries, men who were chiefs and headmen also enjoyed ornate costumes provided by the colonial government. One village headman's uniform was described in 1779–80 as:

> a jacket, a vest, trousers of the finest striped linen, a hat with golden tassels, a lace shirt with cuffs, and a captain's staff made out of cane which had a large silver and gilt knob atop it. With all of this finery, he nonetheless went barefoot most of the time [Staehelin 1913–19, III ii: 217–18].

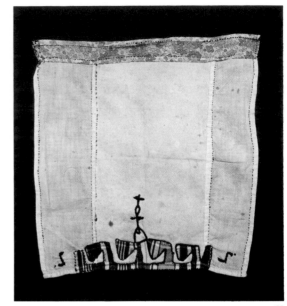

58.

59.

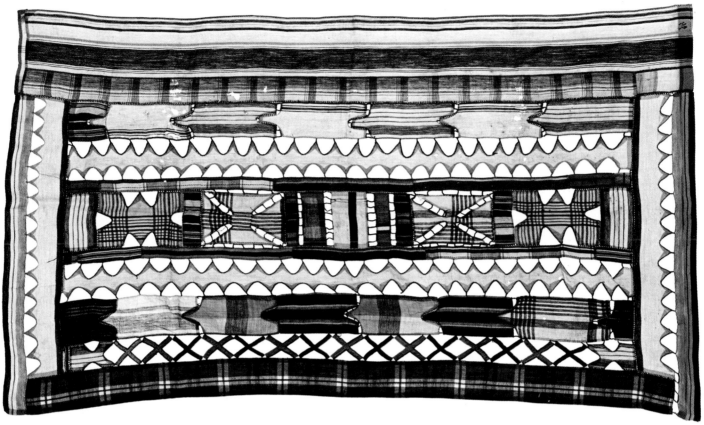

61.

60.

58. Apron composed of four pieces of cloth, with embroidery and appliqué decoration. Collected 1932–38.

59. Saramaka embroidered neckerchief, particularly admired for the way the embroidery thread dyes ran onto the white background. Collected in Dangogo, 1968.

60. Saramaka embroidered cartridge sack. Yarn tassels on ties made of twisted cotton threads. Collected in Dangogo, 1968.

61. Unusually complex patchwork cloth. (In general, openwork textile compositions are more characteristic of eastern than central Maroons.)

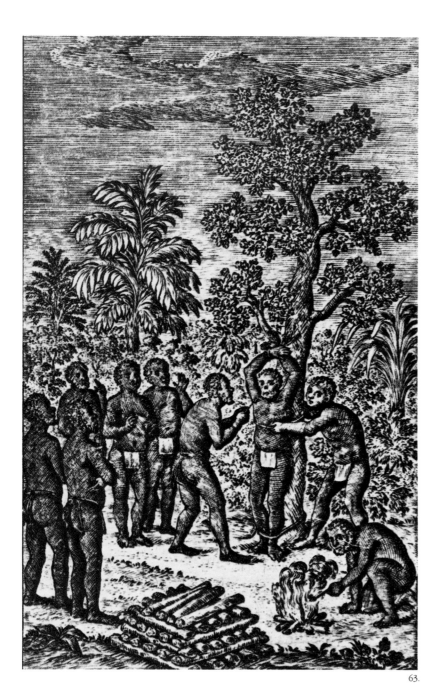

62.

62. Young man wearing a patchwork dance apron, early 1900s

63. Eighteenth-century Saramakas, as sketched by a German Moravian missionary living among them. Torture and execution by burning at the stake was the standard punishment for convicted sorcerers among some Maroon groups until well into the twentieth century.

64. Mid-nineteenth-century eastern Maroons. Note the variety of hats, necklaces, arm and ankle-rings, calf and ankle-bands, neckerchiefs, and chest sashes.

65. Saramaka men's caps: a) Sewn by Peepina, village of Totikampu. This appliqué design, known as "bird's wings," was popular during the first quarter of the 20th century; b) This cap is more typical of those worn by men during the 1930s and 1940s.

66. Alternative style of men's caps, sewn mainly by eastern Maroons

63.

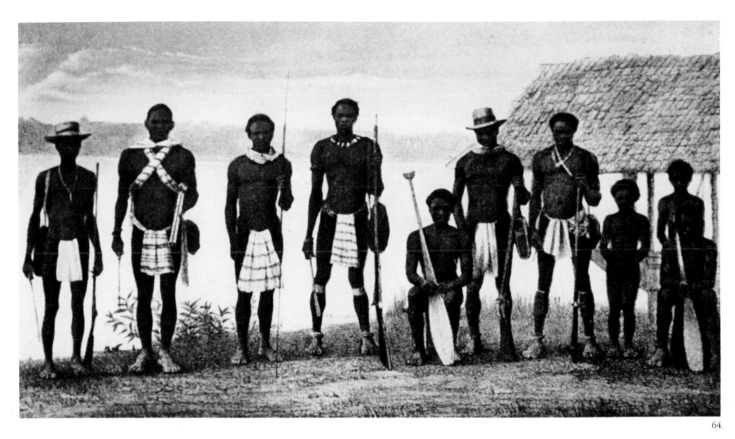

64.

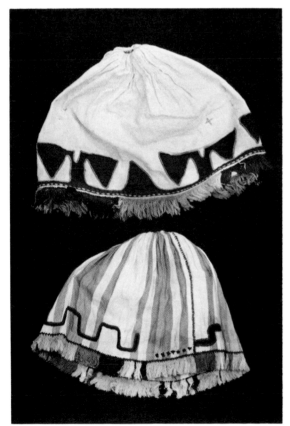

65.

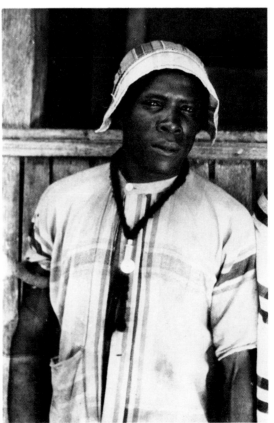

66.

The Saramaka Tribal Chief in 1828 was said to have worn for official functions:

> a blue dress coat trimmed with wide gold braid on the collar and with cuffs on the sleeves; a three-cornered hat with gold braid, an orange cockade, and a black strap; and a gilt crescential breastplate, and a staff with a gilt knob on which are engraved the Government's coat of arms and the following inscription: 'Paramount Chief of the Free Saramaka Bush Negroes, named Koffy' [van Eyck 1830:265].

Several general features of early Maroon dress are evident from the reports of these eighteenth- and nineteenth-century observers. First, the relative scarcity of cloth (the bulk of which was imported from the coast) kept everyday clothing quite simple; women wore a single skirt rather than the double layer in use today, capes were rarely worn, and there is no mention of decorative sewing such as embroidery or patchwork. Secondly, Maroons drew a distinction between everyday and formal dress, and fully enjoyed opportunities to bedeck themselves with special clothing and accessories. They also made extensive use of a wide range of locally made jewelry (most of which served for both ritual protection and personal adornment), and held imported manufactures such as earrings, hats, and tailored "long shirts" in high esteem (Figures 67–69).

During the second half of the nineteenth century, when widespread migration of men to the coast had dramatically increased the availability of cloth in Maroon villages, the artistic potential of trade cotton began to be explored in both men's and women's clothing. (For a schematization of the developments discussed in the next several pages, see Figure 70.)

First, an embroidery style was developed in which curvilinear shapes were created by double lines that shifted from one color to another and often enclosed a "filler" stitch of a contrastive color. Although we cannot specify a beginning date for this embroidery, a Djuka example collected in the late nineteenth century suggests that both design style and technique were well developed by that time. L. C. van Panhuys describes this embroidery as follows:

> On a piece of store-bought cotton cloth destined for use as a skirt or shoulder cape, figures are drawn in charcoal by the men; these figures are embroidered by the women.
> The figures on the accompanying skirt represent: a monkey's tail, a bird's claw with a snake and two 'akema's' (figures with an erotic meaning) placed opposite one another. The meaning of the oblique cross is not known definitely to us. [1899:81; see Figure 71, which we believe to be this cloth.]

The earliest cloths that we have seen in Saramaka are embroidered in the same style (Color Plate VII, Figure 72). This embroidery style seems to have been discontinued by Upper River Saramakas during the first decade or two of this century. The owners of the few more recently made examples we encountered in the field said the cloths had been made by former wives from Lower River villages or from the eastern tribes. Saramaka women who examined the largely undocumented textile holdings of the Surinaams Museum with us attributed all cloths in this style to eastern Maroons (Figures 73–75). On the basis of our dating of the type of cotton cloth on which this kind of embroidery is found, however, we estimate that the style had been discontinued by all Maroons by about 1930.

The second important kind of decorative sewing used by Maroons was a patchwork technique in which compositions were built from square, triangular, and rectangular bits of cloth. Solid red, navy, and white were considered the essential ingredients of these so-called "bits-and-pieces" cloths (also referred to as the "red-and-navy" style[22]), but many examples included yellow, blue, green, or pink as well, and some incorporated occasional pieces of a striped fabric. Most of these cloths were pieced together with seams which were

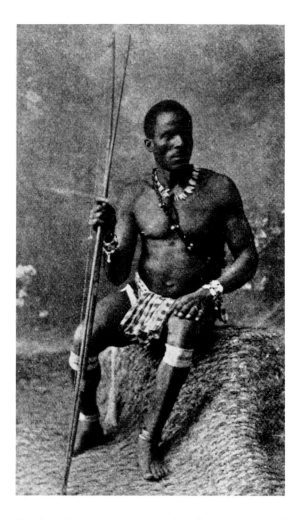

67. "A Bush-Negro of the Saramaka tribe, Dutch Guiana," c. 1900

See page 65 for Color Plate VII.

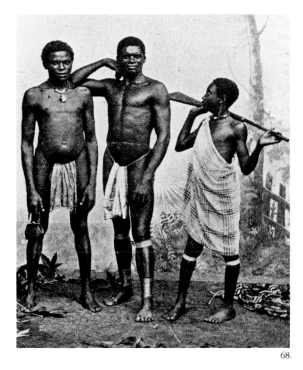

68.

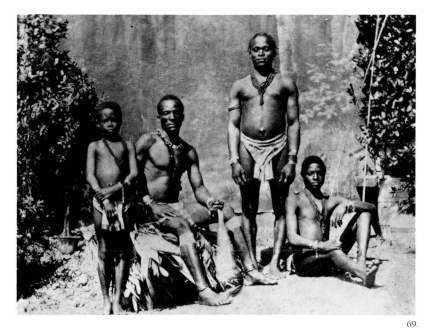

69.

68. "Bush-Negroes of the Aukan [Djuka] tribe, Dutch Guiana," c. 1900

69. Djukas and Saramakas brought to Amsterdam for the Colonial Exposition of 1883

70. Schematization of the five main types of decorative sewing through time. Variations in the thickness of each tapered form reflect changes in the amount of production in that style through time. Beginning and ending dates are approximate only, since they vary significantly by region.

1-*Early embroidery.* Shapes defined by lines of linked stitches and filled with areas of embroidered "textures" in contrasting colors (e.g., Figure 71).

2-*Later embroidery.* Purely linear designs, at first predominantly free-form (planned by women), and later more often geometric (planned by men) (e.g., Figures 35 and 94).

3-*Bits-and-pieces compositions.* Patchwork cloths constructed mainly of squares, rectangles, and triangles of cloth, for which solid red, white, and navy were the basic colors. Although more frequently sewn as a single thickness of cloth, some patchwork compositions (e.g., those made for men's breechcloths) were sewn as a whole onto a larger background cloth (e.g., Color Plates IX and X).

4-*Narrow-strip compositions.* Patchwork cloths made from predominantly parallel arrangements of narrow strips of colorfully striped cotton. These compositions were never sewn onto a background cloth (e.g., Color Plate XII).

5-*Cross-stitch embroidery.* (e.g., Figure 98).

Note: The shaded area indicates the existence of cloths which combined elements of bits-and-pieces and narrow-strip sewing (e.g., Figure 84).

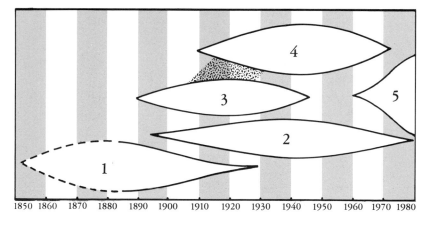

70.

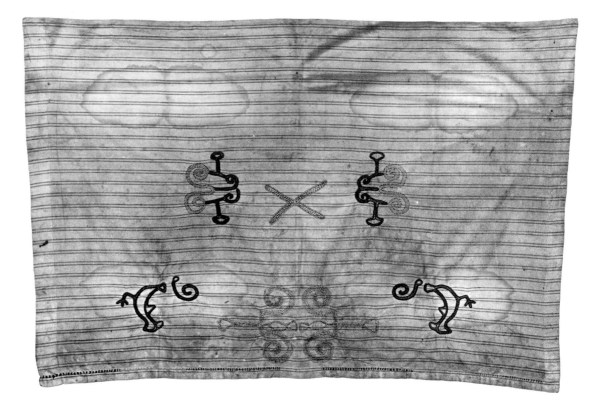

71a.

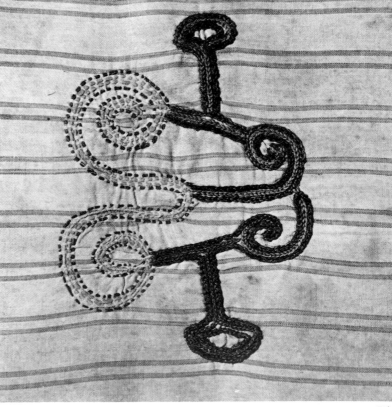

71b.

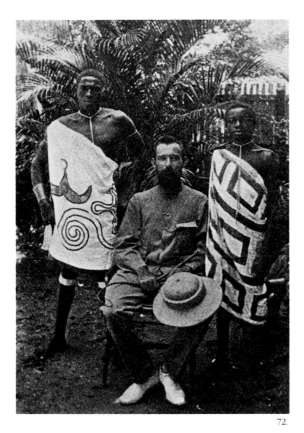

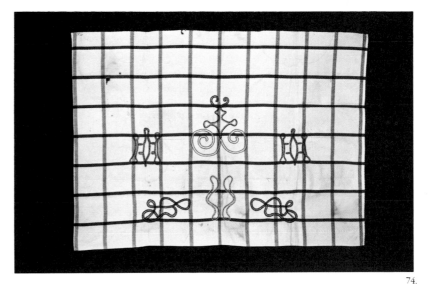

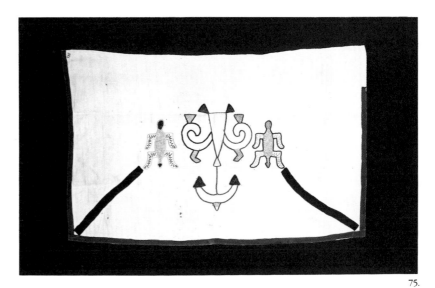

71. Embroidered cloth collected on the Marowyne River in the 1890s. For additional illustrations of embroidery from this period, see van Panhuys 1928: Figures 8–9.

72. The Dutch explorer-geographer R. H. Wijmans, with his Saramaka guides in 1908

73. Djuka embroidered skirt

74. Djuka embroidered skirt, collected 1958

75. Cloth embroidered in red, grey, black, and yellow with red and navy appliqué strips

72.

73.

74.

75.

meticulously hemmed on the underside; others (including all breechcloths) were appliquéd onto a background cloth, often by a line of decorative embroidery (Color Plates VIII–X, Figures 76–79).[23] In a few cases, the curvilinear shapes characteristic of contemporaneous embroidery were executed as appliqués of solid-color cloth, edged with linked embroidery stitches (Color Plate VIIIa,b).

Bits-and-pieces sewing foreshadowed, in a variety of interesting ways, the next major fashion in Maroon textile arts—compositions based on the parallel arrangement of long narrow strips (rather than small triangles, rectangles, and squares) and made with striped (rather than solid-color) cloth. First, bits-and-pieces cloths were usually constructed from composite patchwork strips that were then sewn together only as the final stage of the cape's composition (Figure 80). Women also sometimes alternated composite bits-and-pieces strips with long narrow strips of striped cotton (Figure 81) or framed bits-and-pieces compositions with such strips (Color Plate XI, Figure 82). Still other (apparently transitional) cloths exhibit the compositional complexity of bits-and-pieces sewing, but were made largely with the striped cotton typical of the later narrow-strip style (Figures 83–84). Finally, some cloths create the visual effect of a "standard" narrow-strip textile, but are actually composed of small rectangular pieces of cloth (Figure 85).

In addition to changes in composition, the development from bits-and-pieces to narrow-strip sewing involved an important shift in chromatics. A tricolor aesthetic, centered firmly on red, white, and navy, gave way to a full use of the entire color spectrum. As the principles of narrow-strip sewing were refined over the years, avoidance of a "dominating" color became a conscious aesthetic ideal, and textiles were admired for their success in juxtaposing a varied set of contrasting hues.

Once textiles composed exclusively of narrow strips became popular, around 1920–1930, they maintained their position as the epitome of a woman's artistic offerings to her husband and as the height of men's fashion for almost fifty years. Throughout this period, the bulk of the cloth used by Maroons was colorfully striped trade cotton purchased on the coast by men and brought back to wives and kinswomen in the villages. Women trimmed these cloths parallel to both the selvage (by ripping) and the end (with a knife), saving the

76.

76. Explorers and their guides in the Suriname interior, early twentieth century

77. Man's shoulder cape, probably Saramaka. Like many other bits-and-pieces capes, two of the edge strips appear to have been sewn on (by machine) well after the body was sewn (by hand), perhaps in response to changing clothing fashion.

VI. A Saramaka newborn is formally introduced to her village. A local head-carried oracle that had been consulted frequently during the mother's pregnancy supervises the ceremony.

VII. Saramaka man's embroidered cape, sewn 1900–1910

See page 69 for Color Plate VIII.

See page 72 for Color Plate IX.

See page 73 for Color Plate X.

See page 76 for Color Plate XI.

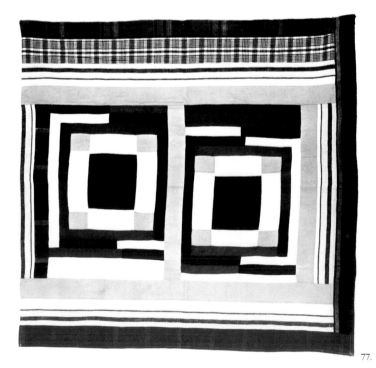

77.

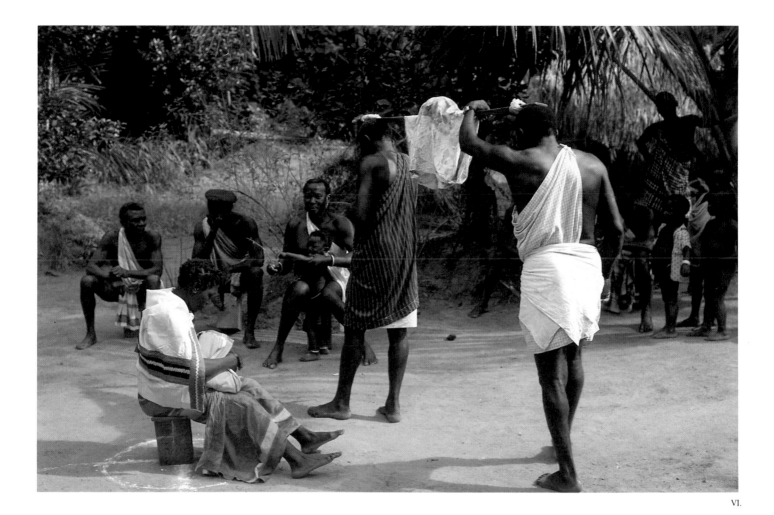

VI.

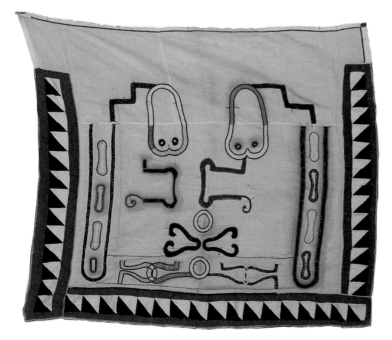

VII.

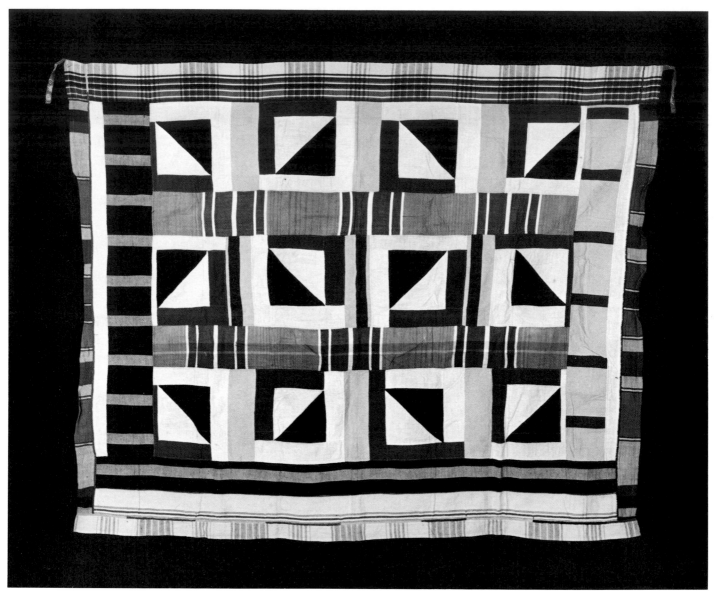

78.

78. Man's shoulder cape. Probably sewn 1920–40 by Pee-pina, Totikampu.

79. Saramaka man's cape. Sewn c. 1920 on the upper Gaan-lio.

80. Saramaka man's shoulder cape, predominantly red, white, and navy, collected 1924–25

81. Man's shoulder cape

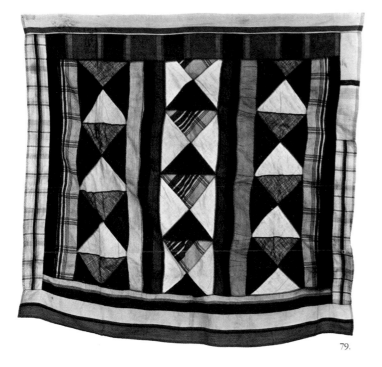

79.

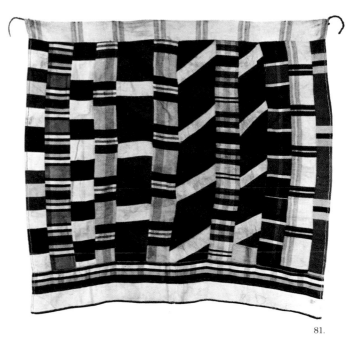

81.

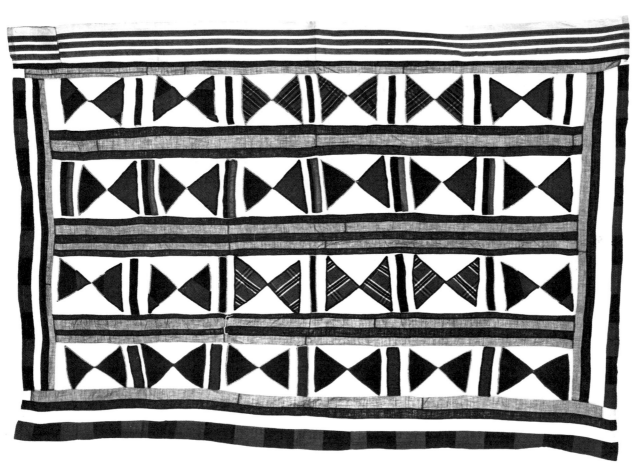

80.

67

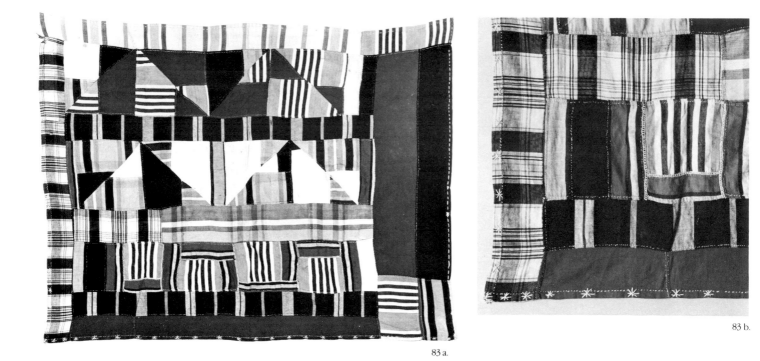

83 a.

83 b.

82.

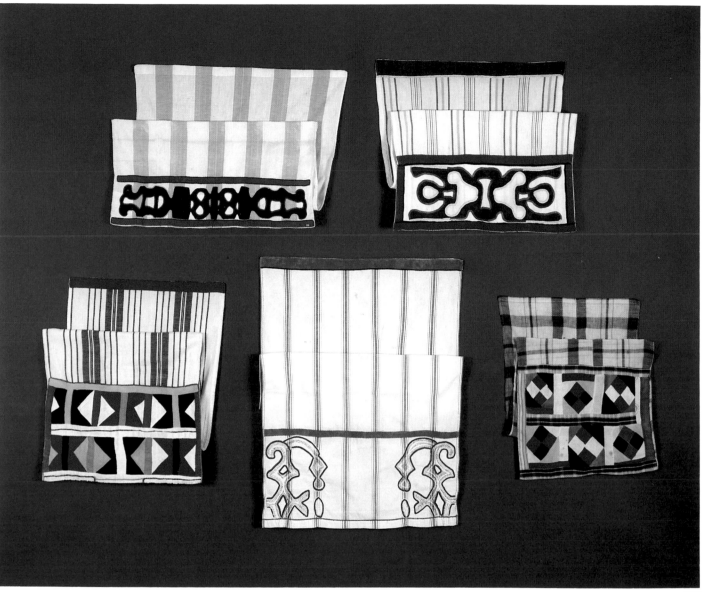

82. Saramaka man's shoulder cape, predominantly red, white, navy, and yellow, sewn 1920s–30s

83. Saramaka man's shoulder cape, collected 1928–29 in Munyenyenkiiki. Note the decorative embroidery overlaying many of the connecting seams; the embroidery along the outer edges was sewn with the kind of cotton yarn usually used for calfbands.

VIII. Five breechcloths, sewn 1900–1950: a) collected 1932–38; b) Saramaka, collected 1978 in Pikiseei; c) Saramaka, sewn c. 1940 in Soola; d) collected 1960s, probably Saramaka; e) no information on provenance. Note that in addition to the principal decoration on the rear portion, many are embellished on the front edge with an appliqué strip of cotton cloth chosen to contrast with the main cloth.

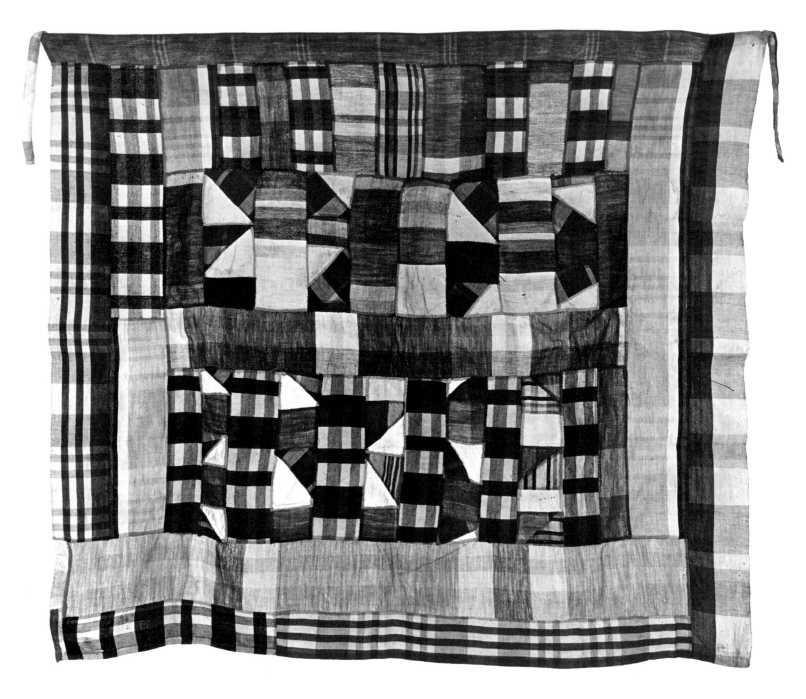

84. Man's shoulder cape

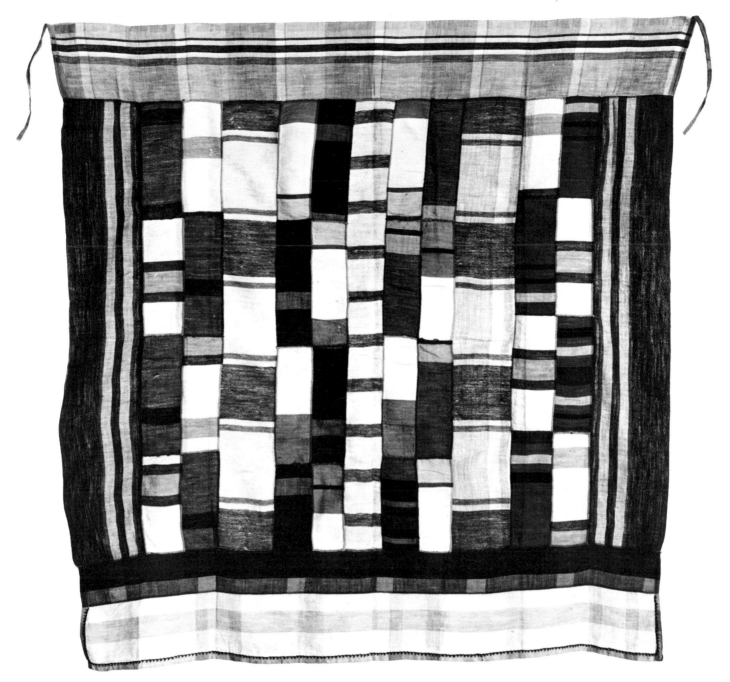

85. Saramaka man's shoulder cape, sewn 1950s–60s

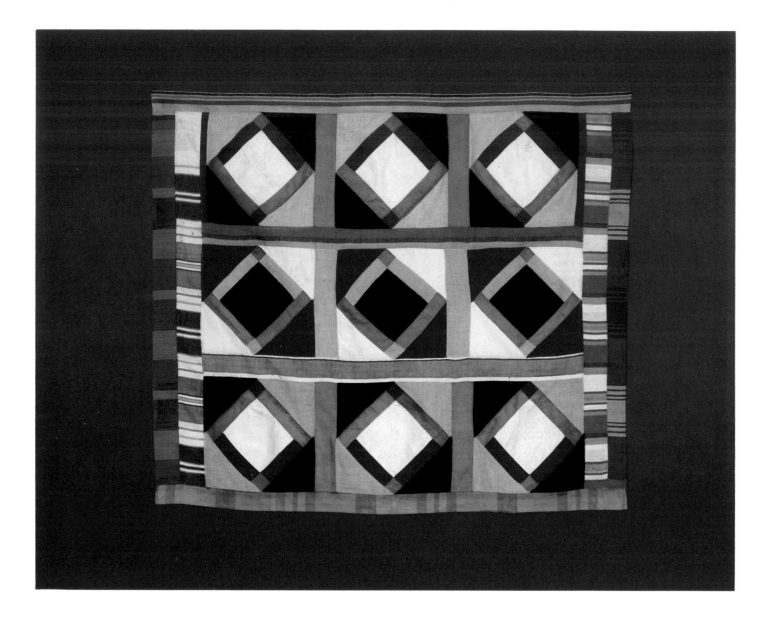

resulting strips for eventual use in patchwork textiles. The vast majority of these narrow-strip cloths have been made as men's shoulder capes, but hammock sheets, men's and infants' caps, men's decorative dance aprons, adolescent girls' everyday aprons, and women's skirts have also been constructed in the same way. (See, for example, Color Plate XII, Figure 52, and van Lelyveld 1919/20: Plate 21.)[24]

Maroon narrow-strip textiles—created by carefully planned arrangements of horizontal and vertical strips, each with internal cross- or lengthwise stripes—are strikingly similar to woven narrow-strip cloths from West Africa (Figure 268). Indeed, the parallels in overall form and color contrasts, the "syncopated" effect, in both cases, of subtle modifications to a dominantly symmetrical grid pattern, and the common use of small motifs as occasional accents within the strip construction (silk inlays in West African cloths, embroidered designs in those of the Maroons) all suggest, on grounds of formal similarity, that the textiles of the Suriname Maroons could well represent a direct inheritance from their seventeenth-century African ancestors. Once we realize, however, that Maroon narrow-strip sewing began only during this century, it becomes

IX. Man's shoulder cape, sewn 1920–40 by Peepina, Toti-kampu.

See page 77 for Color Plate XII.

72

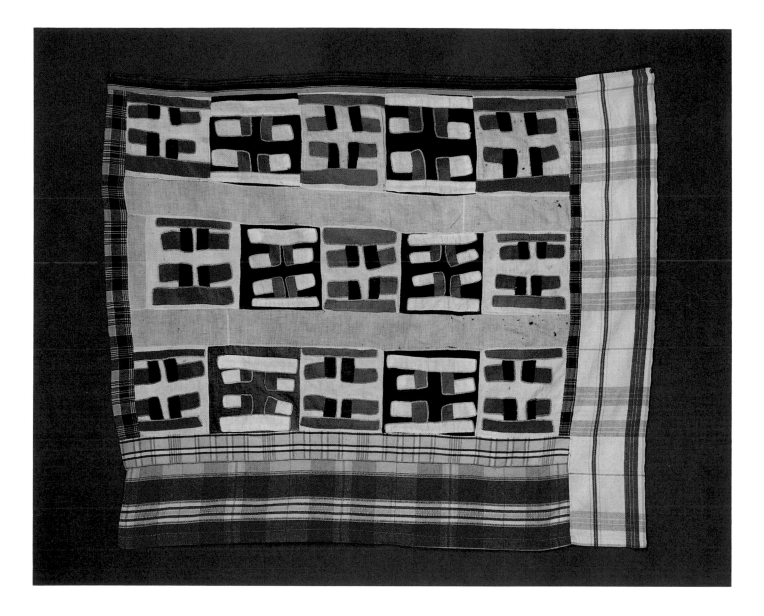

clear that this art could not have been passed down, generation by generation, from African origins, and we are forced to consider other—more subtle and less readily documentable—processes of historical influence. This central and difficult problem will be dealt with in Chapter 8.

Within the general form of narrow-strip construction, variations have occurred through time and from one region to another; we give just four examples. First, patterns based on the horizontal (rather than vertical) arrangement of strips were both more common and more recently practiced among eastern Maroons than among the Upper River Saramaka (compare Figures 86 and 87). Second, openwork textiles such as those in Figures 61 and 86 are more frequently sewn by eastern Maroons than by Saramakas. Third, the attention given to the distinction between strips from the warp and from the weft has varied; Upper River Saramakas have tended to alternate them more consistently than other Maroons (and have become increasingly insistent on this principle over time), while eastern Maroons and Lower River Saramakas have more frequently composed cloths almost exclusively of strips taken from the weft (Figures 88–91). Finally, the practice of cutting edge strips longer than

X. Man's shoulder cape, patchwork and appliqué, probably sewn early twentieth century.

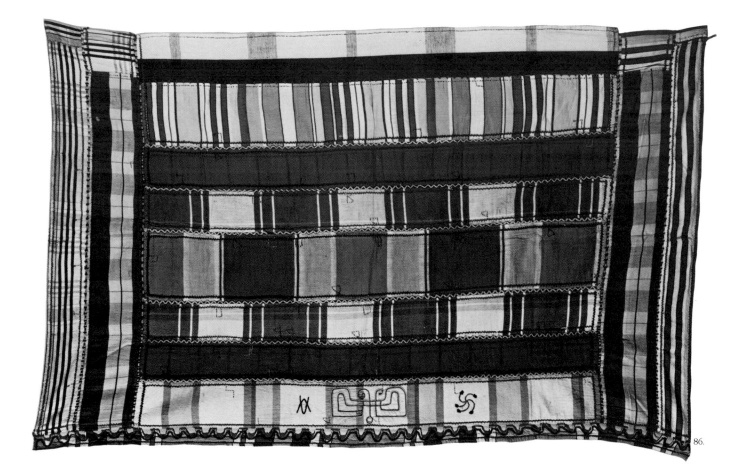

86.

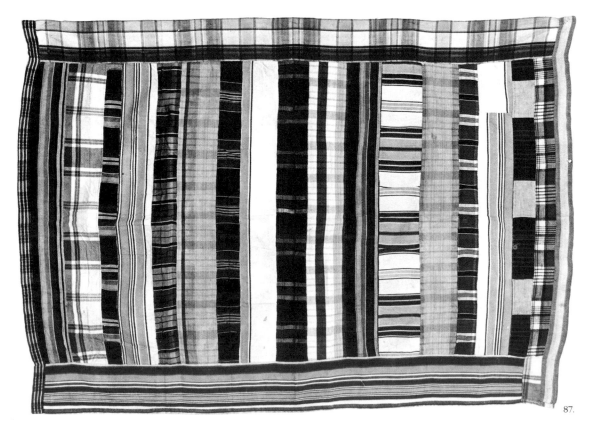

87.

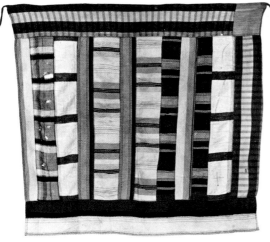

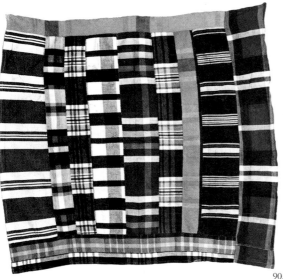

88.

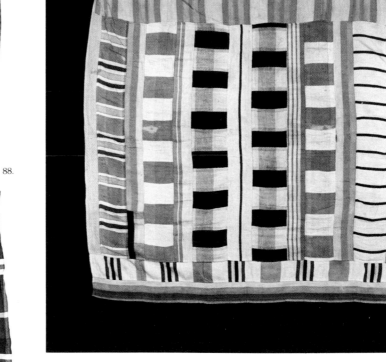

89.

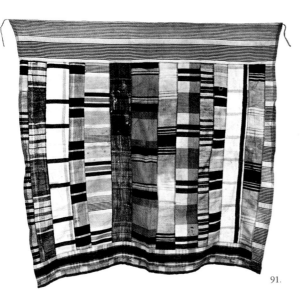

90.

91.

86. Paramaka man's shoulder cape, collected before 1938 in Langatabiki. Both the horizontal placement of strips and the openwork at the lower edge are more common in eastern than in central Maroon sewing. See also Figure 113.

87. Man's shoulder cape, collected 1960s. The vertical arrangement of strips characterizes almost all Saramaka narrow-strip capes.

88. Man's shoulder cape with alternation of warp and weft strips, collected 1960s, probably in Saramaka

89. Man's shoulder cape with alternation of warp and weft strips, collected 1960s, probably in Saramaka

90. Man's shoulder cape composed mainly of weft strips, collected 1960s, probably in Saramaka

91. Man's shoulder cape composed mainly of weft strips, collected 1960s, probably in Saramaka

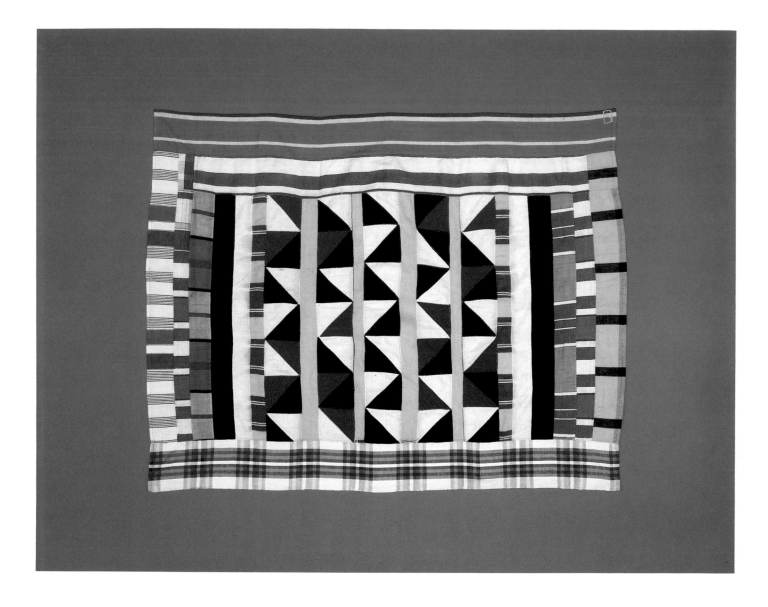

those used for the cape's body is said to be more typical of villages on the upper Gaanlio than of those on the Pikilio (Figures 92–93).

During the same half-century, the art of embroidery continued, but with new stitches and changes in overall style. Designs came to be executed in single (rather than double) lines (Figures 94, 57, and 60); the once-common use of black thread became rare; and the use of fringes made by unraveling strips of cloth gave way to overlays of lace, rickrack and ribbon. Although embroidery has always been executed by women, men's special skills in using a straight edge and compasses have often been enlisted to mark the design before it is sewn; Figures 34–35 illustrate the difference between male and female-marked designs in twentieth-century Saramaka. Over the past several decades, the most popular style of women's capes in Saramaka has consisted of a wide H-shaped overlay, often several layers thick, on a solid-color cloth or a "calico" print (Figures 95 and 19).

The most recent development in textile arts in Upper River Saramaka may serve as an illustration of the actual processes by which artistic change is effected among Maroons. We describe the mechanics of this change in some

XI. Man's shoulder cape, sewn 1920–40 by Peepina, Toti-kampu.

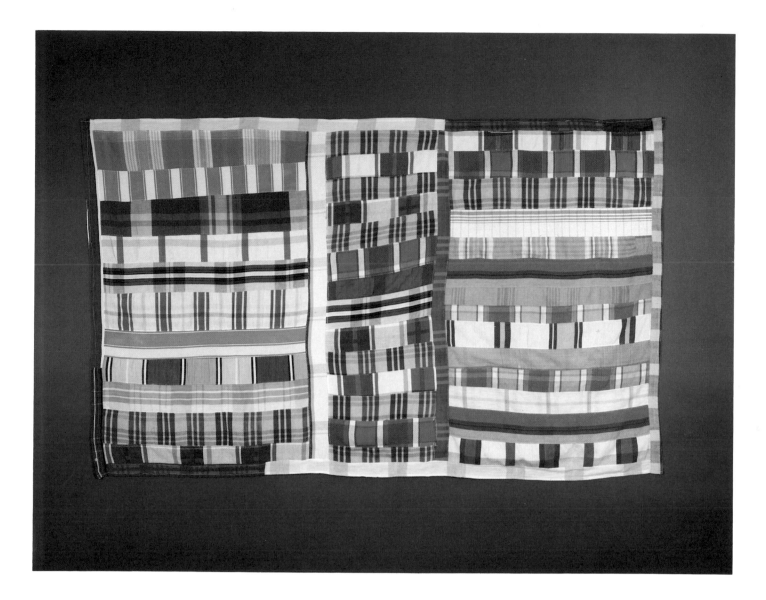

detail, in order to illustrate the paths by which new ideas turn into generalized styles in these societies.

In the 1950s and 1960s, bits-and-pieces capes had been completely discontinued and narrow-strip shoulder capes were the height of fashion. Women devoted tremendous time, thought, and energy to assembling vast collections of cotton strips, arranging them in pleasing combinations, and sewing them in place with tiny, meticulous stitches. Together with crocheted calfbands, these capes symbolized a woman's devotion to her husband, and all men wore them proudly. By the late 1960s, however, young girls from the missionized Middle and Lower River villages and from the villages below the lake had begun to learn the art of cross-stitch embroidery, as part of their elementary school program, and to teach it to the women of their villages. Whenever one of these women who was married to a man from the Pikilio came to visit her husband, her sisters-in-law would watch carefully as she copied a pattern from a needlework magazine. They were fascinated by the notion of having to calculate rows and stitches so exactly, and acutely aware of the pride with which men wore the finished product. Young men were beginning to question the aesthetic

XII. Saramaka hammock sheet sewn by Apumba, Pempe (c. 1890–1978). The absence of a unified central symmetry within each panel is typical of early narrow-strip textiles, though this cloth may have been sewn as late as the 1950s.

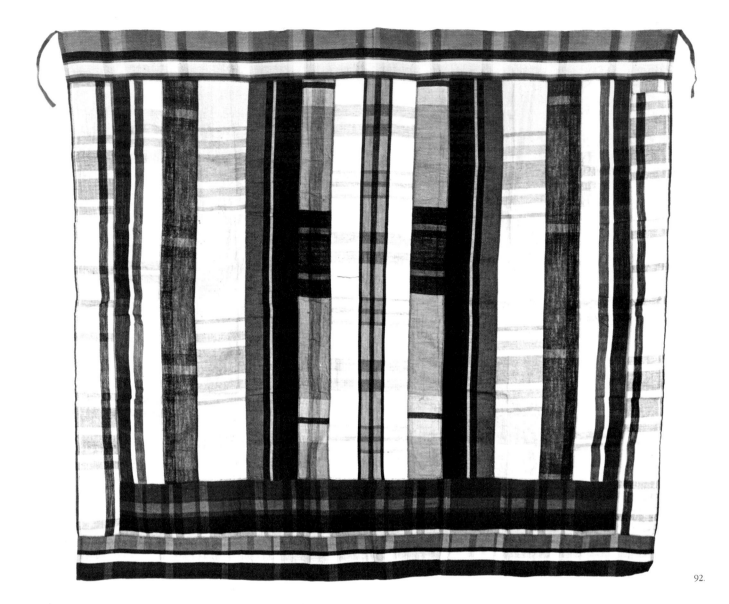

supremacy of the narrow-strip art, and some proclaimed defiantly that they would never be caught wearing such a cape. Many men at that time were wearing the standard alternatives—capes of patterned cloth, embroidered cloth, or cloth decorated with ribbons and lace. The Upper River women continued to apply themselves to narrow-strip cloths and traditional embroidery, convinced that they would never be able to master the cross-stitch skills of their educated sisters-in-law; but the demise of narrow-strip capes was already clearly on its way.

By 1975, all but the older men had packed their once-cherished narrow-strip capes in the bottoms of their trunks, and most women were diligently working to create cross-stitch patterns that imitated the designs depicted in the foreign magazines.[25] The narrow-strip capes (like outgoing fashions before them) were subjected to a new, derogatory terminology which reflected current attitudes toward their status. They became known, for example, as "motor covers" and "*apúku* cloths," since they were said to be useful only for shielding an outboard motor from the elements or paying off a debt to an *apúku* (forest spirit). The extra strips of cotton cloth were being hastily sewn into women's skirts (which had never before been made of strips in Saramaka) or, more frequently, simply

92. Saramaka man's shoulder cape with outer strips extending all the way to the bottom, sewn c. 1960

93. Saramaka man's shoulder cape in which all vertical strips are the same length, sewn c. 1960

94. Man's shoulder cape, collected 1968 in Dangogo. Design is typical of Saramaka embroidery during the 1950s–60s.

95. Saramaka woman's cape with H-shaped overlays of cloth strips, ribbons, and lace, as well as decorative machine-stitching along the lower hem; sewn during the 1970s

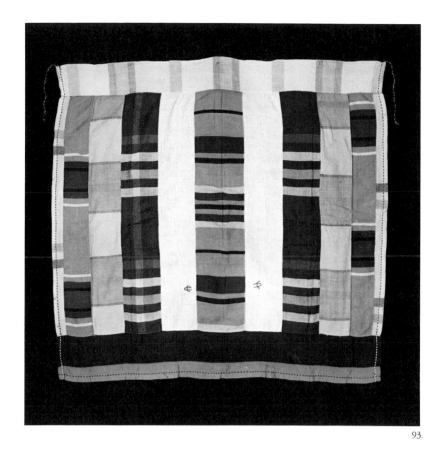

93.

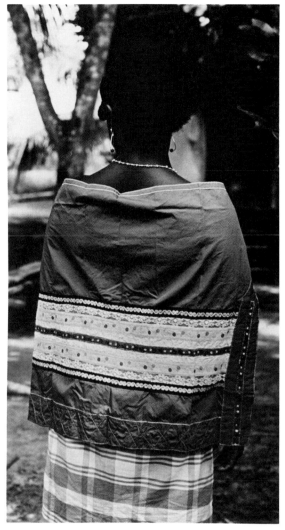

95.

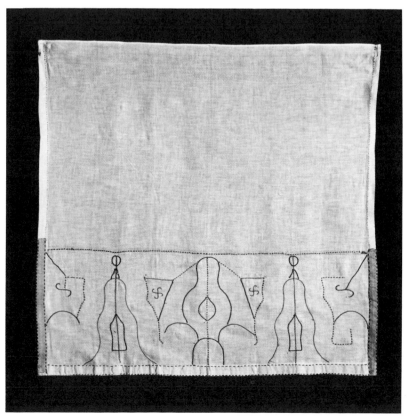

94.

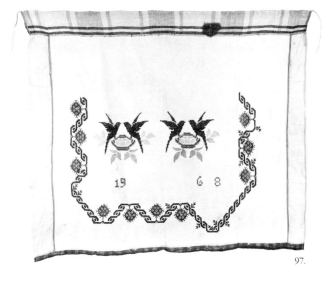

96.

97.

discarded. Although a new bride was still allegedly required to sew a narrow-strip cape for her husband, this part of the marriage exchange was beginning to be treated with some leniency. Realizing that the young girl would probably never sew another such cloth in her life and that her husband would never wear one, older women could either volunteer to lay out an acceptable pattern for the bride or accept excuses that the cape would be done "eventually."

By 1978, cross-stitch art was being executed on every kind of cloth object, from infants' caps to hammock sheets, and it already had a full history of stylistic and technical development. The original exemplars, called "pull-the-thread cloths," were made on fine cotton cloth from which threads were removed at close intervals in order to establish a working grid in the area to be decorated (Figure 96). Later, a somewhat bulkier cloth, with a built-in grid texture on the same scale, made it possible to bypass the tedious initial preparation, and designs began to cover larger areas (Figure 97). Currently, women use an even heavier cloth, with a significantly larger grid, and the patterns are even more extensive (Figures 98–99).

This brief sketch may serve to indicate how even a relatively straightforward replacement of one artistic style by another involves the complex reworking of skills, perceptions, and patterns of use by different members of the community. In this case, men, who wear but do not design the capes, initiated a change which the artists themselves (the women) felt obliged to follow. The different perspectives of men and women are, however, further complicated by differences of generation, experience with other regions and with coastal society, temperament, and even manual skills. As a result, the relative merits of competing styles are worked into the larger idiom through which individuals express themselves and their place within the society. The designing of a cape, the giving of a cape, the owning of a cape, the wearing of a cape, the evaluative discussion of a cape, and even the final rejection of a cape all become, in this context, part of the ongoing definition of cultural identity by individuals and, over time, by the community as a whole.

Cloth Names

We will see, throughout this book, that naming contributes an important dimension to the aesthetic life of Maroons. The creation of an appropriate new name for a person of any age is highly appreciated; patterns of reference and address, which in many societies follow standardized rules based on kinship or other terminological systems, become, in Maroon societies, a lively art (see

96. Man's shoulder cape, sewn 1960–65. The confinement of the design to small areas from which vertical and horizontal threads have been carefully pulled out marks this as an early example of Saramaka cross-stitch sewing.

97. Man's shoulder cape, sewn 1968, Middle or Lower River Saramaka. The design is guided by clear horizontal and vertical lines in the texture of the cloth.

98. 1970s cross-stitch embroidery on a Saramaka shoulder cape and breechcloth—red and blue on bright yellow. Both the designs and the individual stitches are larger than in earlier cross-stitch sewing.

99. Saramaka man's shoulder cape, collected early 1970s. Red and blue cross-stitch on yellow cloth.

100. Women's kerosene lanterns made in Paramaribo from tin cans and other scrap metal. Lantern on left was collected on the Tapanahoni River in 1971; others were collected in Upper River Saramaka between 1968 and 1976. (See Note 26.)

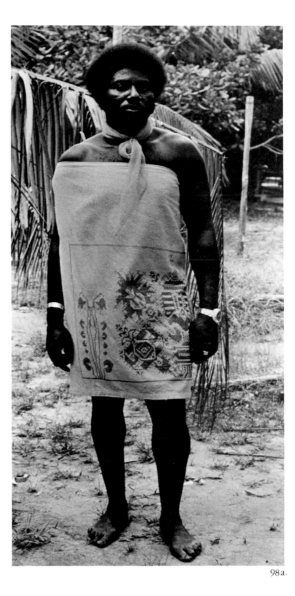

99.

100.

98a.

R. and S. Price 1972b). Indeed, the enjoyment of bestowing names and using them creatively extends to all areas of artistic production and performance. Woodcarving designs and techniques, embroidery stitches, cicatrization designs, legband styles, patchwork patterns, hairdos, calabash designs and shapes, and patterns worked into manioc cakes may be named. In addition, ways of peeling oranges (e.g., the "monkey's head," in which the spiral peel is made adjacent to, rather than centered on, the stem end) and particular placements of gold teeth (e.g., "tilted head" for a single gold tooth on one side or "city street" for a gold tooth on each side) are individually named. Furthermore, imported manufactures are known by names which reflect a fascination with minor stylistic details; machetes, buckets, pots, and tin lanterns are very often referred to by names which distinguish particular features of design rather than by generic words which group all functionally equivalent exemplars of a certain type.[26] Of the various Western manufactures that are imported into Maroon

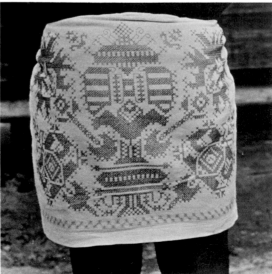

98b.

81

Table I: Saramaka cloth names

1. *Kankanfátu* — blackbird fat — a cloth pattern as vividly orange as the fat of the blackbird.

2. *Sitangáli* — skyrocket — a brilliant, multicolored pattern popular several decades ago, at the same time as a secular song extolling the beauty of the skyrocket.

3. *Lalú wáta* — okra water — a now-discontinued pattern said to have been unusually dark, like okra broth.

4. *Alatjá balán* — it splits *balán*! — a recent pattern, available in several colors, and wide enough to split in the middle to make two skirts rather than one. This name designates both the arrangement of stripes and the width and weave of the fabric.

5. *Límbo muyêè* — clean woman — a yellow-on-white pattern which requires special care in order to look spotless.

6. *Gaamá kôkò* — the Tribal Chief's testicles — a pattern whose beauty was praised by this association with the Saramaka Chief. The original name was later replaced by a more euphemistic form—*gaamá sitónu* ("the Tribal Chief's stones").

7. *Ôndò kólu* — hundred guilders — a predominantly yellow pattern popular for formal dress in the 1960s. Its alternative form, *duzu kólu* ("thousand guilders"), eventually came to refer to an especially expensive grade of cotton cloth available in Paramaribo in the 1970s.

8. *Musu dé [baasá]* — must give [an embrace] — a pattern of the 1960s which was sure to be reciprocated, it is said, by an immediate embrace. The name also formed the central lyrics of a popular song.

9. *Makéba* — Makeba — a red and yellow pattern, introduced shortly after Miriam Makeba performed in Paramaribo, allegedly named by a coastal storekeeper. At the same time, there was a profusion of "Makeba" necklaces, earrings, enamel bowls, hammocks, and so forth, and young Saramaka men used *makéba* as a verb meaning "to fuck."

10. *Djómbo gogó* — jumping buttocks — a dark pattern said to have inspired women to walk with a coquettish wiggle.

11. *Yánga yánga* — a kind of fish — a pattern complimented through association with an especially delicious fish.

12. *Wemína bánti* — Wilhelmina's belt — an early twentieth-century pattern named by a coastal storeowner in honor of a bejeweled belt worn in official photographs by Queen Wilhelmina.

13. *Bómbo de a saáfu [dá pipí]* — cunt is in slavery [to penis] — a pattern in use several decades ago.

14. *Amáka déndu tjá fuká* — hammock bears a burden — recognition that some (the hammock) may have to do the work while others (the couple in the hammock) have all the fun.

15. *Kónu faáka* — royal flag — the pattern of a predominantly white cloth raised in an ancestral shrine to honor Princess Beatrix during her visit to Saramaka in 1965.

16. *Kónu nyá kasába kwákwa* — royalty ate unsoftened manioc bread — ridicule of a member of the Dutch royal family who ate a piece of manioc bread in Paramaribo without dipping it in broth.

17. *Gaamá baasá gaamá* — Tribal Chief embraces Tribal Chief — a pattern named in commemoration of a meeting of Saramaka Chief Aboikoni and Djuka Chief Akoontu Velanti.

18. *Kaupe* — [the name of a man from the village of Godo] — a pattern named after the man who, on the eve of a national election in 1967, set fire to the "office" of the Saramaka Tribal Chief in an unsuccessful assassination attempt.

19. *Ameika gó a gádu* — American goes to "god" [heaven] — commemoration of the first successful moon-landing.

20. *Agbago wáka a opoláni* — Agbago travels in an airplane — a pattern named after the first plane ride of Saramaka Chief Aboikoni (Agbago) to Paramaribo.

21. *Gaamá púu faáka [na Aluku]* — the Chief removes a flag [in Aluku] — Tudendu, Saramaka Tribal Chief from 1934 to 1949, is said to have removed a tattered banner from an Aluku shrine and replaced it with a new cloth, henceforth known by this name.

22. *Akalali púu wísi* — Akalali removes witchcraft — a pattern of the mid-1970s, when witchcraft purges by the Djuka prophet, Akalali, were at their height.

23. *Dangasi tjêke [a gaamá bóto]* — Dangasi danced [in the Chief's boat] — Dangasi, late village headman of the village of Biudumatu, danced in the boat of Tudendu, the then-Tribal Chief of Saramaka.

24. *Tumumbii* — automobile — an early twentieth-century pattern, named after a particularly impressive feature of Western technology which Maroon men saw on their trips to the coast. The subject also formed the focus of a popular Saramaka song of the same period.

25. *Kó gó a Lawa*	come on to Lawa	a pattern popular in the early 1900s, named after important wage-labor opportunities along the Lawa River in French Guiana.
26. *Silaliko ópo lágima*	Suralco raised up the poor man	commemoration of increased job opportunities with the Suriname Aluminum Company in the 1960s, during the construction of the hydroelectric project.
27. *Kónda kabá a Kaise*	Kaise [a coastal store] is out of necklaces	the pattern of a cloth brought by a man to his wife in place of the necklace she had requested.
28. *Abali ábi bómbo*	Abali exposed her cunt	A woman from Masiakiiki, caught stealing a pot in Paramaribo, fell to the ground and spread her legs; there is some disagreement about the reaction of the police who saw this, but the basic incident and the cloth named after it are common knowledge.
29. *Yombe kaí [a taápu]*	Yombe fell [on the stairs]	Several decades ago a Bendekonde woman stole something from the mission at Djumu. In her haste to get away, she fell on the stairs leading down to the river.
30. *Apantu súki*	Apantu's sugar	During a stay in Paramaribo, a former village headman from Lafanti was sent by Saramaka Chief Djankuso (1898-1932) to buy some sugar. When he returned with the container only half-full, Djankuso asked whether headmen were so poorly paid that they had to steal from the Tribal Chief.
31. *Aviee boóko Djumu*	Aviee caused havoc in Djumu	This pattern was named after a young Bendekonde man who stole extensively from a store at the Djumu mission. It is also known as "Aviee ruined Peleki [the store owner]."
32. *Kpokolo kíi Alena*	Kpokolo "killed" Alena	A woman from the lower Gaanlio left her husband for another man.
33. *Baáa kíi baáa*	brother killed brother	an early twentieth-century pattern commemorating the murder of a Bendekonde man by his mother's sister's son.
34. *Agbago síngi a mòtê*	Agbago sank with a motor	On Chief Agbago's first trip from Paramaribo by motor, his canoe sank in the rapids between Botopasi and Kambaloa.
35. *Mangumuyee boóko Daume*	Mangumuyee ruined Daume	A woman from Daume is said to have avoided observance of menstrual prohibitions, thus endangering the power of the local *óbias*.
36. *Gaamá yáka Venipai [a kantóo fu sôsò líbi édi]*	the Chief threw out Venipai [from his office because of bad living]	A young American who had been living in Chief Aboikoni's village in the early 1970s is said to have been wearing a breech cloth of this predominantly blue pattern when he was expelled for his inability to interact appropriately with Saramakas. The cloth is also known as "Venipai cried."
37. *Kambósa pêpè kambósa*	co-wife peppered co-wife	a pink, now obsolete, cloth pattern named after a woman who is said to have added crushed hot peppers to the herbal bath with which her co-wife washed her genitals in the morning.
38. *Siló a bédi*	sloth in bed	A Lower River woman whose husband bought his other wife a bed commented bitterly that he had a [lazy] sloth in his bed; the cloth named after her remark was popular in the 1960s.
39. *Lôndò kíi Gbete*	cunt "killed" Gbete	an "old" (early twentieth-century?) pattern named after a woman whose promiscuity ruined her reputation.
40. *Asensi kulé [da manungú]*	Asensi ran away [from a testicle operation]	Several decades ago a man scheduled to have his enlarged testicles operated on ran away from the hospital.
41. *Amakiti djonkó [a kíno]*	Amakiti dozed off [at the movies]	Djuka Chief Amakiti (1916–1931) was taken to a movie in Paramaribo, but fell asleep in the middle. A cloth name and a secular song were inspired by the event.
42. *Wáta boóko Milanda*	water ruined Milanda	In 1949 a flood ruined a Paramaribo store patronized by Maroons.
43. *Basiá lási [a gaamá djái]*	the assistant headman got lost [at the Chief's quarters]	a purple and blue pattern named after an assistant headman who lost his way in Paramaribo, near the quarters of the Saramaka Tribal Chief.
44. *Basiá kêê [a Kampu]*	the assistant headman cried [in Kampu]	In 1978, Assistant Headman Kooi, of Kampu, cried after some young men wrestled and inadvertently broke the palm-leaf wall of his house.

villages, trade cotton is the focus for one of the most extensive and creative systems of individualizing names; we present here a brief summary of cloth names in use in Saramaka in the 1960s and 1970s to give some idea of the nature of such naming sets and the kinds of "meaning" that they carry.

Cloth represents the most significant portion of the many goods a man brings back from coastal wage-labor trips—both in terms of sheer bulk and as the most generally accepted and actively discussed gauge of his economic success and conjugal devotion (Figure 101).[27] Cloths also constitute the most fundamental element of women's dress, and married women may own several hundred skirts at one time. In the late 1960s, cloth was still used conceptually by Saramaka women as the basic "monetary" unit; those selling rice to the local mission, for example, would express their prices as a certain number of "cloths" (Sar. *koósu*), though they were actually paid in the equivalent numbers of guilders.[28] Finally, the distribution of cloths contributes importantly to ritual life: cloths are offered directly to gods and ancestors as banners hung at shrines (Figure 102); they are the principal ingredient in the vast array of goods with which a person is buried; and they are frequently distributed to individuals as payment for ritual services and as shows of gratitude in situations where spiritual favors are seen to have been active—recovery from a serious illness, the birth of a healthy baby, return from a successful coastal trip, and so on.

Although a few of the names for particular cloth patterns are made up and disseminated by store owners in the city, most are created by the Maroons themselves.[29] Some of the cloth patterns are given straightforward descriptive names (see, for example, Table I: numbers 1–5). Other names are indirect compliments, often through association with a particularly admired person or object (e.g., numbers 6–12); and a few are humorous comments on life (e.g., numbers 13–14). The most common way for a cloth to acquire a name is through association with local happenings that coincide with its introduction to a particular region. Historic events such as the visit of Princess Beatrix to several Maroon villages, a meeting of the Saramaka and Djuka Chiefs, an attempted assassination, or the first moon landing, are almost always commemorated in cloth names (e.g., numbers 15–23). Current details of coastal experiences, from wage-labor opportunities to encounters with coastal women or shortages of particular Western manufactures, provide another important source of inspiration (e.g., numbers 24–27). The great bulk of "commemorative" names, however, are derived from local gossip—sexual scandals, thefts, canoe accidents, quarrels and physical fights, encounters with missionaries and other outsiders, and so forth (e.g., numbers 28–44). In fact, gossip is frequently phrased in terms of potential cloth names, only a small proportion of which eventually make their way into general use. Persons hearing about an event for the first time often react with a name suggestion for the next new cloth they see, so that a particular pattern may have a number of potential names even before it makes its first appearance in a Maroon village.

Table I provides a representative sample of the cloth pattern names that we collected in the field.[30] Note that in addition to the short form generally used in conversation, many commemorative names are expandable (as indicated by bracketed phrases—see numbers 13, 21, 23, 29, 36, 40, 41, 43 and 44) to more precise evocations of the events on which they are based; these fuller versions are known by anyone familiar with the short form, and their (often unmentioned) existence adds significantly to the enjoyment of gossip-through-name-use in this medium.[31]

While it is clearly not the case that women wear a skirt of a particular cloth pattern in order to convey a "message," we can see that cloth patterns are the object of a great deal of interest and carry very real significance for those who wear and view them. On the generally recognized level that is reflected in their pattern names, cloths imply specific associations which mark their place in Saramaka social history: a cloth pattern in vogue during the early 1900s may be thought of in terms of the opening up of job opportunities in French Guiana;

101.

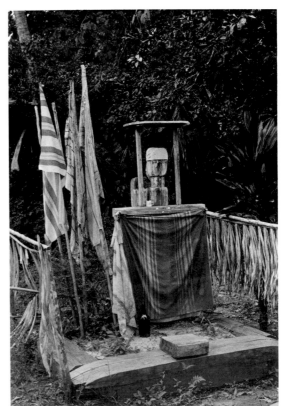

102.

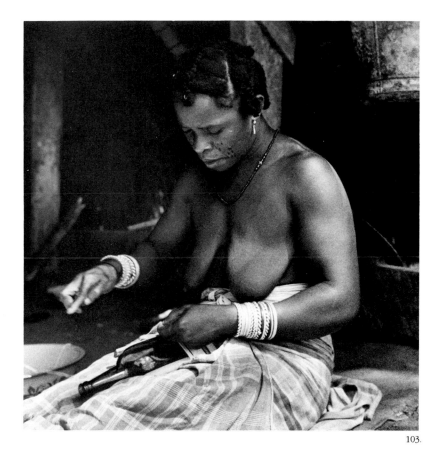

103.

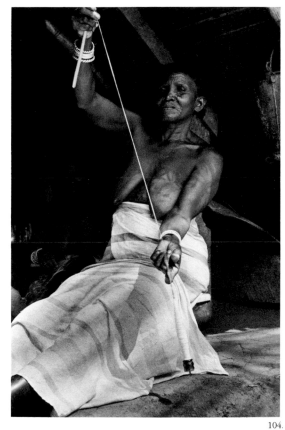

104.

one named after a co-wife fight is an amusing reminder of that scandal and the personalities involved, and so on. On a more individual level (aided by the fact that cloth patterns are named) women remember the exact circumstances under which they were given the cloths for most of their many skirts; particular cloths thus carry strong personal associations which are frequent topics of discussion. Skirts are "individualized" not only by the situation in which they were originally received, but also by those for which they are worn. A skirt used during certain kinds of ritual washings, for example, must never be worn by its owner while she is in menstrual seclusion; and though a woman may have several hundred skirts in her trunks, she is very clear about the ones to which such special prohibitions apply.[32]

Accessories

Maroons enjoy a varied range of accessories, and these often play an important role in folk tales, local gossip, and evaluations of personal beauty.

Calfbands, worn by both sexes, are an important example (Figure 49). Saramakas proclaim flatly that "Funeral rites aren't conducted without calfbands," reflecting the fact that although calfbands are not a necessary part of everyday dress, they are *de rigeur* for public celebrations. When a man is away on the coast, each of his wives is careful to make at least one pair of calfbands, in order to be able to "give thanks" properly for the goods he will present to her upon his return (see Chapter 2).[33] A person wearing a new pair of calfbands will be congratulated by words (and sometimes a little dance and spontaneous song), and warmly embraced by friends and kinsmen. In Saramaka, when a corpse is laid out for burial, it must be wearing a handsome new pair of calfbands, with several other pairs placed on top of them. In short, calfbands are understood not only to enhance the wearer's beauty by accentuating the

101. Bolts of cotton cloth in the "Jeruzalem Bazaar," Paramaribo. About 400,000 yards of such cloth are imported to Suriname each year, now mainly from the Peoples Republic of China and from Japan, for sale to Maroons.

102. Saramaka shrine for ancestors

103. A Saramaka woman crocheting calfbands around a bottle

104. A Saramaka woman spinning locally-grown cotton into thread

calves, but also in many cases to serve as a public reference to a state of celebration, to the relationship between the maker and the wearer, and so on. Once on, these very tight bands will be worn for many months (though men sometimes take them off sooner), and usually must be cut in order to be removed. In the early decades of this century, women sometimes crocheted legbands directly onto the calves or ankles of a husband or lover, who sat patiently for many hours over a several-day period while this labor of love was performed. Today, women use bottles (adjusted for size by the addition of vertical sticks) or cylindrical wooden forms to shape the bands, working with a sharpened umbrella rib and carefully wrapping a cloth around their work each day to keep it clean (Figures 103 and 148). Although in the past the yarn for these bands was spun from cotton grown in the woman's own garden (Figure 104), commercial cotton yarn, purchased in Paramaribo, is now more frequently used. (The same yarn is used in the "knitting"[34] of red, white, and navy ribbons used for men's waist ties or to secure hammock coverings, in the "knitting" of special calfbands worn by infants, and in the making of special ties for beaded necklaces—see Figure 106.) The history of calfbands is discussed in Chapter 8.

Women's stacked aluminum anklets are also worn for several months at a time and, like calfbands, are considered both a means of enhancing beauty and a cause of physical discomfort.[35] These anklets, shaped with a hammer from lengths of aluminum (or, until the 1940s, copper) cable wire acquired on the coast, are carefully graduated to form a smooth, tight, concave cylinder around the lower leg (Figures 19 and 52). They require periodic scourings with a length of rag and fine sand to maintain their polish. Bracelets of the same material are often worn on both wrists, and sometimes these are made from two aluminum pieces twisted around each other (Figure 103). During the early 1970s, some young women began encircling their wrists instead with the black rubber lining rings from the openings of gasoline drums, and even more recently rubber bands of varied colors have served in the same capacity. These last two fads typify the open attitude toward new ideas in dress, many of which involve the innovative use of novel materials. Safety pins and paper clips are common decorative additions to delicate gold neck chains, and the price tags for new hats and umbrellas are sometimes left on, both as embellishment and as a dangling reminder of their newness and value.

Commercial jewelry contributes to Maroon dress in a variety of forms. Gold or silver "button" earrings were worn by both sexes, from the mid-eighteenth century (when they were requested from the government as tribute) until well into this century, and are still required for a corpse being prepared for burial in Saramaka. Today, women and girls enjoy stylistically varied earrings imported from the coast. Watches have now become an almost standard item of men's dress; plastic barrettes and nylon hairnets are often added to hairdos for festive occasions; and necklaces are common for both men and women.

Additional accessories are provided by a person's participation in ritual activities. In the early years of these societies' existence, specially prepared necklaces, armbands, belts, and so on were worn for ritual protection in battle. Currently, similar items are made for protection against witchcraft and sorcery; and sickness is commonly treated by, among other things, the wearing of items prepared during the course of a curative ritual. Such protective accessories often include cowrie shells, small parrot feathers, coins, and leaf mixtures in cloth casings, but the full range of possible ingredients is much wider since the composition of each is directed, through divination or spirit possession, by a particular god, oracle, or spirit (Figures 105–106, 109 and 253). Although these accessories are intended as ritual protection, they are made and evaluated by Maroons according to aesthetic criteria as well.

Finally, some forms of jewelry have been intended as weapons in hand-to-hand combat, especially in grudge fights over women. Saramakas described to us brass knuckles, bracelets with razor-sharp edges, rings with double pro-

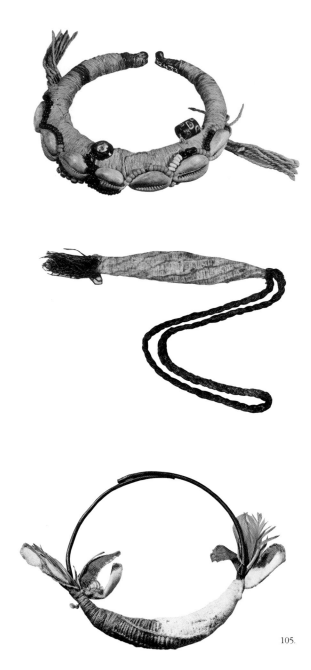

105.

105. Protective jewelry: a) iron arm-ring with cowrie shells, beads, and tassels, collected before 1913; b) braided-fiber necklace with pendant, collected 1928–29 in Niukonde (Saramaka); c) copper arm ring with stitched covering, red and white bits of cloth, and small parrot feathers, collected 1928–29 in Ganiakonde (Saramaka).

106. Protective necklaces made c. 1965 in Upper River Saramaka: a) medicines encased in black cloth, the ends of which are split, strung with white beads, and twisted to form the neck cord; b) coin and red, white, and black beads strung onto a tie made by interlooped knots on a length of cotton yarn.

107. Aluku girl braiding another's hair (Jean Hurault, *Africains de Guyane*)

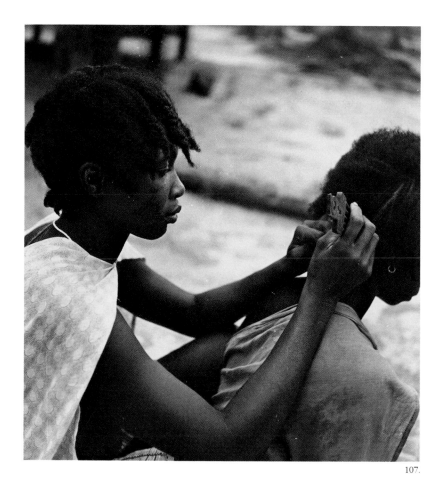

107.

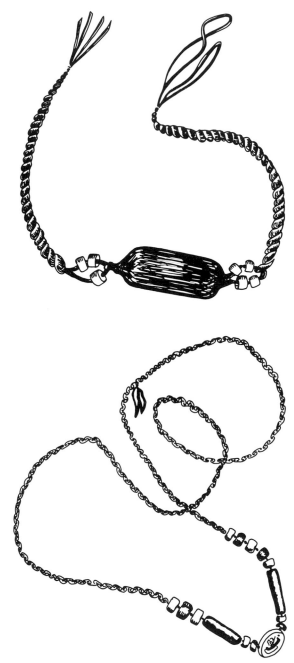

106.

truding spikes, bracelets incorporating claws from certain birds and rodents, heavy arm bracelets that could be slipped over the fist, and several hand-held variants of these fashioned from old machine parts collected on the coast. Missionaries who lived in Saramaka villages immediately following the peace treaties described their common, and highly conventionalized, use (Schumann 1778: s.v. *mulungà*; Riemer 1801: 254–259). Saramakas report that they were worn during fights over women until the 1920s, when Tribal Chief Djankuso confiscated and destroyed those already in existence and prohibited the manufacture of new ones. (Such weapons are widely distributed in Africa and their history goes back many centuries; there, as in Suriname, their use is confined largely to grudge fights and duels; see Lindblom 1924: 93 and 1927.)

Hairdos

Maroon women normally have their hair braided, often by someone else, once every few days. Using long wooden or, sometimes, aluminum combs carved by men (see Chapter 4), or now, rarely, a commercial Afro-pick bought in Paramaribo, the hair is combed out, parted into sections, and braided in one or more distinctive, named patterns (Figure 107). Some braids end in a tiny twisted point, some are tucked under and secured with decorative hairpins fashioned from aluminum wire, and others are incorporated into a braid in another section of hair. Festive hairdos may include fluffed hair or tasseled sections. Figures 32 and 264b illustrate a few of the many named patterns.

During the early twentieth century, many men wore braided hairdos, often as elaborate as those of the women (Figures 42–43). Most of the hairdressing was done by women, but in their absence, men could also braid each others' hair. One famous hairdo of the past, particularly popular among eastern Ma-

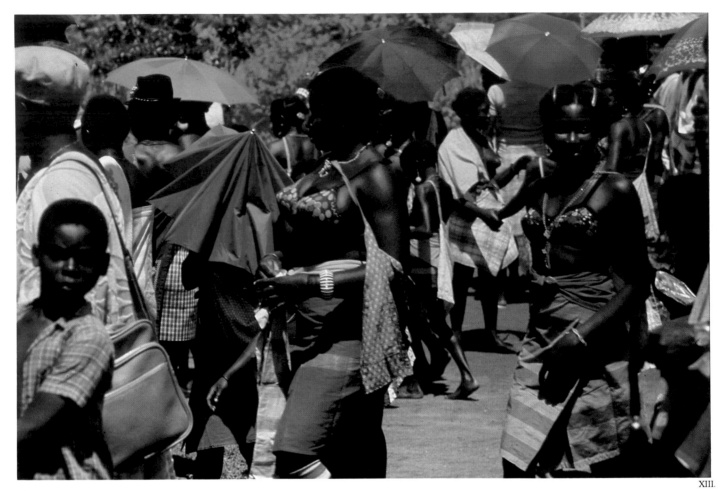

roons, was known as "come this evening" or "husband and wife"; and it is said that a woman would create this pattern of intertwined braids only for a man she loved. By 1934, when Tudendu became Tribal Chief of the Saramakas, men's hairbraiding had largely died out in Upper River Saramaka, though it continued for another five years or so on the Lower River. Among the Djuka and Aluku, men's hairbraiding went out of style during the 1950s (Thoden van Velzen 1966: 20–21; Hurault 1970: 59). During the 1970s, apparently in reaction to trends seen on the coast and elsewhere in Afro-America, hairbraiding once again became fashionable for men. Although they no longer sport the long, elaborate hairdos of a half century ago, many men keep their hair long enough so that a wife or lover can occasionally braid it into a variety of patterns (Figure 242b).

Cicatrization

To Maroons in most regions of the interior, a woman's cicatrizations are an important aspect of her beauty and sexuality (Figures 108–109).[36] Upper River Saramakas are still adamant that a woman without cicatrizations on her thighs and lower back (or a woman who failed to recut her scars periodically) would be ridiculed by her female peers. When men gather of an evening and swap stories of women they have known and loved, an important rhetorical role is played by vivid descriptions of cicatrizations—how those of a certain woman glistened in the sunlight, and so forth. The beadlike quality of cicatrizations is considered highly erotic, and women sometimes heighten this effect during love-making by donning a multi-stranded beaded "wrestling belt" given to

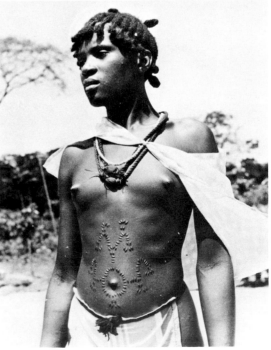

88

them at the time of their first marriage (Figure 110.)[37]

There are significant regional differences in the cultural importance of cicatrization, in the number and placement of designs on the body, in the forms of the designs used, and in the names assigned to designs. Djukas and Alukus have a tradition of more numerous designs per person than Saramakas; Djuka girls who are still several years too young for marriage often have cicatrizations cut on their lower backs and thighs, while Saramaka girls always wait until after they have received the skirts symbolizing their marriageability; the upward spiral with which many Djuka women embellish the corners of their mouths is almost never cut in Saramaka; and so on. Even within Saramaka, regional distinctions are recognized: for example, a double-arc design that is extremely rare in the villages of the Pikilio is common on the foreheads of women from the upper Gaanlio; a thigh design known as "rat's chin" is a specialty of the village of Godo and its immediate neighbors; and a design called "lines beside the ears" is still cut by women in villages along the upper Gaanlio, but considered old-fashioned by inhabitants of the Pikilio.

Several women usually arrange to have their cicatrizations cut together. Preferred occasions in Saramaka include the morning of the "second funeral" (a major setting for romantic involvements) or the day on which a woman is to emerge from menstrual seclusion and rejoin her husband or lover, since freshly cut (or re-cut) cicatrizations are considered particularly beautiful and erotic. A woman experienced in cutting them meets the others in a secluded spot behind one of their houses. The session is filled with joking and teasing about the women's ability to take the pain and the threat of being discovered by men in the village. The woman in charge first draws each design on the body with a stick dipped in a mixture of kaolin and water. (In Saramaka a generation or two ago, men were sometimes called in to mark the designs; but people claim that today no man could resist the sexual temptations implicit in this activity, and the practice has been discontinued.) Special attention is given to horizontal symmetry; if the two halves of the design do not form a symmetrical whole, it is redrawn. Moreover, the total arrangement of designs on a face, abdomen, chest, or lower back should be visibly symmetrical. Some women, however, have different designs on each arm or leg.

Once the design is drawn, the woman in charge pinches the skin between thumb and forefinger and makes a short slash with a razor for each mark of the design. When the designs being cut on one woman are completed, they are rubbed with any of about fifteen irritants and then with carefully sifted ashes, which each woman has provided for herself. Young women usually have their cicatrizations reopened every few months, gradually building up large beads of scar tissue. The first "wakening," which Saramakas also call "removing the kaolin water," is said to be more painful than the original cutting. The woman who cuts or reopens the cicatrizations is "thanked" with a small gift such as some rice or peanuts. Women in their twenties and thirties have the most prominent scars; as they get older, most "waken" the cuts only every few years, and during their forties or fifties they stop entirely.

Until several decades ago, men were also cicatrized, though less extensively than women (Figures 42 and 43). During the early twentieth century, many Saramaka men had the backs of their calves incised with a design which was known as "good-bye" (*duumúndu*), since it was only visible when the man was walking away. Men's cicatrizations tended to be less elaborate than women's, though many designs were considered appropriate for either sex. As with other Maroon arts, the most famous designs have been those that reflect a flair for innovation; people on the Pikilio still talk about a man from the village of Akisiamau who, in the late nineteenth century, encircled his penis with scars, thus attracting the curiosity and sexual favors (it is said) of every woman in the region.

Descriptions by eighteenth-century observers indicate that the Africans who were brought to Suriname carried a variety of cicatrization designs on their

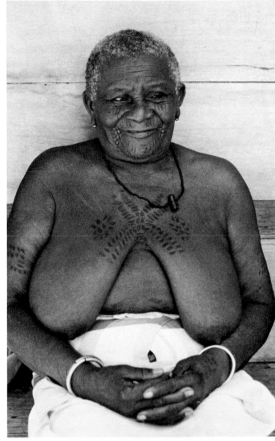

108.

110.

XIII. Festively dressed Saramakas celebrate Tribal Chief Aboikoni's twenty-fifth year in office; many are from the village of Santigoon, where a former wife of Aboikoni lived, and where urban influences on fashion are strong.

108. An elderly Saramaka woman with a cicatrization design frequently cut on the chests of young women around 1900–1910—see Figure 112.

109. Young Djuka girl with abdominal cicatrizations

110. Saramaka woman's "wrestling belt." Navy, yellow, white, red, and light blue beads on white cotton yarn.

111a.

111b.

111. Four African-born Surinamers: a) Coromantyn "ranger," 1770s; b) slave "of the Loango nation," 1770s; c) field slave, 1830s; d) Mentor, slave born on the "Guinea Coast," executed for arson in 1832.

bodies. Hartsinck, for example, described more than twenty ethnic groups among the African slaves in Suriname, giving for each the cicatrization designs by which they could be distinguished: long incisions going from eye to ear on the Ayois; stipples on the cheeks or forehead (among Fida and Annamaboe); complex designs representing lizards, snakes, birds, and other animals which sometimes covered the entire body of a slave from Kaap La Hoe; and so on (1770:919–22). Stedman, writing soon after Hartsinck, also related particular designs to ethnic groups (1796, II:254). The relationship between tribal provenience and cicatrization style was not lost on West African slave traders; Hartsinck reports that some dealers, in order to fetch higher prices, marked their human merchandise with designs characteristic of tribes reputed to provide particularly good workers (1770:918).

Only a few sketches of the designs brought by African slaves to Suriname exist, but these confirm the diversity reported in the early written literature. Figure 111 illustrates cicatrizations on four African-born Surinamers: a Coromantyn "ranger" who fought on the side of the planters against the new rebels in the 1770s; a Loango field slave of the 1770s; a field slave of the 1830s; and Mentor, a young man born on the "Guinea Coast" who, along with two other rebel slaves, was executed for burning down much of the city of Paramaribo in 1832.

There is strong evidence that slaves born in Suriname were not cicatrized. In the early literature, references to an individual's cicatrizations are almost invariably followed by mention of the person's African birthplace; and all available information on the first century and a half of Maroon history suggests that cicatrization was not practiced in the interior until well into the nineteenth century. We have found no mention of it in the extensive first-hand reports of eighteenth-century observers, and it is not listed in the 1778 dictionary of

Saramaccan that was compiled by a missionary living on the Suriname River. Furthermore, the Maroon art of cicatrization described toward the middle of the nineteenth century differs markedly from all of the models known to have been brought to Suriname from Africa.

Several first-hand reports of Maroon cicatrization from the second half of the nineteenth century allow us a relatively full picture of this art during its early years (see, for example, Bonaparte 1884, Coster 1866, Crevaux 1883, Kappler 1854, Martin 1886, and van Panhuys 1934b). Illustrations from this period show designs that are strikingly similar—in technique, style, and placement on the body—to those that have been cut by Maroons throughout the twentieth century. Thus, the art seems to have maintained a fundamental aesthetic unity throughout its history. At the same time it has undergone certain kinds of changes in details of form and in the scale of designs. We present these developments in terms of our understanding of Saramaka cicatrization, but our more limited information on the eastern tribes suggests that they have characterized the history of other Maroons as well.

First, there have always been fads and fashions which change every generation or so. These are never fundamental stylistic changes, but rather specific designs which are popular for some years and are later replaced by others. In cicatrization, unlike woodcarving (see Chapter 4), when Saramakas talk of "old" designs, they are thinking of specific dated motifs rather than different overall styles or design concepts. A number of formerly popular designs have dropped from use; Saramakas claimed, for example, that many of their grandparents' generation—both men and women—embellished the corners of the mouth with a small cross ("spider's claw"), but we saw this design only once, on a woman's wrist. There have also been changes in the conventions regarding the placement of certain designs on the body; for example, one design which was frequently cut on women's temples around 1900 now appears only on other parts of the body.

Second, there has been a gradual abandonment of certain large-scale designs popular around the turn of the century, which is part of a more general tendency toward a reduction of scale in cicatrization designs during this period. Sprawling patterns which in some cases covered an entire back or chest have given way to tight, closed designs, such as a tiny isolated circle of cuts or a small arc between the breasts (Figure 112).

Third, there has been a selective decline in cicatrization in general—for women a reduction in the surface area of the body that is cicatrized, for men (who were cicatrized almost as heavily as women until the early twentieth century) an almost total disappearance of the art. During the past two decades, as women began to be taken to the coast more frequently and for longer periods, many felt some embarrassment about the scars that made them stand out sharply in the context of coastal life. Today, Saramaka women sometimes express regret that they ever had cicatrizations cut on their faces and no longer have these reopened, and most teenage girls are confining their cicatrizations to areas of the body that can be hidden by a dress when they visit the coast. The disappearance of men's cicatrization came earlier in the twentieth century. As men's contact with non-Maroons increased dramatically because of changing labor opportunities (see Chapter 1), cicatrizations (like braided hairstyles) were seen as an embarrassment in coastal society and abandoned. Today, while most Upper River Saramaka men in their sixties have some scars, faded from decades of not being "wakened," few below fifty have any at all.

Taking the long view, the history of cicatrization seems to have reflected quite closely the changing social environment of Maroons. Cicatrization designs were part of African ethnic identity for slaves just off the ships; they were either suppressed or abandoned on the plantations as part of the process of adapting to an alien regime; they reemerged as a major aesthetic form during the first half of the nineteenth century, a period of artistic efflorescence among Maroons more generally; they disappeared for men a century later as part of their having

111c.

111d.

internalized certain coastal values during their years of long-term labor emigration; and finally, they have begun to be limited by women, as a result of increased contact with the coast.

Several of the changes in the art of cicatrization since the late nineteenth century are illustrated in Figure 112. These Saramaka chest designs represent typical generational changes which, in this case at least, also suggest a developmental stylistic series. Such designs are relatively standardized and tend to be shared by most women of the same age in a given region. Although differences in personal preference mean that a design typical of women in their forties might occasionally appear on a twenty-five-year-old, there is almost never any duplication of designs on women separated by more than about three decades. Like the chest designs illustrated here, those on other areas of the body have been undergoing a general trend toward simplification and reduction.

Some Aesthetic Principles

Styles of personal adornment reflect certain fundamental Maroon ideas about art and beauty that not only lend a distinctive character to Maroon dress but, in many cases, influence other areas of their life as well.

One of the most important of these involves color contrast. Both in the manufacture of clothing and in the choice of garments worn together, sharp contrasts are an aesthetic goal (Color Plate XIII).[38] The center stripes of calfbands should "shine" or "burn." So also should a woman's cicatrizations, and though the light skin color of albinos is generally considered unattractive, Saramakas consider their cicatrizations particularly striking because of the sharp contrast between the "green" of the scar tissue and the "white" of the surrounding skin. The combination of shining white teeth and deep black skin figures importantly in ideals of physical beauty. In a narrow-strip textile, each strip should "raise up" those adjacent to it. The continuous lines of an embroidered design frequently shift colors, for example from blue to red to yellow (Figure 35). The end of an embroidery thread is often carried away from the main design into the background area before it is knotted—a way, Saramakas explain, of "dressing up" the cloth through extra color contrast (Figure 113). An outfit that Saramaka women considered especially festive in the 1960s consisted of a yellow skirt striped with blue or green, topped by a bright red waist kerchief; a contemporaneous Djuka outfit, also worn on festive occasions, exploited the same set of contrastive colors (Figure 45); and in the early twentieth century women used to "dress up" a yellow and green skirt by sewing a strip of red cloth along the hem and front edge.

Related to this attitude toward color is a clear interest in positional contrasts within a two-dimensional grid—the juxtaposition and interplay of horizontally and vertically oriented shapes. In narrow-strip capes, the stripes woven into the trade cotton interrupt and offset the dominantly vertical pattern created by the strips, and in one highly admired variant, the vertical strips are extended into the area normally occupied by horizontal strips (Figure 92). Capes decorated with strips of cloth, lace, and ribbons often exhibit an "H-shaped" pattern (Figure 95); this form, in which a horizontal band intersects two verticals, crops up repeatedly in diverse aspects of Maroon material culture, providing one of the most widely utilized "frames" for textile arts, objects carved in wood, and even village entrance gates.

The tendency to crosscut linear patterns, to interrupt the main "grain" of a design, is a recurrent feature, not only of textiles and other visual arts, but of Maroon aesthetics much more generally. When the bands of a calabash carving are crosscut with secondary incisions, Saramakas have explained that the artist was "dressing up" the design, and the very important wood-within-wood technique in men's carving (in wood, aluminum, and calabash exteriors) can be seen as a way of crosscutting linear designs without denying their continuity. Likewise, we will see in Chapter 6 that the structure of everyday speech, formal speech, prayer, tale-telling, song, and dance requires frequent "cuts" (inter-

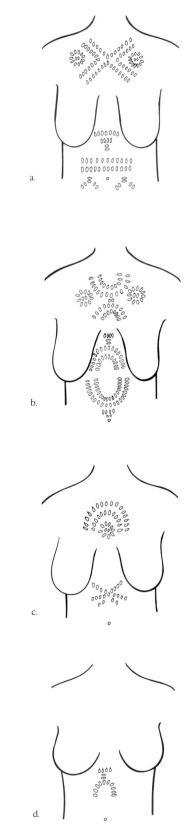

112. Chest cicatrizations on Saramaka women born about: a) 1880; b) 1915; c) 1930; d) 1950.

ruptions) in the form of responses, digressions, or sudden shifts in style.

Symmetry is another aesthetic principle that is highly influential in both the personal arts and other aspects of Maroon cultural life. Proper posture requires a firm stance on two feet, with shoulders squarely set (Figure 52), and any "one-sidedness" is judged with disapproval. Embroidery designs, the placement of cicatrization designs, the layout of modern narrow-strip capes and aprons, and the stripes on calfbands must all observe the principle of regular symmetry along a vertical or horizontal axis. Women are meticulous about adjusting their skirts so that left and right hems are even in front, and their waist ties so that the point (of Saramaka waist kerchiefs) or tassel (of Djuka waist cords) is not off-center. Woodcarving designs almost universally observe at least one axis of symmetry, and even the curvilinear free-form shapes of calabash designs and female-marked embroidery are conceptualized in terms of (imperfectly executed) one- or two-axis symmetry.

The "rhythmic" qualities in Maroons' uses of contrasting colors, grid-based designs, and speech, song, and dance have contributed importantly to the perceived character of their artistic production. Observers have frequently been struck by the "syncopated" quality of Maroon narrow-strip compositions, as well as other plastic arts, song, dance, and speech, and have had no difficulty finding examples from all media that support this impression. In terms of modern plastic and graphic arts, however, we should note that present-day Maroons make a consistent and conscious effort to avoid details that would offset the central symmetry of a design. In textiles, this development has manifested itself most dramatically through changes in the principles of narrow-strip cape composition (see below) and in the importation and development of a rigidly regularized art of cross-stitch embroidery. While the principles of symmetry and syncopation seem to have maintained a dynamic balance during much of Maroon history, then, the present century is witnessing a gradual but undeniable trend toward an emphasis on symmetry in the visual arts.

Maroon artistic ideals concerning color have also changed during this century. We have seen how the replacement of bits-and-pieces textiles by narrow-strip sewing involved a fundamental shift from tricolor (red, white, and "black" [navy]) to multicolor compositions.[39] Among eastern Maroons, this development was paralleled at the same time in men's art, when painting was introduced as a complement to the carving of wooden objects. Beginning with a relatively cautious use of red, white, and black, painting soon became a brilliant decorative medium used on every wooden object, from house facades to food paddles (Color Plates V, XIV). The earlier focus on red, white, and "black" has, however, survived in a number of interesting ways, and can—in spite of the chromatic brilliance of much of Maroon artistic production—be counted as a fundamental feature of the conceptual framework of these cultures. The ties that women sometimes knit for their husbands' hammock covers always utilize red, white, and navy or black cotton. Many ritual objects continue to be decorated with designs of red berry juice, white chalk, and black soot. Linguistic terminology is more developed for these three colors than for any others, in that each can be intensified by a specialized modifier while other color terms cannot. Most color classification is phrased in terms of red, white, and black—for example, okra sauce is "black"; skin colors are either "red" (on light-skinned Maroons and Amerindians), "black" (dark), or "white" (on albinos and Caucasians); and different kinds of woods and earth or clay are distinguished in the same terms. The extensive classification of rice varieties is explicitly divided into "white" and "red" types, and the arrangement of the twenty or so varieties in any one garden is based on the regular alternation, for aesthetic reasons, of these two colors.

It would not be possible to reconstruct, solely from the study of museum collections, the ways in which an artist's abstract aesthetic ideals come together with technical skills, available materials, utilitarian considerations, and the critical commentary of others to produce a finished object. This creative process

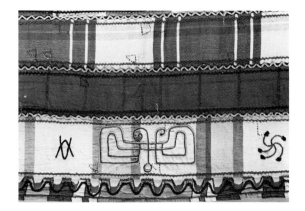

113. Detail of the Paramaka cloth in Figure 86. Embroidery threads are carried into the background areas to provide additional color contrasts.

See page 88 for Color Plate XIII.

See page 96 for Color Plate XIV.

93

can be understood only when attention is given to what the artists themselves have to say about their aesthetic goals and to the actual production process as a reflection of their ideals. In studying Maroon arts, this approach has been useful not only in clarifying the place of artistry in Maroon life, but also in allowing us to understand Maroon attitudes toward the formal qualities which are observable in their arts. We end this chapter with a brief analysis of the construction of men's narrow-strip capes in Upper River Saramaka in the 1950s and 1960s, to illustrate the kinds of insights that emerge from this ethnographic approach.

In planning men's narrow-strip capes, women work with a collection of perhaps one hundred strips, each of which they have trimmed from the side or end of a two-ell length of trade cotton (Figure 114). The composition is rarely prepared in solitude; other women's reactions to alternatives are an important influence on decisions regarding color, pattern, and overall size. The first piece to be laid on the ground is the vertical center strip or "spine"; the preference is for a strip from the "head" of the cloth (cut along the weft), but "side" pieces (from the warp) are occasionally selected on the basis of other considerations, such as color or width. The spine should be the widest strip in the composition. A pair of matching strips, chosen to contrast with the "spine," are placed at the sides, and the composition continues to develop from the center to the sides, with "head" and "side" pieces alternating. Women give careful attention to color contrast between adjacent strips and attempt to avoid excessive repetition of any one color. One to three "side" strips (depending on the height of the intended wearer), which should also be of contrasting colors, are chosen for the lower edging (called the *sepú búka*—"[at the] edge of the calfband"). Another "side" strip, preferably of white, yellow, or some other "unobtrusive" color, is placed along the top, with the selvage to the outside edge. Once a pleasing composition of the right size has been achieved, the upper corners of the vertical strips are tacked loosely together with thread, and the sewing begins. The seams may be made by hand or by hand-cranked sewing machine; these seams are then hemmed carefully under by hand, as closely as possible to the seam line, and all edges except the upper selvage strip are turned into a broader hem. After ties have been sewn to the upper corners, the cloth is washed in the river and folded, wrong side out, into a neat, small packet. (Figure 116 illustrates a narrow-strip cape made according to these principles.)

Certain important aspects of the aesthetics of this form are clarified by Saramakas' comments on cloths in progress, on older examples, and on photographs of cloths from museum collections. We cite five features of Maroon narrow-strip cape compositions as illustrations of the importance of ethnographic fieldwork for the understanding of aesthetics in an unfamiliar society.

1) Discussion with Upper River Saramakas has made clear that the alternation of lengthwise and crosswise stripes, so characteristic of their narrow-strip cloths, is not viewed as an aesthetic preference, but stems rather from a

114. The use of a standard two-ell length of trade cotton. Dotted lines indicate cuts made by the seamstress. (Note that each narrow-strip textile requires strips from many such cloths and that the dimensions of capes, skirts, and the strips themselves vary according to the size of the intended wearer and the aesthetic preferences of the seamstress.)

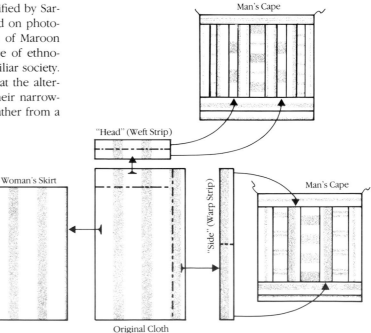

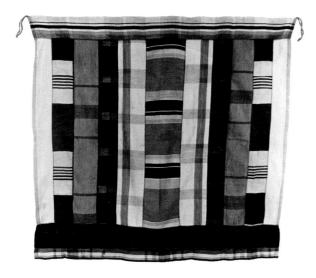

116. Saramaka man's shoulder cape, sewn in Upper River Saramaka in the 1960s. Note that although warp and weft strips have been consistently alternated, this has not produced a regular alternation of crosswise and lengthwise stripes; see also Figure 115.

115. An alternation of warp and weft strips which does not produce alternation of lengthwise and crosswise stripes; see also Figure 116.

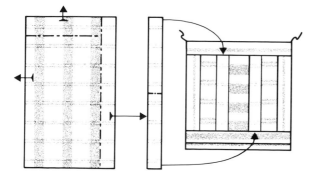

technically motivated rule requiring the alternation of strips taken from the warp and the weft of different cloths. The proof that Saramaka women have in fact focused their attention on warp and weft (as they claim), rather than on the more visible variable of stripe direction, is seen in capes of the type illustrated in Figures 115 and 116. In contrast to the majority of capes, in which the alternation of warp and weft happens to produce a consistent alternation of lengthwise and crosswise stripes (Figure 114), these compositions include some warp strips that "miss" the dominant stripe (which always runs along the warp). At the same time, they *do* show a weaker cross-stripe, thus resulting in a cloth that alternates warp and weft without alternating lengthwise and crosswise stripes. In such cases, Saramaka women are unanimous in saying that the composition was "correct"—that what mattered was the alternation of "side" and "head" pieces (warp and weft) rather than that of lengthwise and crosswise stripes.

2) Occasional deviations from perfect mirror symmetry (through staggered placement of crosswise stripes or modifications in the left-right matching of strips around the "spine") do not reflect an aesthetic ideal of "syncopation"— at least for this region over the past several decades. What might once have been (and what might seem, from an outside perspective, still to be) the use of "aesthetically sophisticated" syncopated rhythms is now produced only because of inadequate resources. A woman who finds herself without sufficient cloth of one pattern may reluctantly resort to nonmatching strips by the time she reaches the outer sides or may be unable to align the crosswise stripes exactly, but this is unanimously viewed as an aesthetic shortcoming. Older Saramaka women who were active textile artists in the early twentieth century also tend to criticize their early work from the perspective of the high value currently placed on symmetry. It is not clear how explicitly the principles of narrow-strip textile composition were articulated at that time, when "staggered" and asymmetrical patterns were more common. We do know, however, that older Saramaka women have adopted the aesthetic of rigid symmetry as much as others in the society; they "excuse" the irregularities in their early creations by explaining that, though they had been technically skillful in their sewing, they were not as successful at figuring out the "proper" principles of composition as their daughters and granddaughters have been.

3) Technical considerations are allowed to limit the aesthetic possibilities of narrow-strip cloths in other ways as well. The introduction around 1970 of a heavier grade of trade cotton which shrinks noticeably when washed, effectively segregated cloth strips into two categories which could not be combined. Once the new cotton was introduced, women carefully avoided juxtaposing strips from these "thickies" (Sar. *dégi míi*) with strips from the thinner grade of cotton (Sar. *avênge koósu*), regardless of the aesthetic attractions of the color combinations.

4) Because of cultural ideas about the relative beauty of different parts of the human body, certain parts of the cape's composition are considered more aesthetically important than others and this, too, has influenced the artist's decisions in creating pleasing compositions. The bottom strips, for example, are chosen with great care to call attention to the wearer's calves, while the choice of the upper strip is given relatively little attention.

5) Saramakas' comments also help us to understand differences in the treatment of symmetry, color contrast, and so on between women's narrow-strip cloths and those designed for men. Women explain that their narrow-strip skirts (which are often machine sewn) exhibit uncentered patterns, not because of a divergent aesthetic ideal, but because it would not be appropriate to lavish on their own narrow-strip clothing the same degree of care given to men's garments. In effect, women see themselves as preserving the social value of the labor and aesthetic sensitivity represented in men's narrow-strip clothing by avoiding both handsewing and preplanning in narrow-strip clothes designed for their own use.

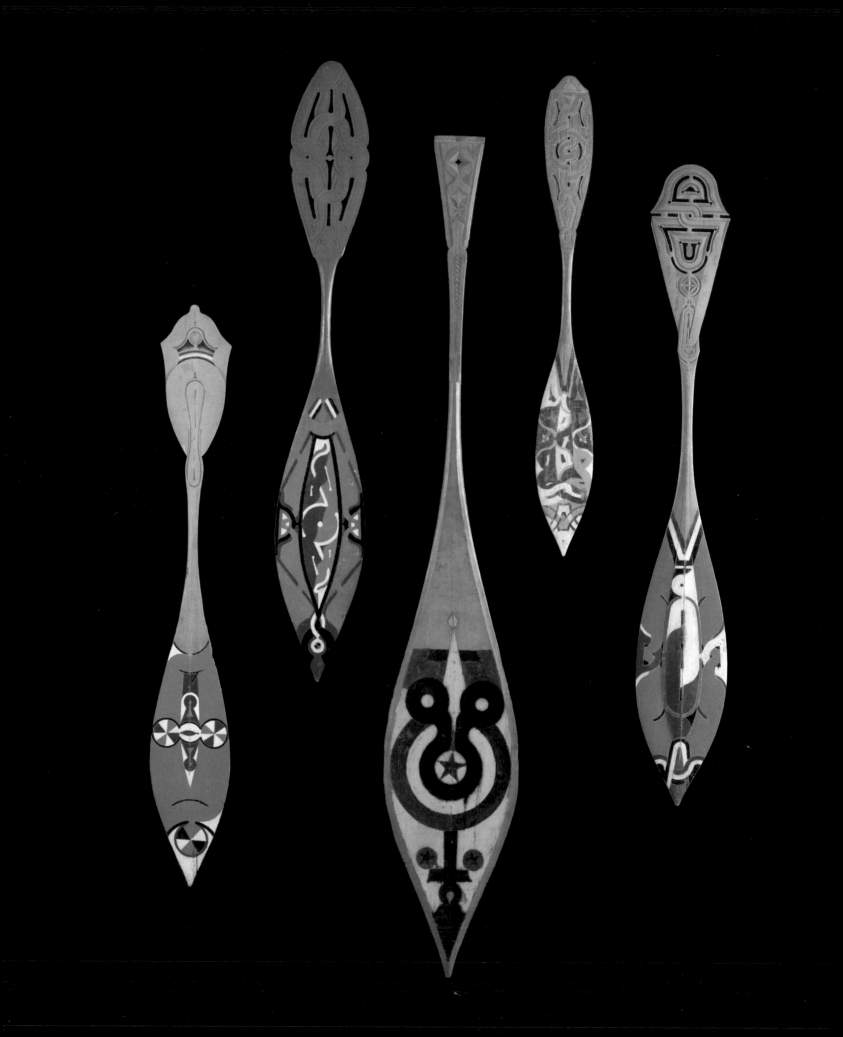

4 WOODCARVING

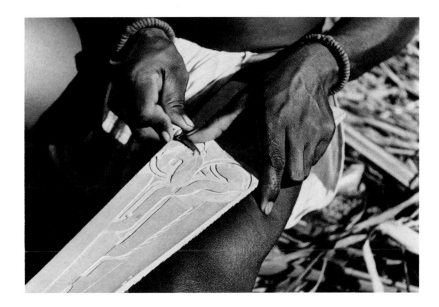

117. Aluku man carving a paddle (Jean Hurault, *Africains de Guyane*)

XIV. Eastern Maroon paddles combine woodcarving and colorfully painted designs: a) Djuka, collected 1971 on the Tapanahoni River; b) modern paddle, no information on provenance; c) Tapanahoni Djuka, collected 1920s; d) modern Paramaka child's paddle; e) Djuka, collected 1971 on the Tapanahoni River.

Introduction

Maroon "art" has usually been equated by outsiders exclusively with wood-carving. Kahn, for example, devoted his entire chapter on art to woodcarving (1931: 193–204); Dark's *Bush Negro Art* (1954), which illustrates 216 objects, includes only 14 not made of wood; Hurault's detailed study of Aluku art (1970) is virtually limited to woodcarving (with only the briefest mention of calabashes and the curious comment that, other than hems, clothing involves no sewing—1970:58); and Herskovits, despite his remark that "Woman . . . is not deprived of an opportunity to show her skill in ornamentation" (1930:159), and passing mention of women's calabash carving, sewing, and cicatrization, gives much the same impression in his writings on Maroon art. Furthermore, woodcarving is the only one of their arts which has achieved any status among non-Maroons. Maroon woodcarving has now been incorporated into the interior decoration of such public buildings as the Paramaribo post office and Suriname's international airport and is the most popular kind of souvenir bought by tourists in Suriname, yet calabashes are rarely purchased by outsiders and Maroon textile arts are almost completely unknown in the capital.

Woodcarving is the male art *par excellence,* produced to some extent by all Maroon men (Figure 117). Until the 1960s in some areas and the 1970s in others, it involved almost no specialization. Even today, with the exception of the occasional sale of a canoe or a mortar, each man in Upper River Saramaka is expected to produce for himself, his wives, and to a lesser extent his un-married kinswomen the entire range of wooden objects necessary to Maroon life—canoes, paddles, stools, combs, food paddles, winnowing trays, mortars, large and small pestles, peanut-grinding boards, laundry beaters, houses and architectural decorations. The cultural importance of woodcarving to Maroons combines with its immediate aesthetic appeal to help explain—if not justify—the exaggerated view of outsiders that it is the "only" Maroon art.

A brief overview of the main kinds of objects carved in wood may serve as an introduction to this art.

Stools. Along with hammocks, stools constitute the most essential furniture of Maroon houses. Stools are carried about the village for use at council meetings, oracle sessions, ancestral rites, and so forth, and they are often taken by their owners on canoe trips to other villages. Older examples are closely associated with the ancestors who originally owned them, and some come to symbolize the official positions (as headman, priest, etc.) these elders held. There are five main types of Maroon stools. The simplest is a one-piece, squat,

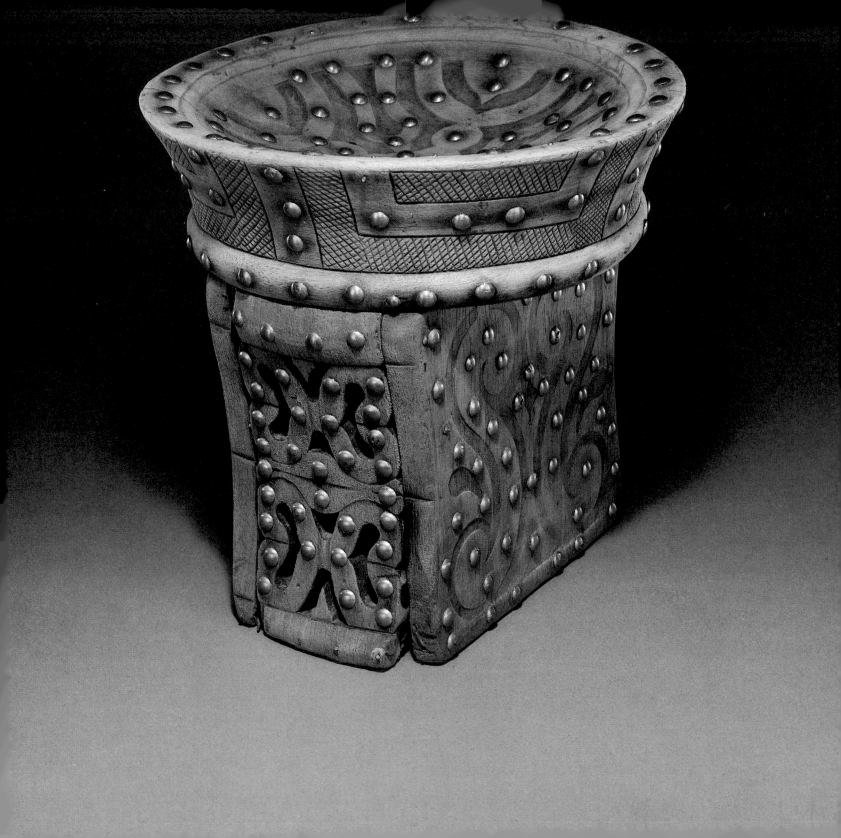

118. A Saramaka *bógolo* stool and the Amerindian stool form on which Maroons say it was modeled

119. Saramaka crescential stool with carved base, collected late 1920s in Pokigoon or Ganiakonde

120. Saramaka crescential stool, carved 1870s–80s by Bongootu, Dangogo

121. Saramaka folding stool carved from a single piece of wood, collected 1928–29

XV. Saramaka round stool, carved c. 1915–20 by Seketima, Godo (see also Figure 181).

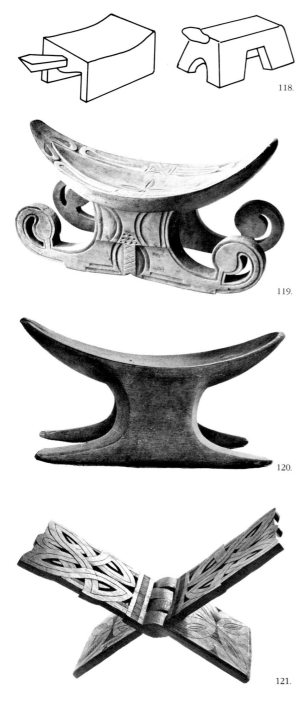

118.

119.

120.

121.

usually undecorated form which Saramakas claim was copied by the original runaways from a common Amerindian stool form (Figure 118).[40] One-piece stools have long been carved in a crescential form as well (Figures 119–120). Composite stools with thick, round concave seats are a third major stool form (Color Plate XV). Composite stools with rectangular tops are carved with both flat and curved seats (Figures 198–199). Folding stools made from interlocked pieces have developed from simpler two-plank models to elaborations of Western reclining chairs made for sale to outsiders (Figures 121 and 196).

Food stirrers. These utensils are used to stir cooking rice and certain foods used on ritual occasions; most women own several of them. Both the shape of the blade and the size of the handle are quite variable; those made by Saramakas tend to be narrow, and those made by eastern Maroons are generally wider (Figures 122 and 209). Food stirrers have also been a popular form for virtuoso carving (Figures 123–125).

Combs. Because they are carved frequently (as gifts for wives and lovers) and sold with relative ease to outsiders (*pace* Crowley 1956:147), combs are among the best-known forms of Maroon woodcarving. Some combs—especially when made for a girl by her first husband—are embellished with multicolored yarn woven through the upper portion of the tines and ending in a fluffy tassel; a more subdued precursor to this colorful decorative touch recently came to our attention on an old comb which still has brittle remnants of a raffia-like fiber from the Mauritius palm carefully woven through the upper tines (Figures 189b, 191c and 192b). A discussion of the historical development of comb shapes, materials, and decorative treatment will be found later in this chapter.

Trays. Round trays are used mainly for winnowing rice, but also as carrying trays and for the presentation of ritual food offerings. A significant proportion of modern examples are only minimally incised, with arcs and circles made by a pair of compasses. Trays have served also, however, as a popular form for some of the most elaborate artistry produced by Maroon men for their wives; these are highly prized by the women who own them and serve as crucial ritual props in presenting food offerings to their ancestors (Figures 126–129 and 174). Rectangular trays, less common than round ones, are used to carry food and dishes to men's meals (Figure 130).

Peanut-grinding boards. These are used, together with a gourd or (rarely) wooden roller, to grind roasted peanuts into the smooth paste that figures importantly in many festive dishes—peanut rice, peanut sauce for meat and fish, and many recipes involving bananas, rice flour, and coconut (Figures 40, 131–133 and 194–195).

Laundry beaters. More popular among eastern than central Maroons, these implements are used to beat bulky laundry, especially hammocks, on stones in the river. The form of the beating end varies from circular to long and narrow; the shaft is often gently curved (Figures 134–135).

Pestles. The large, heavy, double-headed pestles used to pound rice are undecorated. Smaller single-headed pestles used to mash bananas, maize, and other ingredients for festive dishes may have elaborately carved handles (Figure 136).

Canoes. Canoes, painstakingly dug out and then "opened" by fire, represent one of the most striking triumphs of Maroon art and technology (see Color Plate III, Figures 5, 10, and 207). Ranging from less than 10 to more than 50 feet in length, canoes are constructed by all Maroon men. Canoes are decoratively carved on both ends and often on the plank seats as well; eastern Maroons embellish their canoes with colorful painted designs, and Saramakas have recently begun painting the gunwales of some canoes with a single color. The historical development of Saramaka prow carvings is discussed below. (For an excellent illustrated discussion of canoe construction, see Hurault 1970: 62–79.)

Paddles. Paddle size, shape, and decoration vary greatly according to ownership, function, and region. Paddles used for large cargo canoes were tradi-

tionally very broad, but these have become rare in the last several decades due to the widespread use of outboard motors on large canoes. Women's paddles are often half the length of those used by men, and are more elaborately decorated. (The difference in size is related to notions about proper paddling techniques. Men are supposed to paddle with long, slow, smooth strokes, while women's strokes should be short and brisk.) Among the eastern Maroons, paddles are often lavishly embellished with carving and colorful painted designs on both the blade and handle. (See Color Plate XIV and Figures 137–138.)

Architectural decoration. The decoration of Maroon houses seems to have been initiated by Saramakas during the second half of the nineteenth century. Contemporary observers sometimes commented explicitly on the lack of architectural decoration in Maroon villages (e.g., Cateau van Rosevelt and van Lansberge 1873:321), and one points out that the only decorated houses in an eastern Maroon village in the 1890s were three that had been made by visiting Saramaka men (van Panhuys 1928:232). Since then, Maroons have experimented with a wide variety of decorative techniques, including carving, painting, and wood inlays. Many different architectural elements have been embellished, from the ends of protruding beams to the crossed slats atop palm-leaf roofs. Furthermore, whole facades have often been turned into massive works of art; twentieth century eastern Maroon painting was developed most fully on doors and house facades, until the practice began to decline in the 1960s, and open-work or bas-relief carving on house facades and doors was exploited on a similarly impressive scale by central Maroons during the same period (Color Plates V, XVI, Figures 28–30 and 139–143). During the late nineteenth and early twentieth centuries, door locks provided an especially popular aesthetic and mechanical challenge to Maroon woodcarvers (Figures 144–146).[41] Today, the carving of three-piece door frames continues as a lively art in Saramaka villages, reflecting both the creativity of individual carvers and the stylistic trends of particular villages and time periods. (See below for a discussion of the historical development of Saramaka door frames.)

Drums. Of the several distinctive drum forms made and used by Maroons, *apinti* "talking" drums are the only ones that are consistently—and often elaborately—treated with surface decoration (Figures 173 and 246; see also Chapter 6).

There are also numerous less standard objects which may be embellished through carving—washboards, ceremonial swords, soap containers, hammock-making tools, cabinets, planes, the cylindrical form on which some legbands are made, the handle of the legband needle, the wooden "corncob" used to clean legbands, and so forth (Figures 147–154 and 21). Finally, there is an almost infinite variety of carvings made purely for aesthetic pleasure—pierced trays and food stirrers are common, as are virtuoso carvings set in cases or connected by wooden links; wooden copies are carved of items normally made from other materials; and we have seen a wooden pith helmet, a sewing machine, airplanes, umbrellas, an armchair, and a stool with collapsible legs (Figures 155–164).

In contrast to claims in the literature on Maroon art that "the tools of the carver are limited to a machete and a small kitchen knife" (Dark 1954:43), woodcarving technology has for a long time involved the specialized use of a large number of different tools. Saramaka men described to us eighteen distinct tools that were routinely used (though not necessarily owned) by every man in the 1920s, and insisted that at least thirteen of them were in general use well before the turn of the century in the Upper River region. These include the machete and the axe (for each of which several kinds are distinguished), four types of adzes, three gouges, two chisels, two augers of different sizes, a wooden-handled plane, compasses, the compass saw, jackknife, and hammer. Each of these tools serves specialized functions; for example; the three gouges are used 1) to decorate the extreme ends of canoes, 2) to shape drums, trays, and round stools, and 3) as a "drill" for piercing, and they are in no sense

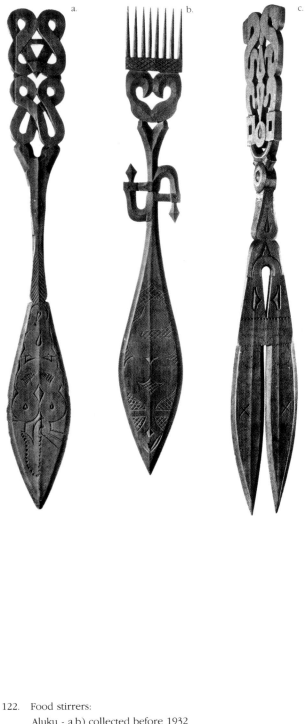

122. Food stirrers:
 Aluku - a,b) collected before 1932
 Djuka - e) collected before 1932
 f) collected 1967 in Fisiti
 Sara Creek Djuka - c,d) collected 1928–29 in Lebidoti
 g) collected 1928–29 (attribution only probable)
 h) collected late 1920s in Pisiang
 Saramaka - i) carved 1955–65, Upper River Saramaka
 j) carved 1963 by Belima, Kambaloa

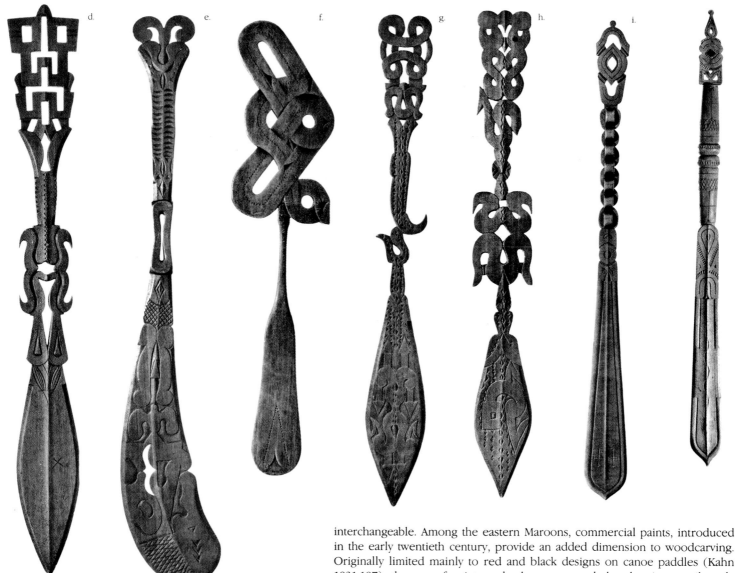

interchangeable. Among the eastern Maroons, commercial paints, introduced in the early twentieth century, provide an added dimension to woodcarving. Originally limited mainly to red and black designs on canoe paddles (Kahn 1931:197), the use of paint evolved, over several decades, into a vibrantly colorful art lavishly applied to wooden objects from houses and canoes to stools and food paddles (Color Plates V, XIV, Figures 137, 28). During the mid-1970s, Saramakas adopted a highly selective use of paints—on the gunwales of canoes, as accents on plank house fronts, and so forth—but have not attempted the complex compositions which have characterized the painting of Djukas, Alukus, and Paramakas.

The symbolic content of Maroon woodcarving has received more attention in the literature than any other aspect of this art. Numerous catalogues of motifs and their meanings have been compiled (see Herskovits 1930, Herskovits and Herskovits 1934, Hurault 1970, Kahn 1931, Muntslag 1966 and 1979, and van Panhuys 1905a, 1905b, 1928, 1930, and 1934b), and descriptions of woodcarving among all Maroon groups are heavily studded with symbolic analyses, both elicited and speculative, of actual pieces. In Chapter 7, we examine this approach critically and attempt to assess its relevance to Maroons' perceptions of their own carvings. Here we wish merely to signal the greater frequency of representational and potentially "symbolic" designs in the carvings of the eastern Maroons. Figures 165–168 illustrate three combs, a paddle, and a tray which include some of the most popular representational motifs—snakes, birds, and human figures. (See also Figures 142–143, 169 and Dark 1954: Plates 1 and 18.)

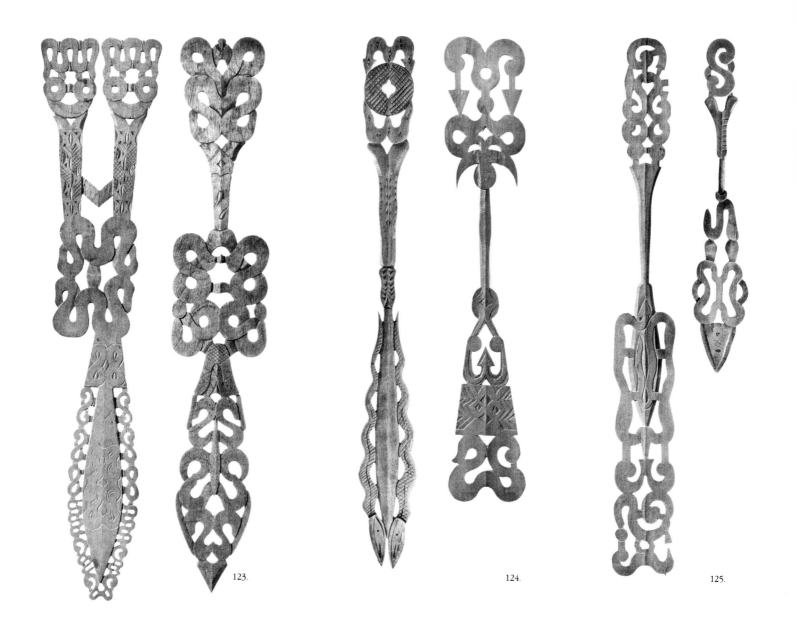

123. Non-functional Djuka food stirrers, collected late 1920s in Pisiang and Maipaondo (Sara Creek).

124. Non-functional Djuka food stirrers: a) collected late 1920s, Tapanahoni River; b) collected before 1932.

125. Non-functional Aluku food stirrers: a) collected before 1901; b) collected before 1939.

XVI. Saramaka interior door, carved c. 1930 by Heintje Schmidt, Ganzee.

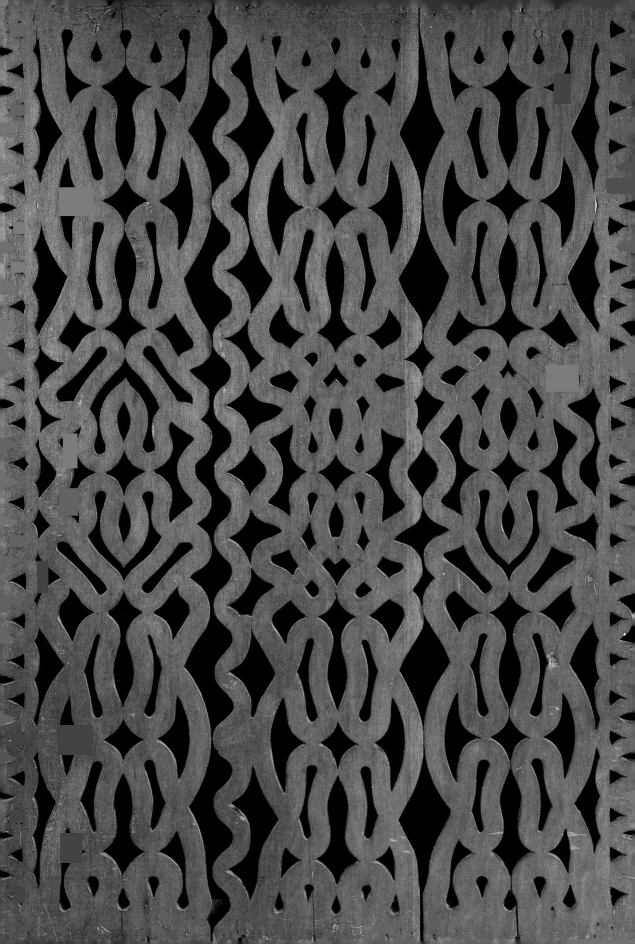

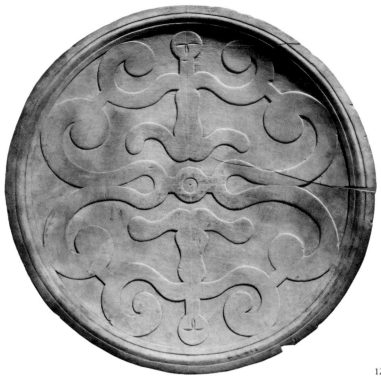

126.

126. Winnowing tray carved with human figures, collected before 1933

127. Saramaka winnowing tray, collected 1928 (see Herskovits and Herskovits 1934: 282–83 for a discussion of the carving).

128. Saramaka winnowing tray, collected 1928–29 in Ganiakonde

129. Winnowing tray, collected before 1932

130. Rectangular serving trays: a) Saramaka, carved c. 1960 in Kampu by Tebini, who inscribed on it the first letter of his own name and that of the wife for whom it was a gift; b) Djuka, carved c. 1970 by Yoping Kanape, Sanbendumi.

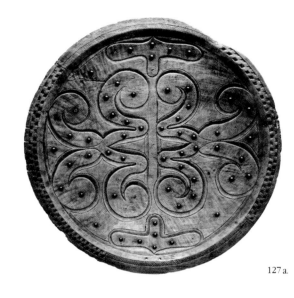

127 a.

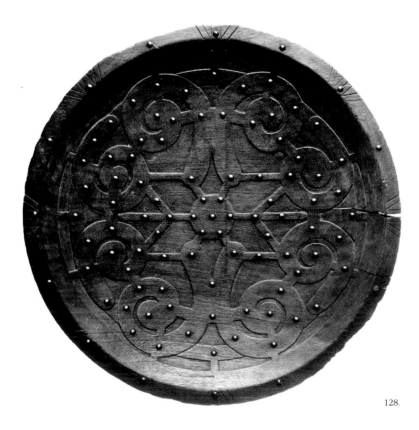

128.

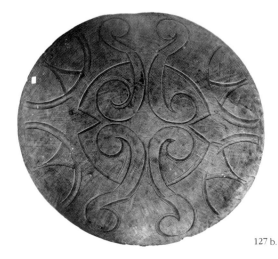

127 b.

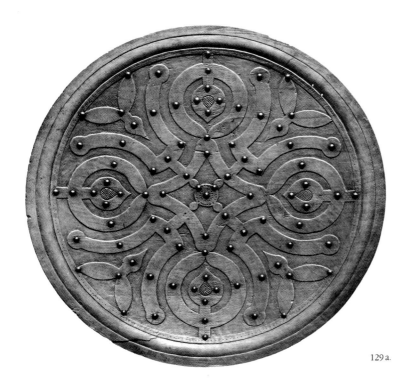

129a.

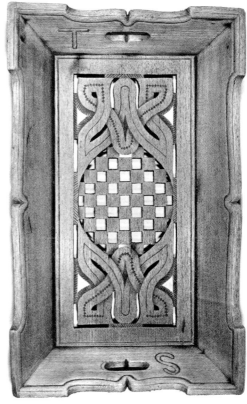

130a.

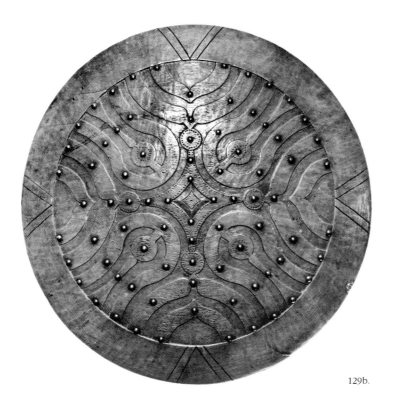

129b.

130b.

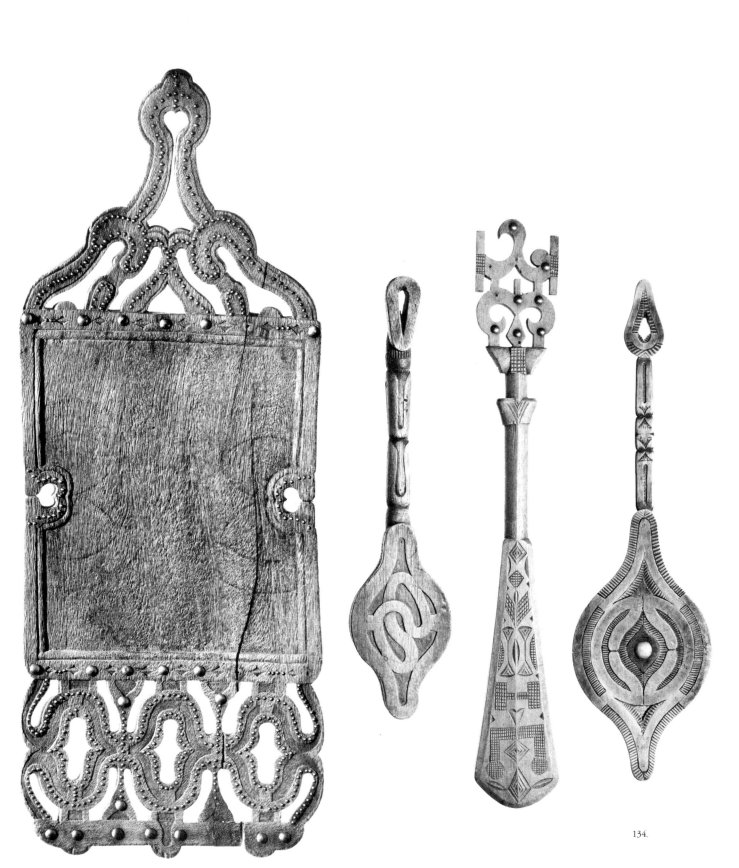

131.

134.

131. Saramaka peanut-grinding board, collected 1928–29, Asindoopo

132. Djuka peanut-grinding board, collected late 1920s, Moompusu (Tapanahoni River)

133. Saramaka peanut-grinding board, collected 1928–29

134. Laundry beaters: a,c) Saramaka, collected 1960s in Guyaba; b) Djuka, collected 1928–29 in Lebidoti (Sara Creek).

132.

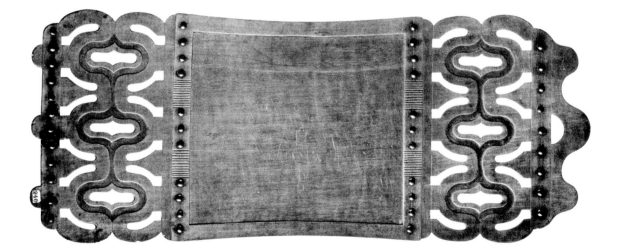

133.

135. Djuka laundry beater, collected before 1881 on the Cottica River.

136. Small pestles: a) Saramaka, collected 1966 in Tumaipa; b) Saramaka, collected 1960s; c) apparently eastern Maroon; d) Djuka, carved c. 1970 by Yoping Kanape, Sanbendumi.

137. Eastern Maroon paddles. a) Tapanahoni Djuka, collected 1920s; b–d) modern paddles, no information on provenance.

138. Saramaka paddles: a) carved c. 1965 by Aviate, Semoisi; b) collected 1928–29 near Ganiakonde; c) collected 1966 in Semoisi; d) collected 1966 in Godo.

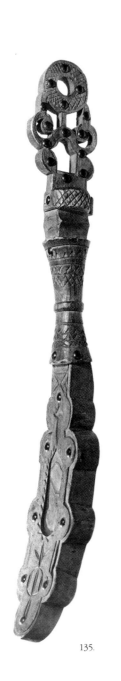

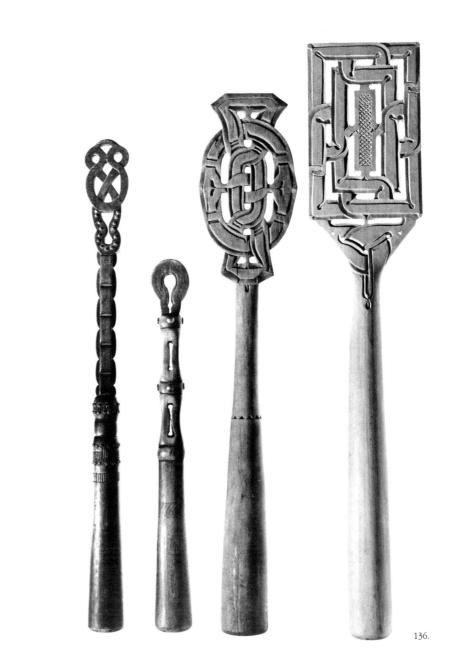

135.

136.

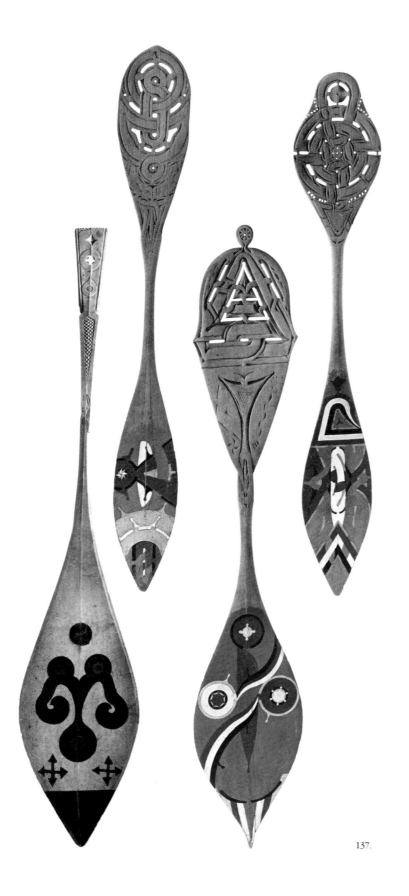

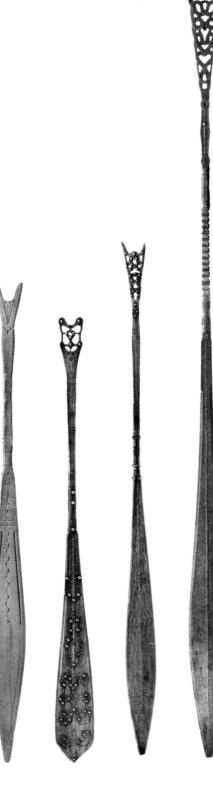

137.

138.

139. Carved house facades: a) Saramaka "raised house" with openwork carving, photographed early twentieth century in Ganzee; b) Aluku house with openwork carving, photographed early twentieth century in Apatu; c) Saramaka house with openwork carving and painted decoration, probably made before 1950.

140. Saramaka carved door, collected 1960s in Semoisi

141. Carved door and frame, collected before 1933, Saramaka-style carving

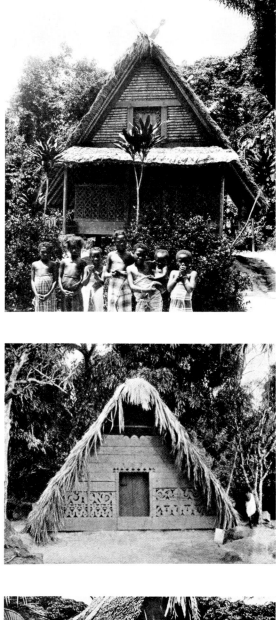

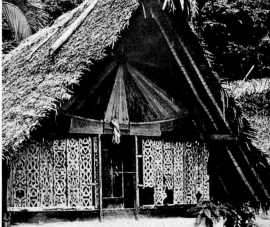

140.

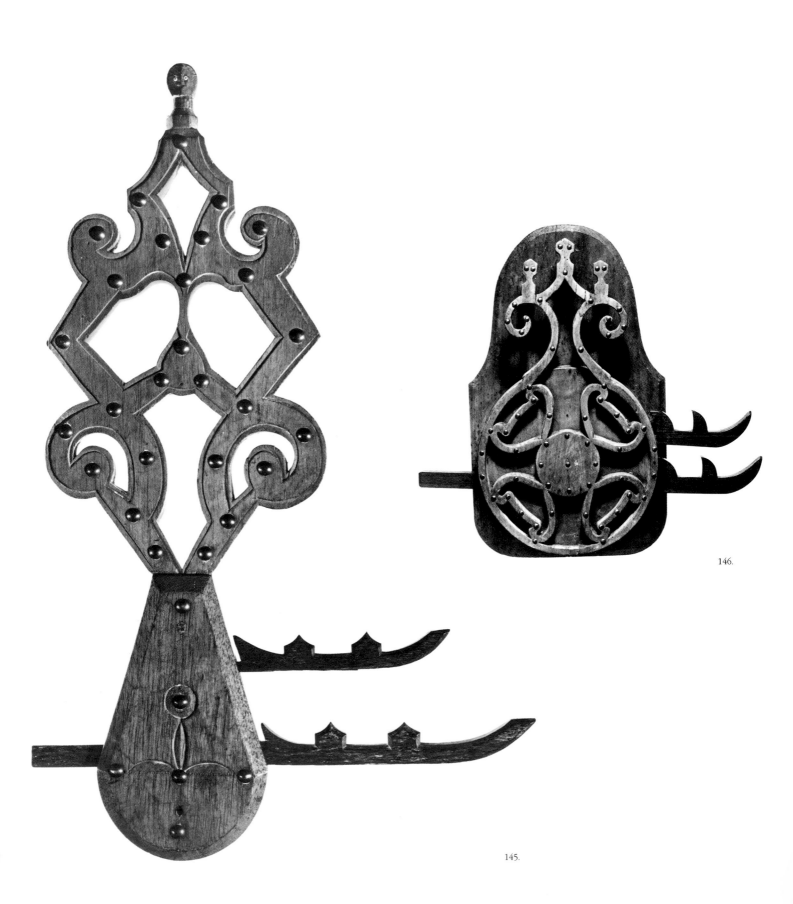

145.

146.

142. Carved door

143. Carved door

144. Djuka door lock, collected before 1922 in Gaaman-staalkonde, and said by the collector to have been carved sixty years earlier.

145. Maroon door lock, collected before 1916

146. Maroon door lock, collected before 1883

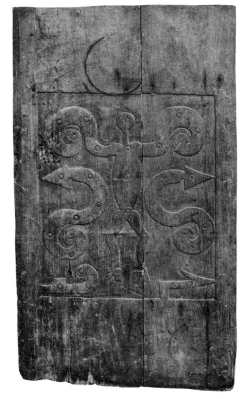

142.

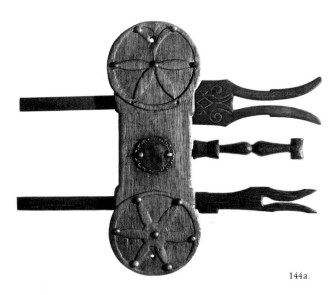

144a.

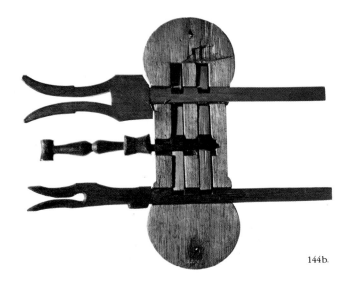

144b.

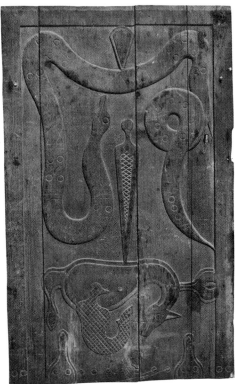

143.

147. Hammock-making tools: a) Paramaka, collected in Nason; b,c) provenance unknown; d) Djuka, collected on the Tapanahoni River.

148. Cylindrical forms used for crocheting calfbands: a) industrial tubing with wooden top and bottom, Saramaka, made c. 1975 on the upper Gaanlio as a present for a young woman from Asindoopo, who was crocheting the calfbands in 1978 with the accompanying umbrella-rib needle; b) wooden cylinder, Saramaka-style carving; c) orange and white calfbands on bottle; d) wooden cylinder, Saramaka-style carving, collected 1932–38.

149. Saramaka wooden roller for grinding peanuts, collected late 1920s in Bedoti. This carved object represents an elegant substitute for the more usual gourd rollers (see Figure 194).

150. Carved wooden calfband cleaners sometimes substitute for dried corncobs: a) unknown provenance; b) Saramaka, collected 1960s in Guyaba; c) Djuka, collected before 1932.

151. Saramaka soap box, collected 1928–29 in Ganzee

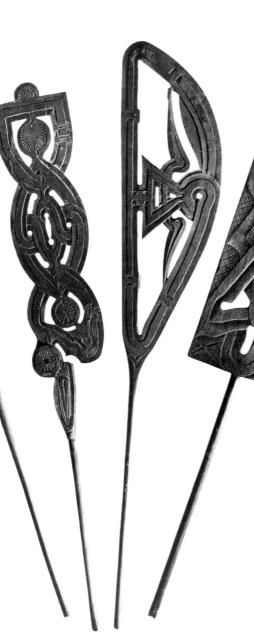

147.

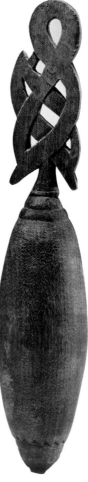

149.

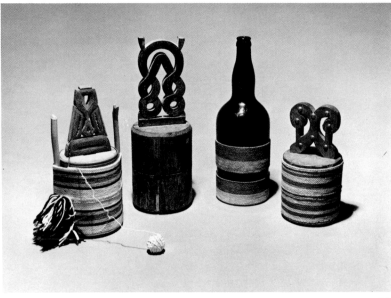

148.

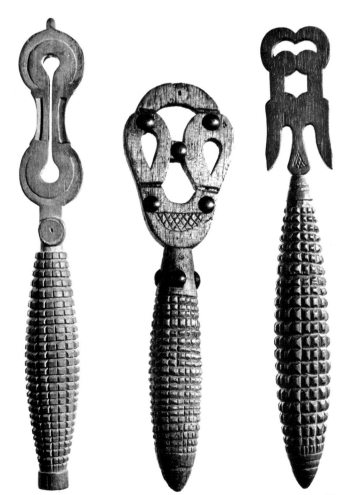

150.

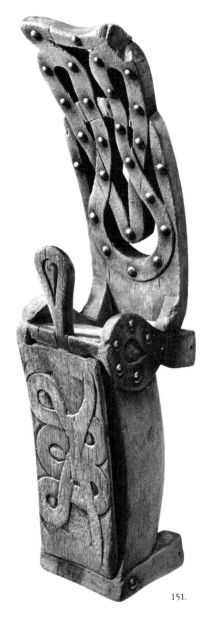

151.

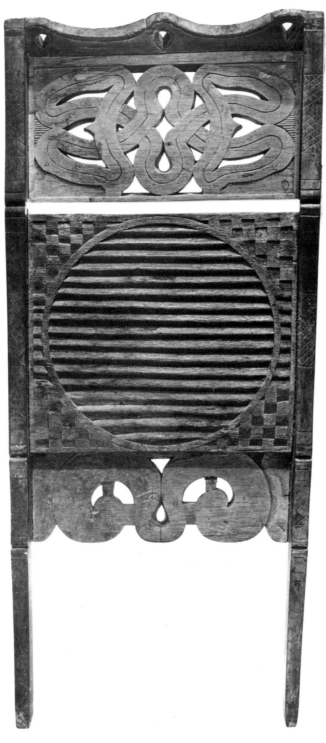

152. Carpenter's planes with decorative carving: a) Aluku, collected before 1939; b) unknown provenance.

153. Djuka carved wooden sword, collected late 1920s in Pisiang (Sara Creek)

154. Saramaka carved washboard, collected 1960 in Dision

155. Openwork tray

156. Carved wooden pith helmet, collected before 1961

157. Carved wooden sewing machine. (For an interesting parallel made by a Tlingit Indian, see Inverarity 1971: Plate 220.)

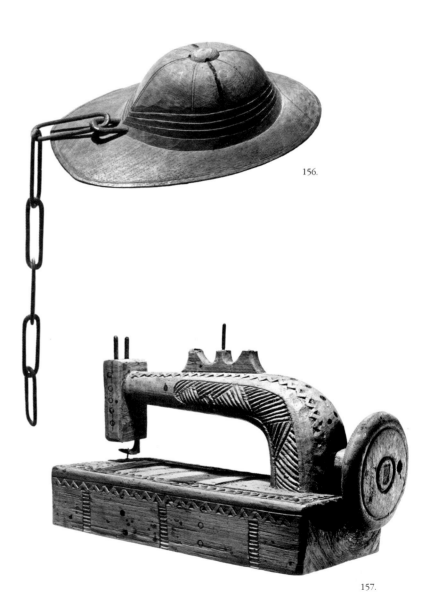

156.

157.

154.

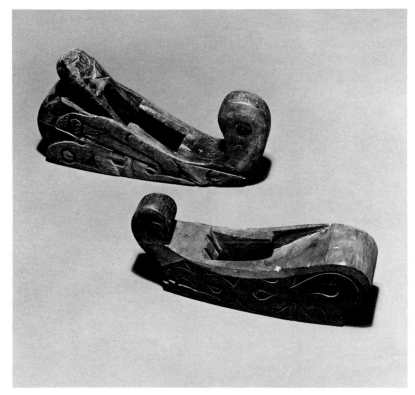

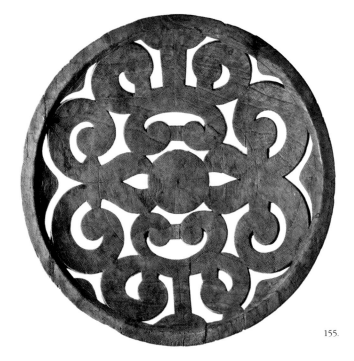

152.

155.

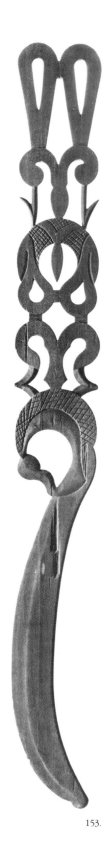

153.

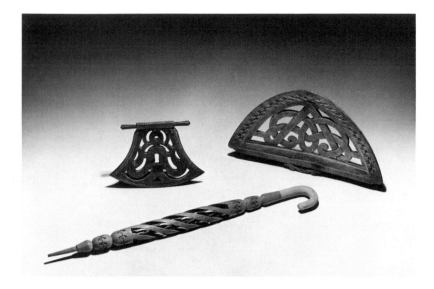

159.

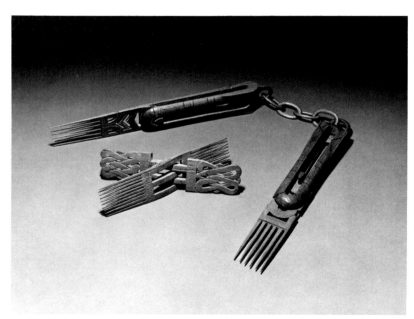

160.

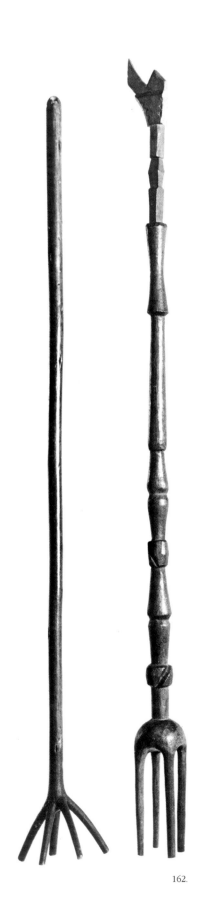

162.

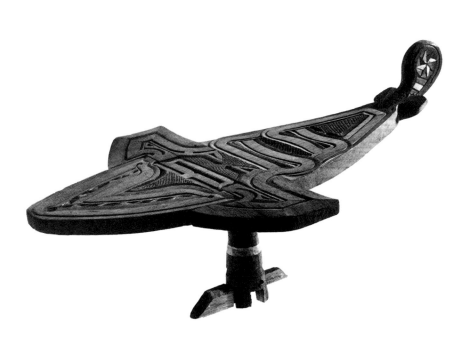

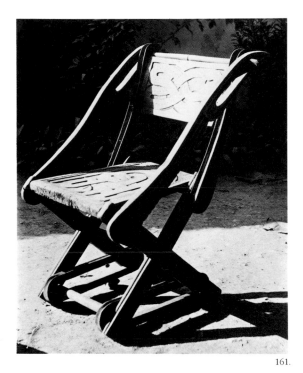

158.

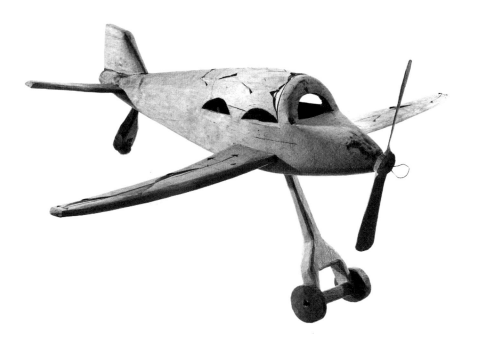

158. Wooden airplanes. During the 1960s, Djukas sometimes decorated canoes with small carved airplanes; the propellers were rotated by the wind when the canoe was in motion (Bonno Thoden van Velzen, personal communication, 1980).

159. Wooden imitations of basketry fire fans and an umbrella: a) Saramaka, collected 1960 in Ligolio; b) Matawai, collected 1958 in Posugunu; c) Saramaka, carved 1979 for sale to tourists.

160. Virtuoso combs. The interlocked pair was collected in Posugunu in 1958; the pair connected by links was collected in 1965.

161. Aluku carved folding chair, photo apparently made before 1938

162. Standard stirring stick used for vegetable sauces (collected 1968 in Saramaka) and a decoratively carved wooden imitation (collected before 1932 in Djuka)

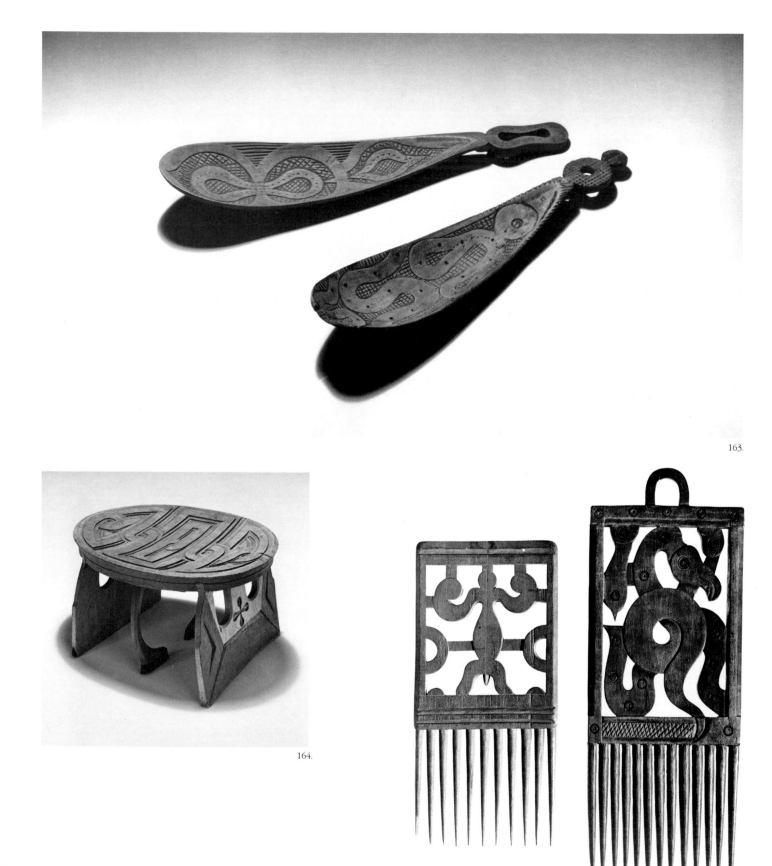

163.

164.

165.

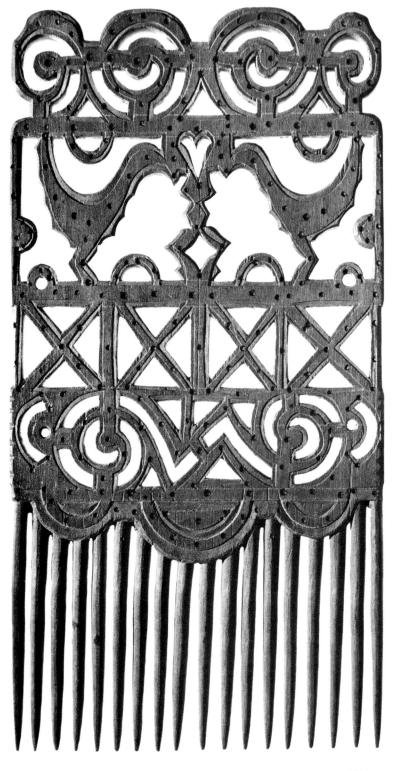

163. Wooden ladles carved in the shape of calabash ladles (see Figure 215): a) collected 1932–38; b) Saramaka, collected 1960s in Tutubuka.

164. Wooden stool with collapsible legs

165. Djuka combs from villages on the Tapanahoni River: a) collected 1893–96; b) collected late 1920s

166. Aluku comb, collected before 1901

166.

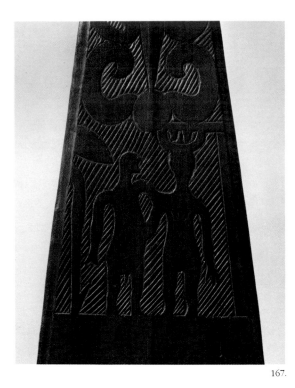

167.

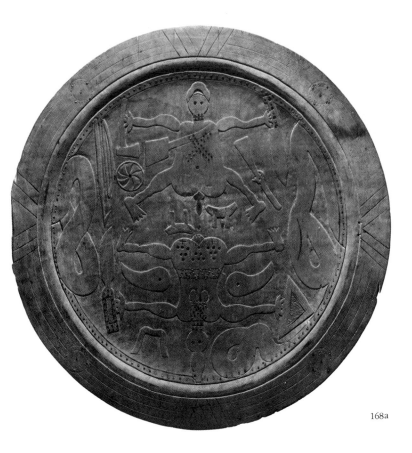

168a

167. Djuka paddle, collected before 1932

168. Winnowing tray carved with human figures

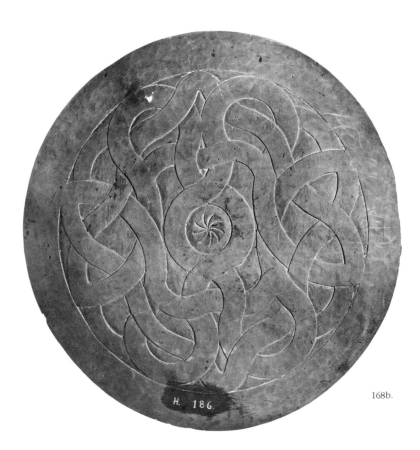

168b.

122

169. Stool with cowrie shell inset, used in rituals, and collected late 1920s in Ganiakonde. Unusual example of representational carving by Saramakas.

170. Food stirrers: a) collected before 1897; b) collected before 1883.

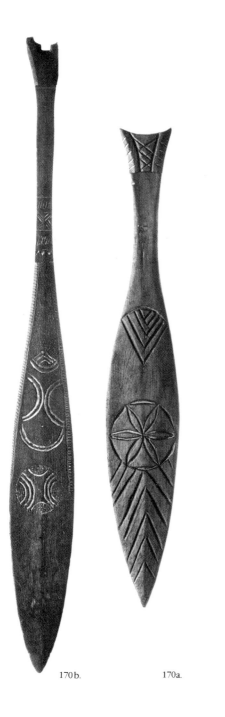

170b. 170a.

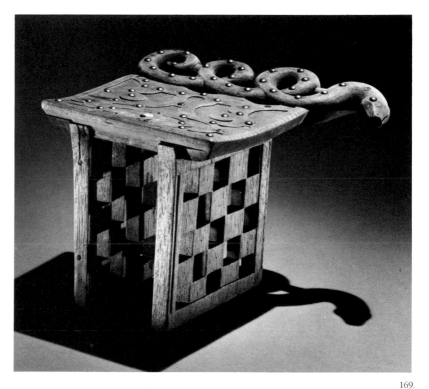

169.

Stylistic Development

Over the past decade, studies conducted among the Aluku and the Saramaka have gone far in dispelling the notion that Maroon woodcarving is a "traditional" and timeless art (Hurault 1970, R. Price 1970b; see also R. Price 1972). Contrary to popular assumptions that it represents a direct and unchanging legacy from Africa (see Chapter 8), it has now been twice demonstrated that the concept of "art *history*" can be applied as appropriately to Maroon woodcarving over the past one hundred fifty years as, say, to European painting during the same period. It now appears that although early Maroon men fashioned mortars, stools and other objects in wood, they rarely embellished them decoratively. Evidence of marked stylistic and technical development in museum collections, the testimony of Maroon oral historians, and the absence of comment on decorative woodcarving in the extensive documents on eighteenth-century Maroons all strongly suggest that decorative woodcarving began to develop only during the first half of the nineteenth century, and underwent a striking efflorescence and evolution during the next hundred years.

Hurault's study of Aluku woodcarving (1970) concludes that this art was a New World creation which only began well into the nineteenth century. "It was apparently created around 1830–1840, and evolved rapidly, reaching what we may call the classic style by about 1870–1880" (1970:84). Hurault divides the evolution of Aluku art into three style periods. The first or "archaic" style dominated Aluku carving between about 1830 and 1870 (Figure 170). In this style, the exterior form of objects is relatively crude; ornamentation is monotonous and poorly executed, and consists mainly of non-figurative incisions; and an abstract, sexual symbolism is (he claims) already apparent. The "classic" style (1860s–1920s) marks the apex of Aluku art (Figure 125). The powerful yet simple compositions are conceptualized holistically; central motif and ornamentation are one, often executed in interwoven bas-relief ribbons; and the frequent semi-figurative representations of humans and animals are, according to Hurault, closely tied to sexual symbolism. Hurault does little to hide his distaste for the third or "modern" style (Figure 171c–e), an "impoverished art"

123

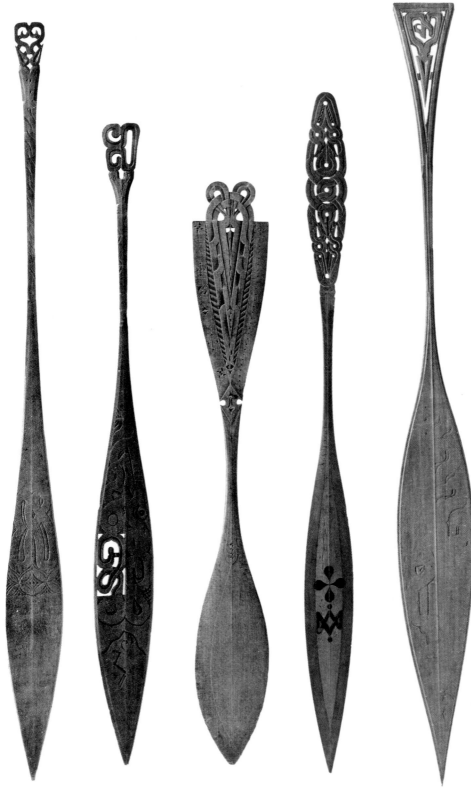

171.

171. Aluku paddles: a) carved late 19th century; b) carved 1920–30; c) carved 1940–45; d) carved 1945; e) carved 1955.

172. Schematic chronology of major Saramaka woodcarving styles. Thickness of tapered forms reflects relative amount of production in that style.

173. Saramaka *apinti* drum, collected 1928–29

172.

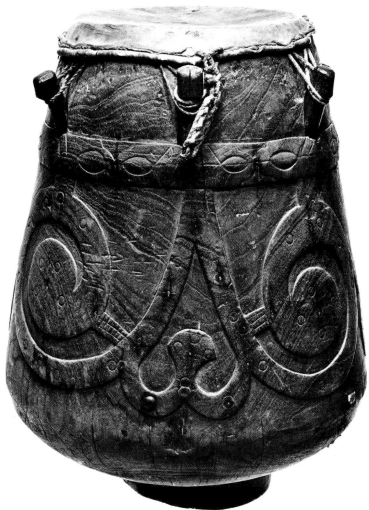

173.

174. Winnowing tray, collected before 1933, probably in Saramaka

175. Saramaka round stool, collected in late 1920s from a headman in Lombe—see footnote 43

176. Djuka round stool with carrying handle, collected 1928–29 in a village on the Sara Creek

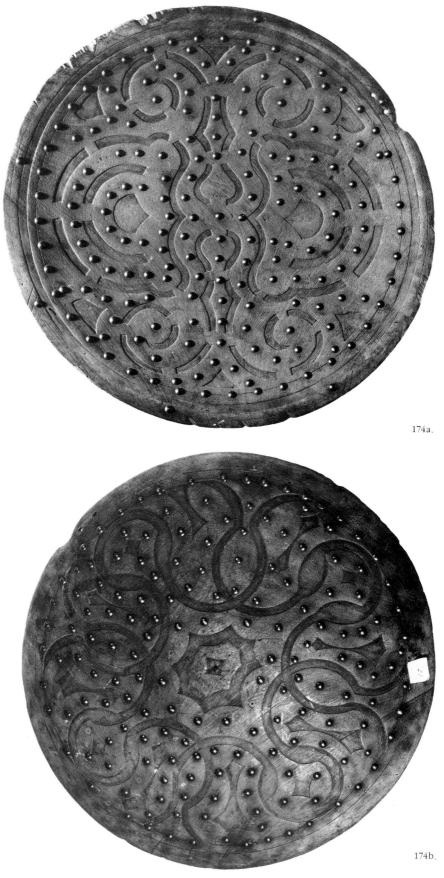

174a.

174b.

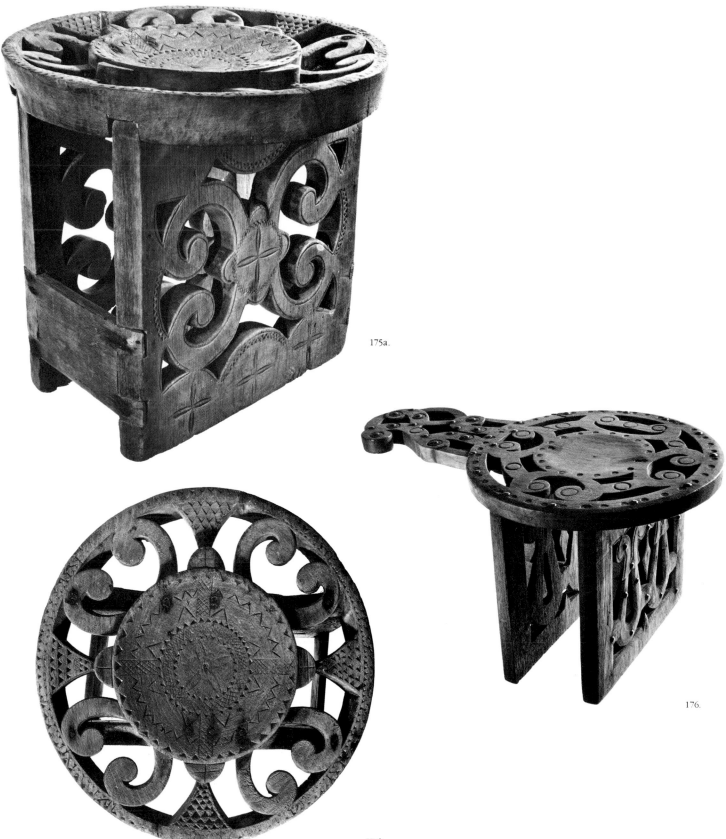

175a.

175b.

176.

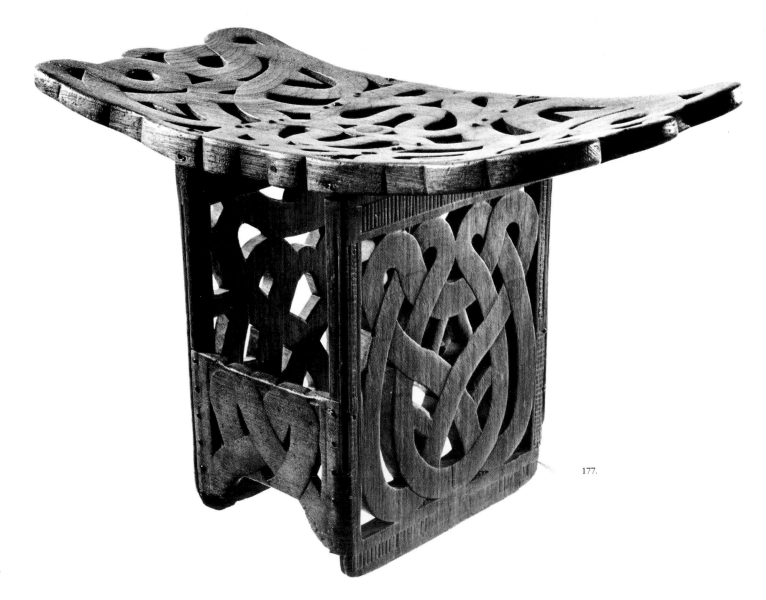

177.

(1970:119) which began during the 1920s and marks "a rupture with the principles of simplicity and sincerity which dominated the earlier art" (1970:90; see also his Plates XVI–XIX). This style includes a proliferation of geometric figures and nonsignificant decoration; symmetry dominates design; the preoccupation with complexity and detail attests to what Hurault has called an "*horreur du vide*"; and symbolic motifs have developed to the point of forming a rudimentary language of conventional signs.

The progression of styles in Saramaka woodcarving closely parallels that reported by Hurault for the Aluku. In Upper River Saramaka, four decorative styles, with clear though somewhat overlapping temporal distributions, can be distinguished.[42] We refer to these as Style I (usually called "owl's eyes" by Saramakas), Style II (known as "monkey's tail"), Style III ("wood-within-wood"), and Style IV (no special term). Figure 172 schematizes the distribution of these styles through time. The very great majority of decorated pieces made during this period can be related to one of these general styles.

In Style I, piercing is crude and often consists merely of large circles ("owl's eyes") or semicircles ("jaguar's eyes"). Designs are simple: incised crescents, circles, or scrolls on smaller surfaces, and bas-relief free forms (of which there were only a few types) on doors, drums and trays. Teeth and crosshatching, when present at all, are typically large and crude. Finally, considerable portions of surfaces may be left empty. Figures 173, 180 and 198 illustrate typical examples.

Carving in Style II shows considerable technical refinement; piercing and toothwork are far more delicate; there is a much more general use of bas-relief, often transforming a whole surface into a stencil-like pattern; designs are relatively complex and busy, and free spaces are rare; fancy scrolls or spirals (the "monkey's tails") are common; and the use of decorative tacks, which was limited in Style I, reaches its apogee in the later carvings in Style II. Color Plate XV and Figures 138b, 169 and 174–175 illustrate carvings in Style II.[43]

Style III is characterized by the use of a completely new technique which has dominated Saramaka woodcarving for the past half-century—interwoven bas-relief ribbons ("wood-within-wood").[44] In Style III, these ribbons form sinuous, curvilinear designs; surfaces are completely filled, as in the most complex examples of Style II; decorative tacks, used liberally on early pieces in this style, gradually diminish in importance, but there is continued technical development in toothwork and crosshatching. Figures 177 and 178 illustrate characteristic Style III carving.

In Style IV, the wood-within-wood technique continues to appear on most pieces but dominates design much less than in Style III; it now tends to be used in angular rather than sinuous patterns, and these are almost always accentuated by an incised line through the center of each ribbon (in contrast to Style III, in which ribbons were more usually left blank or studded down the center with tacks). Bas-relief is less pervasive than formerly, and many designs are executed exclusively with incised lines, characteristically reinforcing one another to compose concentric or "nestled" forms. There is widespread use of intricate toothwork, but piercing (especially on stools and paddles) and decoration with tacks are less frequent than before. Figure 179 illustrates Style IV carving and contrasts it with an early Style III example; see Figure 138a for another Style IV paddle.

We should note that the development of these four styles cannot be traced to the introduction of new tools. As we have seen, almost all the tools of the modern woodcarver were available by the 1880s, brought by the first large groups of men returning from wage labor on the coast.[45] Even the most dramatic technical development in Maroon woodcarving history, the wood-within-wood technique, involved the new use of an old tool—applying compasses (which had been used for many decades in plank-making and calabash carving) to the surface decoration of wooden objects.

In order to illustrate these four Saramaka decorative styles in more detail,

177. Saramaka rectangular-top stool, carved by Apenti (c. 1885–1970), Dangogo and Kayana

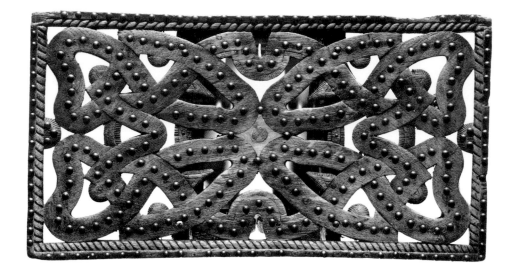

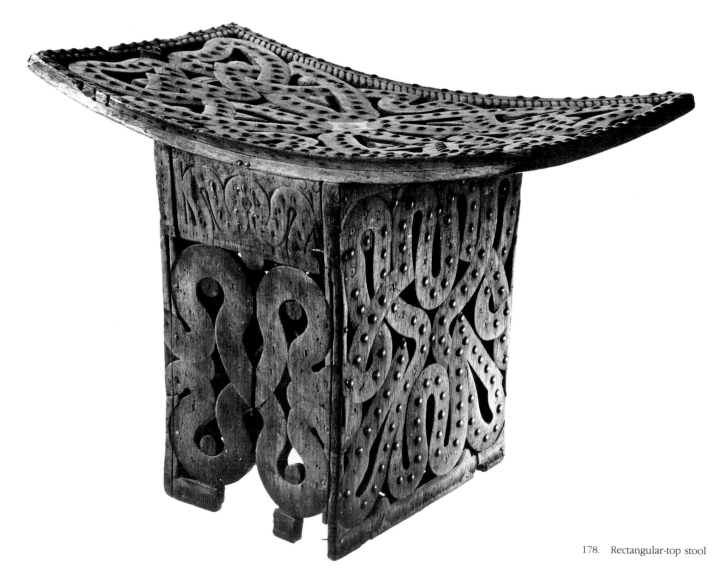

178. Rectangular-top stool

we have chosen three representative types of objects: round stools, door frames, and combs. Every type of object poses distinctive problems to the carver—woods have different characteristics, practical functions are limiting (e.g., drums cannot be pierced), traditions of form dictate special treatment (e.g., "in the round"), and so forth. Partly because of these special problems, the dates of the transitions between styles differed slightly from one type of object to another; for example, Style III replaced Style II on doorposts about fifteen years after the transition occurred in combs.

Round stools. Round stools are one of the five main types of Saramaka stools. Although commonly used by men as well as women until the early twentieth century, they are now thought of mainly as women's stools and are made much less frequently than in the past.

Style I is illustrated by one of two similar stools made by a man from the village of Godo about 1900–05 (Figure 180). The pictured stool was a gift to his future wife, while its larger mate was intended for his own use in her village. Today the Tribal Chief, a brother of the woman, always sits on the larger one when he visits his natal village, Dangogo. The sides of the stool illustrate the characteristic pierced "owl's eyes" and "jaguar's eyes" (from which the horizontal base has broken off), as well as the typically sparse decoration (in the photo only slightly exaggerated by wear). The seat is decorated with a simple single-line design and two sets of "teeth"—crude triangles around the center and a circle of dots along the edge. The presence of tacks (of which there were three types, only partially visible in the photo) mark this stool as a late example of Style I carving.

The stool depicted in Color Plate XV and Figure 181 was made about 1915–20 by another young man from Godo, one of the most famous Saramaka carvers of this century, and is an outstanding example of Style II. Graceful bas-relief scrolls fill the broader side panels; the crown of the stool is rimmed with unusually fine crosshatching; and the deep concave seat is a perfectly controlled and delicate composition, studded (like the rest of the stool) with the brass tacks so characteristic of later Style II work. The forms on the subtly curved narrower side panels recall those on the seat but are executed by piercing instead of bas-relief.

Another stool made by this same master carver, probably in the early 1930s, illustrates Style III. Very similar in conception to the previous example, it differs in its use of the wood-within-wood technique on the seat and on the narrow side panels (Figure 182).

The Style IV stool in Figure 183 was made about 1963 by a young man as a betrothal gift for a Dangogo girl. The design is executed in intricate toothwork and linear incisions rather than in the bas-relief ribbons of the Style II and Style III examples. These lines and teeth reinforce one another, creating a characteristic nestled design on the side of the stool. As in most Style IV pieces, tacks are used only sparingly.

Door frames. The doors of all men's and many women's houses in Saramaka are framed by doorpost and lintel, almost always fashioned from cedar (Figures 184–187). Unfortunately, we have no information about doorposts in Style I; older Saramakas could not recall ever having seen one, and we are not certain that they were ever carved at all. The earliest examples Saramakas remembered were made in the 1880s in Style II and, according to their descriptions, consisted simply of a single monkey-tail spiral. Although to our knowledge no such pieces are extant, an 1894 sketch of a Saramaka door frame exactly matches their description (Figure 188a). During the first fifteen years of this century, doorpost designs were rather standardized elaborations of the monkey-tail spiral; older Saramakas from Dangogo claimed that men actually stenciled whatever design was currently popular, and that about 1915 all doorposts in the village (perhaps fifty) were nearly identical. The vertical portions of the door frame in Figure 188b are the only remaining example of this particular Style II pattern and were carved in Dangogo by a young man about 1910.[46]

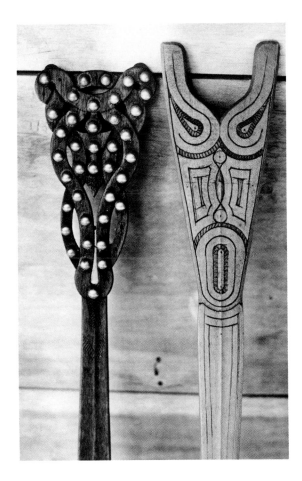

179. Details of Upper River Saramaka paddles carved c. 1920 by Seketima, Godo (left) and c. 1965 by Kondemasa, Dangogo (right)

See page 98 for Color Plate XV.

180a.

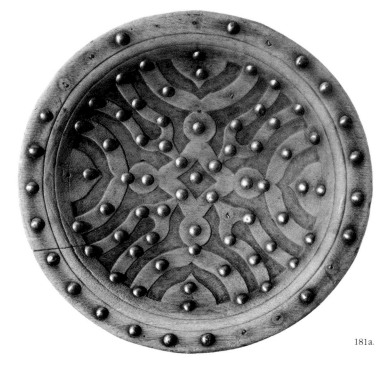

181a.

180b.

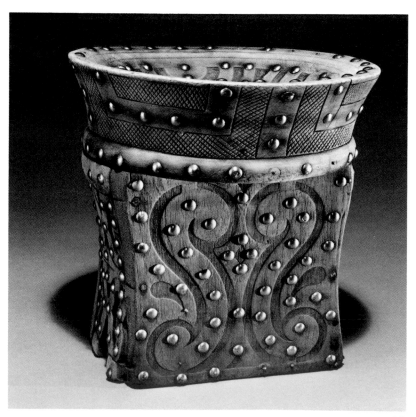

181b.

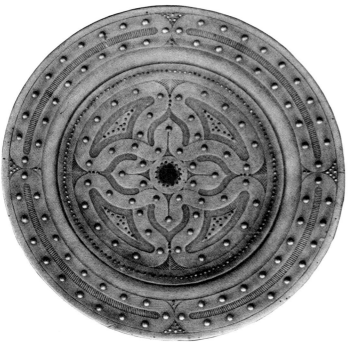

182a.

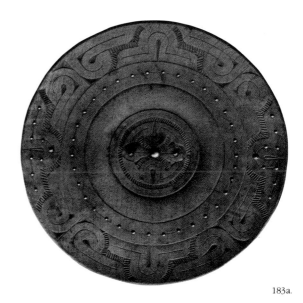

183a.

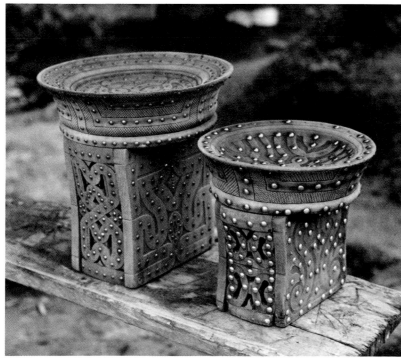

182b.

183b.

180. Saramaka round-top stool, carved about 1900–05 by Akoosu, Godo

181. Saramaka round-top stool, carved c. 1915–20 by Seketima, Godo (see also Color Plate XV)

182. Saramaka round-top stool, carved c. 1930–35 by Seketima, Godo: a) top; b) shown with a smaller stool carved 15 years earlier by the same man (shown also in Color Plate XV and Figure 181).

183. Saramaka round-top stool, carved c. 1963 by Akudjuno, Asindoopo: a) top; b) detail of base

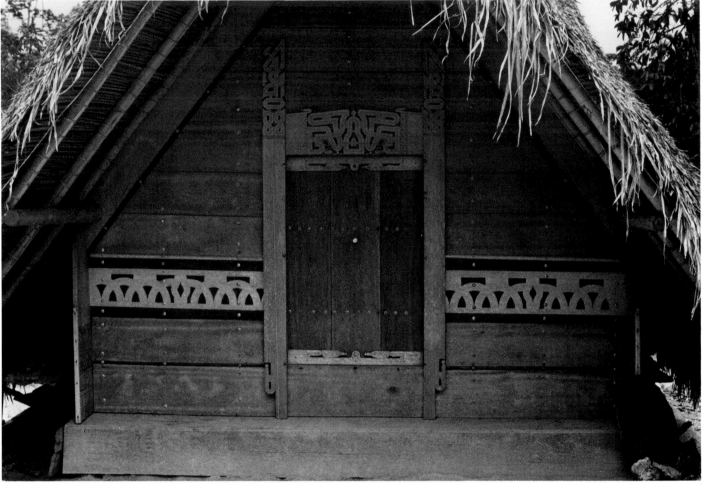

184.

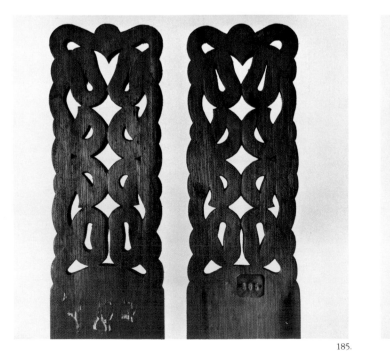

185.

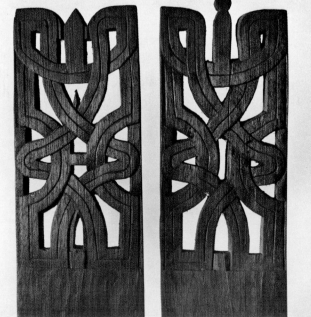

186.

184. Saramaka house facade, made c. 1966 by Gaduansu, Dangogo

185. Pair of Saramaka doorposts

186. Pair of Saramaka doorposts

187. One of a pair of non-identical Saramaka doorposts, collected 1928–29 in Bendekonde. (The second was unavailable for illustration.)

188. Three Saramaka door frames: a) on the house of a Saramaka man living near Albina on the Marowyne River in the 1890s; b) carved c. 1910 in Dangogo, though the lintel may represent a later addition; c) carved c. 1920 in Dangogo.

188a.

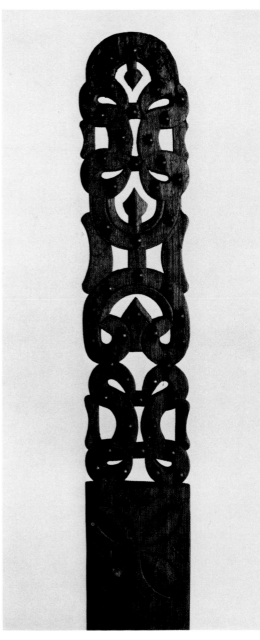

187.

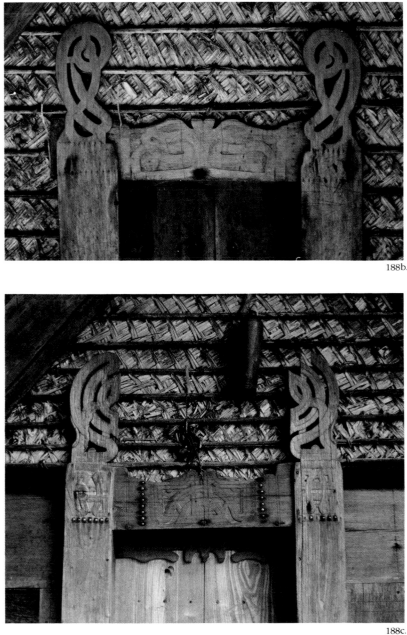

188b.

188c.

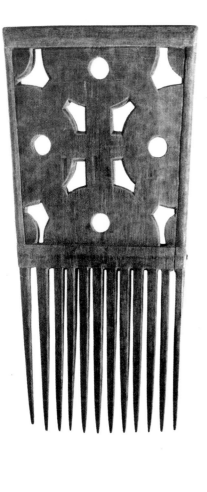
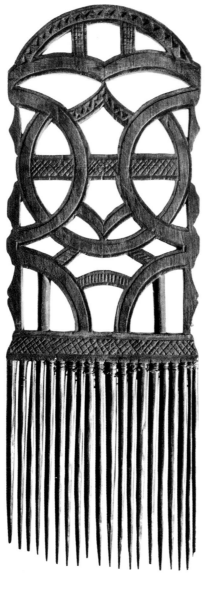
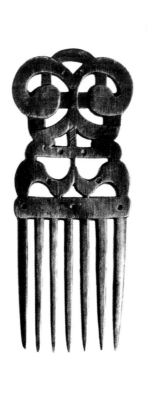
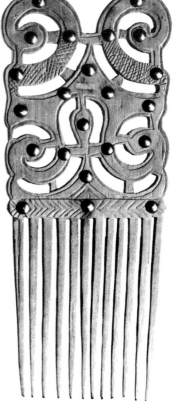

189. Four early combs: a) Djuka, collected late 1920s in Pisiang (Sara Creek); b) probably Saramaka, collected 1928–29; c) Saramaka, collected 1974 in Niukonde; d) Saramaka, collected before 1899.

Soon after 1915, it became fashionable to carve original designs on door frames (as had always been the case on other kinds of objects). The door frame in Figure 188c, made about 1920 by a twenty-year-old from Dangogo, was, according to the carver, a conscious attempt to transform the standardized Style II pattern (illustrated in Figure 188b) into Style III. Later door frames on the Upper River further developed this style, using wider interwoven ribbons and, in many cases, brass tacks, much like two examples from the Middle River photographed by the Herskovitses (1934: facing p. 284). Figure 184 shows a door frame made about 1966 by a young man from Dangogo. The complex, intricate and relatively angular design, the daringly thin connections between pieces, the delicate piercing, and (on the lower crosspiece) the nestled forms make this a good example of Style IV work.

Combs. Because combs break and are discarded after several years' use, those we saw in the field were almost all Style IV, and the large Suriname River collections made by Kahn and the Herskovitses in the late 1920s include only one Style I comb from this region. Older Saramakas remember local Style I combs as very large, relatively broad, and decorated with crude piercing. Upon being shown photographs of museum objects, they suggested that the comb in Figure 189a as well as the Aluku comb in Dark 1954: Plate 2A would have been typical examples. Figures 189b–d illustrate Style II combs, with charac-

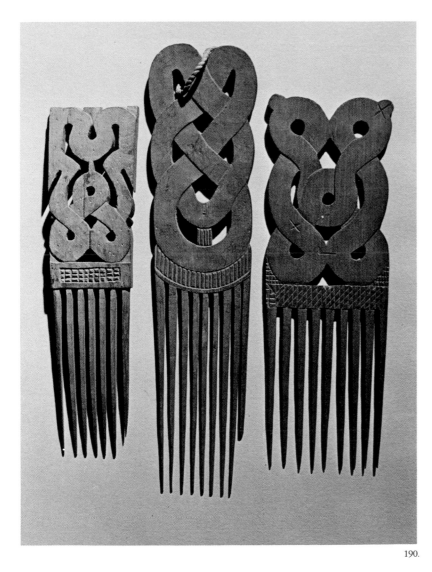

190.

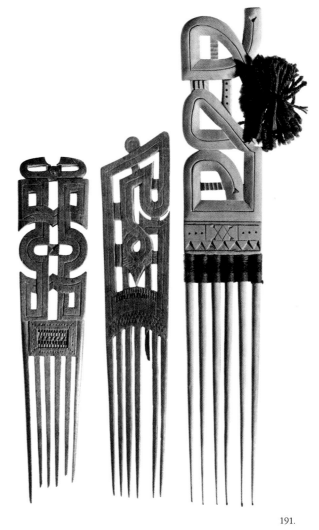

191.

teristic scrolls, delicate piercing, and some studding (see also Dark 1954: Plate 6G). Three Style III combs, with typically convoluted bas-relief ribbons, are illustrated in Figure 190. Figures 191 and 192a,b picture five Style IV combs—three wooden ones and two aluminum ones. Note particularly the angularity of the wooden combs and the virtuoso appendages of the aluminum examples.[47] During the 1970s men continued to carve most combs in the manner of the 1960s, but made others by a new technique—using bicycle spokes for the teeth, and varnishing the wooden handle, which they incised with very simple designs (Figure 192c,d).

Because these four Saramaka decorative styles span only a century of known artistic history, one or even two major stylistic transitions have occurred during the active lifetime of many carvers. Some men have shown themselves to be much more adaptable than others to the changing fashions they see around them. While some carvers have worked in Styles I, II, and III, continuing to learn new techniques well into their old age, others have solved the problem of keeping their carvings up to date with the help of younger kinsmen, for example by giving them pieces carved in Style I to embellish further with Style III designs. Still others have simply continued to carve more or less in the style they originally learned. Examples of Styles II and III presented above (Figures 181–182) illustrate one carver's complete mastery of two different styles. More-

190. Saramaka combs, collected 1928–29

191. Modern Saramaka combs: a,b) carved c. 1963 on the Pikilio; c) carved 1979 in Guyaba.

137

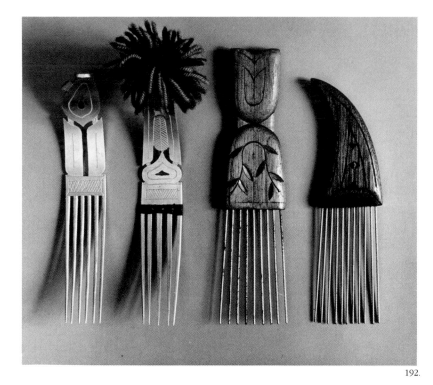

192.

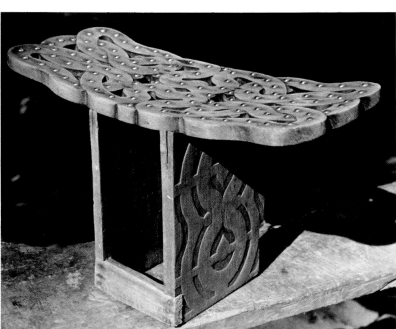

193.

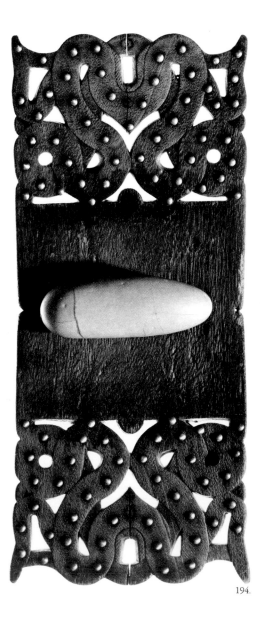

194.

192. Modern Saramaka combs: a,b) aluminum and commercial yarn, made 1965; c,d) bicycle spokes, wood, and commercial varnish, made 1975

193. Saramaka rectangular-top stool, carved c. 1920 by Seketima, Godo

194. Saramaka peanut-grinding board and gourd roller. The board, carved c. 1900 on the upper Gaanlio, illustrates early wood-within-wood carving.

195. Saramaka peanut-grinding board, collected 1966 in Ganiakonde, that illustrates mature wood-within-wood carving.

over, one finds rare pieces that exhibit two of these styles, though always on different surfaces, such as a stool by this same carver with a typical Style II pattern on the side panels and a flowing, delicately pierced Style III design on the seat (Figure 193).

Our stress thus far on the characteristics of each of the four styles should not obscure the constant development through time from early to late work within each. Both the level of technical skill and particular artistic conventions allow a knowledgeable Saramaka to distinguish early and late Style II, early and late Style III, and so forth. We were shown, for example, how in Style III, early pieces may be identified by such features as the relative breadth of their bas-relief ribbons (taking into account the type of surface involved), or the way in which each ribbon passes under several others before passing over one. This last trait was gradually modified until, by the time Style IV began, it was already considered a sign of technical ineptitude not to alternate the over-and-under passes as strictly as possible (compare, for example, Figures 194 and 195).

In addition to these four major styles, we should mention a fifth which has only limited importance within the region. For the past two decades, an "airport art," designed primarily for the tourist trade, has been flourishing in and around the capital of Suriname. Originally derived from the standard modern style of Saramaka villages along the Middle River, this style is now used by most Saramaka men who carve for sale in the capital, regardless of their native village. Indeed, in a handful of cases, men are staying in their own villages and carving commercially in this style. The carvings are characterized by the relative softness of the wood, the extensive use of relatively large toothwork, and other devices designed to allow rapid production. Figure 196 illustrates an unusually fine example. (For a book devoted largely to this style of carving, see Muntslag 1979.)

Other Kinds of Change

Thus far, our description of woodcarving development has been limited to general decorative style. There have been, however, a large number of traits quite independent of the main styles which have appeared (whether by invention or introduction from the outside) at a specific point in time, enjoyed a period of widespread popularity, and then gradually disappeared, and which

195.

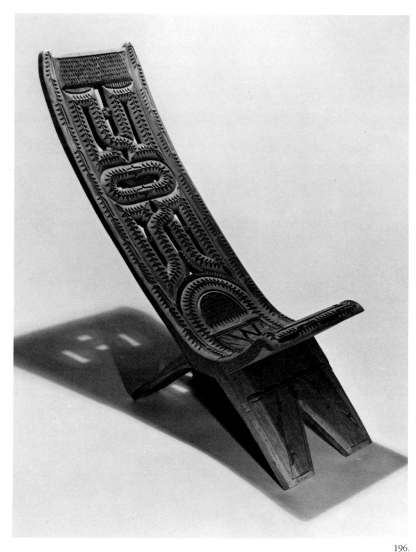

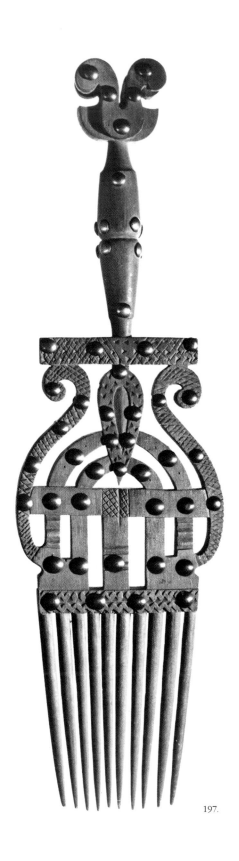

196.

197.

often provide important clues for the dating of individual pieces.

New shapes have appeared at one time or another during the history of almost every type of object carved by Maroons. We cite two Saramaka cases. One new comb shape developed about 1890, was extremely popular for twenty-five years, and then gradually disappeared. This *sindó muyêê pénti* ("comb for a woman who 'sits down' [is faithful]") had a distinctive cylindrical handle, which sometimes formed a connecting piece with a flat decorated handle (Figure 197 and Dark 1954: Plates 5B and 7E). Although almost all men who learned to carve by 1915 made such combs during their youth, those who began in the 1920s already considered this shape old-fashioned. The forms for the blades of Saramaka food stirrers also changed about 1890 from the shapes used for the blades of canoe paddles (Figure 170) to ones with straighter sides (Figure 122i,j), and by 1910 only a few old men were still making the "paddle" forms.[48] Many similar examples could be cited from the history of stools, peanut-grinding boards, and so forth.

Perhaps the most important change in Saramaka ideals of form came about 1900 with the application of the "curved" shape to many objects traditionally carved in the flat. This curved form, which had previously been limited to canoes and one-piece crescential stools, began to be used for composite plank-top stools and combs (compare Figure 198 with Figure 199, and Figure 189c

140

198a.

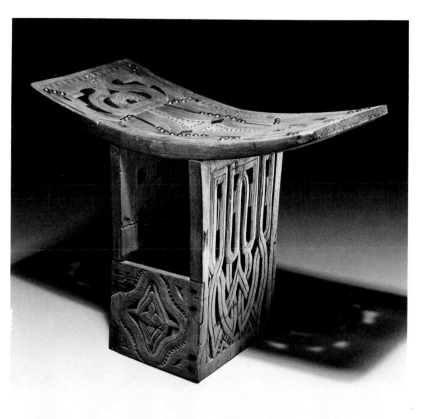

199.

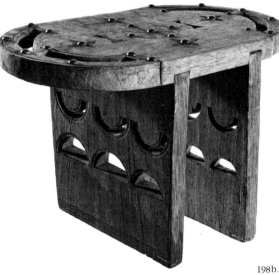

198b.

196. Folding chair, carved early 1970s from a single piece of wood for sale to tourists.

197. Saramaka comb, collected late 1920s

198. Plank-top stool, collected before 1883

199. Saramaka curved plank-top stool, carved 1965 by Aviate, Semoisi.

200. One-piece stool, collected c. 1895

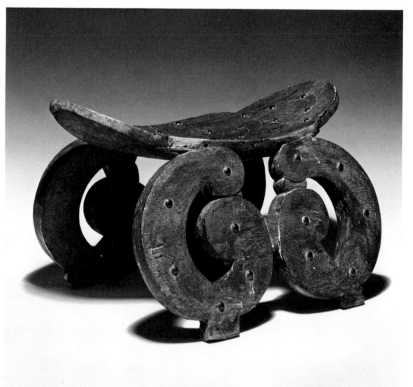

200.

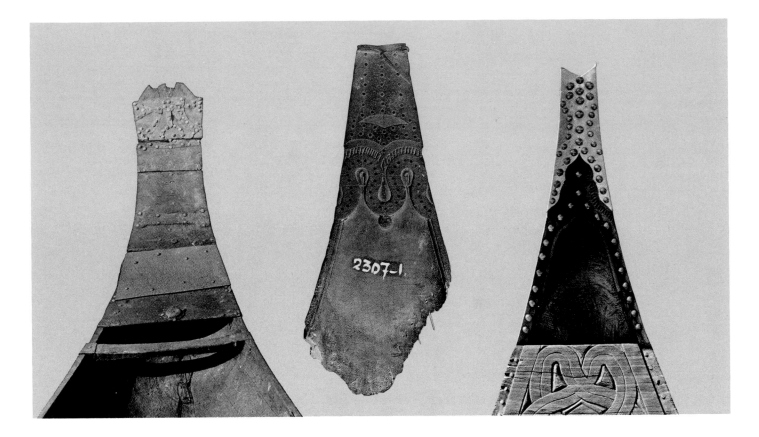

with Figure 191b), as well as for laundry beaters and even some food stirrers. One older Saramaka asserted that, aside from canoes and crescential stools, plank-top stools were the first objects to be treated in the curved form, in conscious imitation of crescential stools. An unusual, apparently intermediate stool in the Tropenmuseum, collected in the 1890s, tends to support this claim (Figure 200). Though made from a single piece of wood (like a crescential stool), its seat and legs are unformly thin (as in a plank-top stool) and the seat is gracefully curved. Throughout the century the curve on all curved objects has become increasingly pronounced; each decade, for example, the ends of canoes are curved more sharply and the curve of combs is more exaggerated (although this design decreases the durability of all but aluminum examples, in which—significantly—the concept is most completely realized; see Figure 192a,b).

One clear reflection of such changes is that only four of the fifty-three combs collected by the Herskovitses in the 1920s were curved (Crowley 1956:152), while the very great majority of combs made in the 1960s in Upper River Saramaka have this form. During the past five years, flat combs have again come into fashion, and represent at least half of all combs made in this region today.

The decoration of the inside ends of canoes provides another example of carving fashions that are independent of stylistic changes in other objects. During the past hundred years, these have received four distinct and quite standardized treatments in Upper River Saramaka: the first lasting from some-time before the 1880s until c. 1910, the second c. 1890–1940s, the third c. 1910–1950s, and the fourth from the late 1930s until the present. Older Sara-makas described the earliest of these styles (which they had been told about but had never seen) as a complete planking-over of the dugout portion at the ends of the canoe, with decoration on this planking. After hearing about this style in the field, we came upon a handsome example in the Tropenmuseum which had belonged to Tribal Chief Akoosu (1888–1897); its planked-over stern,

201. Saramaka canoe prows: a) owned by Tribal Chief Akoosu (1888–97); b) probably carved in 1920s; c) carved c. 1965 by Adelmo, Heeikuun.

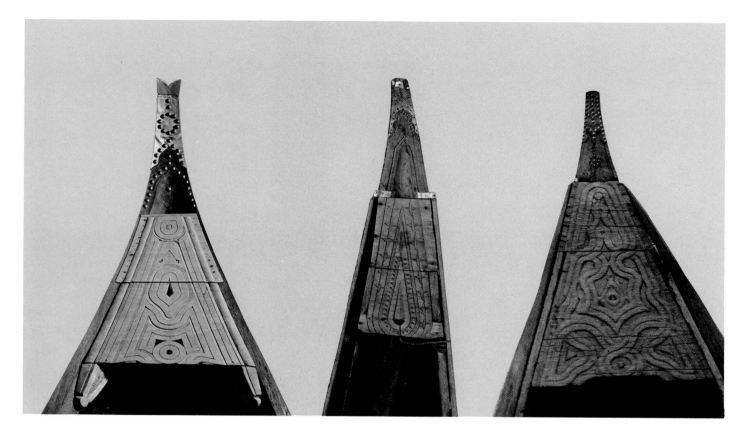

which even includes a sheet of scrap iron, is decorated with a characteristic monkey-tail design (Figure 201a). In the second of these styles (for which we have only Saramakas' descriptions and sketches), the planking stopped much farther from the two ends of the canoe and the dugout portion was considerably extended with a small gouge to form a crescent, giving this style its name, "new moon." As in subsequent styles, the extreme tips of the canoe were covered with tin, cut to accentuate the carved design, and embellished with tacks.[49] In the third style (which Saramakas described and sketched for us), this gouge-work was extended still father up the neck of the canoe, at both ends, in a complex form with delicate embellishment, called "tapir's hoof." Figure 201b illustrates an example of this style in the Tropenmuseum. Finally, in the current style, the carved-out portion ends an inch or two lower than in the third, and is surmounted by a distinctive design (Figure 201c). The origin of this final style illustrates the role individual creativity can play even in such a standardized type of carving. In the late 1930s, a man from Asindoopo made a canoe which opened unevenly and, as was usual in such cases, did not bother to embellish it by fully carving out the ends in the "tapir's hoof" pattern. Instead, he cut a simpler variation, which was admired and copied by others, and is today the only style still to be seen on the Upper River.[50] Regional differences further nuance this style progression, and it is almost always possible for Maroons to identify the region in which a canoe was made by the type of carving at its prow. Figure 202, for example, illustrates typical current designs from the Saramaka villages of Asindoopo, Pikiseei, and Kambaloa.

Even innovations in fairly minor details may suddenly become the rage and spread to distant villages. For example, about 1920 two distinctive curves were cut into Saramaka comb handles for the first time—one in the village of Semoisi, another in the village of Akisiamau—and these simple designs became so fashionable in woodcarving that women throughout the region began cutting them as cicatrizations. A well-known Saramaka carver from the village of Pempe

202. Saramaka canoe prows, carved 1970s: a) carved 1978 by Fotobakaa, Asindoopo (for a full view of this canoe, see Figure 5); b) Pikiseei; c) Kambaloa.

143

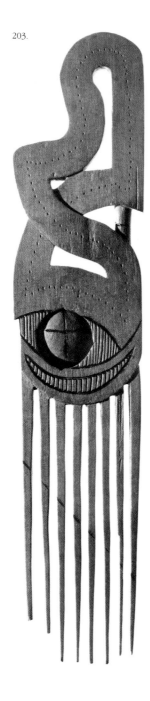

203.

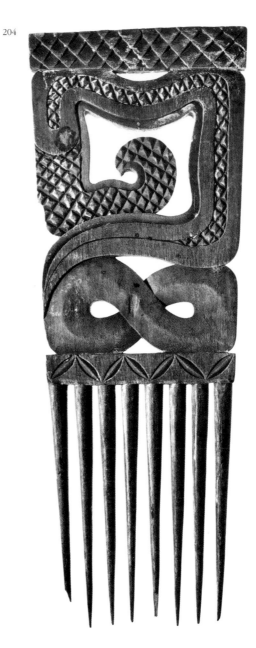

204

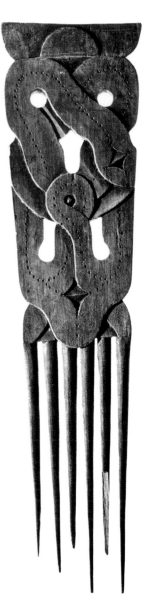

203. Comb carved with moveable boss, collected 1928–29, probably in Saramaka.

204. Eastern Maroon combs: a) Djuka, collected 1961 in Mooitaki: b) Djuka, collected in Diitabiki; c) Aluku, collected before 1939; d) Aluku, collected before 1939; e) late nineteenth-century style carving (see Hurault 1970: 116).

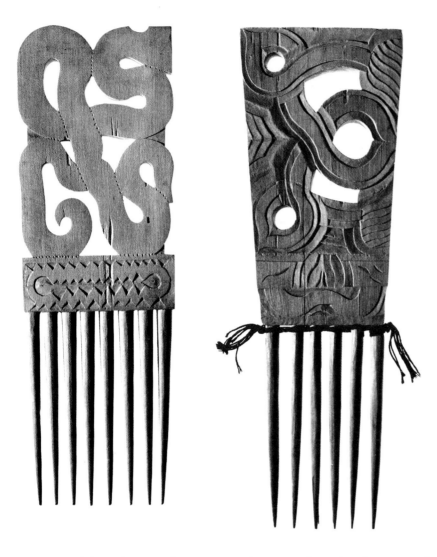

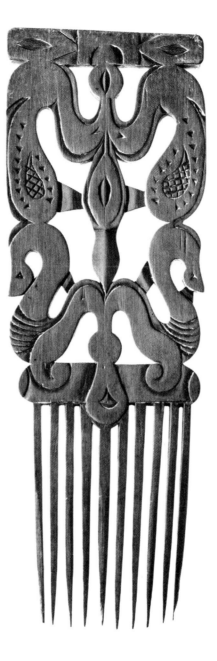

invented the technique of cutting around a piece of wood in the center of a design in such a way that it rattled but did not fall out; and this innovation, too, was quickly taken up by other carvers (Figure 203). Another Pempe man, about 1920, created a comb handle in the shape of a gunstock which, by means of a boss, could be partially freed from the body of the comb.

A number of the minor decorative techniques used on all kinds of objects have undergone significant changes during the past century; three brief examples may illustrate the kinds of changes we have in mind. At the turn of the century in Saramaka, branding with the sawn-off tip of an umbrella, an umbrella rib, or the point or head of a nail was widespread (see Figures 165b, 166 and 208 for examples carved by eastern Maroons). A decade or two later these techniques had been replaced by incising lines with a hot machete or a knife (Figure 249); and today, branding is completely out of fashion in the Upper River region of Saramaka. Likewise, the local repertoire of decorative "teeth" has changed somewhat from one generation to the next. In a certainly partial inventory, Saramakas showed us or described eleven technically distinct, named types of toothwork, of which some have long since disappeared, while others were introduced or invented during the lifetimes of living people. Finally, the use of decorative tacks has also passed through several phases. The original popularity of large brass tacks or studs bought in Paramaribo, the later introduction at different times of two smaller sizes of copper tacks from French Guiana, and the recent adoption on house fronts of broad-headed galvanized

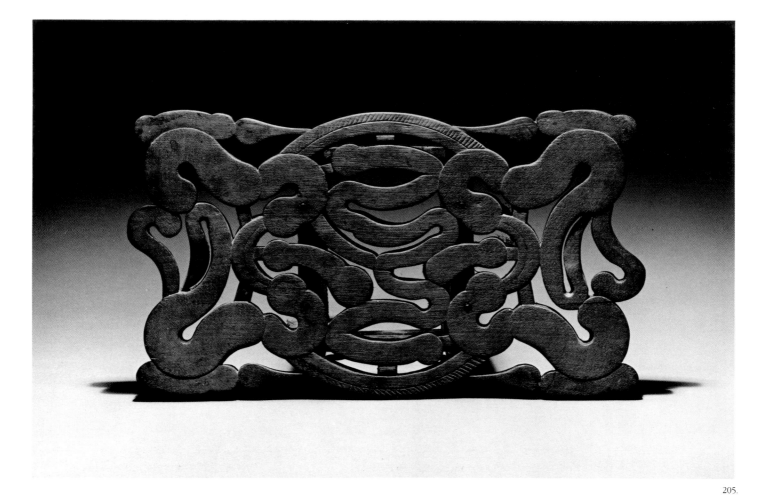

nails bought in Paramaribo are all closely linked to the history of coastal wage labor and to the role such nails have played as signs of success in the outside world.

As a final note on the development of woodcarving, we should mention that changes have occurred in the repertoire of standardized, named (but generally non-significative) designs which appear on many objects. Our information on the history of two dozen or so such designs (other than toothwork) suggests, however, that change may have been less rapid here than in most other aspects of woodcarving—or, for that matter, in the named designs of other Saramaka art forms such as women's calabash carving (see Chapter 5).

Regional Variation

It should be clear from the foregoing pages that Maroon woodcarving styles are continually being reshaped through the artistic innovations of particular individuals, and that new introductions are differentially accepted by the carvers of particular villages and regions. The result is a recognizable regional diversity among, and even within, the various tribes. For example, most of the "airport art" sold in coastal tourist shops is executed in a distinctive style first developed in Middle River Saramaka villages; there are recognizable differences between the two tributaries of the Suriname River in the curvature of stools; and we have already seen how the complex prow carvings on canoes are specialized by villages. The stylistic differences between one tribe and another are yet more striking, both to outsiders and to Maroons. Most men from Upper River Saramaka, for example, are confident that they can distinguish Djuka and Sar-

205. Plank-top stool with carving typical of eastern Maroons

206. Djuka winnowing tray, collected 1960s on the Tapa-nahoni River.

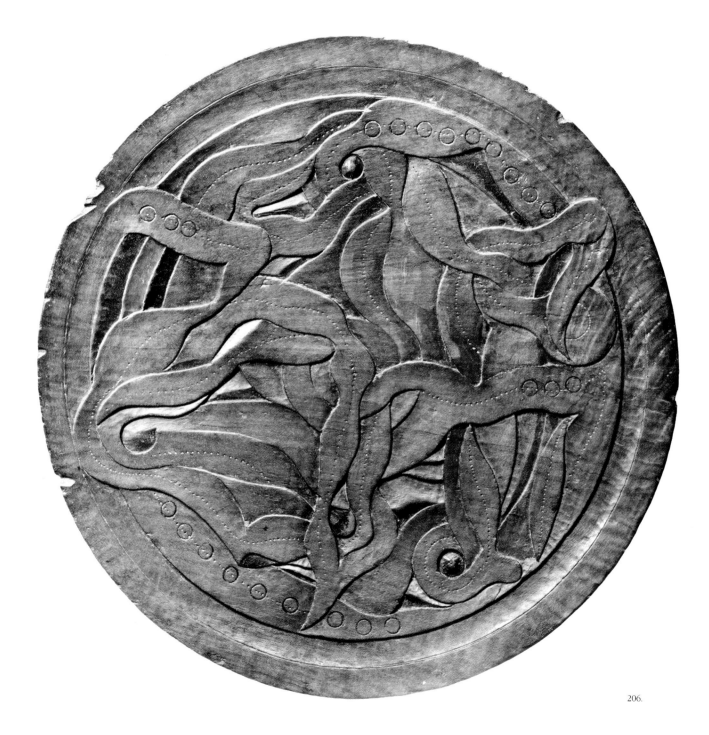

206.

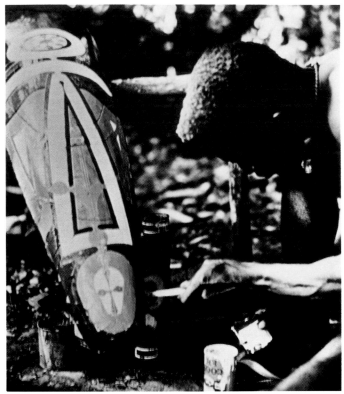

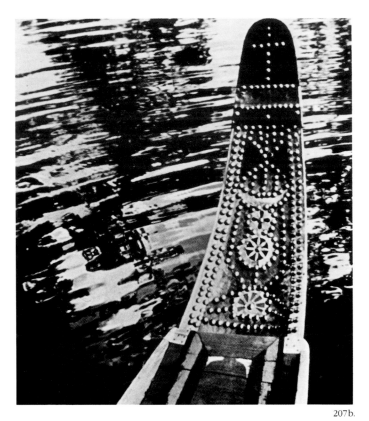

207a.

207b.

amaka carvings at a glance. Even if not always borne out, this belief reflects the existence of very different expectations about the arts of these two largest Maroon tribes and, more generally, the arts of the eastern and central tribes collectively. We mention here a few of the more notable contrasts.

The varying width of eastern Maroon ribbons, which often bulge and taper, contrasts with the more even-edged Saramaka style (Figure 204a, b, e). Eastern Maroon carvers make less frequent use of compasses, producing freer undulations in the ribbons and a less strictly geometric effect than is seen in Saramaka patterns (Figure 205). The common eastern Maroon practice of dividing ribbons along their entire length into two or even three different levels is extremely rare in Saramaka carving (Figure 204d).[51] The ends of these ribbons are often pointed in eastern Maroon carvings, but almost always rounded in Saramaka ones (compare, for example, Figures 189c,d and 204a,c). The wood-within-wood technique is less important in eastern Maroon carvings, which have a great deal of piercing and bas-relief of other kinds (overlapping but not intertwining ribbons, small sloping planes, and so forth) (Figure 206). Brightly colored paints are used extensively in modern eastern Maroon decorative work, particularly on paddles, house fronts, and canoe tips (Color Plates V, XIV, Figures 28–30, 137, and 207). There has been continued use of branding among eastern Maroons, including the use of instruments unknown in Saramaka, such as lead pipes (Figures 165b, 166, and 208). The shapes of many eastern Maroon objects are distinct from those made in Saramaka—for example, paddles and food stirrers have shorter, broader blades and larger, more ornate handles than those in Saramaka (Figure 209); canoes are narrower than in Saramaka; and combs are still often made in the gigantic, broad form not seen in Saramaka for many decades. Finally, the fact that eastern Maroons make more frequent use of naturalistic designs (see Figures 165–168 and, for representational motifs in other media, Figures 210 and 256) and aesthetically unintegrated clusters of "signs" (Figure 258b) reflects a different balance between concern with symbolic potential and abstract design among eastern Maroons and Saramakas (see Chapter 7).[52]

207. Djuka canoe prow made c. 1970

208. Aluku stool, carved from a single piece of wood and decorated by branding. Collected before 1939.

209. Djuka food stirrers

210. Paramaka calabash bowl, collected 1965 in Langatabiki

208.

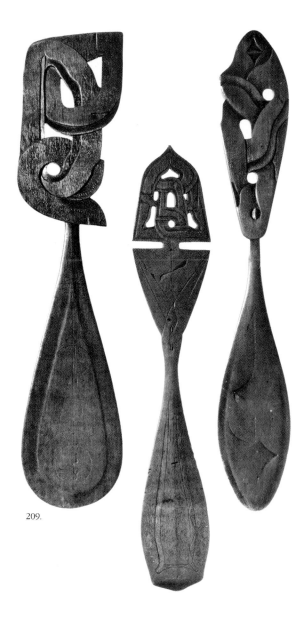

209.

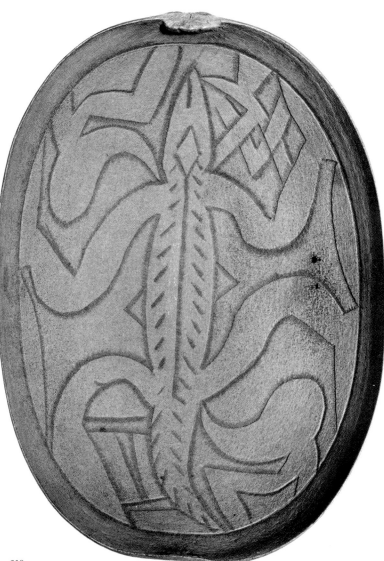

210.

149

5 CALABASHES

211.

Both calabash trees (*Crescentia cujete* L.) and "bottle gourd" vines (*Lagenaria siceraria* [Molina] Standley) provide raw materials for the manufacture of Maroon containers. In spite of the resemblance of the fruits (and the repeated confusion of the two by outside observers), calabashes and gourds not only belong to unrelated botanical families, but are prepared by different technical processes and assigned mutually exclusive niches in Maroon material, ritual, and social life. Moreover, calabashes constitute an important artistic medium for Maroons, while gourds do not.[53]

Calabash trees, owned by individual women, are scattered throughout Maroon villages, and their fruit is used to make a wide variety of housewares (Figure 211). At least seven varieties of the tree are recognized by name and differentiated in terms of use: one variety provides large rice-washing bowls; two others supply fruits for the manufacture of spoons and ladles; another is used for covered containers; and so on. In terms of the products made from the fruit, Maroon terminologies distinguish three general types: covered containers, bowls, and spoons/ladles/rice mounders. Within these categories, distinctions are made according to both form and function.

Covered containers. The two pieces of these containers are made from a single fruit, cut apart along the equator, and decoratively carved on the exterior surface by men. Large containers may either be decorated and used to store rice, or left plain and used to store salted meat or fish. Most medium-size containers are handsomely carved and used to carry winnowed rice to a husband's village. Small containers are undecorated; some are used to store salt, and others (sometimes with a fiber handle) are used for herbs, kaolin, and other ingredients for rituals. Covered calabash containers may also serve as lunch boxes for men away from home for the day; a covered bowl containing the food is put inside, together with a drinking calabash and a spoon, and the whole is tied together in a cloth.

212a.

213b.

Bowls. Calabash fruits are cut through the stem to produce roughly hemispheric bowls, which are decoratively carved on the interiors by women. Bowl types include those used to give water to babies (small and sparsely decorated), water-drinking bowls (round, medium-sized, decorated, and served at men's meals), hand-washing bowls (shallow, slightly elongated, medium-sized, decorated, and also served at men's meals), rice-washing bowls (larger and very simply decorated), and bowls used for ritual purposes (large and completely undecorated).

Spoons, ladles, rice mounders. Calabashes cut through the stem into more than two pieces are used for these utensils, which women decorate on the interiors with carved designs. Rice mounders may also be made by trimming broken calabash bowls to the correct proportions. The Maroon classification

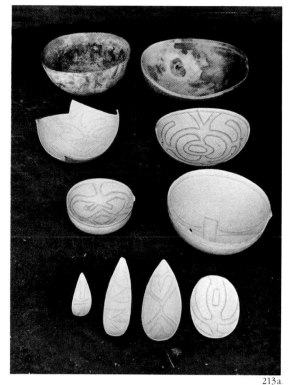

213a.

212b.

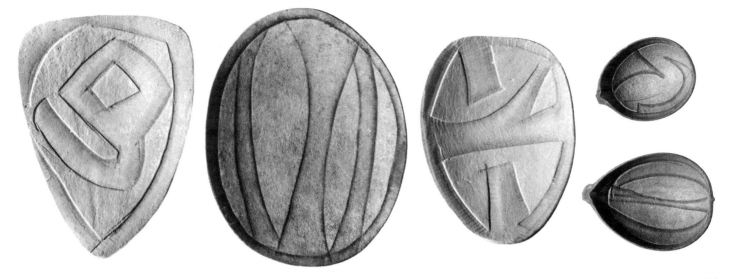

distinguishes "small spoons," medium-sized "okra ladles" used in daily cooking, "large ladles" used in cooking for community events, and shallow oval "rice mounders" which are used to scoop rice out of the pot and to shape it into a smoothly hemispheric mound in the serving bowl. The decoration on all of these, though fairly minimal, is related stylistically to the more complex designs carved on bowl interiors (Figure 212).

Although the great majority of calabashes are made into containers, some are used for rattles, others have provided rings on which round-bottomed containers may be set at meals, and discs cut from the stem ends of calabashes may be temporarily affixed to the chest as a treatment for certain illnesses. Figures 213–215 illustrate the principal forms.

Calabash preparation begins with selection of the materials. Fruit that appears ready is knocked with a kitchen knife; Saramaka women explain that if it is ripe, it answers a sharp "*ká! ká! ká!*", and if not, it sounds a dull "*pòpòpò.*" Several pieces are thus selected and broken from their stems. The next day these are sawed in half with a knife and the pulp removed with the fingers or a metal spoon. They are immersed in a large vat of boiling water for something under a half hour, after which the remaining mushy pulp is scraped out with a spoon at the river's edge. (Calabashes destined to become rattles are boiled whole, after which a stick inserted through a small opening is manipulated to loosen the pulp.) When the woman is ready to decorate her calabashes, she sits on the ground or on a low stool with her legs outstretched. Her first job is to shape the bowl or utensil, which she does by breaking off bits along the side with her hands and teeth and smoothing the edge with a knife. She then prepares a small piece of glass by knocking a bottle with the handle of her knife until it breaks in the desired shape, and begins to plan the design. Many women begin by drawing the interior border; then they mark the central design itself, thoughtfully rotating the shell in their hands again and again as they place, for example, a central lozenge and its curved appendages in the appropriate position. The piece of broken glass is then used to incise the design clearly; each line is scraped to form a sharp edge along one side and a shaded effect along the other. A band may be scraped along the exterior of the bowl, and the carving is finished. The calabashes are soaked in water for about a week to soften them, rubbed smooth with an abrasive leaf and then with fine sand, and dried in the sun. Finally, they are rubbed with lime halves, rinsed, and dried again.

Women prepare the calabashes used for covered containers in a similar way before giving them to men to be decorated with woodcarving tools—a pair of

214. Small calabash forms: a–c) Saramaka rice mounders (nearly flat), collected 1960s–70s on the Pikilio; d–e) Paramaka drinking cups for infants (hemispheric), collected 1960s–70s.

215. Calabash ladles: a–c) collected before 1887; d) Djuka, collected before 1881; e) Aluku, collected before 1935.

216. Eighteenth-century calabash bowl from Suriname

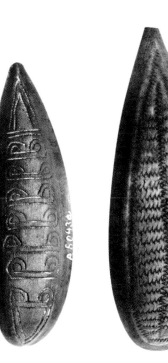

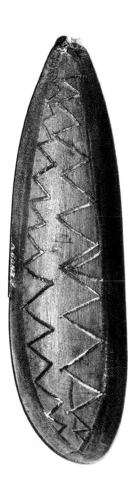

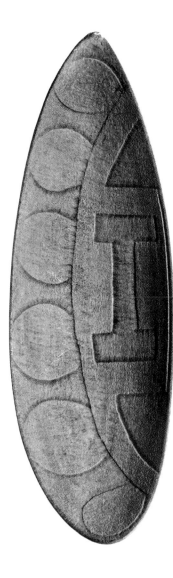

215.

compasses, a pocket knife, and a small chisel.[54] Even when decorated by men, however, calabashes are envisioned strictly as women's property—grown and prepared by women, and returned to them as soon as the design is complete.

In terms of techniques of preparation, tools used, and general kinds of designs applied, the calabash containers present in Maroon villages today show relatively minor variation. Those cut through the stem are decorated on the inside by women with pieces of broken glass. Those cut along the equator (perpendicular to the stem axis) are used as closed containers and decorated on the exterior by men using compasses, a knife, and a small chisel. However, the historical record—contained in both written reports and museum collections—indicates that calabashes have been subjected to a startlingly varied range of decorative techniques and styles, by Maroons and other Surinamers, over the past two and a half centuries. The shells have been pierced with round holes, turned into elaborate mesh baskets with handles and pedestals, carved in bas-relief on both interiors and exteriors (with knives, broken glass, chisels, and compasses), painted with natural dyes and commercial paints, rubbed with kaolin, lacquered with urine, varnished, topped with elaborately carved wooden handles, and adorned with cloth and paper appliqués. The designs have ranged from angular to curvilinear, abstract to representational, geometric to free form, and busily textured to starkly simple.

The following sketch of the development of Maroon calabash art will spill over into discussions of calabash decoration by Amerindians and coastal Afro-Surinamers as well, since Maroons have interacted with outsiders in this me-

216.

dium—through trading, cooperative production, and stylistic borrowing—throughout their history.[55] Although the written reports of early observers sometimes leave doubt about whether a particular calabash was the work of coastal Afro-Surinamers, Amerindians, or Maroons, we do know that Maroons have been fashioning calabash spoons, bowls, and covered containers since their very earliest years in the interior (Schumann 1778: s.v. *gollu, kallabas, kuja, kujeri, tappadorro*; and Staehelin 1913–19, III ii: 198, 213) and that these were being decoratively embellished by at least about 1800 (von Sack 1810:81).

Afro-Surinamers first learned how to prepare calabash shells from Suriname Indians, who employed them as their "everyday dishware and kitchen equipment" (Fermin 1769, I:194), as well as for spindle whorls and rattles. We have reason to believe that the earliest extant calabash alleged to represent Maroon artistry is in fact the work of Amerindians. This remarkable piece is one of a stylistically homogeneous set of calabash bowls in the Musée de l'Homme which were collected in Suriname and French Guiana sometime before 1792 (Figure 216). Exhibiting a high gloss and intricately painted exterior and interior designs in yellow, bluegray, and white on a black ground, it is listed as having been collected from the *Nègres Bosch* (Djuka) of Suriname.[56] The radical stylistic gap between this calabash and all other examples made by Maroons suggests, however, that it was not the work of a Maroon. Rather, we suspect that it (and the others collected with it) was designed by tropical forest Indians. A nineteenth-century naturalist, writing of his travels on the lower Amazon, describes "*cuyas*" made by these Indians as

> sometimes very tastefully painted. The rich black ground-colour is produced by a dye made from the bark of a tree called Comateü, the gummy nature of which imparts a fine polish. The yellow tints are made with the Tabatinga clay; the red with the seeds of the Urucú, or anatto plant; and the blue with indigo, which is planted round the huts [Bates 1873:116].

Likewise, Indians living nearby on the upper Rio Negro produced highly polished calabash containers. There,

> the cups are polished brown on the outside and lacquered black on the inside; while the edge or the whole exterior is ornamented with incised patterns. The lacquering is done in a curious way. The calabash, after being well smoothed on the inner surface and washed with a decoction of carayuru (Bignonia) leaves is turned upside down over some cassava leaves sprinkled with human urine, where it remains until such time as the inside becomes black and shiny. [Koch-Grünberg 1910, II:232, translated in Roth 1924:302.]

Because the range of colors and the polished quality of the surfaces described in these passages fit quite precisely the entire set of eighteenth-century calabashes at the Musée de l'Homme, we feel safe in concluding that these calabashes represent Amerindian artistry, and that they were designed by groups living to the south of the areas inhabited by Maroons.[57] However, because calabashes were important items in the active trading networks among different Amerindian groups and between Amerindians and Maroons, it is likely that such calabashes were known, and sometimes owned, by Maroons. Amerindians have decorated calabashes with carved as well as painted designs, but we have no evidence of their artistic influence on Maroon calabash carving. The historical literature refers to Amerindian calabashes decorated with incisions (for example, Roth 1924:302), but those few documented examples available in museum collections are, compared to Afro-Suriname calabashes, characterized by very minimal design and rather crude execution (Figures 217–218). Our sources indicate that today Suriname Amerindians no longer carve calabashes at all and that the few specimens still found in their villages have been acquired by trade from Maroons.[58]

217. Calabash bowl carved by Wayana Indians in Suriname, collected before 1965.

218. Two-piece calabash container carved by Carib Indians in Suriname, collected before 1912.

219. Small calabash rattle collected in 1818

220. Nineteenth-century calabash carving: a,b) collected before 1887; c) collected before 1874. The interiors of these bowls are undecorated.

217.

218.

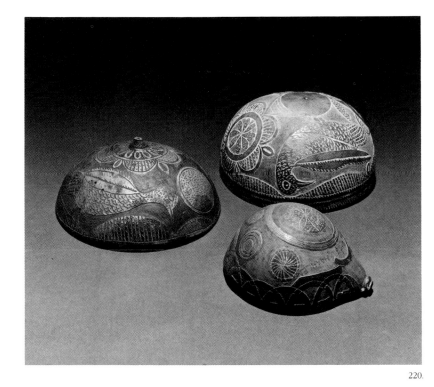

220.

The first calabashes clearly decorated by Afro-Surinamers were carved on their exterior surfaces with textured geometric (often circular) designs and rubbed with kaolin. As one observer reported:

> There are some Negroes who engrave on the convexity of this fruit compartments and grotesques in their own style, the hatchings of which they then fill in with chalk; which produces quite a pretty effect; and although they employ neither straight-edge nor compasses, these designs do not fail to be quite exact and quite agreeable [Fermin 1769, I:194; see also Stedman 1796, II:120].

This eighteenth-century style of calabash decoration is visually similar to certain decorative styles used on the exteriors of gourds in West Africa (see, for example, Chappel 1977 and Griaule and Dieterlen 1935).[59] The earliest extant example of this style is a calabash rattle in the Rijksmuseum voor Volkenkunde in Leiden, which was collected in 1818 (Figure 219). Notes written in 1824 by the original donor describe its use:

> A rattle, *sacca sacca*, used at Negro dances. The Free Negroes and Coloreds as well as many Slaves have dance societies.... They ... have the '*Gold Society*,' the '*Silver*,' the '*Amber*,' the '*Fashion*' and the '*Love Society*.' This rattle belonged to a member of the '*Love Society*'; the incised figures are symbolic [Rijksmuseum voor Volkenkunde, Leiden, Archief Stuk 123a].[60]

This African-looking style, in which rosaces, other geometric shapes, border designs, and sometimes animal figures are textured with incised flecks and rubbed with kaolin, continued to be found in Suriname—sometimes in Maroon villages—until the second half of the nineteenth century (Figure 220; see also Hurault 1970: Plates III–V and, for an unusual example collected in the early 1800s, Neumann 1961).

During the second half of the nineteenth century, Maroons experimented with several new modes of calabash decoration. Maroon men, for example,

219.

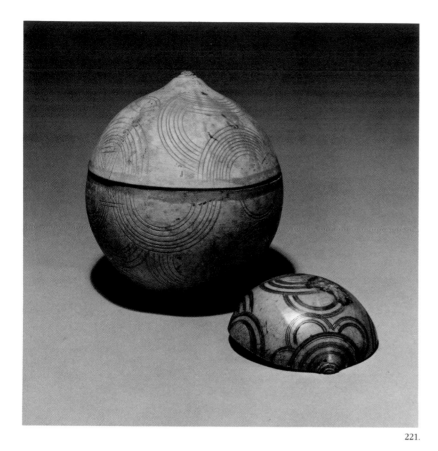

221.

224a.

224b.

began using compasses to incise the exteriors of some calabashes with sets of concentric arcs and circles in a style that lasted only a few decades (Figure 221a). Furthermore, Maroon men and women were producing calabashes that combined their respective artistic styles, men designing the exteriors and women the interiors (Figures 222–224). Over time, this cooperative mode of decoration disappeared as men limited their efforts to covered containers, and women to bowls and ladles. During the same period, calabashes provided a meeting ground for Maroon and non-Maroon decorative arts. Late nineteenth-century collections of Suriname artifacts abound in calabash bowls colorfully embellished inside and out with hearts, Dutch aphorisms, scenes of daily life, and garlands of flowers executed with glossy commercial paints. These are attributed to ex-plantation slaves in the coastal region and bear no technical or stylistic resemblance to contemporary Maroon calabash art (Figure 225a). There are also many calabashes, however, that have coastal-style paintings on one surface and incised Maroon circle-and-arc designs on the other (Figures 221b and 225b). Museum catalogues list some of these mixed pieces as plantation artistry, some as the work of Maroons; but it seems clear that each one was in fact first decorated by a Maroon and later by a coastal Surinamer. Although they have become increasingly rare over the past several decades, these "bi-cultural" artifacts still serve occasionally as wall decorations in the homes of coastal Surinamers. Their most recent incarnations—which combine interior designs carved by Maroon women with exterior scenes painted on later by Creole men—were inspired by Suriname's independence in 1975. Figure 226, for example, shows the juxtaposition of prototypical Saramaka designs with representations of modern life in coastal Suriname.[61]

Nineteenth-century experimentation with calabash decoration also produced the two styles that soon came to dominate Maroon calabash art and have persisted with only minor change into the present (Color Plate XVII). Men used

225a.

225b.

222a.

223a.

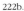

222b.

221. Calabashes decorated on the outside with compasses:
a) covered container with plain interior, collected before
1912; b) bowl with painted interior (see Figure 225), prob-
ably made 1850–70.

222. Aluku calabash bowl, collected 1878–81

223. Calabash bowl collected from Afro-Surinamers on a
coastal plantation before 1883 (though it had probably been
obtained by trade with Maroons).

224. Calabash bowl collected before 1883

225. Painted calabash bowls: a) coastal Afro-Surinamer in
"koto-missie" dress; inscription along border states in Dutch
that "Health is wealth;" the interior is painted solid red.
Collected before 1894. b) interior of bowl illustrated in Fig-
ure 221b.

See page 161 for Color Plate XVII.

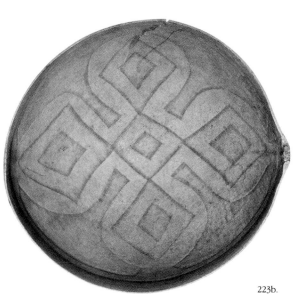

223b.

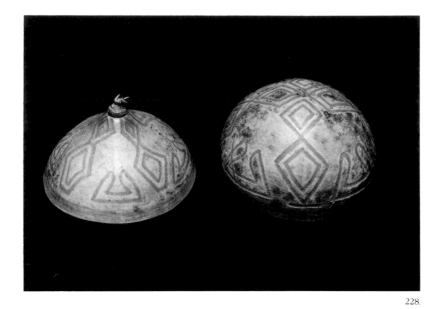

228.

226. Calabash bowl collected 1978 in Paramaribo, made for sale.

227. Saramaka calabash container, collected late 1920s in Bedoti.

228. Calabash container, collected before 1883

229. Maroon calabash container

230. Maroon calabash container

231. Maroon calabash bowl, collected before 1894

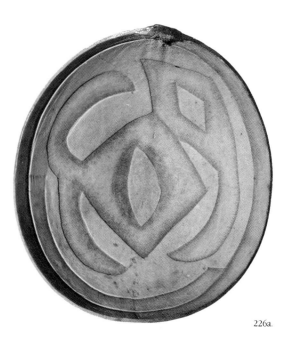

226a.

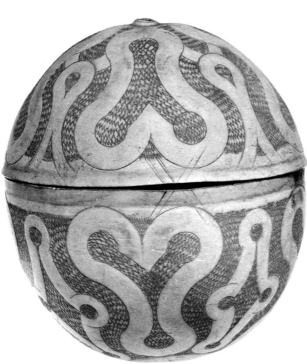

227.

226b.

158

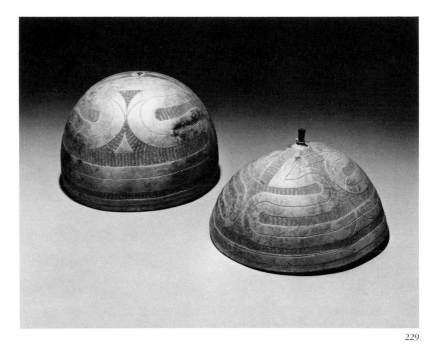

229.

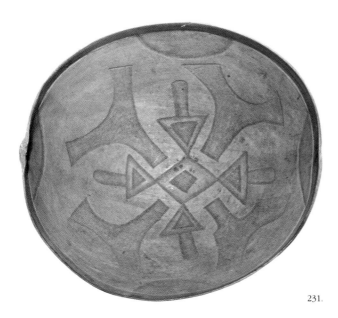

231.

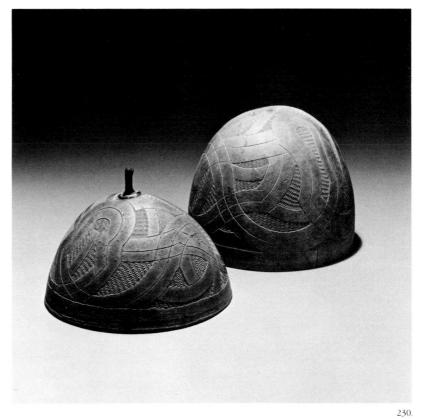

230.

chisels and pocket knives to create the complex, textured designs which became the universal mode for men's decoration of two-piece calabash containers (Figures 227–230). Women developed both the technique of carving calabash interiors with pieces of broken glass and the design style based on symmetrical arrangements of even-sided bands which have characterized women's calabash art among all Maroons during the twentieth century (Figure 231). In terms of both techniques and types of designs, then, modern Maroon calabash art was firmly established about one hundred years ago.

Twentieth-century women's calabash art presents an illustration of the kinds of regional variation that can be found in all Maroon media. As with language and other aspects of culture, the greatest differences are between the eastern Maroons and those in central Suriname. While the technique of forming "shaded" bands with a piece of broken glass is shared, the definition of figure and ground in these designs is reversed in the two geographical areas (Figures 232–233). Aluku, Djuka, and Paramaka women envision and execute their designs as bands shaded (scraped) to the outside; Saramakas and Matawais create similar designs, but form the bands with scraping on the inside.[62] In addition, the shape of these bands differs subtly. Among the eastern tribes, bands of varying width are convex; in contrast, the Saramaka style produces appendages which are concave. This difference in design elements is perceptible on purely formal grounds. It is also confirmed by contrasts in the assignment of design names; eastern Maroons give names to the convex, externally shaded areas and Saramakas, to the concave, internally shaded areas.[63]

One possible (common) origin of both these styles is suggested by several calabash designs which can be viewed in terms of *either* their concave, internally scraped areas which constitute Saramaka-style designs *or* their bulging, externally scraped areas which constitute designs typical of eastern Maroon calabashes (Figure 233c). Were it possible to determine that these "ambiguously defined" designs predated the current design styles, we would be able to argue that a shared style gradually came to be "read" with inversed definitions of figure and ground by Alukus, Djukas, and Paramakas on the one hand, and by Saramakas and Matawais on the other. An alternative explanation for the development of these styles is suggested by the fact that the earliest available examples of band designs—including some collected in eastern Maroon villages (Figure 222b)—are in the "Saramaka" mode. It may be that *all* Maroons originally carved these concave, internally scraped bands, that one or more women from one of the eastern tribes began to experiment with the "background" shapes of the designs, and that this innovation was copied and eventually became universal in the eastern tribes. In either case, a sensitivity to the contours of the "ground"—which is frequently evident in aesthetic commentary by modern Maroon women—seems to have been important to the gradual development of divergent regional styles of calabash decoration.[64]

Even within particular groups, calabash designs exhibit strong regional variation. Saramaka calabashes provide several examples. The joining of two bands is frequently "closed" in designs made in the village of Santigoon, but "open" in those from villages farther upstream (compare 4d and 4e in Figure 232). Women from the downstream half of the territory scrape no exterior border on their bowls, but this is an absolute requirement for all bowls made in upstream villages. Particular overall shapes and design motifs are strongly associated with their villages of origin and tend to be produced much more frequently there. For example, the arrow motif in Figure 232 (4f) and (4g) and rice mounders with pointed ends (Figure 214a) are both considered "Pempe carving"; spade-shaped designs (Figure 234) are made chiefly in the village of Godo; and the designs in Figure 232 (5d)–(5f) are a specialty of Asindoopo, as is the sharply notched "motorboat" hand-washing bowl—see Figure 232 (5a), (5b) and, for a Lower River variant, (5c).

Maroons from all regions have experimented with applying art styles from other media (such as woodcarving, patchwork sewing, or embroidery) to cal-

XVII. Men's and women's calabash arts: a) covered container, carved by an Aluku man and embellished with a wooden handle, collected before 1932; b) calabash bowl, carved 1960s by a Saramaka woman (Keekete, Asindoopo).

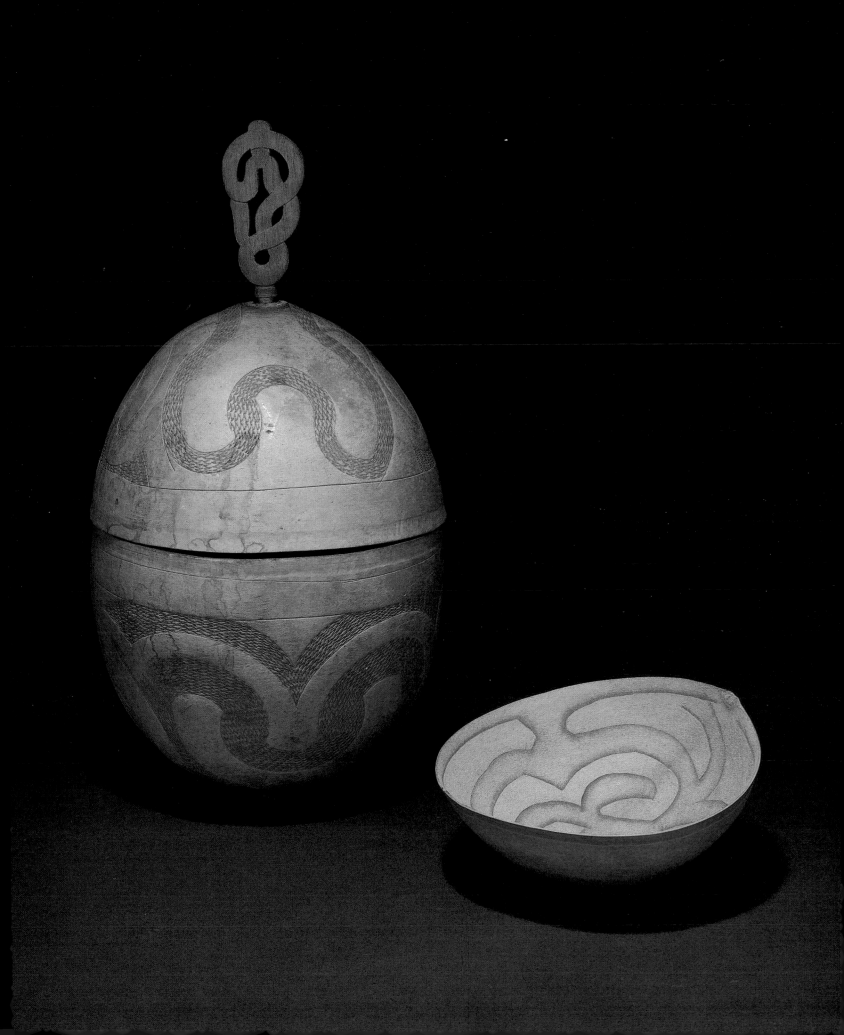

232. Modern women's calabash art:
row 1: a–c) Paramaka
 d–g) Djuka, Tapanahoni River
row 2: a–c) Matawai
 d–g) Aluku
row 3: Saramaka
row 4: Saramaka
row 5: Saramaka

To our knowledge, the oldest of these is 2d, which was collected before 1939.
See the text for more specific information on where these calabashes were collected.

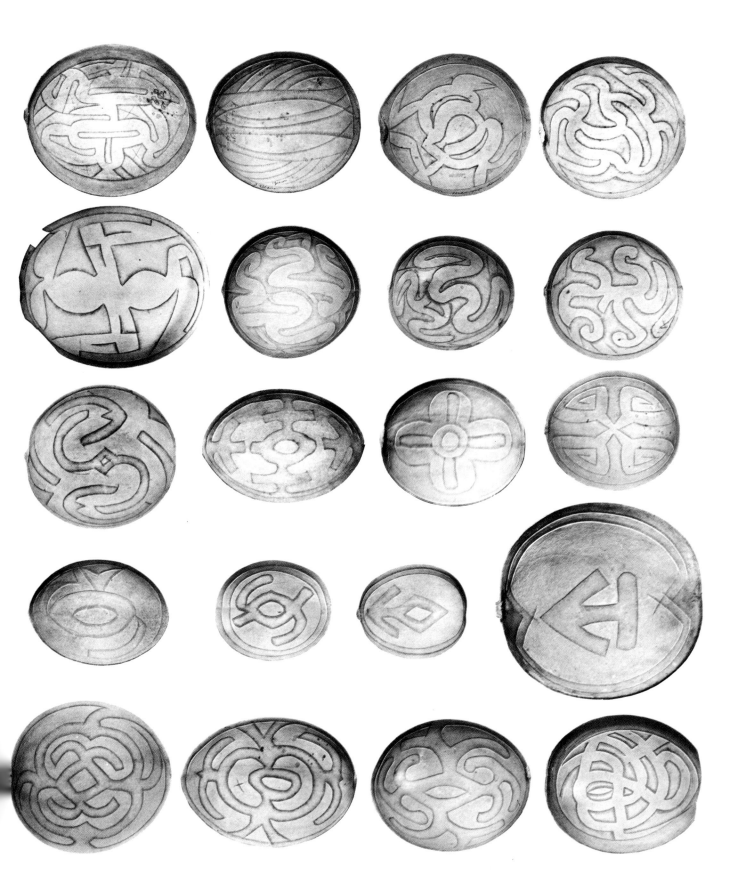

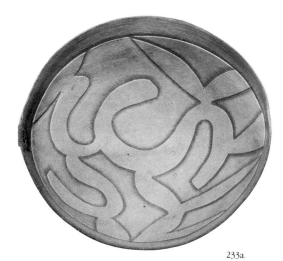

233a.

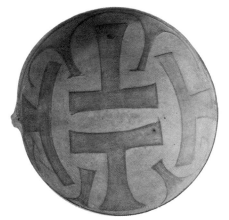

233b.

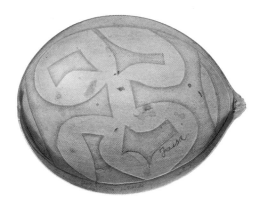

233c.

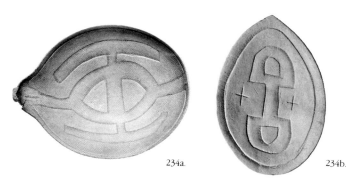

234a.

234b.

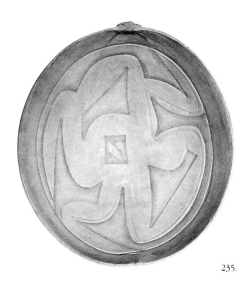

235.

abashes. The design in Figure 232 (5g) is one of many imitations of the widespread wood-within-wood technique in woodcarving; the layered bands of eastern woodcarving have been replicated on the calabash in Figure 235; and Maroon women have often cited men's woodcarving as the inspiration for calabash designs that to us were less obviously similar. The Djuka container in Figure 236 substitutes for the usual elements of exterior calabash carving the shapes characteristic of bits-and-pieces patchwork sewing, which was still being produced at the time this piece was collected. The container in Figure 237 replicates the bands with zig-zag "filler" stitches that were often embroidered on early twentieth-century clothing (Figure 238). (See Chapter 8 for additional examples of interchange between calabash decoration and other arts.)

As we mentioned at the outset of this chapter, "bottle gourds" are also cultivated and used for containers by Maroons but, unlike calabashes, are not subjected to artistic treatment. Once gourds are picked from their vines (which are grown in both villages and horticultural camps), they are placed in a creek for several weeks to rot. The thin outside skin is then rubbed off. Gourds to be made into containers (usually water vessels) are cut open at the stem end, and the seeds are removed. Those to be used for rolling pins (Figure 194) are allowed to dry uncut. Gourd containers, which are never carved, are important props for many rituals, for example funerals and rituals of "separation" from evil spirits. The only embellishment of gourds that we know of is aimed at ritual rather than aesthetic ends; for instance, black and red stripes (made with soot and the juice of red berries) may be applied with a finger to gourd containers kept in the shrine houses of certain types of gods. Until the mid-twentieth century, gourds were cut in half to form the sounding box of a stringed instrument (Figure 250); and they are still carved into masks worn

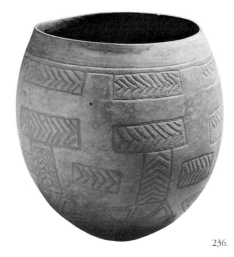

236.

238.

during funeral rites and used, unembellished, as children's dolls. Finally, tiny rings cut from the stem end of a small gourd are tied on the ankles of children who are just learning to walk, as a medicine intended to aid their progress.

Changes in the uses of both gourd and calabash containers illustrate a common pattern in the history of Maroon culture—the gradual confinement over time of particular objects, musical genres, verbal forms, and so on to ritual settings. While gourd water vessels—once a standard household item—have largely been replaced by imported metal buckets, they are required for specialized uses in certain ritual settings. In many cases, for example, water intended for use in ancestral rites may not be carried in commercial buckets, and Saramakas specify that a body being prepared for burial must be washed with water taken from the river in two vessels—a gourd container and an imported pottery jug. A parallel change has occurred in the use of calabash spoons over the past few decades in Upper River Saramaka. Although the tiny calabash eating spoons (which until about 1940–50 were a standard domestic item) have gradually been replaced at meals by imported aluminum spoons, they are still made and decorated in that region because they are required for the meals served at certain stages of burial rites. The use of Maroon-made pottery has undergone a similar development. The technique and forms seem to have changed little since eighteenth-century descriptions and early nineteenth-century examples (see R. and S. Price 1979); but the varied earthenware objects which once formed an integral part of Maroon domestic furnishings are now restricted largely to ritual settings: large Amerindian-style vessels are used for community-wide ablutions, small bowls hold offerings for particular gods, and pipes are used to blow purificatory smoke over the participants in rites honoring particular spiritual powers.

These changes reflect basic Maroon understandings concerning the proper treatment of gods and ancestors. Harmonious relations with the spirit world constitute one of the most fundamental requirements for personal and communal well-being, and efforts are continually being made to allow clear communication with these beings and to comply with their expressed wishes. One of the ways in which ancestors are satisfied is through the maintenance, in ritual settings, of details of Maroon culture as they had known it during their own lifetimes. Thus, they may be honored with singing, dancing, and drumming in obsolete styles; they are often offered libations of water from the area of the river where their villages once existed; and they are given food from dishes they once owned.

237.

165

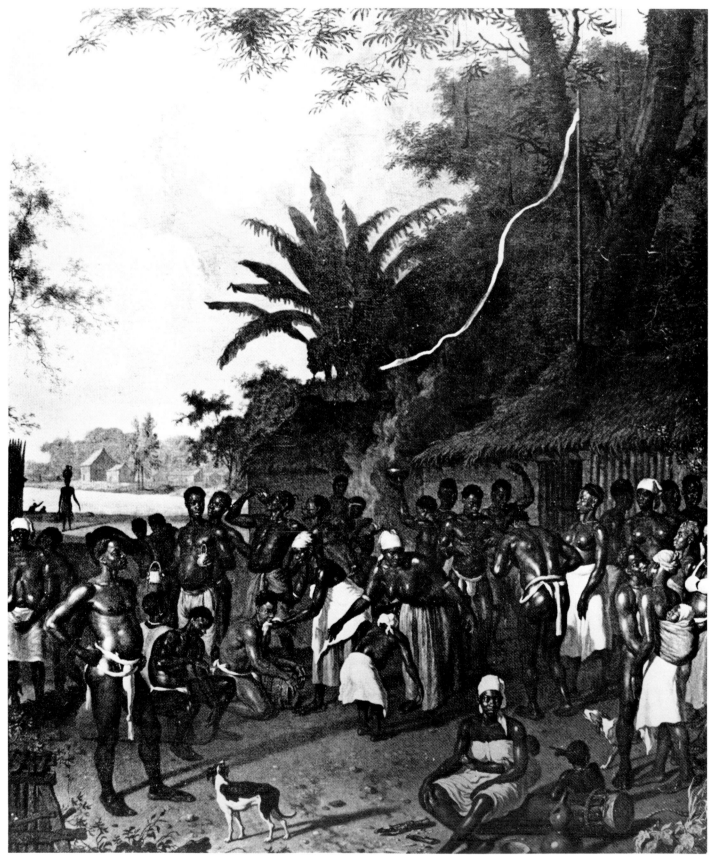

239.

Performance in Maroon Life

The Maroon emphasis on individuality, expressiveness, and personal style—described in Chapter 3 in regard to dress and adornment—is a very general feature of Maroon life. A special attention to "performance" marks social interaction of all kinds, and Maroons exhibit a keen appreciation of nuances of speech, gesture, and posture. Playfulness, creativity, and improvisation pervade everyday conversation, making even ordinary speech a lively art. Newly invented elliptical phrases frequently substitute for standard words so that, for example, a watch becomes a "back-of-the-wrist motor," food "under-the-nose-material," and a stool "the rump's rejoicing." The love of mimicry reflects Maroons' interest in distinctive characteristics of individual (or even tribal) mannerisms. We once saw two friends, separated by a roaring rapids, silently greeting each other; one began with a humorous imitation of the dance style of a fellow villager, and the second—who had no trouble identifying the subject of the impersonation—countered with his own rendition of another man's performance of the same dance. The expressive, dramatic quality of Maroon life may be seen also in the spontaneous songs and dances that are frequently sparked by mundane but happy events. To cite just two of innumerable possible examples: an elderly woman, who had been fishing without success for over an hour, was finally rewarded with a tiny fish; dropping into a sitting position in the shallow water, she broke into a sinuous dance of celebration with her upper torso. Another woman, noticing a neighbor passing her door with a new enamel bucket on her head, sang a spontaneous little song: "The red bucket suits my 'sister-in-law,' look how the red bucket suits my 'sister-in-law'."

Spontaneous expressiveness shades directly into more formally delineated kinds of music, dance, and verbal art. The melodic phrase with which a woman breaks the monotony of a morning of rice-cutting may later be expanded by a repeated response and sung by a soloist and chorus at the next community-wide celebration in her village; a man's entertaining description of an agouti he saw washing itself while he was hunting in the forest is stylized into a dance which is performed to the accompaniment of drums and handclapping; another's rendition of the rhythms of a Coca-Cola bottling machine he saw on the coast becomes a popular piece for local drummers; and so on. Just as Maroons incorporate into their visual aesthetic framework such features of everyday life as tin lanterns, outboard motors, or varieties of rice, they enjoy building the sounds, gestures, and language of daily living into their more formal performing arts.

Certain features of Maroon performance seem as relevant to everyday expressive moments as to the most formal performance settings, whether oracle sessions, tribal council meetings, or funeral rites. We would like to delineate briefly some of these general principles of performance, as a complement to our discussion in Chapter 3 of some general aesthetic principles in the graphic and plastic arts.

Maroon performances at all levels of formality are characterized by total participation and the highly structured nature of interplay among participants, rendering inappropriate the analytical use of Western distinctions between "audience" and "performer." There are, for example, certain stylized contrapuntal patterns that structure everyday speech and gossip, the formal rhetoric of ritual and judicial sessions, and public song/dance/drum performances. Normal conversations are punctuated by one of the listeners, who offers supportive comments such as "That's right," "Yes indeed," or "Not at all." Even when men living on the coast send tape-recorded messages back to their villages, pauses are left after each phrase, and the "conversation" assumes its proper two-party form once it is played. In formal settings, stylized responses become more frequent, and responsibility for providing them is assumed by someone who is not a principal participant; discussions with a Tribal Chief, for example, are always conducted with the rhetorical aid of a third party who explicitly represents all other witnesses to the event. Prayers also assume an antiphonal

239. 1707 painting by Dirk Valkenburg of a slave "play" on the Suriname River plantations of Palmeneribo-Surimombo.

structure, as participants periodically support the speaker's words in unison with slow handclapping and a specially intoned declaration of "Great thanks!" Solo work songs are repeatedly interrupted by the comments of others present, and popular song forms (e.g., Saramaka *sêkêti*, see below) are built on the alternation of a soloist and a responsive chorus. Whatever the specific context, this fundamental contrapuntal pattern expresses the ongoing, active engagement of people other than the principal speaker or performer.

A closely related feature of Maroon performance is frequent role-switching between soloist and other participants. For example, in an evening of tale-telling, not only is one person's tale followed by someone else's, but each story is interrupted at several points by shorter tales narrated by still other people. Likewise, song/dance/drum performances are characterized by the emergence of a succession of individual soloists, each of whom briefly assumes the central role and then is replaced by another. This structure supports the balance between the complementary values of communal participation and individual virtuosity (as well as the related Maroon stress on "name" or reputation). In other words, in terms of the structure of participation, Maroon performances resemble a jazz jam session rather than the performance of a piano concerto.

Many kinds of Maroon performance exhibit a common diachronic structure characterized by repeated interruptions. An initial exposition is interrupted by another exposition, which in turn may be interrupted by a third, with subsequent portions of each unfolding—often with further interruptions—throughout the performance. (The link between an interruption and the narration it interrupts is usually a thin, and often obscure, thread of meaning.) For example, a typical sequence in a tale-telling session or in a divinatory seance with an oracle would be: A (the first tale or case of the session) is interrupted by B which is interrupted by the continuation of A which is interrupted by the end of B which is followed by the continuation of A which is interrupted by C which is interrupted by the whole of D which is followed by the continuation of A which is interrupted by the end of C which is followed by the end of A. The description of tale-telling at the end of this chapter illustrates this principle more concretely. There, we will see how one telling of a tale about the origin of drums was interrupted by one about a wrestling match, was continued briefly, was interrupted again by a tale of an extraordinary dance performance, which was followed by a tale about the Devil before continuing on, with three additional interruptive tales, to its conclusion. This pattern of interrupting and overlaying segments strung out through time, which characterizes formal council meetings, oracle sessions, and folk tales, is closely related to central features of Maroon musical performance—e.g., the staggered points of entry of performers and the importance of polyrhythms. Indeed, we would suggest that these generalized rhythmic features of performance reflect fundamental Maroon concepts about the unfolding of events through time (see R. Price n.d.2).

Another widespread feature of Maroon performance is the creative use of indirection or ellipsis, the art of allusion through proverbs and other condensed verbal or gestural forms, as well as other spontaneous or conventional means of avoiding direct reference. Although the use of such devices intensifies in formal contexts (prayer, council meetings, and so forth), even everyday ways of addressing or referring to people are treated as a complex and subtle art. As we have pointed out for Saramaka,

> To avoid using any of [a person's names], one can substitute kin terms, official titles, references to kinship [e.g., 'So-and-so's mother'], residence ('the man up the hill'), physical characteristics ('the dark one'), temporary states ('the woman who was sick'), recent actions ('the man who killed the tapir'), and so forth. Often reference becomes a kind of sophisticated word play in which the speaker uses progressively less ambiguous terms seriatim until the identity of the referent becomes clear to the listener [R. and S. Price 1972b: 353–54].

Likewise, as we saw earlier in this chapter, Maroons place a high value on the substitution of elliptical phrases for everyday words, and this is as true with circumlocutions for common verbs as it is with those for, say, "food" or "watches." But the richest and most highly developed uses of verbal allusion involve proverbs. Maroon proverbs constitute a central repository of moral wisdom and values, and form an important part of almost any formal conversation. As people grow older they tend to use proverbs more frequently and with greater skill—which in Maroon terms means more elliptically (and more often in esoteric ritual languages). On the simplest level, this involves speaking the first half of a proverb, with the expectation that the listener will complete it mentally and apply its message to the subject at hand. More commonly, a person cites a proverb simply by referring to "the one about so-and-so" or by mentioning a key word or character.[65] From a Maroon perspective, the ability to use proverbs and proverbial allusion in speech represents the ultimate achievement in the verbal arts.

Finally, as we have already implied, playfulness and the appreciation of novelty are as important in Maroon performance as in the graphic and plastic arts. Just as people have admired the innovative carving of a folded umbrella in the medium of wood or the fanciful incising of a man's penis with cicatrizations, participants in village festivities have delighted in such novelties as one dancer's use of a Chinese paper fan, which he gradually and deliberately unfolded as he danced. We have also seen how everyday speech is peppered with creative indirection, but speech play takes other forms as well: verbal dueling, involving the improvisation and recital by young men of long strings of imaginative insults; borrowing words and phrases from French Guiana creole, Dutch, English, or coastal Suriname creole; and the creation—usually by groups of young men—of secret play languages.[66] As we shall see below, creativity and play are an equally important aspect of formal song, dance, and drumming performances, and contribute both to the enormous vitality of these arts and to the ongoing processes of stylistic change through time.[67]

Although performance is an important aspect of all public behavior, the large communal events which Maroons call "plays" (Sar. *pêê*, Ndj. *pee*) provide the setting for their most complex, intense, and highly stylized performances. At plays, large gatherings of festively dressed people from a number of villages participate in multi-media performances of song, dance, and drumming. Plays, which often continue until dawn, are also the primary public occasion for meeting potential lovers or spouses. Plays are organized for a variety of reasons. They are the high points of each of the several stages of funeral rites; they accompany the installation of chiefs, headmen, and other officials; and they are used to honor particular gods and ancestors. Each specific context—whether, for example, a gathering in honor of a forest spirit or the climactic rites of a funeral—calls for a different set of specialized dances, drum rhythms, and song styles. Large-scale plays have been a prominent feature of Maroon life throughout their history. For example, German missionaires living among the Saramaka in the eighteenth century reported in their diaries the arrival of up to five hundred visitors to their village for night-long funeral celebrations devoted to singing, drumming, and dancing, and the Herskovitses describe in some detail similar celebrations which took place during their visits to the Suriname River in the late 1920s (1934).[68]

Because of the "impermanence" of performance, compared to plastic or graphic arts, an analysis of change is particularly difficult. There are, however, many suggestive indications (in eighteenth-century manuscripts and pictorial representations) that the central features of modern Maroon performance constitute an integrated whole that dates from the initial period of these societies' formation.[69] The eighteenth-century missionaries were frequently struck by Saramakas' attention to performance in daily life, by the value they placed on eloquence, by their "frivolous" love of novelty, and by their strong interest in singing, dancing, drumming and other music. These same missionaires inad-

vertently bear witness (through their frustrations in interactions with Sara-makas) that other central aspects of Maroon performance, such as indirection or elliptical speech and structured interruptions, were common in the eighteenth century as well. One missionary complained, for example, that he was frequently interrupted while delivering a sermon:

> One person said, 'Master, today we understand your words.' Another one said 'It is true.' A third said, 'I see that our *óbia*-men have deceived us.' A fourth said, 'I believe that the Great God is the only god . . .' [Staehelin 1913–19, III iii:41].

Complaints about interruptions in other verbal contexts also occur in the diaries. Even central evaluative terms such as "sweet" (Sar. *súti,* Ndj. *switi*)—which is today a term of strong approbation used for speaking, singing, dancing, drumming, tale-telling, and sexual performance—appear in the eighteenth-century materials. In short, those indications that we have from early accounts suggest strong continuities in the central features of Maroon performance. The strikingly realistic 1707 painting introduced in Chapter 3 (Figure 239) provides further evidence. The plantation "play" that it depicts combines dancing, drumming, and meetings between lovers in a style quite like its modern equivalents. In addition to the similarities of clothing style mentioned in Chapter 3, there are numerous postures and gestural attitudes which could as easily have been taken from a photograph of modern Maroons—the standard stance with shoulders and hips thrust back, the "getting-down" position in solo dancing, the method of carrying infants, the posture when carrying water, and the way one of the dancers wipes the sweat from a drummer's face.[70]

The historical continuities in the fundamental features of performance and in the general structure of plays have been accompanied by considerable dynamism. New songs, dances, and figures of speech are constantly being created; new play languages are being invented; and whole new styles of song, dance, and drumming are being evolved. To cite just one example: while the overall concept and form of Saramaka funeral plays has remained relatively constant, the musical novelty of the 1960s was *kawína,* a calypso-type song/drum/dance performance at a designated point in the festivities, which was replaced, after the introduction of gasoline generators in the 1970s, by soul music combos using Japanese-made electric instruments. Or again, at the climax of these same rites, masked dancers appear in order to chase the departing ghost definitively from the village; while the young men who make these masks have always striven for novel ways to increase their scariness (Figure 240), the availability of commercial Halloween masks in coastal stores has recently enlarged the possibilities (Figure 241). As with clothing styles, woodcarving, or cicatrization, then, the long-term history of the Maroon arts of performance has been characterized by continuities of aesthetic ideas combined with ongoing change on the level of form (see Chapter 8).

The remainder of this chapter is devoted to an overview of some of the Maroon arts of performance—dance, song, drumming and other instrumental music, and selected verbal arts. As we hope to have made clear, these arts are not generally performed in isolation, but are embedded and combined in immensely rich public events. For example, funerals involve a complex inter-working of cooking, dress, grooming, song, dance, drumming, riddle and tale-telling, prayer, oratory, divination, and purificatory rites in prescribed combinations and sequential orders over a series of many months. For purposes of this brief presentation, however, we have found it necessary to discuss these arts separately.[71]

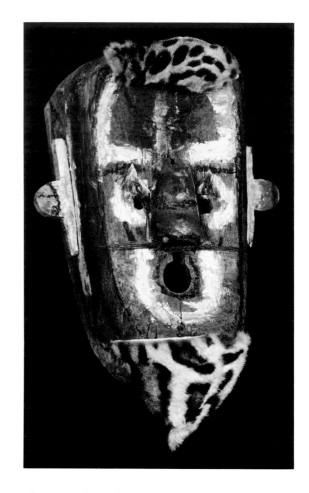

240. Saramaka mask used in funeral rites, made c. 1965 in Dangogo. Wood decorated with solutions of kaolin (white), soot (black), and berry juice from *Bixa orellana* (red) and with agouti hair and jaguar skin.

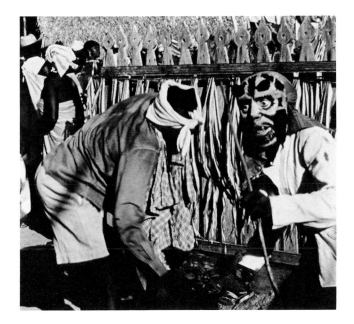

Dance

Maroon children are encouraged to dance—their hands on their hips, their torsos rotating rhythmically, and their feet planted firmly in one spot—as soon as they can stand, and they become adept at a whole range of dance styles by the time they are five or six years old. Eighteenth-century missionaries treated the subject of dance, like ritual, with disparaging remarks more than ethnographic description, yet their dismay at the competence of even very young children in performing the dances of various possession gods and at the importance of dance to even the very oldest women indicates that this was as central an activity then as it is today (Staehelin 1913–19, III i:83 *et passim*).

Maroon dance styles exhibit the same regional diversity and tendency toward evolution through time as do other kinds of Maroon performance. During the past two decades the most popular dance styles at funerals and other large public events have been Saramaka *tjêke* and Djuka and Aluku *awasa*. *Tjêke* is danced by both men and women against an accompaniment of *sêkêti* singing and handclapping (see below). This form involves the alternation of periods of light rapid footwork that almost seems to lift the dancer from the ground and more restful "holding patterns"; dancers delicately manipulate arms, wrists, and fingers, and periodically descend to a crouching position while balanced on the balls of the feet—a position considered the ultimate demonstration of agility and grace (Color Plate XVIII, Figure 242). *Awasa,* performed to the accompaniment of a drum choir, is danced with thick anklets of seed pods on each leg, rhythmically accentuating the dancer's hard-stomping footwork (Color Plate XIX, Figure 243). A large number of other dance styles are known and performed and—as in the other arts—they often pass from one region to another, drop in and out of fashion, and undergo changes in the settings in which they are considered appropriate. *Susa* and *agankoi*, for example, are considered Djuka dances, but both enjoyed a brief period of popularity, several decades ago, in many Saramaka villages. Likewise, *lama*—originally a dance from the coastal area—moved from the missionized villages of the Lower River to the Upper River region during the 1930s, enjoyed a period of intense popularity, and was dropped. *Adunké*, which is said to have preceded *tjêke* as the most popular secular dance in Saramaka, has now taken on historical associations (as has its associated song and drumming style) and is performed only in rites honoring those ancestors who were accustomed to it during their lifetimes. *Alesingô*, in which the dancer balances on long horizontal poles

241. Saramaka masked dancers at a funeral. One dancer wears a rubber Richard Nixon mask bought in Paramaribo.

See page 172 for Color Plate XVIII.

See page 173 for Color Plate XIX.

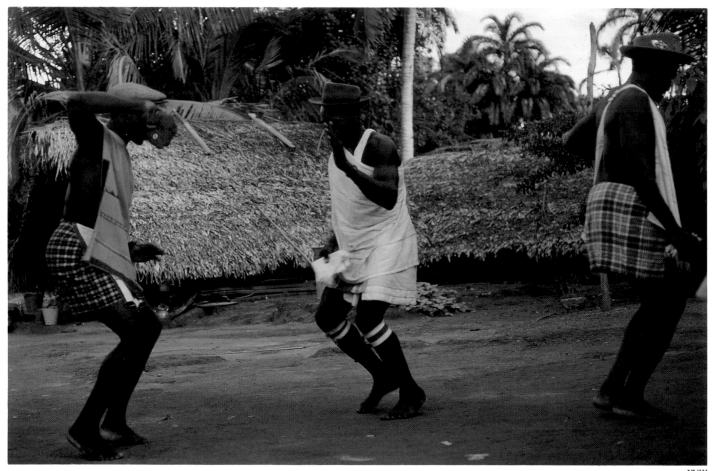

XVIII.

manipulated by two men, was imported to the Pikilio in the 1950s but seemed on its way out by the mid-1970s, when a new form of dancing, on vertical stilts, was introduced. Because of the ephemeral nature of dance, even compared with the other performing arts, our information on the variety of dance styles through time is fragmentary; but we have collected enough names and descriptions of now-obsolete styles to be certain that stylistic evolution and a love of novelty are as central an aspect of Maroon dance as they are of other Maroon arts.[72]

During much of the twentieth century, the most prestigious, highly stylized form of Saramaka dance was *djómbo* ["jumping"] *sêkêti*, performed by a male soloist accompanied by a *sêkêti* drum choir. Unlike most dance styles, *djómbo sêkêti* is performed only by a few masters in any region during a given period. A great *sêkêti* dancer must frequently create new dances, each of which is named and mimetic. The general repertoire—like that for songs (see below)—is in constant flux. On the evening of such a performance, typically as part of funeral celebrations involving visitors from a number of villages, the dancer carefully prepares himself for this most virtuoso of all Saramaka performances. Before entering the dance area, he carefully dresses himself in a specially faded short cape, with a broad embroidered dance apron over his breechcloth, and a home-sewn cotton cap (or a fashionable storebought hat). He smears white bands of kaolin around his calves and puts on black cotton anklets filled with specially prepared ingredients that insure lightness of step and provide protection from jealousy and sorcery that could make him lose his balance. As women flap lengths of cloth up and down before him to create a breeze, or hoot constantly with a cupped hand over the mouth, the dancer positions

172

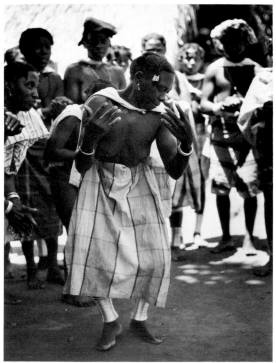

242a.

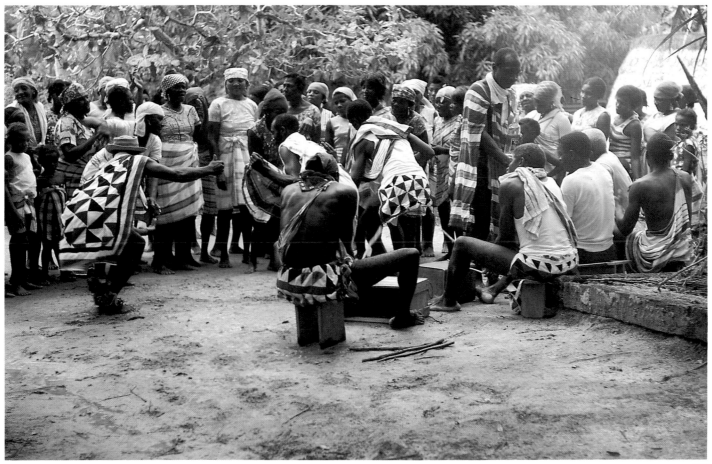

XIX.

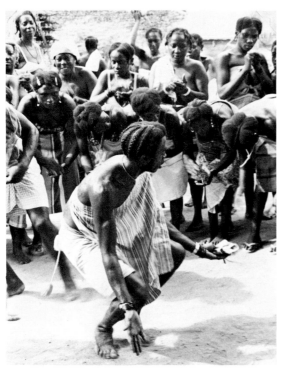

242b.

XVIII. Saramakas dancing *tjêke* at a funeral

XIX. Matawai *bandja* dancers wearing "sawtooth" patchwork clothing.

242. Saramakas dancing *tjêke* to the accompaniment of singing and handclapping.

himself regally on a stool, legs relaxed, head high, face expressionless, waiting for the right moment to begin. As the drums take up the rhythm, he stands and very deliberately adjusts his cape and apron, then suddenly bursts into motion—his face an unmoving mask, his every movement bespeaking absolute control. Various stylized gestures, lasting some twenty seconds each, alternate with less spectacular holding patterns. The intense bursts of brilliance are varied—e.g., stylized imitations of a rodent digging up sweet potatoes in a garden, a hummingbird drinking nectar, a jaguar killing a turtle, a steamship leaving the city pier, or the capping machine at the Coca-Cola bottling plant in the capital. At certain times his feet are stamped down flatly, at others moved with lightning speed to give the dancer a striking "off the ground" effect. Dance/drumming sequences of two to three minutes alternate with rest periods, when the dancer returns to the stool for a minute or so and some of the women fan the dancer with their cloths, while others hoot continuously. The drums begin again and the dancer strikes a posture, holds it, does a few quick steps, and strikes it again, emphasizing the perfect balance and symmetry that are so important a part of this tense, highly controlled style of dance.

At plays for the various gods, people perform the dances associated with them whether or not they have ever been possessed, in order—they say—to be ready should a god decide to enter their head (Color Plates XX–XXI). Such dances differ dramatically. In Saramaka, for example, forest spirit gods characteristically hop on one foot at a time; warrior gods may swoop with arms outstretched like a buzzard or stealthily pad around like a jaguar; snake gods dance with arms whipping gracefully from side to side, index fingers pointing toward the ground; and so on. Other types of dancing are closely integrated into various rites. In a major ceremony aimed at cleansing a village after a burial, masked dancers who have concealed every part of their body (with cloth, leaves, or other coverings) dance obscenely with long wooden penises, simulating copulation with drums and making suggestive advances toward other participants in the event. The masks worn by these dancers—large wooden or gourd faces embellished, for example, with peccary hair, jaguar skin, and locally made dyes or, today, sometimes commercial rubber masks imported from the coast—are illustrated in Figures 240–241. Furthermore, the great powers credited with supporting particular clans during the original wars of liberation are each honored with a special type of dancing (as well as distinctive drumming and song). Finally, there are other dances appropriate to a broad range of settings. Saramaka *bandámmba*, for example, is a sexually suggestive women's dance, accompanied by its own style of drumming. It is closely associated with fertility and the cult of twins, but it is also used in rites dedicated to the original Maroon ancestors (who are said to have enjoyed it) as well as in less formal celebrations, e.g. when a long-absent man unexpectedly returns from a coastal trip.

Song

Maroons have always enjoyed a wide range of song styles in a variety of settings. The missionaries who lived in Saramaka villages in the eighteenth century made frequent reference to singing, mentioning one type that has since disappeared—songs sung by groups of men paddling large canoes. These songs were characterized by "a lively melody and countless repeats" (Staehelin 1913–19, III ii:185) and were addressed to various spirits for protection on the river, success in hunting and fishing, and so forth.[73] Today, Maroons continue to perform certain songs they say were sung by their eighteenth-century ancestors; these songs are reserved for specific ritual settings and provide lyrical interludes in accounts of early history. For example, in the account of the conclusion of the peace with the whites in 1762 which we present below, a Saramaka elder brought out the tone of the celebration and the feelings of the individual participants by inserting songs in his narrative. After performing a song originally sung to celebrate the peace, he described the *aléle*, a dance

243. Dance anklets (Sar. *kawái*), worn by Djukas and Saramakas for *awasa* and by Matawais for *bandja* dancing—see Color Plate XIX. Seed pods (*Thevetia peruviana* Schum.) attached to bands made from commercial cotton twine, collected 1979 in Santigoon. In the past Maroons bought these anklets from Amerindians who live on the upper Marowyne River; since Amerindians have stopped producing them, Maroons now make them themselves.

See page 176 for Color Plate XX.

See page 176 for Color Plate XXI.

which, with its accompanying singing and drumming, is still remembered as the climax of the treaty-signing festivities. He next told of the origin of a song that commemorates the frustration of a woman whose jealous husband locked her in her house to prevent her from participating in that *aléle* dance.

> . . . When they had finished praying, the women said it was time to dance. The men said 'Let's dance, let's celebrate, peace has come.' Then they called:
>
> > Peace has come, *kó dénde*, freedom,
> > *Kó dénde*, freedom's come.
>
> Peace had come. After that, well, the women danced *aléle*. They danced:
>
> > *Kalíkatí, tuléle; kalíkatí, tuléle.*
>
> Then the women danced *gilin gilin gilin* [intensifiers].
> The men danced, moving their hips . . .
> The house . . . the village was going 'zzzz. . . .'
> When they finished this celebration, doing it all around the village, then the woman . . . well, then . . . that other one who had not stayed behind said: 'Child [term of affection], with the size of our celebration, at Baakawata [the village], with that fantastic *aléle*, how come *you* didn't show up?' She said: 'Oh! My husband locked me up and left me in the house. That's why I didn't come. That [untranslated perjorative expletive] Kwasi [husband's name] didn't want me to come.' Then the woman sang out:
>
> > Diítawêndjèmánu [the woman's name],
> > Why didn't you come to the *aléle? Hóókóó.* . . .
> > [Expletive] Kwasi didn't want me to come. *Hóókóó.* . . .

(A recorded version of this historical narrative, with a Saramaccan transcription, is included in R. and S. Price 1977.)

The use of songs as social commentary has continued on into the present, though their style has been modified over time. Saramakas draw a sharp distinction, for example, between the *adunké* style of popular song which lasted into the early twentieth century and the *sêkêti* style which displaced it, though the two share certain central features—from the recursive structure of their lyrics to the kinds of incidents and personal idiosyncrasies they depict. A late nineteenth-century *adunké* song that we heard in Saramaka, for example, chronicles the antics of a brash young married woman from the Pikilio; calling out audaciously to her lover during a large "play," the woman defiantly publicized her affair to the entire community and, with the aid of her sister, summoned him to her (see R. and S. Price 1977 for a recording and transcription). The performance of this song that we heard was followed by a description of how the woman's husband, who was also present, angrily tried to grab his wife, but caught only her skirt, and how she escaped by running naked through the large crowd.

Today, popular *sêkêti* songs treat much the same subject matter, concentrating on local scandals, interpersonal disputes, and the joys and sorrows of lovers. People sing these songs as an accompaniment to the daily round—while harvesting rice, paddling a canoe, carving a comb, composing a textile design, or doing any other quiet activity. During the course of a community play, these same songs become a central public activity. Individual men and women take turns performing them as soloists, often while executing a dance, and are supported by a chorus of women who both provide the responsive segments and accompany the entire performance with a strong beat of steady handclapping. We illustrate this type of song with the lyrics of a few representative examples, giving the response of the chorus in parentheses.

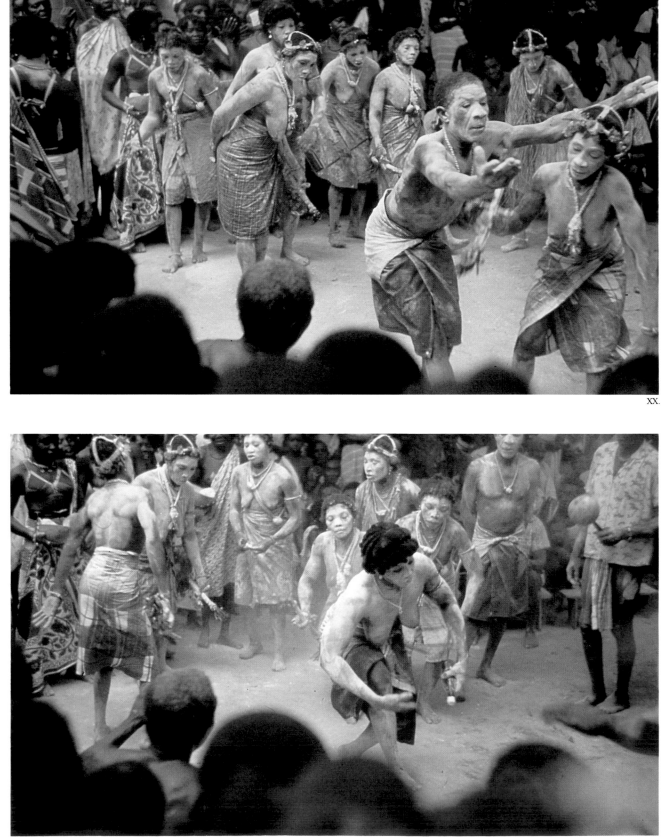

XX.

XXI.

Do you see that walk walking along?
Hey, woman, I want/love you.
(Wilhelmina, the queen.)

[A man expresses his desire for a woman whose way of walking
attracts his eye. The chorus extends the compliment through ref-
erence to the former Dutch queen—meaning simply, in this case,
someone very special.]

She's jilted me, she's jilted me,
my sister-in-law has become my co-wife.
(Chorus repeats same.)

[A woman accused her sister-in-law of being unfriendly by com-
paring her behavior to that expected of a co-wife.]

Seliso, your mother telephoned.
(Chorus repeats same.)

[Because "to telephone" is used as a euphemism for lying, this
simple song was an effective way for one man to insult a fellow
villager with whom he was having problems.]

The rapidity with which these songs pass in and out of the repertoire of any
region is closely related to the focus of their lyrics; as the incident which
inspired each song becomes a part of social history, so does the song itself,
and Maroon popular songs are as short-lived as their counterparts in Europe
and the United States. During 1975, in going over a list of 156 *sêkêti* songs we
had heard in Saramaka in 1967–68, we found not a single one that was still
being sung. Although residents of the region remembered the melody and
lyrics of each, as well, in most cases, as the incidents that had inspired them,
they had replaced them with an entirely new and equally extensive pool of
songs which commented on more current social events.

The songs sung by men engaged in hard physical labor—felling trees with
axes or hauling logs through the forest to the river—are very different from
these popular songs, both musically and linguistically (Figure 244). Only small
bits of the lyrics are in the language of everyday speech; more is expressed in
phrases used to communicate with forest spirits or in other esoteric languages,
and there are many words which are used exclusively for these two types of
singing. These long, linguistically complex songs summon a variety of ancestors
and gods (especially the forest spirits who have jurisdiction over the part of
the forest where the work is taking place), and ask them to give the men
strength, to lighten the work, and to provide protection against injury. They
are boastful and arrogant in tone; the men describe their strength, courage,
and skill, recite their "praise names," quote appropriate proverbs, and com-
mand the women to fetch water and food (see R. and S. Price 1972b and, for
a recording of a tree-felling song, R. and S. Price 1977).

Saramaka men call on their knowledge of yet other esoteric languages in
the songs that culminate certain night-long ceremonies held after a death. *Papá*
designates the language/songs/drum rhythms that are closely associated with
the concept of death and are surrounded by complex ritual prohibitions which
provide protection from their strong and potentially dangerous powers. Men's
komantí songs constitute another immensely rich and varied set of musical
forms. Equally rich sets of songs (as well as drum rhythms and dances) are
performed by male and female adepts in the cults of forest spirits, snake gods,
river gods and sea gods, and in each of the localized "great *óbia*" cults owned
by particular clans and villages.

Although there are indications that stylistic change in song parallels that in
other arts, we are unable to describe it in any detail. Saramakas perceive gradual,
ongoing change in all kinds of song, and have pointed to changes in both *sêkêti*
and *papá* singing since the early twentieth century as examples. But until
musicologists analyze what information is available about the nature of changes

244.

244. Standing on a platform high above the ground, two
men fell a tree in an area they are clearing for a garden.

XX. Djuka "play" honoring snake gods

XXI. Djuka "play" honoring snake gods

since, for example, Saramaka *sêkêti* was first reported by travelers in the mid-nineteenth century (Cateau van Rosevelt and van Lansberge 1873:323–24), we can only indicate the existence of stylistic change in all forms of vocal music.[74] Regional and tribal differences in song style represent another fruitful area for future inquiry. While it is clear that the degree of difference between, say, the various Djuka and Saramaka song styles is as great as that between their styles of dress or woodcarving, insufficient descriptive work has been done among the eastern tribes to permit a systematic comparison.

Drums and Drumming

Drumming holds a preeminent place among the Maroon performing arts. Even the folk tale that recounts the original discovery of drums in the land of the devils is told in a form that presupposes that the main characters have the anachronistic knowledge of the centrality of drums in Maroon life:

> [Son to dying father:] The thing known as Drum—well, I've heard of it, but I've never seen it. Well, wherever Drum may be, I'll go get it to play at your funeral. Because, well, I've heard it said that the thing known as Drum is a very important thing for us Maroons.

In other words, it is almost as if it were impossible for Maroons to imagine a time when drumming did not exist. Unfortunately, however, details of drumming history are absent from the historical record. Eighteenth-century European documents frequently mention the importance of drumming—e.g. "[there was] a ceremony after their [Saramaka] fashion, with musket salutes and drumming" (Dorig 1763b)—but little is said of social context and nothing of style. While Maroon oral history also makes clear the importance of eighteenth-century drums—in rituals of diverse kinds, in signaling and in "speaking" proverbs at council meetings—material evidence about the early history of drum forms or of styles of drumming is largely absent. The Suriname plantation drums in Figures 239 and 245 represent the only relevant eighteenth-century depictions known to us.

Maroons classify drums not only by their form but also by the role they play in particular types of performance. For example, Saramakas refer to the kind of drum shown in Figures 173 and 246 as an *apínti* when it is played alone as a "talking drum" but as a *tumáu* when it takes on a specialized rhythmic role in the drum choirs which accompany women's *bandámmba* dancing and rites for warrior gods or forest spirits. The major Maroon drum forms are indicated in Figure 247.[75] Different drum choirs and particular styles of drumming mark each of a large number of specialized performance contexts—e.g., rites for forest spirits, snake gods, warrior gods or early ancestors; various stages of funeral rites; and a variety of secular settings (Figure 248). Each such style of drumming is specialized, sometimes involving formal apprenticeship, and the repertoire of pieces within each style is enormous and ever-changing. Even in the styles considered—for ideological reasons—least subject to change, such as the Saramaka *papá* drumming that is played throughout the climactic night of a funeral, there is significant development over time. The *papá* style of today's fifty-year-old masters is recognizably different from that of the oldest living generation of players, and Saramakas make clear that this has always been the case.

Most Maroon men acquire a basic proficiency in the most common drum rhythms, but—in contrast to most artistic talents—drumming is often spoken of as a natural "gift," and there is clear recognition of the "masters" in any village or region. Skill in drumming, as in other performing arts, brings a strong measure of prestige. A gifted drummer easily persuades the waiting gods and

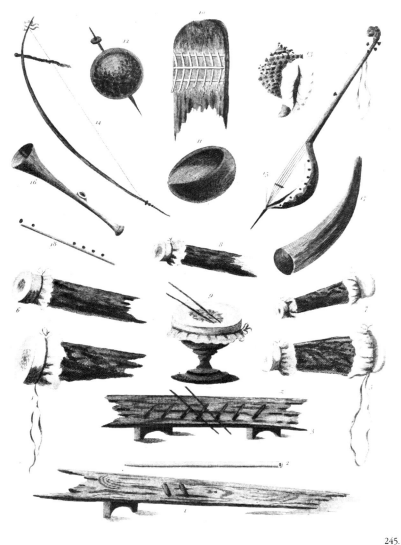

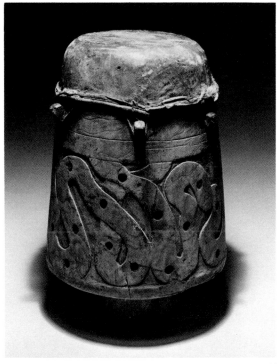

245. Musical instruments of Suriname slaves, 1770s

246. Paramaka drum, collected late 1920s, on the French Guiana side of the Marowyne River.

spirits to join villagers through possession; and he is rewarded with frequent congratulatory embraces from participants, as well as by food, liquor, cloth, and other gifts. While many drum styles are used throughout a region (e.g., Upper River Saramaka), others are restricted to particular villages. Regional differences in drumming style parallel those in the visual arts. Although, for example, a Djuka drumming style occasionally becomes fashionable for a brief period in Saramaka, differences in "tribal" drumming styles are as marked as are the linguistic differences between the groups.

The *apinti* is a "talking drum" used at major council meetings and at certain important rituals. (It is not unique in this speech function; the *agidá*, for example, communicates in similar paralinguistic forms, with the various kinds of snake spirits.) The *apinti* acts as a kind of town crier at certain community events. At Saramaka council meetings, for example, its rhythms officially open the proceedings; summon and greet particular gods, ancestors and public officials; comment on current events; help set the tone for the meeting through the imaginative use of proverbs; formally dismiss people at the end; and so forth. Saramaka oral traditions describe the use of *apinti* drums during the eighteenth century, and the "drum names" used at that time to summon important people to council meetings are still used to summon the spirits of those ancestors to rites today.[76] Each drum phrase can be transposed into a rhythm-

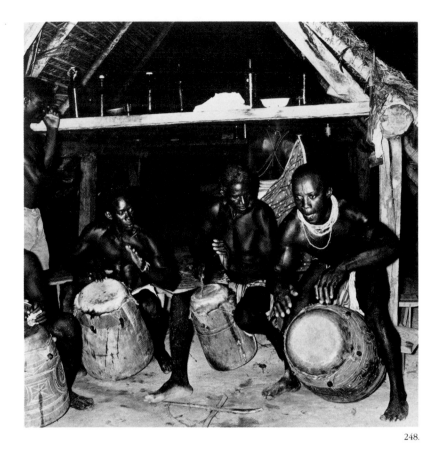

248.

247. Five Saramaka drum types: a) *apínti*; b) *deindein* (beaten with sticks); c) *agidá* (the principal drum at snake-god rites, played with one stick and one hand); d) *apúku doón* (the principal drum at rites for forest spirits); e) *lánga doón* (the principal drum at *papá* funerary performances).

248. Aluku drummers at a funeral rite (Jean Hurault, *Africains de Guyane*)

ically similar verbal form (either in one of several esoteric languages or in special *apínti* language), which is translatable into the language of ordinary speech. For example, the Saramaka *apínti* rendering of the proverb "Smoke has no feet, but it makes its way to heaven" is based on the rhythm of the proverb as expressed in the language of their *komantí* warrior gods (*Dabikuku misí améusu*) rather than its form in ordinary Saramaccan (*Simóko án a fútu ma a nángo a gádu*). "Good morning," which is simply "*wéki*" in everyday Saramaccan, on the drum becomes an elaborate rhythmic phrase which Saramakas verbalize in "*apínti* language" as *Keí keí dí día, kêtekeí dí día, kilinkilíng kidíng tjêkele díng tjêkeledíng díng díng díng*. . . . We give a transcription here of an actual *apínti* performance from the beginning of a Saramaka tribal council meeting in 1968. Spaces indicate pauses between phrases, during which one of two simple "holding" rhythms is played; brackets indicate Saramaccan translations for which we have no verbalized *apínti* equivalents. We do not indicate consecutive repetition of phrases. (For a recording of this performance, see R. and S. Price 1977.)

4"

247.

a.　　　b.　　　c.　　　d.　　　e.

Ting; tjêkele gín din gín din . . . gilíng	"Listen"; opening call
Asantí kotoko bu a dú okáng, kobuá, o sá si watera dján de, djantanási, dum de dum; kediamá kédiampon ódu a sáisi ódu a kêèmponu sasi naná bêtiè	Recital of the drum's "praise name," including words for its parts (wooden body, pegs, ties, head); call to supreme god and the earth
Opête nyán opête; sêmbè sindó gêde gêde gêde, sêmbè sindó gêde hía	Call to junior assistant headmen; remark that "many people have sat down"
Gídi gídi kúndu bi a kúndu; opête nyán opête; kokóti bái batí	Call to senior assistant headmen; call to junior assistant headmen; call to headmen
Kásikási têgètêgèdé	Call to senior women
Keí keí dí día, kêtekeí dí día, kilinkilíng, kidíng tjêkele ding, tjêkeledíng, ding ding . . . ; kilíbe tente, odú akásambile fu wán pandási; sekúinya ti sekúinya kata kái na tí sekúinya; [bégi]	Good morning; call to the Tribal Chief; proverb ("However great the problem, the Tribal Chief can take care of it"); prayer
Kediamá kédiampon ódu a sáisi ódu a kêèmponu sasi naná bêtiè	Call to supreme god and the earth
Kilíbe tente, odú akásambile fu wán pandási; alíbête benté, bébetiêbenté a falí; otíbilíbití tja ko bêèdjô; kilíng king diá keng dia kéng eti; kásikási têgètêgèdé; fébe tutú máfiakata bánta nási betê; [piimísi]; atupeteezú atuá petee zú ahuun wásikan djáni bobo; [piimísi]	Call to the Tribal Chief; proverb ("The water hyacinth floats downstream with the ebb tide, but the tide will bring it back up as well"); call for liquor; apologies to the elders; call to senior women; proverb ("When the mouth starts moving, hunger is afraid"); apologies (for anything bad that might have inadvertently been drummed); call to the "headmen of the river" (gods); apologies
Kokóti bai batí; asákpa a pênde, makáiya pênde; gídi gídi bú a fô	Call to headmen; call to two important ancestors
Ahála ba tatá gánda volabutan; Dabikúku misí améusu; [bégi]; [piimísi]; kokóti bai batí; kilíbe tente, odú akásambile fu wán pandási; ma in tênè, ma in tênè búa	Call to city officials; proverb ("Smoke has no feet, but it makes its way to heaven"); prayer; apologies; call to headmen; call to the Tribal Chief; proverb ("When a leaf falls in the water, it's not the same day that it starts to rot")
Tjaketeke [. . .] [piimísi]; [gaamá ku mása gaán gádu]; ding ding ding . . . , kokóti bai batí; ding ding ding . . . , gídi gídi kúndu bi a kúndu; gidi gidi bêeyo; ding ding ding. . . .	Proverb ("You can't measure your foot against the Tribal Chief's"); apologies; call to the Tribal Chief and supreme god; "The Tribal Chief is walking [coming]"; call to headmen; "The Tribal Chief is walking"; call to senior assistant headmen; call for food to be brought; "The Tribal Chief is walking"

Other Musical Instruments

In spite of the cultural preeminence of drums, Maroons have always used a variety of other musical instruments: some are combined with drums in prescribed ritual contexts; some are important solo instruments in specific settings; and others are played informally, purely for entertainment. Calabash rattles (Figure 219) and iron "gongs" have always been the most widely used accompaniments to drum choirs in specified rituals. For example, rattles play a central role in snake god, forest spirit, and warrior god rites (sometimes in accompaniment to singing without drumming); and gongs, usually composed of a metal hoe blade struck with an old machete blade, are an essential part of plays for warrior gods and *papá* performances.[77] Other more specialized instruments are associated with particular local cults; for example, the members of the Nasí clan are said to use a serrated wooden cylinder called a *gombí* or *kumbí* scraped with a second piece of hardwood, in certain rites.[78]

Wooden signal horns or trumpets (*tutú*), found today in only a few villages in Saramaka, were until recent times a ubiquitous feature of council meetings, funerals, and certain other public gatherings (Figure 249). During the wars they were used "to command advancing, retreating, &c." (Stedman 1796, II:287; Figure 245), and the European commander arriving on the upper Suriname River to seal the peace of 1762 was greeted "with blaring trumpet and beaten drum" (Dorig 1763b). During the eighteenth century, wooden trumpets were used for general celebration: "They are blowing *tutú*, some men have returned from the city" (Schumann 1778, s.v. *tutú*). Well into the early twentieth century, all important men (and some women) had a "horn name," which was blown on the horn to summon them to council meetings and important rites, particularly funerals. (A separate system of personal "drum names" has always been used, as we have seen, in many of the same contexts.) As with the *apínti*, horns not only called names but also spoke in proverbs, and older Saramakas are still able to give the verbal "translations" of certain horn phrases.[79]

Two other instruments, both of which are played solo and called *bèntá*, have been important for entertainment throughout Maroon history: the recently obsolete *gólu-bèntá* (gourd *bèntá* or *agbadó*), consisting of three "musical bows" inserted through a gourd, and the *papái bèntá* (split-reed *bèntá* or "finger piano"), made from four or five split reeds fastened tightly over two wooden bridges to a flat board (Figures 250–251 and see Figure 245 for an eighteenth century slave example). Both instruments are held between the knees; the first is plucked and the second played with the index fingers. The *bèntá* is a young man's instrument, played for individual pleasure and occasionally to entertain others. The gift of *bèntá* virtuosity is held to demonstrate an affinity with forest spirits, and it is said that some legendary players were able to walk on water across the river while playing. Like the rhythms played on the *apínti* and some other Saramaka drums, the *bèntá* plays rhythms that are "transformable" or "translatable" into verbal sounds. Some pieces imitate bird or animal calls, some comment on personalities or current events (much in the manner of *adunké* or *sêkêti* songs), some imitate rhythms played on drums, and others are used in children's games (to indicate, for example, whether the seeker of a hidden object is "hot" or "cold"). We cite as an example the verbal version of a *bèntá* composition which comments satirically on an event in the Saramaka village of Bofokule:

Djebikese kulé butá dí kándu	Djebikese runs to place the "protective charm"
Adombokui kulé butá dí kándu	Adombokui runs to place the "protective charm"
Djebikese kulé tí kangóti	Djebikese runs *tí kangóti* [sound of his running]
Djebikese tungi mi túngi	Djebikese runs *tungi mi túngi*
Djebikese tá séti bô	Djebikese sets up the bow [a particular type of "protective charm" in the form of a bow]

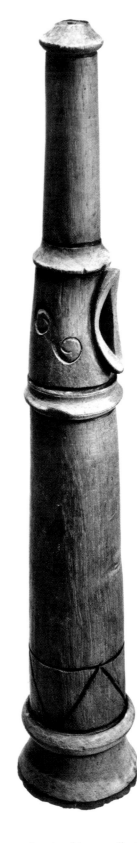

249. Saramaka wooden signal horn, collected 1928–29 in Dangogo.

The split-reed *bèntá* represents important continuities with the African past, in terms of its form, its association with forest spirits, and its imitations of other cultural sounds. Yet it is worth noting that the materials used to make it, the spirits with which it is associated, and the drum rhythms it imitates are distinctly Maroon rather than African. The *bèntá* represents, then, a good example of the ways in which Maroons adapted a widespread African form (along with its associated meanings), but at the same time transformed it into something very much their own (see Chapter 8).[80]

We know of still other instruments used at one time or another by Maroons, and there are undoubtedly others that have disappeared without a trace. Fife and drum music is reported as part of an eighteenth-century celebration (Staehelin 1913–19, III ii:198) and a Maroon "xylophone" was described in the early nineteenth century (von Sack 1810:82–83), but none of these instruments seems to have survived. Likewise, Stedman's eighteenth-century drawing depicts other instruments made by the "African Negroes" (apparently slaves)—a musical mouth bow called *benta*, a nose flute, a mouth flute, and others (Figure 245)— but we have no specific indications regarding Maroon use. The most interesting of all eighteenth-century musical instruments from Suriname is a calabash banjo, made by a slave and collected by Stedman in the 1770s (Figure 252). It represents, to our knowledge, the oldest extant banjo from anywhere in the Americas, and it is a fine example of the four-stringed instruments made and used at least since the seventeenth century by Afro-Americans in many parts of the hemisphere (see, for example, Epstein 1977:1–46; see also R. and S. Price 1979:131, 138).[81]

Finally, Maroons have always enjoyed novelty in music-making, as well as in their other arts. One of the rare eighteenth-century Saramaka converts to Christianity apparently became adept at playing a kind of French horn (Riemer 1801: Plate 8; Staehelin 1913–19, III ii:150); late nineteenth- and early twentieth-century Maroon visitors to French Guiana occasionally returned with concertinas that they had learned to play; and a set of Yamaha electric instruments recently imported to Upper River Saramaka has encouraged young boys to make and master wooden guitars that are excellent copies of the imported plastic and chrome models.

Proverbs, Riddles, and Tales

As we have already mentioned, proverbs are woven into everyday conversations, oratory, and prayer and are viewed as an enhancement of the beauty and power of any speech. Many proverbs can be cited both in the language of ordinary speech and in one of several esoteric languages.[82] Many are translatable into distinctive drum rhythms that are performed on the *apínti* "talking" drum and into musical forms that allow them to be played on wooden signal horns. Indeed, the ability to select proverbs appropriate to the particular issues under discussion in a tribal council meeting is seen as one of the most important skills of an *apínti* player. (For an illustration of this use of proverbs, see the transcription of an *apínti* performance given earlier in this chapter.)

Proverbs may be cited verbally in any of several conventional forms. They are occasionally spoken as full sentences ("If you don't poke around in a hole, you won't know what's in it"). Such statements are often preceded by a reference to the person, animal, or other being credited with the observation ("The elders say: 'Spider monkeys don't beget howler monkeys'" [Like father, like son] or "The lizard says: 'Speed is good, but so is caution'"). More frequently, the proverb is left half-finished ("If you don't poke around in a hole . . ."), in the expectation that listeners will complete it mentally themselves. In many cases, one or two key words from the proverb are cited in isolation, or an allusion is made to its characters or to the being traditionally credited with its invention. The simple mention of "*nóuna*," for example, recalls the lesson of a proverbial tale in which this nonsense word is used to protect secret

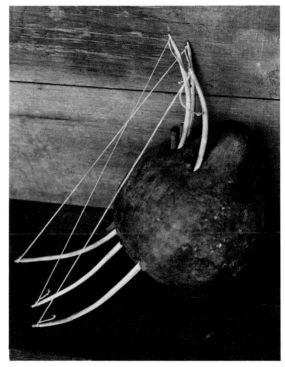

250.

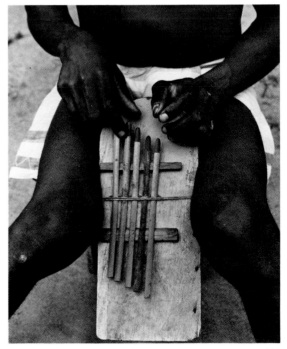

251.

250. Saramaka stringed instrument with gourd sounding box.

251. Saramaka split-reed finger piano

knowledge from discovery by outsiders (see R. Price 1979a). The phrase "the one about River Grass" communicates the moral of a proverb expressed, in its full version, in terms of a conversation between a certain fish and the vegetation in a rapids; and "The talk of Chicken" represents the wisdom of a proverb introduced as having originally been spoken by that fowl. These various types of proverbial allusions do not always represent proverbs of a specific conventionalized form, but are used also to refer to long folk tales, to so-called "dilemma tales," to well-known proclamations of living Maroon elders, or to any philosophical fragment that a person can expect a listener to have heard.

In contrast to proverbs, both riddles and tales are closely associated with funeral rites.[83] All-night wakes include the telling of riddles—posed and answered in rapid-fire succession—followed by many hours of long tales, which are offered by a number of different men and women. Each riddle and tale is preceded by a conventional call and response; the telling of a tale at a Saramaka wake, for example, begins when the narrator calls out "*Mató*" and a listener replies "*Tòngôni.*" Each tale is also "answered" every few phrases by a listener, and is "cut into" several times by abbreviated versions of other tales. Listeners interrupt with questions and personal reactions as the tale unfolds, commenting, for example, on how they would have handled situations differently if they had been there, asking about details the narrator has not mentioned, and so forth.

To illustrate the characteristic structure of such performances, we present a fragment of a riddling session and summaries of two tales, taken from Saramaka materials recorded in the late 1960s.[84] In the riddling selection, note that there tend to be sub-groups of riddles which exhibit a common form (those based on an imitation of a particular sound, those which refer to the speaker's father, and so forth); the whole string is told as quickly as possible, however, without pauses or other indicators of segmentation.

> —*Hílíti*
>> —*Dáiti*
> —A creek splits into twelve tributaries
>> —Silk-cotton tree [which has a long trunk topped with a complex branch formation]
> —*Hílíti*
>> —*Dáiti*
> —A single man at the prow of a ship headed out to sea
>> —Needle
> —*Hílíti*
>> —*Dáiti*
> —I make a house for myself. I paint the outside with green paint. I paint the inside with red paint. All the people who are inside wear black jackets.
>> —Watermelon
> —*Hílíti*
>> —*Dáiti*
> —Indian up high
>> —Awara [a tall palm tree with bright orange fruit]. . . .
> —*Hílíti*
>> —*Dáiti*
> —Two brothers go hunting. They see a tapir behind a stone. One takes a gun and shoots the stone, pierces it, kills the tapir. The younger one walks through the hole and takes the tapir away. The sister is back in the village boiling its liver and has it ready for them to eat when they return. Who is the cleverest one?
>> —The sister. . . .
> —*Hílíti*
>> —*Dáiti*
> —*Kolólo kolólo*
>> —Okra's gone from the plate [i.e., sound of the spoon scraping an empty plate]

252. A four-stringed calabash banjo made by a Suriname slave, collected in the 1770s by John Gabriel Stedman.

—Hílíti
 —Dáiti
—Tjobó tjobó
 —Dog swimming
—Hílíti
 —Dáiti
—Kalala kom
 —Poling stick [of a canoe] hits a rock. . . .
—Hílíti
 —Dáiti
—My father has a dog that barks from morning to night. It's never
 silent.
 —Rapids
—Hílíti
 —Dáiti
—My father has a jug. He loads it with water again and again. It never
 gets full.
 —Ants' nest

Maroons view the tales they tell at wakes both as repositories of moral wisdom and as a major form of communal entertainment. Although some tales (including the two summarized below) purport to chronicle the origins of local institutions, and tales are typically told in an exaggerated "eye witness" style, Maroons always clearly distinguish tales (Sar. *kóntu*, Ndj. *mato*) from historical knowledge.

Tale I. Long ago, there was an old man who had three daughters and three sons. Feeling that his time to die was drawing near, he summoned his children and asked them how they planned to honor him at his funeral. The oldest son said he would cry and cry for days. The oldest daughter said she would dance and sing until her voice gave out. The middle son planned to construct a magnificent coffin and supply great riches to distribute among the guests. The middle daughter would prepare a great feast. The youngest daughter said she would volunteer her sexual favors for every male guest, to assure that they would feel welcome. Finally, the youngest son offered to discover Drum, and to bring it back to play at his father's graveside. He had heard that the (*apínti*) drum was "an important thing for us Maroons," and vowed to make whatever journey was necessary to find it. The old man was indeed pleased.

Three days later, the old man died, and the children did just as they had said. The oldest son's crying was so loud that no one could hear anything else. The oldest daughter sang until her voice gave out, and then she drank an herbal mixture and started right in again.

> (Here, someone briefly interrupted the speaker, relieving his narrative with a fanciful description of a wrestling match between Squirrel and Mouse and a little song in the language of warrior gods. When he was done, he told the speaker to go on with his story, and the tale of the funeral continued.)

The feast prepared by the middle daughter was so lavish that no one in the village could eat another bite.

> ("Well, the man they were burying there was old Anasi's father-in-law," broke in another man, and he went on to describe how well Anasi [the spider] honored him at the funeral:) Anasi captured a little bird and had someone hold it until he was ready to dance. Quietly, he slipped the bird under the front of his breechcloth and began his dance, while the bird sang:
> *tjentjen tjeen kina-e,*
> *tjeintjein tjeein kina-o,*
> *tjeintjein tjeein, kina,*
> *tjeintjein tjeein, kina-e*

tjeintjein tjeein, kina-o
tjeintjein tjeein.

Everyone rushed to Anasi to congratulate him for his magnificent performance. The bird had already flown off. ("And while that little thing was chirping inside Anasi's breechcloth," broke in an old woman, "the Devil was right there, thinking about eating the [old man's youngest] boy." Her song, also in the language of warrior gods, was the Devil's rejoicing over the meal he was about to enjoy. The woman signaled the end of her interruption with a conventional phrase, and the principal tale was resumed.)

The beauty of the coffin and the quantity of goods provided were beyond belief, and the youngest daughter's house was turned into a veritable brothel. Meanwhile, the youngest son prepared for his journey by finding three parrot feathers, three cowrie shells, and three balls of kaolin. He walked along until he came to a river, but there was no way to cross.

> (Here, another woman interrupted, describing how Spider Monkey was watching the boy at the river's edge and sang a little song [in conventional "folk tale" language] about him. Then she passed the narrative back to the main speaker.)

Finally, a large cayman appeared and the boy arranged—in exchange for a payment of one feather, one cowrie shell, and one ball of kaolin—to be transported across on its back. The cayman also promised to be available for the boy's return trip.

> (The woman who had last interrupted broke in again: "I was standing right there when the cayman took the boy across." She sang the boy's song to the cayman—in the esoteric language known as *Púmbu*—and then turned attention back to the first speaker.)

The boy continued his journey, and was transported across two more bodies of water by two more caymans, providing the same payment to each. The last one offered detailed advice, describing the land of the devils which the boy was about to enter, and specifying exactly which drum would be safe to take. The boy did just as he was told and started back with the correct drum. But he was so struck by its beauty that he couldn't resist trying it out, and sat down to play a little song:

Kadím kadím mitólia,
Kadím kadím mitólia,
Sibamalé sibamalé,
Kadím kadím, mitólia.

This song was heard by the devils, who had been away at work, and they rushed back in a fury to punish the trespasser.

> (In the final interruption of the tale, a man declared that he had been present at the river's edge as the devils were imploring the cayman to drown the boy, and that he had witnessed another event there as well. He told, in kernel form, the story of a fish that dragged a canoe carrying a woman and her child down into a deep in the river, ending with a song in "folk tale" language and a conventional phrase that returned attention to the tale of the drum.)

The boy's return journey was filled with suspense. The devils were in desparate, violent pursuit and each cayman insisted on hearing the drum's song before taking the boy on its back. Just as final preparations for burial were being completed, the boy arrived back in the village. He played the drum at the head of his father's coffin, before it was finally carried off for burial. (The tale ended with an acknowledgment of the importance of the boy's journey for Maroon life and a conventional concluding remark: "That's as far as my story goes.")

Tale II. Long ago, it used to be that women lived in one village and men in another. No man had ever gone to the women's village and survived, but Anasi [the spider] was tempted to try.

> (Here, a man inserted an "eye witness" description, including a song, of a wrestling match between Turtle and Jaguar that occurred near where Anasi was standing.)

Anasi started out and soon approached the place where the women lived. There, between their village and the river where they got water, a giant tree had fallen across the path. Anasi hollowed out the trunk of the tree and bored a hole through the bark. Then he climbed inside, lay on his back, and stuck his penis (which had, meanwhile, grown to a considerable size) up out of the hole. It wasn't long before a woman came along the path on her way to fetch some water. As she stepped over the tree, she noticed that her buttocks were moving in a peculiar way, and that she felt a strong urge to linger. Later on, she told her sister about the strange sensation she had had and sang a song about the "sweetness" of the wood. Her sister wanted to see this tree for herself; once she had tried it, she could barely be pulled away. "What kind of wood is it that's sweet the way this wood is sweet?" she wondered aloud.

> (At this point a young man interrupted to state that he had been present at the time all this was happening.) In those days, a man was only allowed to have one wife. Anyone who had more would be punished by the Tribal Chief. Well, a man named Sokotilama defied the rule and took four wives, and the Tribal Chief summoned him to be judged and sentenced. (Here the teller made apologies to any of his mothers- or fathers-in-law who might be present, for the indelicacy of the subject, pointing out that during the telling of tales at wakes, normal rules of propriety are temporarily suspended.) The Tribal Chief addressed Sokotilama sternly, "Although you knew that no one is allowed to have four wives, you went ahead and took four wives. Well, show us how you screw all four at once! If you can, you'll be set free. If you can't, we will kill you!" (The teller then brought his story to a dramatic climax through a stylized dance. Holding a long stick in front of him, he showed how Sokotilama thrust once into each woman in turn, repeating the feat again and again, and accompanying his actions with a song. At the end of the song and dance, the speaker thanked Sokotilama, on behalf of all Saramaka men, for paving the way for future generations to enjoy more than one wife, and turned the performance back to the principal speaker.)

Back at the tree, Anasi worked his way through all the women until not a single one remained to be experienced. Time passed, and the first woman to have crossed the hollowed-out tree began to feel peculiar. Her belly hurt and her body didn't seem well. Then her sister and, finally, the others felt it, too, until every woman was in the same condition. They were bewildered and were sure they would die. Finally, the first woman gave birth to a daughter. She called her sister and said, "Look at this thing I've delivered! It's made just the way we are!" She was frightened at what had happened to her and wanted to kill the thing, but her sister dissuaded her. Soon her sister also gave birth, but to a boy. She noticed that it had something between its legs and, terrified of its unnatural form, wanted to kill it. But her sister persuaded her to wait and see what would happen. Soon all the women in the village had given birth, some to girls and some to boys; not a single one had a (recognized) father. The children grew up; and after a while the ones that were made like the women and the ones that were made differently began noticing each other. Nothing more really need be said about what happened after that; their work was all cut out for them. Anasi was pleased at having broken through the isolation of the two villages. And that's how this way of life began.

Any attempt to present the artistry and aesthetics of a people whose cultural understandings differ from our own involves special difficulties and responsibilities. One becomes, in a real sense, a spokesman for people who have not yet had the opportunity to speak directly for themselves. One must become a listener (which means having full command of the language) before becoming a lecturer, and make every effort to assure that the sense of the final analysis does not violate the sense which the people themselves make of their own artistic life. This means transcending, insofar as possible—both in the field and in the composition of a book—Western cultural assumptions about "art" and about "Third World peoples." In short, it involves a constant drive toward attaining, and then attempting to translate and interpret for a home audience, an inside view.[85]

From this perspective, much of what outsiders have written about the graphic and plastic arts of the Maroons is problematical. Both scholarly and popular commentators have consistently equated meaning with iconography (see, for example, Herskovits and Herskovits 1934:268–86, Hurault 1970, and Muntslag 1966 and 1979). Particular visual forms, according to this view, are directly "translatable" into such concepts as love, fertility, wealth, or death; and it is often argued that having once acquired a knowledge of these symbols, an outsider can (making some allowances for the artists' subjectivity) interpret the meaning of any design. Moreover, visitors to Maroon villages have vied with one another to "discover" sexual symbolism throughout the arts. Published reports clearly show that Maroons often objected strongly to the interpretive suggestions made by outsiders, but the visitors generally dismissed these protests as less perceptive than their own readings of the art. We would suggest that Maroons have understood very well what such observers want and what they are willing to pay for, and have often provided just that. In the late 1960s, for example, one woodcarver set up shop on the road between Paramaribo and the Suriname airport, bought a copy of Muntslag's recently published book on the "symbolic meanings" of Maroon motifs (1966), copied several of the designs onto each of his carvings, and simply referred tourists to the book for an "explanation" of what they had bought.

This chapter attempts to challenge some of this received wisdom about the overriding significance of iconography in the Maroon arts and to transmit some sense of the variety of ways in which Maroons themselves view, evaluate, and interpret their own artistry.[86]

Iconography and Representation in the Maroon Arts

In the Upper River region of Saramaka, neither iconographic nor representational motifs have ever had more than a very limited importance.[87] Saramaka men have occasionally carved human figures in conventionalized sexual positions, especially during the early twentieth century, but the very great bulk of Saramaka woodcarving as well as other artistic production has always been characterized by non-representational, non-iconographic design. In countless discussions of particular decorated objects with Maroons from this region, we were struck by the lack of attention to symbolic concerns. Exhaustive inventories of wooden objects in a number of houses showed, for example, that the very great majority of woodcarving designs are neither named nor conceptualized as being meaningful. Many "filler" patterns in woodcarving are named, usually after natural or manufactured objects (e.g., "lizard's teeth," "beach-chair frame") but these names are simply descriptive, no more nor less meaningful in terms of their symbolism than the term "herringbone" when applied to a tweed suit. Of the motifs or designs that *are* named, the great majority likewise carry no symbolic charge and are named *ex post facto,* almost always after an object they in some sense resemble (e.g., "tapir's hoof" or "monkey's tail"). These names, like those for woodcarving "fillers," play no role in the artist's choice of design or in Saramaka appreciation of the carving. The only Upper River woodcarving motif that is iconographic is infrequently used today—a more or less conven-

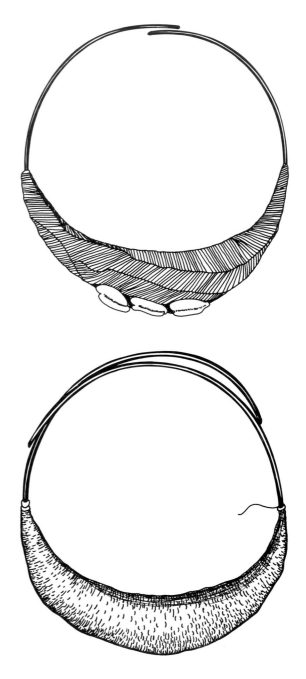

253. Saramaka arm-rings with protective powers; the casing stitches are known as a) "dog's teeth" and b) "cocoon."

tionalized representation of coitus known as "husband and wife" (Figures 126–127). In addition, carvers from this region frequently add one of a limited set of simple, conventionalized signs to a woodcarving upon its completion. Six of these signs transmit a message of love, two communicate thanks to anyone who compliments the piece, and six address specific curses to anyone who insults it.

The other arts of this region offer an even stronger case against the pervasiveness of iconography. While the naming of designs is common, their use on a cloth or calabash in no way implies the intent to communicate a message. We have seen, in Chapter 3, both the importance and the lack of symbolic charge in Saramaka cloth names, and the same situation exists in regard to decorative embroidery stitches and patchwork patterns. Such common names as "herringbone" (Sar. *helen bónu*) and "sawtooth" (Sar. *sán tánda*) simply represent convenient descriptive labels for V-shaped embroidery stitching and a triangular patchwork pattern. Two casing stitches for protective armrings are known as "dog's teeth" and "cocoon" (Figure 253). Likewise, women's calabash designs are frequently named, but always after a form that inspired them or to which they are retrospectively likened—for example, "around the head" (after a circular pattern of hair braiding with the same name) (Figure 264); "house gable" (two bands forming an angle like that on a housefront) (Figure 212b); and "embroidery markings" (after the women's free-form embroidery style that inspired this common design) (Figure 254).

Finally, some objects in Upper River Saramaka display a single "mark" somewhere on their surface. Women make clear, however, that the scratched-in marks they place in "free" areas of a calabash design or on the edge of the bowl's exterior surface (most commonly a simple X, H, or V) (Figures 254–255) are neither named nor viewed as signs, but are intended rather as marks of ownership. Women who readily confirmed the meanings of the limited conventional signs sometimes added to finished woodcarvings vehemently denied any equivalent possibilities for calabashes; "We don't know how to write our names, so we just put a 'number' on, to prevent it from being stolen." Their claims find support in the fact that those few women who have recently learned to write their names sometimes inscribe these, instead, on the calabash's exterior (Figure 255). Clothing, too, is often marked by women with small embroidered Xs, Vs, and other simple shapes (Figure 93). A wife of the Saramaka Tribal Chief once called a particular skirt to our attention, showing us how the raised mark would allow her to identify her own skirt "even in the middle of the night." Pots and pans are commonly embellished with scratched-in marks or with shiny red tape; though these are often appreciated from an aesthetic viewpoint, their primary purpose is always said to be identification.

Among the eastern Maroons, iconography plays a similarly limited role in the arts, through representational designs and conventionalized signs are more common than in Saramaka. Designs representing animals and humans have long played a role in the arts of the Djuka, Aluku, and Paramaka. Lizards, snakes, birds, and human forms are common woodcarving motifs (see Chapter 4), and such animals are occasionally depicted on Djuka men's caps as well (Figure 256). The only modern example of representational calabash carving that we have seen comes from Paramaka (Figure 210). The existence of such recognizable depictions should not, however, be equated with iconography. That is, the designs do not normally stand for abstract ideas; they are created simply for aesthetic enjoyment.[88]

Since the beginning of the twentieth century, the eastern Maroons—apparently because of increased exposure to the idea of literacy—have developed both an indigenous system of writing and a separate pool of conventionalized signs used on woodcarvings.[89] The so-called "Djuka-" or "Afaka-script" of the early twentieth century was never used decoratively, however, and it is relevant to the arts only because its genesis and use reflect motivation similar to that influencing the contemporaneous development of conventionalized signs in

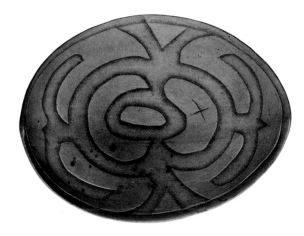

254. Saramaka calabash bowl, carved 1950s–60s by Keekete, Asindoopo.

eastern woodcarving.[90] Conventionalized signs were already well developed among the eastern Maroons by the 1920s, when Kahn reported:

> If some of the pieces are examined closely, it will be seen that they have odd symbols, apparently placed at random, not conforming to the general pattern of the piece. These marks represent personal messages from the giver to the recipient, special indications or signs of affection, comparable to the marks at the end of Victorian *billets doux* indicating the place to kiss [1931:200].

Hurault describes the identical use of conventionalized signs among the Aluku in the 1950s, though he stresses their dynamic character.

> There is an increasing tendency to express through signs, which constitute a rudimentary synthetic language, intentions, desires, and even jokes and insults.... [This system] is constantly evolving, since it represents an activity confined to youths, like the creation of play languages ... or songs [1970:91].

Such conventionalized signs have generally been restricted to men's woodcarving, and even at the height of their popularity have constituted only a small proportion of eastern Maroon design vocabulary, usually being placed on carvings after the central design has been completed. The disproportionate interest of outsiders, particularly tourists, in the "meaning" of these conventionalized signs has encouraged their proliferation on objects carved expressly for sale. Indeed, the publication and commercial success in Suriname of a badly misinformed book devoted largely to the "translation" of such signs has lent further encouragement to their growing predominance on commercial carvings (Muntslag 1966, 1979).

In sum, then, the arts of the eastern Maroons contrast with those of the Saramaka in their more frequent use of representational designs and conventionalized signs; but neither of these features in any sense dominates the art on objects produced and used within eastern Maroon villages. Only a small proportion of eastern Maroon objects contain representational designs, and conventional signs are confined to a limited use in the single medium of woodcarving.

The Emperor's New Clothes

Given the limited importance of iconography and naturalistic representation in Maroon arts, the preeminent place these have been given in writings on this subject deserves some explanation. A brief discussion of how the myth of pervasive Maroon symbolism developed may also contribute to our understanding of the ways in which Maroons themselves view their arts. We would suggest that a process something like that described in the European tale of the "Emperor's New Clothes" is largely responsible for the tendency to see Maroon symbolism where it simply does not exist, just as the Emperor's subjects marvelled at the beauty of his new clothes while he paraded through the streets stark naked. Several influences have combined to produce this syndrome: outsiders' conceptual expectations regarding the nature of "primitive arts"; Maroon attitudes toward writing and literacy; a confusion by outsiders between design names and iconographic meaning; field methods which have tended to favor these misunderstandings; and Maroon ways of dealing with non-Maroon visitors to their villages.[91]

On a conceptual level, certain Western ideas about so-called "primitives" and certain Maroon ideas about literate peoples have been mutually reinforcing. The cherished misconception that the arts of "tribal peoples" are invariably intended as "symbolic" statements—most often of a sexual or religious nature— has prevented many outsiders from accepting Maroon explanations of their art

and has inspired them to "force" artificial interpretive statements in the field. Maroons, in turn, have always had a very real respect for the power of writing and believe on an abstract level that any marking at all may carry a message, if only one knew how to read it. This almost mystical belief in the power of writing was undoubtedly involved in the invention of Afaka's "Djuka script" (see above). It also explains why Maroons use totally blank calabash bowls in ritual contexts; they reason that a bowl with the usual decorative markings might convey an inappropriate message that would offend one of the spirits in attendance, and that since they do not know how to "read" the markings, it is safer to use a blank calabash. Western notions about "primitive symbolism" and Maroon notions about their own position as illiterate people in a literate world thus work together to foster an interpretation of Maroon art that comes from outside Maroon culture, not from within. Many Maroons, not surprisingly, have acquiesced to their visitors' insistence on symbolic meaning; and those who have not acquiesced have generally enjoyed only a short career as ethnographic informants.

Furthermore, the names by which Maroons refer to designs or decorative techniques—in woodcarving, calabash decoration, embroidery, and so on—have often been misinterpreted by outsiders as iconographic explanations. We have seen in previous chapters that while Maroons enjoy creating and using names in their arts (as well as for commercial imports, for people, for places, and so forth), they only rarely interpret their named designs and techniques (except to outsiders) as implying messages such as "jealousy," "cooperation," "purity," or "fidelity" (Muntslag 1979). The subtle problems of distinguishing names from "symbolic meanings" and of understanding the ethnographer's own influence upon what he or she is told by members of another society are certainly not limited to the study of Maroons. Venice Lamb, a leading authority on West African textiles, has politely criticized R. S. Rattray, the prolific student of early twentieth-century Asante society, for asserting "that some cloth patterns are clan insignia rather like the Scottish tartans" (Lamb 1975:136). She suggests that

> in his quest for clan symbolism in Asante cloth, Rattray was giving way to his own national predilections, a rare event for such an objective student of Asante life and manners.... The desire to attach names and meanings to art forms is as powerful in Africa as elsewhere, and one cannot help feeling that it is possible to read more into these patterns than was originally intended. The weavers, particularly when being subjected to questioning by an outsider, may well feel under some obligation to construct meaningful stories and legends to explain abstract patterns which in themselves are really just beautiful examples of textile design [*Ibid*].

Other inferential field methods have further contributed to the misunderstanding of meaning in the Maroon arts. In many cases, Maroon explanations have been bypassed in favor of the observer's own interpretation of form. Hurault confidently claims to have "establish[ed] with near certainty the meaning and value of a large number of [Aluku] motifs" for which Maroons offered no "symbolic" interpretation, by his own classification (on the basis of form and patterns of grouping) of the motifs on more than four thousand objects and photographs (1970:93–94). Other observers who *were* given Maroon interpretations have tended to reject these in favor of their own free associations. Van Panhuys writes of a design on a paddle that "without doubt" depicted

> a human form, *even though* the Bush Negroes explained to us only that [it included]...the moon or else...a spindle...and a parrot's tongue [1928:232–33, 248, our italics].

Elsewhere he described another design as

255. Identifying marks on the exterior of calabash bowls

256. Djuka draw-string cap with ties, collected before 1881. Double thickness of white cotton cloth with navy appliqué and some embroidery.

256.

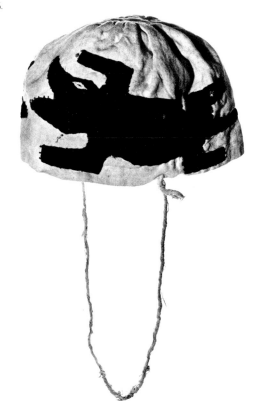

a naked man, wearing on his head *what my informant thought to be perhaps* the rib of a boat, *but what is, in reality,* a bonnet.... This figure *without doubt* represents a ... red-cap soldier, belonging to the Negro soldiers who were formerly employed in the fights with runaway slaves [1930:731, our italics].

This cavalier attitude to Maroon interpretation again appears in the explanation of the symbolism of a food-stirrer. He describes how Abjensi, his informant, though prodded,

> could give no other explanation than that there were perhaps two parrot tongues in it ..., with lines around them. But [van Panhuys continues] if we place the drawing upside down as is done in our illustration, we presume the whole represents a candlestick, such as there are in our collection [1930:732].

What little has been written on Maroon arts other than woodcarving reflects the same reluctance to take no for an answer when iconographic meaning is in question. De Vries-Hamburger, for example, insisted that a decoratively embroidered cloth hanging in the doorway of a house in a Christian Maroon village must have a secret "pagan" meaning (which it clearly did not).

> On inquiry concerning the meaning of this [the central] motif, no one gave a direct answer. The women of the village ... answered: ... 'a flower.' As this response was not very enlightening, a very old man was asked. His unsatisfactory answer was the same, 'a flower.' Obviously, people considered it inappropriate to clarify the meaning of this private decoration to foreign visitors, especially when it referred to religious beliefs that were no longer (openly) professed [de Vries-Hamburger 1959:109].

The Herskovitses, though much more sophisticated, were nevertheless not entirely free of such biases. Beginning with a conviction that Maroon art carried explicit symbolic associations, they were undaunted by the fact that "we were entirely unsuccessful in obtaining a single explanation of design during our first visit to these people" (Herskovits 1930:160). A close reading of their accounts of how they finally elicited symbolic analyses from Saramakas, during their second several-week visit, suggests that their informants were often merely agreeing to interpretations that the enthusiastic investigators themselves offered (see Herskovits and Herskovits 1934:276–86).[92]

Finally, Maroons have developed to a high art the game that slaves in many parts of the Americas referred to as "puttin' on ole massa." For example, Saramakas serving as informants for government workers mapping their territory have provided Saramaccan obscenities as village names, and these have been dutifully entered onto official maps. They have taken similar pleasure in telling unsuspecting census takers, when asked, that their mother's or father's current "address" is the village of Paasitonu (a local cemetery). The interpretation of their arts offers similar opportunities for creative responses. One Saramaka, for example, produced an explication for van Panhuys that suggests this kind of imaginative play:

> On the top of the doorposts are carved two upside-down monkey heads, then one sees a Western woman [*femme du pays des blancs*], who has ... [do these dots imply hesitation?] the head of a monkey [1928:232].

Almost defensively, van Panhuys added that his informant knew him and received him amicably; but then he noted, ingenuously, that the man seemed particularly "proud" of his explanation—as well he might! (*Ibid.*).

In many ways, the "Emperor's New Clothes" seems an apt metaphor for the history of studies of meaning in the Maroon arts. Like the Emperor and his subjects, outside visitors and Maroons are in a vastly asymmetrical relationship

of wealth and power. Like the Emperor, outside visitors have been afraid of appearing ignorant; and in both cases, the result has been the creation and public maintenance, in interactions between the two parties, of a tenuous fiction. The main difference between the two cases is that although some Maroons have tried to play the part of the innocent child in the crowd who sees through the fiction and cries out that the Emperor is naked, their protests have consistently been rejected.

Kinds of Meaning

We have argued throughout this book for listening seriously to what Maroons themselves have to say about their arts, to one another as well as to outsiders. Our aim is not to compile a dictionary of iconographic motifs which force Maroon arts into our own terms, but rather to build an understanding of these arts in their own social and cultural contexts. In earlier chapters, we have sought to convey, whenever possible, Maroon perceptions about their arts. From this perspective, for example, the presentation of finely carved calabash bowls for a husband's meal or the "dressing up" of a woman's house with lavish displays of carved calabashes have been seen to contribute more importantly to the ways in which Maroons conceive of calabash art than the etymologies of such designs as "turtle penis" or "monkey's tail." More generally, we have suggested that, for Maroons, the meaning of any artistically designed object involves a complex integration of aesthetic, technical, functional, iconographic, historical, and social considerations.

As we have seen, aesthetic discussion and commentary are common, focusing on such qualities as symmetry, color contrast, curvature, and so forth. Technical detail is also of great concern: women who disparage the asymmetrical patchwork designs made by their mothers' generation are lavish in their praise of the tiny, even stitches with which these cloths were sewn; and in many arts, the option of having a design "marked" by one person and executed by another often leads to lively discussions of technical skill as an aesthetic variable. Maroons pay special attention to an object's functional condition as well: cracked calabashes are routinely thrown away or used to bail a canoe; combs with broken tines are frequently discarded; and, in the absence of special personal associations, torn textiles may be used as rags, regardless of their beauty. Some objects (though, as we have seen, a distinct minority) contain designs that carry iconographic meaning, often of a sexual nature. But most of the names for designs on Maroon objects are not "meaningful" in this sense and serve rather as the basic terminology with which Maroons discuss certain features of form. Maroons also view an object in terms of its general historical and cultural context, associating technical and aesthetic features with the particular tribe, region, or village where it was made and the historical period it represents. Finally, as we have seen, the most important aspects of an object's meaning to a Maroon are often its personal associations. An object is thought of in terms of who designed and made it, for whom, and for what occasion; and this, in turn, influences its current and future use—e.g., who can sit on a stool and in what circumstances, the selection of an appropriate tray to offer food to particular ancestors, or the choice of cloths to be placed in a person's coffin before burial.

Our belief in the importance of "ethnoaesthetics" is one of the two guiding principles that have structured this book. It is based on the conviction that the arts of any people are first and foremost their own, and that we enjoy them as privileged guests. It also implies that the more we understand how a people create, evaluate, and use what we call their "arts," the more our own appreciation of these arts will be deepened and enriched. Our second guiding principle has been that a full understanding of the arts, like any other aspect of culture, rests in part on historical interpretation. It is to the integration of the various historical processes discussed in previous chapters that our final chapter is devoted.

8 CONTINUITY-IN-CHANGE:
African aesthetics and Afro-American dynamism

In the previous chapters, we have picked up the story of the development of most artistic media at some point between the late eighteenth and late nineteenth centuries, when we first find either descriptions by outsiders or datable objects themselves. In this chapter, we will adopt a broader historical perspective, looking back to the very beginnings of Suriname Maroon societies and considering change and continuity over their entire three-hundred-year history. We will draw some general conclusions about the various processes of dynamism and change that have been described medium-by-medium in previous chapters and explore the nature of long-term continuities in the arts. Because the chapter is lengthy, the argument complex, and our conclusions at odds with much previous scholarship, it may be useful to lay out briefly the path we will follow.

We begin with a discussion of the initial process of culture-building by newly arrived Africans from a diversity of Old World societies, and then examine the unique cultural synthesis that had emerged in the Suriname rain forest by the mid-eighteenth century. We next review developments in the arts since that initial synthesis, first in terms of individual media and then by identifying more general processes of change. The final half of the chapter is devoted to an assessment of Africa's cultural legacy to the Maroons. We review and criticize previous attempts to identify the African contribution to Maroon arts on the level of form, and then—stressing historical process and drawing on materials from previous chapters—present an alternative assessment of the nature and richness of the African legacy. By addressing the whole broad sweep of Maroon art history, this chapter makes explicit our studied conclusion that the arts of the Maroons represent a unique balance of continuity-in-change that makes them, in the fullest sense, Afro-American.[93]

The Development of Maroon Arts

The Early Years[94]

One of the most notable features of the initial groups of escaped slaves that coalesced in the Suriname forests was their cultural heterogeneity. Each such group was composed of Africans from a large number of ethnic ("tribal") and linguistic backgrounds, many of whom had been slaves—for varying periods of time—on a particular plantation in coastal Suriname.

Some idea of the ethnic diversity of the Africans transported to Suriname can be gleaned from the lists of "nations" of origin used by Suriname planters to classify their slaves. At least fifty are mentioned in colonial sources; and labels commonly used by planters, such as "Kongo" or "Koromantee" (the first taking in a vast and ethnically diverse kingdom, the second denominating a port through which people of quite varied ethnic origins were shipped), in fact lump together slaves who had very different cultural backgrounds. Table II illustrates the remarkable geographical spread of the African ports of shipment for Suriname slaves (see, for further details, R. Price 1976:13–16). In Suriname, the cultural heterogeneity of the African labor force was further maintained as a matter of deliberate policy. For reasons of security, planters—using a divide-and-rule strategy—routinely separated newly arrived shipments of slaves

> not putting any two in one Lot, because they would [i.e., wished to] separate 'em far from each other; nor daring to trust 'em together, lest Rage and Courage should put 'em upon contriving some great Action, to the Ruin of the Colony [Behn 1688:166].

In addition, during the first hundred years of the colony's existence, other local management practices further encouraged Suriname slaves to orient their allegiances in New World rather than African directions. For example, planters routinely refused to break up slave families by selling members to different masters, and made it a practice (for business rather than humanitarian reasons)

to avoid separating mothers from children, or husbands from wives. Suriname plantation slaves were, in effect, considered to belong to the soil, and were to be sold, not as individuals or even as family groups, but only when the estate itself changed hands (and even then efforts were made to keep the whole group together on the old plantation). Two consequences of these practices were the rapid development of extended localized kinship groups among the slaves, and strong ritual attachments between slaves and their particular locality. Indeed, not only did the slave force of each plantation soon develop a distinctive character and identity (many, to cite but one example, possessing their own easily recognizable style of drumming), but its members addressed each other with the special term, *sibi*, which had originated as an address term for Africans who had shared passage on the same slave ship.

Early Suriname plantations (which were quite large by comparative standards) were, then, the matrix for a rapidly developing Afro-American culture, including a new Afro-American language, a new religious synthesis, and so on. The high mortality of slaves and the severe repression of the local plantation regime brought in their wake the need for unusually high levels of new labor imports from Africa. This meant that at any time during, say, the first hundred years of the colony's existence, more than 90% of plantation slaves were African-born, over half had arrived in Suriname during the previous decade, and a third had left Africa only within the previous five years. Those slaves who marooned ran off individually or in small groups more often than in large bands, but they usually regrouped in the forest with fellows from the same or neighboring plantations. Their new communities were largely constituted, then, of people who were African-born, from a wide variety of societies, and who had varying degrees of exposure to plantation society and culture, depending on the amount of time they had spent in the New World.

The early bands of Maroons confronted challenges of remarkable complexity. In a harsh and hostile environment, pursued relentlessly by enemy troops, they were faced with nothing less than the task of creating a whole new society and culture. Let us consider briefly the cultural resources they brought to this task.

Table II. African Provenience of Dutch Slaves

	1640s–1700	1701–1725	1726–1735	1736–1795
Windward Coast	—	—	*4%*	*49%*
Gold Coast	*2%*	*17%*	*29%*	*26%*
Slave Coast	*64%*	*50%*	*33%*	*1%*
Loango/Angola	*34%*	*33%*	*33%*	*24%*

NOTE: For present purposes, these four areas are defined as follows: The "Windward Coast," which stretches from just south of the Gambia all the way to Assini, corresponds to the coastal regions of the modern states of Guinea-Bissau, Guinea, Sierra Leone, Liberia, and Ivory Coast (and thereby encompasses Curtin's [1969] "Sierra Leone" and "Windward Coast" areas). Our "Gold Coast" is roughly coterminous with modern Ghana, stretching from Assini in the west to the Volta in the east. Our "Slave Coast" corresponds to the coastal regions of present day Togo and Benin. Our "Loango/Angola" stretches from Cape Lopez south to the Orange River (corresponding to Curtin's "Central Africa" region), with the Dutch trade focused on the area between Cape Lopez and the mouth of the Congo. The figures in Table II were originally calculated for R. Price 1976; ongoing research based on Postma 1976 and archival sources will soon permit a more nuanced understanding of the African origins of Suriname slaves (R. Price n.d.2).

First, the members of a Maroon band cannot be said to have shared any particular African culture. Although most of them had spent their formative years in Africa, they came from a bewildering variety of ethnic groups, spread across the whole of West and Central Africa. Except in very limited realms, then, such individuals were in no position to try to carry on their specific cultural traditions, which would have differed substantially from those of their fellows. In other words, immense quantities of knowledge, information, and belief must have been transported to Suriname in the minds of the enslaved Africans; but they were not able to transfer the human complement of their traditional institutions. Members of tribal groups of differing status, yes; but different status systems, no. Priests and priestesses, yes; but priesthoods and temples, no. Princes and princesses, yes; but courts and monarchies, no. In short, the personnel responsible for the orderly perpetuation of the specific institutions of African societies were not transferred intact to Suriname. Thus the organizational task facing the newly escaped slaves was that of creating institutions—institutions that would prove responsive to the needs of everyday life in a hostile, largely unfamiliar forest environment.

Second, the members of each band did share at least some familiarity (depending upon the length of their stay on the coast) with the newly developed culture of Suriname slaves. This shared cultural core—which had been developed on plantations by Africans interacting with one another as well as with Amerindian fellow sufferers and with Europeans—formed an important common base on which Maroons would later elaborate their own way of life.[95]

Finally, early Maroons—though they did not share any particular African culture—did share certain general cultural orientations that, from a broad comparative perspective, characterized West and Central African societies as a whole. In spite of the striking variety of sociocultural forms from one African society to the next, there existed—we believe—certain underlying principles and assumptions that were widespread: ideas about social relations (e.g., what values motivate individuals, how one deals with others in social situations, the complementarity and relative independence of males and females, and matters of interpersonal style); ideas about the way the world functions phenomenologically (e.g., ideas about causality, how particular causes are revealed, the active role of the dead in the lives of the living, and the intimate relationship between social conflict and illness or misfortune); and broad aesthetic ideas (which we discuss below). We would suggest that these common orientations to reality would have focused the attention of individuals from West and Central African societies upon similar *kinds* of events, even though the culturally prescribed ways of handling these events may have been quite diverse in terms of their specific form. To cite a simple example: the Yoruba "deify" their twins at birth, enveloping their lives and deaths in complex rituals, while the neighboring Igbo summarily destroy twins at birth; but both peoples may be seen to be responding to the same set of underlying principles having to do with the supernatural significance of unusual births.

From the perspective of any early Suriname Maroon group, these deep-level cultural principles, which would have been shared by the ethnically diverse Africans who were its members, would have represented a limited but crucial cultural resource. They could serve as a *catalyst* in the process by which individuals from different societies forged new institutions and provide frameworks within which new cultural forms could be developed.[96] As we have seen, the process of culture-building by Maroons involved contributions by individual Africans with unique cultural knowledge, who shared a general openness to new cultural ideas and a firm commitment to forging a new way of life together, as well as a familiarity with plantation culture and certain more abstract, generally unconscious, understandings that were part of a generalized African heritage. A hypothetical example may help illustrate how this process could have unfolded.

Let us imagine that one of the women in an early Maroon band gives birth

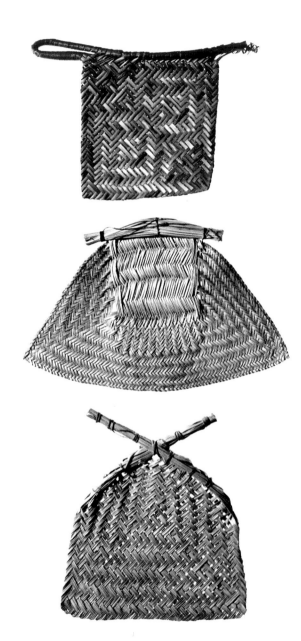

257. Fire fans, known by Saramakas as *balúma wawái, ingi wawái* and *alidja wawái,* respectively: a, c) collected 1968 in Dangogo; b) collected 1971 on the Tapanahoni River. (See Note 95.)

to twins (or becomes insane or commits suicide or experiences any one of a number of events that would have required *some* kind of highly specialized ritual attention in almost any society in West or Central Africa). It is clear to all that something must be done, but our hypothetical mother of twins has no special expertise herself, nor does anyone of her own ethnic background in the group. However, another woman, one of whose relatives may have been a priestess of a twin cult in another part of Africa, takes charge of the situation and performs the rites as best she can remember them. By dint of this experience, then, this woman becomes *the* local specialist in twin births. By performing the special rites that would be necessary if the twins should sicken or die, by caring ritually for their parents, and so on, she may eventually transmit her specialized knowledge (which represents a fairly radical selection and elaboration of what her African relative's cult had been) to others, who themselves carry on (and further elaborate) the new knowledge, as well as the associated statuses and roles.

The result of such processes and events, multiplied a thousandfold, was the creation of societies and cultures that were at once new and immensely dynamic. African in their overall tone and feeling, they were nonetheless wholly unlike any particular African society. The governing process had been a rapid and pervasive inter-African syncretism. The cultural synthesis which had emerged by the mid-eighteenth century in the Suriname forests (and which is visible to us through contemporary missionary and government documents) was surprisingly full-blown and "mature." When we consider the subsequent two centuries of Maroon cultural history, we are struck by a strong sense of continuity on this level of fundamental cultural principles, in spite of the existence of considerable surface change. From this earliest period of Maroon cultural formation, "continuity-in-change" seems a key theme. Let us now turn back to the arts to examine the way these general cultural processes influenced their development.

In spite of marked differences of form between the arts of one West or Central African society and the next, a large number of fundamental aesthetic ideas were widespread in the region—ideas about the human body as an aesthetic form, notions about rhythm (in music, speech, and the visual arts), expectations about dynamism and change in the arts, ideas about the relationship of performer and audience, the notion of multimedia "plays," and so on. Indeed, aesthetics is one of the areas of life for which the hypothesis of a widely shared African set of fundamental assumptions can probably be most persuasively argued (see, for example, Armstrong 1971; Lomax 1970; Szwed and Abrahams 1977; and Thompson 1966, 1974). Moreover, certain aspects of the horrendous experience of enslavement and transport tended, as we have seen, further to reinforce or emphasize selected features of this broad African aesthetic—the stress on individual style and dramatic self-presentation, the openness to new ideas, and the valuation on innovation and creativity (see Chapter 3).

Out of these shared African aesthetic orientations and common New World experiences, then, emerged a new, uniquely Maroon cultural synthesis; and this emergent synthesis, already perceptible in the earliest accounts of Suriname Maroon culture, has shown strong continuity throughout the succeeding centuries. Having referred to the essential features of this synthesis many times in previous chapters, we simply list them here: an emphasis on personal style, a dramatic concept of the self, and a generally "expressive" style of life; a strong appreciation of individuality and individualization; a love of novelty, innovation and creative playfulness, and an expectation of constant change and development in artistic forms; aesthetic ideas about the human body, such as the importance of the calves (as seen in calfband styles and the importance of bright clothing in the calf area) or the special appreciation of certain tactile aspects of sex (as seen in cicatrization and women's beaded "wrestling belts"); widespread structural features concerning rhythm—syncopation, polyrhythms,

interrupted symmetry; specific notions about color contrast and its importance; ideas about formal balance and symmetry; and a set of ideas concerning the relationship of names and things and the nature of meaning in the arts. This complex of features, which had already emerged by the eighteenth century, constitutes the central *continuous* force in subsequent Maroon art history.

From the Eighteenth to the Twentieth Centuries

The emergence of the visual arts was not contemporaneous with this initial synthesis of aesthetic ideas, but came considerably later. The main lines of this emergence have been traced in previous chapters, and we simply review them briefly here.

From the very first, Maroon men fashioned objects in wood. Using axes, machetes, knives, and other tools, they built houses and canoes and shaped mortars and stools; but all evidence points to an initial absence, or extreme poverty, of decorative embellishment. Both the internal evidence of stylistic and technical development seen in museum objects and the absence of comment on decorative woodcarving in the extensive documents on eighteenth-century Maroons strongly suggest that decorative woodcarving began to develop only during the first half of the nineteenth century, and underwent a striking efflorescence and evolution during the succeeding hundred years.

Textile arts followed a parallel course. Some sewing was done from the first, and needles, as well as red, blue, and white thread, were among the items that Maroons insisted on receiving as a condition of the treaties. Yet neither eighteenth-century descriptions and depictions nor extant examples of early Maroon clothing suggest that women engaged in decorative sewing, as opposed to hemming and seaming. The art of embroidery seems to have emerged toward the middle of the nineteenth century. By the end of the century, this art was technically and aesthetically highly developed, and it has continued to evolve stylistically right into the present. Moreover, toward the end of the nineteenth century, a new textile art emerged, built on the juxtaposition of small pieces of cloth to form a composite whole. Patchwork textiles soon developed into one of the most vibrant forms of Maroon artistic expression, moved through a series of extensive stylistic changes, and were finally abandoned during the 1970s.

Calabash carving presents a somewhat more complex picture, and must be considered in terms of both the external and the internal decoration of the shell. Until well into the nineteenth century, calabash decoration—like almost all "calabash" art in Africa[97]—was limited exclusively to the fruit's exterior surface. The earliest examples combine geometric shapes and representational figures in a style reminiscent of several African models. Although in many cases we cannot be certain whether these early examples were carved by Maroons or by plantation slaves (or whether the carvers were African- or Suriname-born), it is clear that this style was at least known to Maroons. By the mid-nineteenth century, when the arts of Maroon woodcarving, embroidery, and cicatrization were in their infancy, this "African-looking" style of calabash carving seems to have been abandoned and two totally new modes of decoration were taking shape. The first was the rigidly geometric, non-representational style with which men embellished the exteriors of two-piece calabash containers; beginning with simple arrangements of concentric arcs and circles executed with a pair of compasses, this style gradually evolved into the complex, textured designs which Maroon men have been making throughout the twentieth century. The second was a revolutionary use of the fruit's interior surface; a new technique which utilized broken glass (rather than knives or chisels) was joined with a design style based on roughly symmetrical arrangements of curved bands and soon became a central medium for Maroon women's artistic expression. By the late nineteenth century, the main lines of men's and women's calabash arts were firmly established and—aside from regional differences in the definition of figure and ground (which crystallized by the second decade

of this century)—the subsequent development of each has been characterized by minor changes within a relatively stable stylistic mode.

Finally, the history of cicatrization closely parallels that of interior calabash carving. Apparently absent as a developed art until the mid-nineteenth century, its technique and overall style emerged in relatively "mature" and full-blown fashion, and changes have been more in the realm of individual designs than in overall style.

It was just a decade ago that we first proposed, very tentatively, that Saramaka woodcarving, far from being "an African art in the Americas," had its beginnings in the Suriname forest during the early nineteenth century (R. Price 1970b). Since that time, we have spent countless hours in museum collections around the world, made five additional trips to Suriname to conduct fieldwork in Maroon villages, and devoted many months to the examination of eighteenth-century documents describing Maroon life—none of which has brought to light any evidence that would alter our earlier assessment. Nevertheless, we are sharply aware that the existence of a previously unknown finely carved stool or a calabash with a beautifully designed interior dating from the eighteenth century, might be discovered tomorrow, as might a detailed eighteenth-century description of women's embroidery or cicatrization. Clearly, such evidence would modify and enrich our understandings of the beginnings of these arts in significant ways. But it is also worth pointing out what such hypothetical new evidence would *not* change. If new evidence were to "push back" in time the beginnings of these arts, it would not diminish the significance of their essential "newness" and "uniqueness" as they emerged. Even external calabash carving, which *may* have begun among Maroons in a style that represented an uninterrupted development from Africa, underwent a complete break with this past, and a new beginning during the course of the nineteenth century. Thus, our stress on the new cultural syntheses represented by the emergent arts is not dependent on the precise dating of their beginnings.[98]

Since the emergence of the visual arts during the nineteenth century, dynamism and change have been continuous. It may be useful at this point to summarize the major types of change, not medium-by-medium but in terms of general processes.

Long-term trends. Viewed from the maximal century-long perspective which most Maroon media afford us in any detail, the arts taken as a whole seem to display several very gradual, unidirectional developments: larger patterns have given way to smaller patterns, intricacy and busyness have increased, relative irregularity and syncopation have yielded to greater uniformity and symmetry, and a relatively simple tripartite color scheme has been replaced by lush multichromatics. Woodcarving and cicatrization offer excellent examples of the long-term reduction in the overall size of designs. The related increase in the intricacy of designs, in the gradual transition from visual simplicity to busyness, can perhaps best be seen by contrasting Saramaka woodcarving's "Style I" with "Style IV," or early and recent embroidery styles, culminating in cross-stitch work.

The textile arts and woodcarving provide striking illustrations of the gradual trend toward regularity and symmetry: the near-total disappearance of free-form embroidery and its replacement by regular, symmetrical, geometric compositions; the contrast between early, vividly syncopated narrow-strip capes and the later strictly symmetrical models; the gradual regularization and uniformization of woodcarving design over the course of a century; and the parallel development through time, in Saramaka woodcarving and sewing, of an insistence on the regular alternation of over-and-under ribbons of wood and of warp and weft in narrow-strip textiles. Finally, long-term trends in the uses of color can be seen in both the textile arts and in the decoration of woodcarvings. By the 1930s the red, white, and navy combinations that dominated nineteenth-century textile compositions had given way to the use of a strikingly varied set of color combinations; and the initial, early twentieth-century use of colors on

woodcarving, which was generally restricted to red, white, and black, later blossomed into the almost "electric" multichromatism of post-World War II eastern Maroon woodcarvings.

We would suggest that these long-term unidirectional trends in the arts may be related to broader developments in Suriname Maroon societies—their changing relationship to the world outside, and the resulting changes in their self-perception and ideology. We would tentatively relate the shift toward greater regularity (fewer free-form designs, more insistent symmetry) and more concern with technical exactitude to increased exposure to Western technology, in particular to the products of literacy (magazines, newspapers, books). This trend has been accompanied by a gradual shift in the balance of female-male aesthetics, with the more mechanically oriented, Western-influenced men's styles gaining precedence (e.g. with male-marked embroidery, executed with a carpenter's compasses, displacing female free-form styles). Women's cross-stitch embroidery—sometimes copied from (or elaborated upon) examples seen in books—represents another extreme along this continuum, as does the replacement of male *sêkêti* singing in Upper River Saramaka by modified Western generator-powered electric band combos. We are thinking less, however, of a simple process of direct "Westernization," as in the last two examples, than of the subtle and gradual influence of Western notions of technical regularity, straight lines, and male technical dominance which we believe have strongly influenced the course of Maroon arts during the past one hundred years, as a consequence of increased Maroon contacts with coastal society. If the (current) end point on this continuum produces art that causes some outside critics to decry the triumph of technique over aesthetic integrity and to long for "the good old days" (see Hurault 1970:90), it should be remembered that it was this same trend toward regularity and symmetry that produced an artistic style—the woodcarving of the 1920s—that is considered by these same critics as the very height of Maroon artistic accomplishment.

Fads and Fashions. At the other extreme from these long-term, unidirectional trends are the ever-changing fads and fashions that move rapidly in and out of the artistic universe of any Maroon group. In contrast to unidirectional trends, these fads and fashions do not reflect fundamental changes in aesthetic ideas. Always innovative and surprising on the micro-level, they nevertheless represent "more of the same" when viewed from a distance. As Hurault has pointed out for the Aluku, the continual invention of new fads is a very generalized activity, particularly among the young, producing a rapid turnover in everything from woodcarving motifs and play languages to children's games and popular songs (1970:91). The earlier chapters of this book have cited numerous examples from every Maroon group—dramatic changes in the length and width of men's necklaces and breechcloths, subtler variations in the size and placement of stripes on legbands, the endless succession of decorative "teeth" in woodcarving, the short-lived popularity of particular secular dances, and so on. What persists is the cultural emphasis on dynamism, the expectation of change at the level of such fads and fashions, and these features apparently date from the very earliest days of Suriname Maroon societies. Surely, societies differ in their love of novelty on this non-fundamental level. We would like simply to underline here that the rate of change in the fads and fashions of industrial society (Paris women's clothing, recent North American teenage footwear, songs on the hit parade) is fully matched by the pace of innovation and obsolescence in Maroon sartorial and musical domains.

Style Changes. We have seen that a kind of almost "organic," continuous development characterizes the history of many artistic media or genres: the development of Maroon woodcarving over the past century and a half; the changes between 1900 and 1950 in the colors and contours of embroidery designs; or the internal stylistic evolution during the past fifty years within *sêkêti* singing or *papá* funerary performances. Style changes of this sort are of a different analytical order from what we have called "fads and fashions." They

258. Djuka comb carved c. 1970 in the shape of a toy wind-up duck. The back has been incised with marks typical of eastern Maroon "writing" symbols.

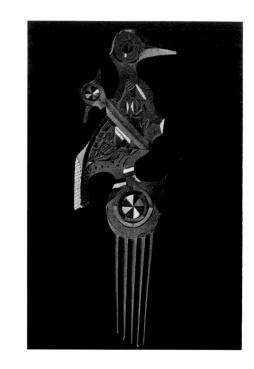

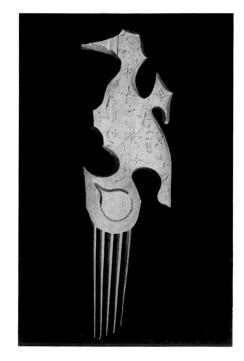

200

are genuine *developments*, in a directional, generally non-reversible sense (though they are not at all necessarily influenced by "Westernization" of any kind). These changes, in contrast to fads and fashions, gradually become institutionalized ideologically; that is, they involve shifts in generally accepted concepts of form. Finally, these style changes are broadly enough defined to permit significant internal experimentation and development.

Changing media. The introduction of new materials, or new ways of using old materials, has periodically afforded Maroon artists new creative opportunities. For example, during the late nineteenth century, most imported commercial cloth was either monochrome (navy, white, or red) or white with a regular (usually blue) stripe. At this time, Maroons realized their love of bright color contrast by sewing bits and pieces of the contrasting solid colors onto pale background cloths. Once colorfully striped cotton (which juxtaposed, for example, orange with green or yellow with blue) became available in the early twentieth century, the new art of strip-sewing was created, which could play on the built-in color contrasts of the commercial cloth to achieve similar aesthetic ends. (See the end of this chapter for more detailed discussion of this development.) Or, to cite two simpler examples, we have seen that the availability of commercial paints after World War I led to an explosion of multichromatism in eastern Maroon woodworking and that the new familiarity of post-World War II Maroon industrial metalworkers with sheet aluminum permitted experiments in comb curvature that had previously been impossible because of the structural limitations of the traditional wood. These examples suggest that the introduction of unfamiliar materials, rather than automatically fostering radically new arts, tends to permit or encourage the development of familiar aesthetic ideas in directions not previously possible.

The Mobility of Maroon Arts. Considered as a whole, Maroon art history has been notable for the ease with which ideas and forms have moved from one region to another and from one medium to another. Contact among the various major Maroon groups—ritual exchange, political cooperation, intermarriage—has marked Maroon life from its very beginnings, and aesthetic ideas and artistic forms have always been part of this interchange. A man who takes a wife from another tribe or region is, in effect, importing a set of foreign artistic skills and styles for selective adaptation by his fellow villagers. His kinswomen supervise the ceremonial unloading of the marriage basket which the new wife brings when she arrives in the village for the first time, and are careful to note the details of design on each calabash container, the distinctive flavor of each specially prepared delicacy and even the selection of items included in the basket. As the woman's stay in the village progresses, some of her cultural imports may be imitated and partially incorporated into local artistry. Wage-labor opportunities for Maroon men have also produced situations conducive to cultural exchange, for example when Saramakas went to work in the gold mining villages along the Marowyne River in the late nineteenth century and when Djukas worked at the hydroelectric project on the Suriname River in the 1960s. Furthermore, there has always been frequent inter-tribal travel aimed explicitly at making use of the special bodies of ritual knowledge and expertise associated with particular Maroon groups. Through such contacts, a Djuka dance style was taken over and developed by Saramakas in the early twentieth century; bits-and-pieces patchwork, the rage in Saramaka fifty years ago, has recently reemerged as the height of fashion among the Matawai (Color Plate XIX); and so on. The process represented by our own "artificial" reintroduction of a calfband design abandoned by Upper River Saramakas in the early twentieth century (see Note 15) must have occurred countless times, as styles and techniques from one group moved into another, were abandoned by the first, and then, much later, were reintroduced.

Similar cultural interchanges have always been a feature of relationships between Maroons and coastal Surinamers (particularly Afro-Surinamers) and throughout Maroon history these have remained a source of new stimulation

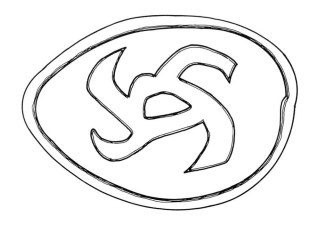

259. Saramaka calabash bowl. The design, first carved in the 1960s by Dofia, Asindoopo, was inspired by a rubber duck that a man brought back from Paramaribo for his child.

in the arts. Whenever men have gone to the coast to work, they have devoted careful attention to the merchandise in city stores. The discovery of something new and attractive—a new type of cassette recorder, a woman's tin lamp of particularly pleasing shape, or an idea for a new woodcarving technique—was complimented and discussed enthusiastically upon the man's return to his village, and added significantly to the perceived success of his trip. Many of these discoveries have inspired imaginative artistic responses; for example, toy ducks have been "copied" by Djukas and Saramakas in both wood and calabash carvings (Figures 258–259) and carved wooden umbrellas became a highly admired accessory for men during the 1970s (Figure 159c). During the past decade or two, men have begun bringing their wives and children to live on the coast for extended periods; there some of them learn the coastal language (Sranan), attend schools, and interact in a variety of ways with their non-Maroon neighbors. This trend has served to demystify coastal culture for women, to nuance the earlier image of Paramaribo as a boundless storehouse of goods supplying the needs of life in villages; and—by involving women as well as men—to introduce new influences on Maroon artistic life. Although there have always been examples of new design motifs—in woodcarving, embroidery, and calabash art—that have been inspired by objects seen on the coast, it is important to note that artistic stimulation from coastal experiences has not been derived only from the products of Western technology. For example, the importation of large numbers of Africans into the slave population long after the Maroon groups were closed to new runaways meant that during most of the eighteenth century and well into the nineteenth, plantations included many more people who had been born in Africa than did the Maroon villages of the interior. It would not be surprising, then, if late eighteenth-century Maroons— already several generations removed from the Middle Passage—knew of the "African" style of calabash carving which was done at that time (see Chapter 5) largely through their contacts on plantations, where there were still many African-born slaves.[99]

The mobility of ideas and forms between artistic media is another notable feature of Maroon art history. In addition to conscious imitations of particular designs, there are clear inter-media influences on a more general stylistic level, due to the fact that each person works in more than a single medium and often allows artistic ideas to flow from one to another (see, for example, Figures 260–261). Saramakas pointed out that a number of calabash motifs were attempts to copy embroidery designs (Figure 262) or woodcarving techniques (Figure 263); that the design of one hairdo is also found in a calabash design and a pattern traced into manioc cakes (Figure 264); that the radial spokes of a half-finished basket appear in a woman's cicatrization design and a hairdo; and that several types of woodcarving "teeth" are paralleled by stitches used in decorative embroidery. Moreover, there are occasional virtuoso pieces which reproduce objects from one medium using the materials of another (Figures 159a,b and 162–163). Because such innovations are highly appreciated and frequently discussed, it is often possible to learn how, where, and when each one was introduced. We know, for example, that the notched form for calabash hand-washing bowls was invented in the late 1950s or early 1960s by Keekete of Asindoopo, during the period when the first outboard motors were being bought by successful young men and canoes were being notched in the rear to accommodate them. The introduction of outboards was celebrated, not only by such "motorboat" calabashes, but also through the lyrics of a number of new popular songs.

260. Calabash bowl and round stool, designed by Saramaka men (see Figures 36a and 183a).

261. Hunting sack cover and calabash bowl designed by Saramaka women. The embroidery was sewn c. 1940 by an adolescent girl from Godo; the bowl was carved at about the same time in a Pikilio village.

262. Three realizations of a common Saramaka women's design: a) a calabash drinking bowl, carved 1960s by Yimbaamuyee, Asindoopo; b) a breechcloth, apparently sewn in the early twentieth century; c) an embroidered cape sewn 1950s–60s by Kaadi, Botopasi.

263. Borrowing of the wood-within-wood technique: a) Saramaka calabash bowl that imitates the interwoven ribbons common in twentieth-century woodcarving. Carved 1931 in Ganzee; b) detail of the Saramaka peanut-grinding board illustrated in Figure 195.

264. A Saramaka design known as "around the head," realized in a calabash bowl, a child's hairdo, and a manioc cake.

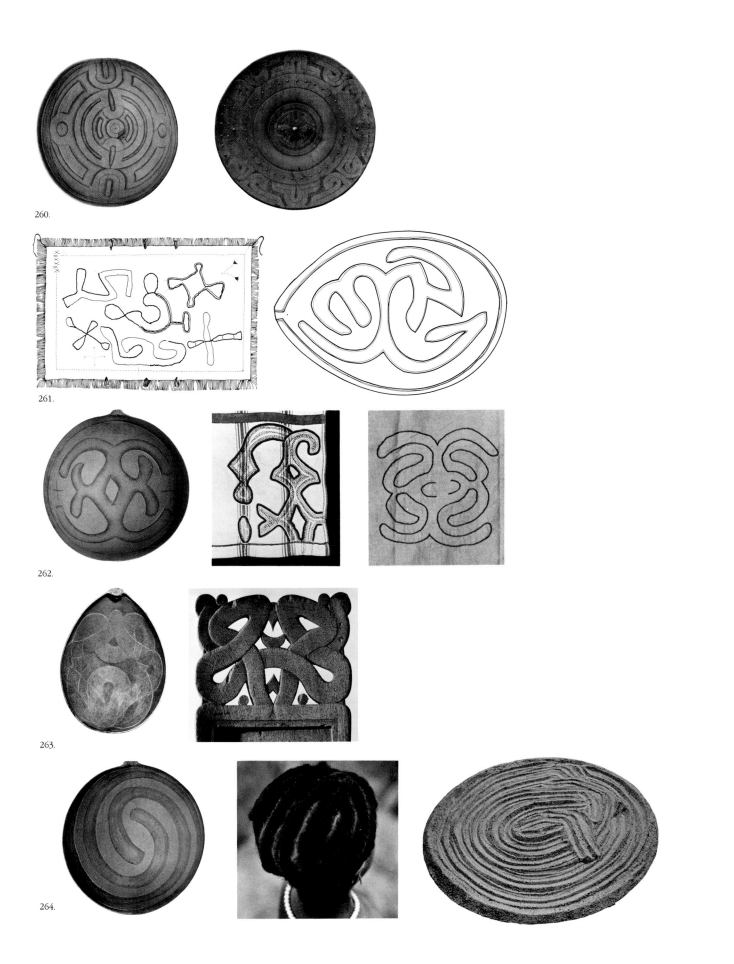

260.

261.

262.

263.

264.

Africa's Legacy

Having now reviewed the whole broad sweep of Maroon art history, we are finally in a position to consider the nature and extent of the African contribution. This is an issue that not only is highly charged ideologically; it also constitutes something of a methodological minefield. With the facts of the case laid out in previous chapters, however, we should be well prepared to examine the various claims and counter-claims, and perhaps to reach some informed conclusions.

265.

The Search for African Continuities: Some False Starts

For a long time, it has been fashionable to view Suriname Maroon societies as a "Little Africa in America" (Kahn 1954). The titles of scholarly articles are often explicit: "We find an African tribe in the South American jungle" (Vandercook 1926), "African customs and beliefs preserved for two centuries in the interior of Dutch Guiana" (van Panhuys 1934a), "Africa's lost tribes in South America; an on-the-spot account of blood-chilling African rites of 200 years ago preserved intact in the jungles of South America by a tribe of runaway slaves" (Kahn 1939); and so forth. The arts have figured importantly in this image—Dark subtitled his *Bush Negro Art* (1954) "an African art in the Americas," Volders called Maroon woodcarving "an original African art form" (1966:141), and Herskovits, in an article entitled "Bush Negro art," characterized Maroons as "having remained faithful to their African traditions [thus presenting] the unique phenomenon of an autonomous civilization of one continent—Africa—transplanted to another—South America" (1930:160).

266.

Such general claims that the Maroon arts are, as Kahn called them (1931), "West African survivals" are often supported by a comparison of the form of selected African and Maroon objects. We give three examples of this mode of comparison.

1) A distinguished Africanist art historian has presented for comparison an openwork Akan throne from Ghana and a Saramaka peanut-grinding board (Figure 265), noting that "the Akan preference for arabesques in openwork, for even-sided flat bands, and for brass studs to enhance curvilinearity . . . [is] also present, rearranged and reconsidered" in the ornamentation of the Maroon peanut-grinding board (Thompson 1970:18). (Note that the center panel of the Saramaka openwork door in Figure 140 may present even more striking similarities to the Akan piece.)

2) Another well-known specialist on Africa, in a note concerning "the origin of Bush Negro art," suggests that there exists a "marked affinity" between the Duala (Cameroons) style of stool carving and that of the Suriname Maroons, reproducing as evidence a sketch of a Duala stool (Figure 266), that, he says, represents "a fully developed style of woodcarving which of all African styles, in my opinion, shows most resemblance of form and feeling to the generally sinuous character of Bush Negro carving" (Fagg 1952:121–22). Although Fagg illustrates no specific Maroon parallel for the Duala example, the stool in Figure 267 could certainly have been used as support for his argument.

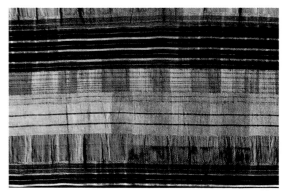

268a.

3) As a final example of visual similarity, a nineteenth-century narrow-strip textile from Dahomey may be compared with a twentieth-century Saramaka cloth (Figure 268; see also Color Plate XII); a comparison in color would make the formal similarities even more striking.

In this mode of comparison, intended to demonstrate the "Africanness" of Maroon art, the research procedure is to search for individual pieces that display noticeable visual similarities, and then to let the resemblance speak largely for itself as testimony to direct historical continuity. But this procedure contains fundamental methodological and conceptual weaknesses: it is based on a biased selection of examples; it infers specific historical continuities on the basis of visual similarity; it underestimates Maroon creativity; and, in focusing on form rather than process, it misconstrues the nature of cultural change. Each of these problems deserves reflection.

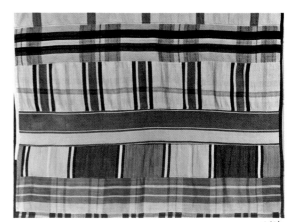

268b.

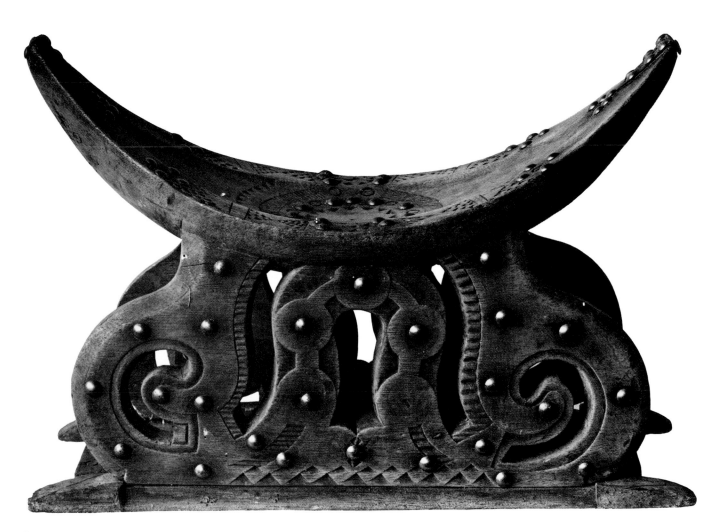

267.

265. An Akan throne made c. 1700 and a Saramaka peanut-grinding board collected in 1929. (For a full view of the peanut-grinding board, see Figure 40).

266. "Carved stool from Duala, French Cameroons"

267. Saramaka crescential stool, collected 1928–29 in Botopasi.

268. Narrow-strip textiles: a) collected c. 1849 in Dahomey, West Africa; b) sewn mid-twentieth century in Saramaka, by Apumba (born c. 1890), Pempe (see also Color Plate XII)

Even when dealing with societies that have had virtually no contact with each other, a determined researcher can usually locate some objects or design styles in one that closely resemble objects or design styles in the other. Compare, for example, the form and feeling of the openwork designs on the wooden objects in Figure 269—an Alsatian chair carved with an interlaced motif from the High Middle Ages and a twentieth-century Saramaka peanut-grinding board.[100] Or again, compare the designs in Figure 270—a very typical Saramaka calabash and a common lime-tube design used on betel-chewing implements in Indonesia.[101] When dealing with Maroon and African art objects, the task of finding "matches" is even simpler, because the fact of general historical connection *does* lend greater resemblance to the arts of these two areas than, say, to those of Medieval Europe and modern Suriname. But the methodological pitfalls are no less real: by focusing only on "look alikes," one misses the full range of forms, and is bound to arrive at a distorted picture of the arts in question and of their history. Indeed, it is our studied conclusion that Maroon forms with direct African parallels have at no time ever accounted for more than a small proportion of Maroon artistic production.[102]

The "matching pairs" approach to Maroon art history implies a substantial leap of faith—from the existence of visual similarity to the existence of historical continuity. When scholars of this persuasion find a particular Maroon object that resembles an African one, they tend to assume that its basic form has simply been passed down from one generation to the next. Once we begin to examine the actual development of Maroon arts during the centuries which these African forms are said to have bridged intact, the dangers of such presumptions of continuity become apparent. In the more descriptive chapters of this book, we have tried to give some sense of the pervasiveness of change in all artistic media, especially in terms of formal features. Many gaps remain in our reconstructions, but extensive fieldwork, oral history, archival research, and examination of museum collections have permitted at least a preliminary exposition of the complexity of the developmental processes that were actually involved. In light of such historical research, let us now reconsider the three examples of African-Maroon look-alikes introduced above.

1) The Akan throne and the Saramaka peanut-grinding board. Regarding the "arabesques in openwork," we have seen in Chapter 4 that openwork in Maroon woodcarving is in fact a relatively late phenomenon, developing only during the second half of the nineteenth century. Likewise, the Saramaka use of "brass studs to enhance curvilinearity"—which Herskovits, too, saw as "the survival of the African ornamentation of woodwork with iron" (1930:162–63)—represents no simple continuity. On his visits to Saramaka in 1928 and 1929, Herskovits was struck by the greater use of brass studs in the Upper than in the Lower River region, suggesting that in "the deep interior ... where the African elements have been most faithfully retained," the use of metal had somehow survived *(Ibid.).* Our research suggests, however, that brass studs were first used in Saramaka only in the mid-nineteenth century (when trading contact with the coast was regularized), became popular on the Upper River only after the turn of the century, reached a peak during the 1920s, and markedly declined in popularity thereafter. Moreover, the differing use of studs on the Upper and Lower River during the 1920s, which puzzled Herskovits, was almost certainly related to the very different patterns of wage labor and attitudes toward coastal goods in these two regions at that time, and had nothing to do with the alleged "fidelity" of Upper River people to African elements of form. In sum, historical research can sometimes demonstrate—as in this case of Akan-Saramaka look-alikes—that those features of form that are thought to look most "African," and that scholars have assumed were passed down from one generation of carvers to the next, are relatively recent developments in Saramaka woodcarving, products of complex processes of cultural change.

2) The Duala and Saramaka stools. A consideration of these two stools calls attention to several formal features—besides the "generally sinuous character

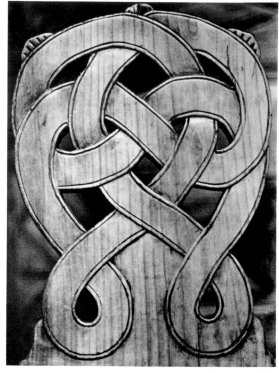

269a.

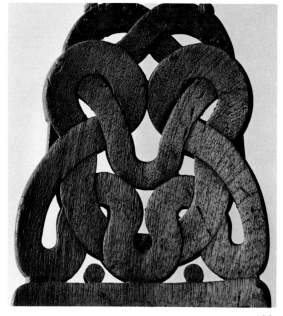

269b.

269. Interwoven ribbons in woodcarving: a) A mid-nineteenth-century Alsatian chair known as a *"Brettstellstuehl,"* carved in a motif from the High Middle Ages. b) A twentieth-century Saramaka peanut-grinding board (see Figure 195 for more information on provenance).

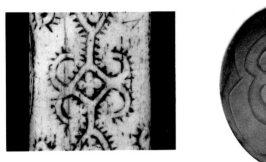

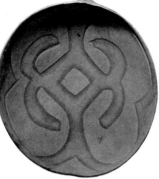

270.

270. Designs carved on a bone lime tube from Timor (Indonesia) and a Saramaka calabash drinking bowl from Asindoopo.

271. Saramaka stool, carved 1966 in Lombe for John C. Walsh, in dual celebration of his birthday and the rescue of the 5000th animal (a giant armadillo) from the rising waters behind the Afobaka dam (Walsh and Gannon 1967).

272. Three Amerindian stool forms from Suriname

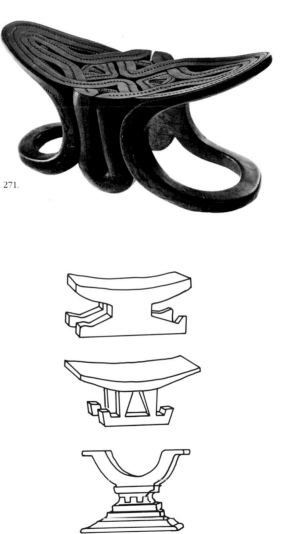

271.

272.

of . . . carving" pointed out by Fagg—that have interested scholars comparing African and Maroon stools: the "crescential" form of some examples, the curved rectangular top of others, and the lowness-to-the-ground of almost all. The history of Maroon crescential and curved-seat stools belies the presumption of direct formal continuities from Africa, suggesting that the actual developmental sequence may even have moved in the opposite direction from what a "direct survivals" proponent might expect. Crescential stools were simple and relatively unembellished well into the late nineteenth century (Figure 120) and only later developed—with the popularization of piercing and brass studs—into the sometimes elaborate compositions which are visually more reminiscent of African models. The strongest Maroon parallel for Fagg's example dates from the first quarter of the present century, and the stool with the next most striking resemblance was made only during the 1960s (Figures 267 and 271). Likewise, although both Herskovits (1952a:188) and Fagg suggested that Maroon stools were an African survival, and others have claimed they were derived directly from Ashanti models (Volders 1966:141), we have seen that rectangular tops began to be carved with curved seats only within the last hundred years. Historical research suggests that the influences upon various formal features of Maroon stools may have been significantly more complex than anyone has yet realized. The Amerindians with whom Maroons were in direct contact since their earliest years carved stools that might easily have served as models. Amerindian stools that resemble Maroon crescential stools are widespread in tropical South America, as are stools with curved rectangular seats (Figure 272; see also Ahlbrinck 1931: Figure 79). Even the lowness-to-the-ground so characteristic of African stools is fully matched in the earliest Amerindian examples. Furthermore, Maroon forms (however much they are visually similar to African or Amerindian examples) may have developed independently, from Maroon antecedents; the development of curved seats on rectangular-top stools may well represent such a case (see Chapter 4). In short, historical research on those features of Maroon stools which have been thought to be most "African" suggests both the absence of direct continuities of form and the complexity of the processes of change through which they actually developed.

3) The Dahomean and Saramaka narrow-strip textiles. Both the patterning of these compositions and the aesthetics of color combination are strikingly similar in the two cloths illustrated in Figure 268, as well as in countless other narrow-strip textiles from Suriname and Africa. Our examination of the history of Maroon clothing in Chapter 3 has shown, however, that such narrow-strip textiles are a twentieth-century art (separated by over a century from the last African-born Maroons) that developed in response to specific changes in the availability of certain kinds of trade cotton in coastal Suriname. At the end of the present chapter, we will discuss the processes by which these striking parallels in textiles came about, not denying an historical continuity, but locating it—through attention to fashion history, sewing techniques, economic developments, and basic values—in areas other than visual form.

Our rejection of many alleged continuities of form, on the basis of historical research, is in no way intended to deny Africa's enormous cultural contribution to the Maroon arts. Even at the level of discrete forms, we have seen that there exist a number of direct, historically documented continuities—from "finger pianos" to "fighting jewelry." But the initial historical process of inter-African syncretism and the pervasiveness of change during the subsequent centuries of Maroon history have affected all aspects of the arts. Even those cases of demonstrable continuities of form, when examined in their broader cultural context, can be seen to fit into this pattern of ongoing change. Finger pianos are used to imitate the latest Maroon (not African) drum rhythms and songs, and they put the player in a special relationship with Maroon (not African) forest spirits. Likewise, Saramaka fighting bracelets or rings—made from filed down sugar mill machinery—were used as part of a distinctly Saramaka process of dispute settlement. Such facts of change (and their obvious necessity, given the circumstances of Maroon history) in no way diminish the poignancy of those formal continuities that have been maintained; but they suggest something of the limitations imposed by an exclusive focus on form. Our own intellectual unease with the analysis of formal continuities (like that with the analysis of cultural "traits"—see Mintz and Price 1976:4–11) stems from the conviction that this level of analysis severely limits an appreciation of historical process and, hence, of the full weight of Africa's contribution. In the next section, we argue for a broadening of perspective, from a concern with form to a concern with process, in order to arrive at a more complete understanding of the legacy of Africa in the arts of Maroons.

Process over Form:
African Aesthetics and Afro-American Dynamism

In the preceding section, we reviewed two methodological problems with the "Africanist" approach to Maroon arts—the bias introduced by a selective focus on look-alikes, and the tendency to infer actual historical continuity on the basis of visual resemblances. We turn now to a critique of some of the conceptual underpinnings of this same approach, particularly its treatment of the role of creativity and the nature of cultural change, its tendency to view Maroons as passive repositories of cultural traditions rather than as makers and shapers of new cultural forms.

Africanist approaches to the cultural history of Suriname have generally taken either of two forms. One views Suriname Maroon societies as some *particular* African society simply transplanted to Suriname, postulating, for example, that Ashanti slaves (joined by a much smaller number of other Africans) recreated in the Suriname forest a society that was a faithful copy of that which they had left. The second alternative views Suriname Maroon societies as a cultural "mosaic," suggesting that customs from several African ethnic groups were put together like bits of mosaic tile, and "fixed" once and for all three hundred years ago in the Suriname forest, where they are still recognizable in terms of their discrete cultural origins. In spite of their differences, however, these two approaches share a fundamental assumption about Afro-American culture history: both are based firmly on a notion of cultural stability over time. Each assumes that, except for external pressures (the dreaded "assimilation"), Maroon societies—whether "transplants" or "mosaics"—would "retain," "survive," and remain suspended in time.

Behind such views, and perhaps motivating them, is the myth that so-called "primitive" societies exist somehow outside of history, that they are strongly resistant to change, and that they change only because of the impingement of other, "more advanced" societies. A recent journalistic assessment of Maroon life epitomizes such views: "For more than 350 [*sic*] years, they have maintained a 'Little Africa' in [the] jungle, that is 'more African' than much of Africa is today, because of the European influence on that continent" (Counter and Evans n.d.:2). In fact, modern anthropology has shown that societies differ enormously

in their attitudes to change and in the extent to which they exhibit an internal cultural dynamism. By any measure—as we hope to have shown in previous chapters—Suriname Maroon societies (like the vast majority of societies in pre-twentieth-century West and Central Africa) have always been highly dynamic.

A corollary of the view of Maroons as "timeless primitives" is the notion that change implies assimilation, while resistance to change reflects a conscious fidelity to Africa. From a Maroon perspective, however, change in itself has never been equated with assimilation into the Euroamerican sphere, nor has culture change or dynamism been considered in any way an infidelity to a collective African past.[103] For Suriname Maroons, the allegiance to Africa—an ideological identification with a generalized land of origin—has never implied an opposition to change. It has always been possible for Maroons to be fiercely anti-European in outlook yet supportive of creative new cultural developments from within their own societies. Indeed, it could perhaps be argued that it was because the ethnically diverse escaped slaves shared no one set of African cultural forms that they saw cultural change, not as a loss, but rather as a creative way of making things truly their own.

If we turn our attention away from comparisons of African and Afro-American forms and focus instead on the creative processes that have generated them, we may arrive at a very different image of Africa's cultural contribution in the New World.[104] In a study of Maroon and other Afro-American personal naming systems, for example, we were able to demonstrate that the strength of African influence on 1) underlying naming principles and 2) the actual pool of names in use have often been inversely related. That is, an Afro-American naming system with a relatively high proportion of "African" names (such as Cudjo, Kwasi, or Chitunda) can be *less* similar to African systems in terms of the ways that names are created, conceptualized, and used than that of another Afro-American group which has very few such names. We argued that:

> Even the Gullah [coastal South Carolina-Georgia] system, in which locally used names are 'nearly always a word of African origin' (Turner 1949:40), may be less 'African' in an important sense than the Saramaka system, in which only about one-sixth of names are lexically African. Might it not be that the dynamism and creativity of a cultural tradition developed with minimal Western influence have allowed the Saramaka to be mildly prodigal with their gradually declining pool of lexically African names, yet more faithful to West African naming principles at a deeper level? [R. and S. Price 1972b:362].

More generally, if it is legitimate to claim that the Suriname Maroons are the "most African" of all Afro-Americans, this is not because they have retained, say, more original Akan personal names or more Cross River graphic signs than their brothers and sisters elsewhere in the Americas; indeed, for many such specific traits they have *not*. In fact, it can often be shown that tenacious fidelity to "African" forms by an Afro-American culture reflects the stagnation of once-vital aspects of an African past. Certainly, one of the most striking features of West and Central African cultural systems is their internal dynamism, their ability to grow and change. Roger Bastide, considering the general question of "Africanisms" in the New World, divided Afro-American religions into those that are "canned" or "preserved" (*en conserve*)—such as, he claimed, Brazilian *candomblé* or Cuban *santería*—and those that are "living" (*vivantes*)—such as Haitian *vodoun*. The former, he wrote, represent a kind of "defense mechanism" or "cultural fossilization," a fear that any small change may bring on the end, while the latter are more secure of their future and freer to adapt to the changing needs of their adherents (1967:133–55). As he has argued, Afro-American adaptation to changing conditions

> does not imply breaking with the past. It is in point of fact the most touching evidence for fidelity. Survival does not imply rigidification,

209

separation from the ever-changing flow of life.... On the contrary, survival presupposes plasticity [1967:45].

Of all Afro-Americans, the Suriname Maroons have had the greatest freedom to combine and extrapolate African ideas and to adapt them to changing circumstances. This perspective, which focuses our attention on process rather than form, helps us to understand why scholars who have examined Suriname Maroon life find it so "African" in feeling even though it is virtually devoid of directly transplanted African systems.

The actual cultural heterogeneity of the original Maroons gives the immediate lie to the notion of a whole African civilization having been transplanted to the New World. Our examination of the initial processes of culture-building, as well as our review of the extraordinary panorama of change and development since Maroon beginnings, should shake the credibility of the view that early on, an African mosaic was cemented together once and for all deep in the forests of Suriname. What we might imagine instead (recognizing that it has all the weaknesses of a partial metaphor) is a kind of kaleidoscope, in which the combinatory principles are broadly African (and shared by most Maroons), the initial multicolored chips come from a diversity of African societies, and new chips (Amerindian, African, European) are added from time to time. Let us pursue this image further. There are on the one hand the central, fairly stable principles at the heart of the system—broad aesthetic ideas, including attitudes about dynamism and change. And there is on the other an original vocabulary of forms from a variety of African sources, with Amerindian and other forms added in as time goes on. Such a general device, because of its very nature, would assure that invention or creation would often mean reinvention or recreation, and such processes are frequently attested to in Maroon history—both within and across the boundaries of particular areas of culture.

The cultural history of Maroons has in fact been characterized by such continuity-in-change, by creative and dynamic Afro-American processes operating within a general framework of broadly African aesthetic ideas. Three extended examples, drawing on materials that have been introduced in previous chapters, may illustrate some of the ways that this broad system has worked through time.

Calfbands. Aspects of the development of Maroon calfbands may illustrate how a widespread African aesthetic idea can be maintained fully within the context of New World cultural influences and in spite of significant change through time.

Fiber ties, sometimes strung with beads, were worn just below the knees by many seventeenth-century Africans, and were one of the few material items that survived the Middle Passage to arrive intact in Suriname (see Figure 273b,c). We saw in Chapter 3 that throughout their history Maroons have worn some kind of ornamentation on the calves: simple strings; strings hung with animal teeth, feathers, tassels, or shells; white "crocheted" bands; or colorfully striped bands, sometimes embellished with braided ties or tassels. On the basis of this information, it might be tempting to view Maroon calfbands simply as a continuation, in the Americas, of a specific item of African dress. The full history of Maroon calfbands cannot be understood, however, without considering the influence of other models available to slaves and early Maroons and the development of the form in the Suriname interior over the past two hundred years.

Amerindians in Suriname have also adorned the calves throughout their history; as one eighteenth-century observer noted:

the girls at ten or twelve years old work a kind of cotton garter round their ankles, and the same below the knee; which being very tight,

and remaining for ever, occasions their calves to swell to an enormous size by the time they are grown women, and gives their limbs a very odd and unnatural appearance. [Stedman 1796, I:387; see Figure 273a.]

In addition to the basic interest in accenting this part of the body, there are more specific parallels between Amerindian and Maroon calfbands. In both cases, the bands are intended to fit as tightly as possible, even to the point of serious discomfort; ideals of physical beauty favor large calves (below the constricting band); the bands may be fashioned either on a wooden cylinder (Roth 1924:105) or directly on the wearer's legs; the single-element, interlooped stitch, executed from left to right with an eyeless needle in a continuous circle, is identical in the calfbands of the two groups (Figure 49); and the Maroon term for calfbands is of Amerindian origin. This is then a case in which an African form lent itself to adaptation in Suriname—most notably through new construction techniques—under the influence of local aboriginal cultures.

Maroons also developed the idea of calf ornamentation in ways that were uniquely their own. First, stylistic developments over the years responded to general trends in their art and material culture: the decline in the popularity of men's ritual jewelry during the early twentieth century coincided with the abandonment of protective hangings on calfbands, and the dramatic efflorescence of color in Maroon woodcarving and textile arts was paralleled in contemporaneous calfband fashions—which began with pure white, passed through models with conservative one-color stripes, and more recently have exploited bold combinations of multicolor stripes, edging decoration, and large tassels. Calfbands were also incorporated into Maroon culture in other ways: the cylinders and needles used to construct them and the "corncob" tools used to clean them were all embellished with distinctively Maroon styles of carving (Figures 148a,b,d and 150); special forms were created for infants just learning to walk; calfbands came to serve as a central symbol of a wife's faithfulness and affection; they became institutionalized as an important part of burial rites; and different styles took on specific regional associations like those that characterize every kind of Maroon artistry.

Names for cloth. In Chapter 3, we saw that fashion and naming are closely linked; the popularity of particular clothing styles, jewelry, cloth patterns, and hairdos is invariably emphasized and heightened by the bestowal of special names. These names drop in and out of favor, and their connotations (of praise,

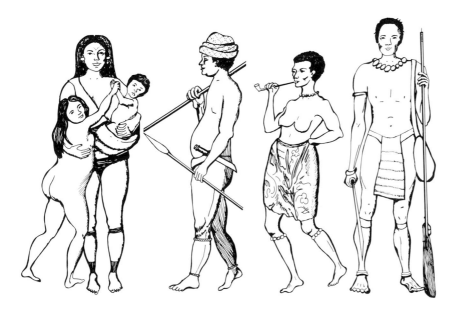

273. Calfbands worn by: a) an eighteenth-century Carib Indian in Suriname; b) an eighteenth-century African; c) an eighteenth-century arrivant in Suriname; d) a nineteenth-century Maroon

derision, and so forth) shift quickly, along with the fashions themselves. Among the hundreds of cloth names that we have heard, however, none is recognizably "African" in origin (in contrast to the words used in many areas of Maroon culture—see, for example, R. Price 1975a). Yet the principles of the naming system—the ways in which special labels are assigned, used, manipulated, and eventually discarded—are strikingly like many in Africa. We shall draw here on Akan examples, since this often neglected subject has received considerable attention from ethnographers there (Lamb 1975, Rattray 1927, Warren and Andrews 1977).

The similarity between the "language of fashion" among the Suriname Maroons and the Akan peoples of West Africa begins with its importance in the respective cultural systems. In both areas, for example, it has long been traditional to assign a distinctive name to every cloth pattern, a number of potential cloth names may be suggested before one finally becomes accepted, and familiarity with a vast number of cloth names is a standard part of cultural knowledge.[105]

Furthermore, once a name for a particular cloth pattern or clothing style is established, its use in daily speech involves playful manipulation, abbreviation, and disguise. A Saramaka cloth named "[Chief] Agbago traveled in an airplane" is often referred to as "The Chief goes to heaven"; another known as "Aviee caused havoc at Djumu" (after a man who stole from a store at the mission post of Djumu) can also be called "Aviee ruined Peleki [the store owner]"; and a third labeled "The Chief threw Venipai [an American visitor] out of his office because of bad living" is sometimes spoken of as "Venipai cried." Terms for clothing styles in Ghana are playfully manipulated in much the same spirit; we cite as an example a set of names created during the time when flared trousers were in fashion:

> 'Perhaps you feel shy' ('Gyama wo fere') refers to a type of Afro trousers with [only] moderately flared bases. . . . 'Gun and bullet' ('Tunabo') is a teasing title for a pair of trousers without a flared base. The trouser leg represents the gun and the leg, the bullet. 'Po', the sound made by a gun shot, is the same as 'Tunabo.' 'Po' was introduced after people were beaten up for shouting 'Tunabo.' At times the 'critics' don't say anything, but rather run past and fall down in front of the person indicating that he has shot the 'critic' dead with the 'tunabo' [Warren and Andrews 1977:15, 14].

This last example illustrates, not only the manipulation of a name's form, but also the responsiveness of cloth and clothing terms to changing fashion in both Maroon and Akan cultures. A style of headkerchief that had fallen out of favor became known among young Akan women as "Do you still use it?", but when it became popular again, the name was changed to "I Apologize," in an attempt to make up for the former insult (Warren and Andrews 1977:15). Maroons, too, change names for clothing styles in order to reflect their current status. The bits-and-pieces textiles which were so prized in the early decades of this century became known as *awangálio*—a specially coined term reflecting pretentiousness and garishness—as they were replaced by narrow-strip clothing; and the narrow-strip textiles have, in turn, been denigrated by new names such as "[outboard] motor cover" as they have fallen out of favor.

Finally, many sources of inspiration for cloth and clothing names are shared by the Akan peoples and Maroons: (1) popular songs and recording artists, e.g., the Maroon cloth named "[Miriam] Makeba" or the several cloth names cited by Warren and Andrews (1977) as originating in popular songs; (2) references to the work required to provide the cloth, e.g., the complex, time-consuming Asante pattern known as "My skill is exhausted" (Rattray 1927:237; Lamb 1975:30) and Maroon names referring to the wage labor which bought the cloth, or a very simple decorative embroidery stitch known as the "lazy one's line"; (3) political leaders and royalty, e.g., Maroon cloths such as "[Queen]

Wilhelmina's belt" or "The Chief's testicles" and Asante cloths such as "The Queen Mother of Mampon" and many proper names from royal families (Lamb 1975:136; Rattray 1927:236–50); (4) references to economic status reflected in the ownership of a particular cloth, e.g., the Asante poor man's cloth known as "I lack even a penny" (Rattray 1927:245) and certain expensive and desirable cloths which Maroons call "a hundred [or a thousand] guilders"; and (5) specific incidents in local social history, e.g., an Asante cloth called "catch the leopard," after an Asante king who sent off one of his subjects with orders to catch a leopard alive (Rattray 1927: 245–46) or innumerable Maroon cloth names citing local scandals, public events, and historic moments (see list in Chapter 3).

We would argue that certain very basic attitudes toward cloth, clothing, and changing fashions have persisted throughout Maroon history, and that, while the actual clothing and associated terminology have undergone continual change, the ways in which they are created, thought about, and used expressively have remained remarkably constant—and fundamentally "African"—over time.

Narrow-strip sewing. Narrow-strip textiles are certainly one of the most striking visual parallels between African and Maroon arts. Their common aesthetic features—the juxtaposition of strongly contrastive colors, the "interruption" of long strips with short cross-stripes, the occasional use of small embroidered or woven accents within the grid structure, and the regular or syncopated bilateral symmetries of the strip arrangements—combine with the basic form of joined parallel strips to suggest arts that sprang from a single source. Yet we have seen that Maroons only began to make narrow-strip cloths in the early twentieth century, long after the last Africans had been brought to Suriname. How could this have happened?

First, the practice of joining strips of cloth to form a larger garment may well have existed in specialized contexts or in limited regions throughout Maroon history. The structure of a Saramaka cape popular in the 1920s illustrates one of the many ways in which the technique of sewing composite cloths could have existed in isolation from the artistic features (use of color, pattern of layouts, etc.) of the narrow-strip art.[106] The special construction of this cape was motivated by a desire to produce vertically striped capes for men; and it was necessary because available cloth was only about 80 cm wide—too narrow for a man's cape except when the stripes were placed horizontally. Figure 274 illustrates how the cloth was widened without sacrificing the verticality of the stripes. Because the final product looks deceptively like a simple piece of cloth, such a construction could easily have existed, unremarked by outsiders, at any period of Maroon history.[107]

Secondly, we have seen that sharp color contrasts have been an aesthetic ideal throughout Maroon history, kept alive in a variety of contexts. Notions of personal beauty include the blackness of skin against the whiteness of teeth; rice gardens are carefully arranged to alternate "red" and "white" varieties;

274. Saramaka *atángo* cape construction. Dotted lines indicate cuts; solid lines indicate seams.

wooden objects made from light woods are inlaid with small pieces of darker woods and vice versa (Figure 184); white calfbands are intended to beautify through their contrast with the wearer's dark skin; clothes are hemmed with threads that contrast rather than blend with the cloth; and so on.

It seems likely that at the end of the nineteenth century, when cloth had become more plentiful, the notions of color contrast and composite textiles, which originated in Africa and had been maintained in separate areas of Maroon culture, were innovatively reintegrated through the development of bits-and-pieces patchwork art. Although most of the cloth at that time was either of solid colors or low contrast stripes (especially blue or gray on white), color contrasts could be created by cutting and joining cloths of different colors. These composite pieces could have been made in any shape; but Maroon seamstresses chose in most cases to form them as strips, which they then joined in a parallel, basically unidirectional, alignment (Color Plate XI, Figure 80). Color contrast and strip construction were thus combined, with time-consuming labor, in a new and unique textile art.

Somewhat later, when coastal merchants began to sell large quantities of multicolor striped fabrics, it became possible for women to create a brightly contrastive strip textile much more easily, and the art of narrow-strip textiles came into being. Stripes in the cloths' patterns served both to reinforce and to interrupt the dominant parallel linearity of the compositions, and the possibilities for brilliant contrasts were limitless. During the formative years of this art, some women continued to cut and rearrange different cloths within a single strip (Figure 85), but the less time-consuming exploitation of the cloths' built-in color contrasts soon became universal.

Although less labor is necessary to make a narrow-strip cape than a bits-and-pieces cape, there is no evidence that women spent less time making textiles for men. Our data suggest rather than they invested the same amount of labor but produced more capes. Indeed, in the 1960s when cross-stitch embroidery became fashionable, women once again had to devote more time to each cape, and the total production of capes decreased. Since the turn of the century, then, despite considerable stylistic change in textile design, the social value of this form of women's labor has remained stable.

Basic notions about clothing construction and the aesthetics of color combination, which grew out of the Maroons' African cultural heritage, have remained remarkably constant over the course of Maroon history. The variable element has been available materials—cloth scarcity during the early years, chromatically limited fabrics during the late nineteenth century, and finally an abundance of colorfully striped trade cotton in the twentieth century. The maintenance of a basic technique and of certain broad aesthetic values in effect allowed for the creative (prototypically Afro-American) re-invention, once suitable materials were available, of a distinctively "African" mode of artistic expression.[108]

These three examples—calfbands, cloth and clothing names, and strip-sewing—illustrate the degree to which continuity-in-change characterizes the arts of the Maroons. On the one hand, there are the relatively unchanging features of Maroon artistry—notions of color contrast, syncopated symmetries, and so forth—which are based on a broadly African set of aesthetic ideas. On the other, there is the celebration of artistic innovation and individual creativity, which guarantees that Maroon arts are ever changing, inventing, and playing with new forms and techniques. The result is arts which are at once African and American, reflections of cultural processes that are uniquely Afro-American.

As we have seen, the initial synthesis of aesthetic ideas, drawn from a variety of African cultures, was forged during slavery and the earliest years of Maroon existence. This set of ideas has always pervaded Maroon life, even outside the realm of strict artistic production. Aesthetic considerations are of the greatest importance, for example, in postures, the layouts of rice fields, or the serving of meals. Discussions of imported manufactures—from pots to cloth to soap—

are also dominated by aesthetic concerns. All of this is crucial in helping us comprehend how ideas that in the twentieth century have been realized in woodcarving, strip-sewing, or calabash carving could have been maintained and passed down, first during slavery and then during a long period of relatively reduced formal artistic production. Even under the maximally repressive conditions of slavery in Suriname, and during the century-long period of guerrilla warfare against the colonists, people still made use of opportunities for storytelling, dancing, drumming, and singing; they made choices about the way they walked, carried their babies, and wore their hair; they expressed aesthetic preferences in the arrangement of their house furnishings, the mending of their clothes, the serving of their meals, the layout of their gardens, and countless other aspects of life that did not require the specific resources of elaborately developed art forms. Throughout a long period of material hardship—first during slavery and then in the rain forest—artistic production was to a great degree curtailed; but ideas capable of influencing the character of formal arts were kept alive—through the ongoing activities of everyday life and, most important of all, through daily *talk* about aesthetics. Even in the absence of any particular artistic activity, then, a panoply of aesthetic ideas, from the general to the extremely specific, would have been passed on from one generation to the next.

We have also seen throughout the previous chapters that Maroons enjoy artistic innovation, play, and creativity. Whether in woodcarving or textiles, hairdos or songs, the Maroon arts exhibit an inventiveness and dynamism that provide a telling contrast to the conventional image of the arts in non-industrial societies.

Viewed in a broad comparative context, the history of Maroon arts may be seen to be characterized by continuity-in-change, by what Amiri Baraka, writing of Afro-American music, has called "the changing same" (Jones 1967). In building creatively upon their collective past, the early Maroons synthesized African aesthetic principles and adapted, played with, and reshaped artistic forms into arts that were quite new yet still organically related to that past. The arts of the Maroons, forged in an inhospitable rain forest by people under constant threat of annihilation, stand as enduring testimony to Afro-American resilience and creativity and to the remarkable exuberance of the Maroon artistic imagination working itself out within the rich, broad framework of African cultural ideas.

NOTES

1. The first half of this introductory chapter borrows heavily from R. Price 1976, where Suriname Maroon history is presented in greater detail.

2. The English word "maroon," like the French *marron*, derives from Spanish *cimarrón*. In the New World, *cimarrón* originally referred to domestic cattle that had taken to the hills in Hispaniola, and soon after to Indian slaves who had escaped from the Spaniards as well. By the end of the 1530s, it was already beginning to refer primarily to Afro-American escaped slaves, and had strong connotations of "fierceness," of being "wild" and "unbroken." (For further discussion of the connotations of "Maroon" and "Bush Negro," see R. Price 1976:2–3.)

3. The translations from Dutch, French, German, and Saramaccan that appear throughout this book are our own, unless otherwise indicated.

4. In Chapter 8 we discuss the formation of early Maroon societies in greater detail.

5. We use the term "tribe" selectively and in a technical sense in this book to imply a combination of segmentary organization, territorial control, and the strong interpenetration of principles of kinship and locality with economic, political and religious life. With Suriname's recent emergence as an independent nation, "tribal" institutions (which have been maintained in part as an aspect of the broader colonial situation) are in rapid change, and it may soon be more appropriate—at least in some contexts—to speak of six Maroon "ethnic groups."

6. Maroon languages divide similarly into two groups—variants of Saramaccan, which are spoken by Saramakas, Matawais, and Kwintis, and variants of Ndjuka, which are spoken by Djukas, Alukus, and Paramakas. In citing Maroon terms in this book, we employ a modified version of the orthography developed by Jan Voorhoeve (see R. and S. Price 1976:40): vowels have "Italian" values except that è = e (as in English "met") and ò = o (as in "all"); vowel extension is indicated by double letters; and in Saramaccan, an acute accent (′) indicates high tone, while low tones are unmarked. In the spelling of Saramaka proper names (both people and places), we follow the current Suriname convention of omitting diacritical marks.

7. Eighteenth-century documents clearly show that men's ownership and display of selected imported items dates from the earliest years of Maroon history. During periods of relative Maroon prosperity, such as the French Guiana Gold Rush years at the turn of the present century, outside observers expressed wonderment at Maroons buying "tea sets, clocks, and boxes," and dragging pieces of fancy European furniture over the rapids back to their villages (van Panhuys 1908:38; Franssen Herderschee 1905:53–54; see also de Beet and Thoden van Velzen 1977).

8. Decorative rings made of pottery, wood, or calabash have sometimes been used to raise calabash bowls off the ground. Although these exist in a number of museum collections, they have not, to our knowledge, been used by Maroons for several decades.

9. The (Maroon) view of Maroon culture as a sharply diversified whole is even more frequently expressed in terms of language. People often explained to us, in an admittedly overstated rhetoric, why Saramaka ways are more difficult to learn than, they claimed, those of other societies. To quote one young man: "It's because every village has its own language. Akisiamau and [its stone's-throw neighbor] Asindoopo don't speak the same language, though we do understand each other. When you get to Langu [the Gaanlio], things [differences] get really fierce—there you might as well be in Matawai [another Maroon tribe]!"

10. Although we have witnessed this institutionalized gift exchange several times, our descriptive fieldnotes are less successful in capturing its significance to Saramakas and its general tone than this verbatim, "idealized" description by a Saramaka woman, recorded in 1976. In addition to the sequence of exchanges she outlines, our own notes describe spontaneous singing and dancing and the participation of a somewhat wider range of kinsmen.

11. Woodcarving for sale has been a money-making option for Maroon men living on the coast for several decades. Carvers' stands are in operation along the highway between Paramaribo and the international airport; there are a number of souvenir shops in Paramaribo stocked largely with Maroon-made combs, food stirrers, paddles, and even coffee table tops; and some carvers peddle their wares through the city on foot.

12. Until recently, newly made pieces were generally considered by Saramakas to merit a higher monetary value than older ones (which were considered to "depreciate" through use). During the past several years, we saw evidence for the first time that the art collectors' valuation of older art was beginning to be understood by some Maroons, especially those serving as middlemen between other Maroons and visitors from outside. For example, we have now witnessed exaggerated claims of ancientness, supported by spurious genealogies of the original owners, designed to enhance prices. Even those few Maroons who are successfully adapting to this market situation by such means have little idea, however, of the monetary value these pieces assume once they leave their hands.

13. During the same period, young men in a Cottica Djuka village were reported to have attended a feast for the dead wearing garments "with a yard-long train which is carried by children" (Köbben 1968:86). The contemporaneous rage in Saramaka was a shoulder cape, often made from a terry cloth beach towel, that reached all the way to the ground and was worn only by men in their late teens and early twenties.

14. See below for a discussion of Saramaka textiles in the early twentieth century, which shows that this "new" style represents, from a non-Matawai perspective, an interesting recycling of an important earlier Maroon fashion. We are very grateful to Bonno Thoden van Velzen, Ineke van Wetering, Chris de Beet, and Miriam Sterman for sharing with us their extensive firsthand knowledge of fashion in Djuka and Matawai, on which we draw throughout this chapter.

15. Our own presence inspired a temporary revival in one Pikilio village of the turn-of-the-century red, white, and black style. After our first year of fieldwork, we returned to the United States for three months and saw the bands illustrated in Figure 49b at the American Museum of Natural History. Already equipped, at that point, with knowledge of the basic stitch, S. Price was able to produce a pair of calfbands with the multicolored V-shaped pattern when we returned to Saramaka. Although the oldest villagers recognized it and knew its names, the method of alternating colors had been forgotten and young women were eager to be taught this "new," and in their view innovative, technique. In 1978, we overheard people discussing the style, unaware of its origin, as "belonging" to the village in which we had lived a decade before.

16. For further discussion of clothing and textile arts, see S. Price n.d., from which most of this section is taken.

17. Breechcloth construction has varied over time, sometimes incorporating cloth ties and sometimes consisting simply of a long rectangular cloth draped over a separate waist string. Nineteenth-century illustrations suggest that men's breechcloths were, at least in some cases, constructed differently from those worn in the twentieth century, with cloth wrapped around the body rather than being looped over a separate waist tie (see, for example, Figure 69). There is also some evidence that eighteenth-century Saramaka men may have worn only a frontal apron (Figure 63).

18. Several decades ago, not all Maroon men owned a pair of pants. "If a Bush Negro is not fortunate enough to own a pair of trousers, he may rent one for ten Dutch cents a day ... from small shopkeepers who have their stores near the bank of the river" (Kahn 1931:47).

19. Some weaving has been done by Maroons since the formation of their societies in the eighteenth century (see, for example, Schumann 1778: s.v. *fumm krossu*). Many older Saramakas remember having seen people weaving hammocks when they were children, and hammocks were still being woven in Matawai in the 1970s (Chris de Beet and Miriam Sterman, personal communication 1980). Throughout Maroon history, however, cloth supplies have been heavily dominated by imported commercial cotton.

20. Figure 239 illustrates slave dress on the Suriname River plantations of Palmeneribo-Surimobo, from which the ancestors of the Saramaka Dombi clan escaped during the second or third decade of the eighteenth century. Because this painting was made in 1707, it provides an invaluable view of the clothing, postures, musical instruments, and so on, used by the very slaves who—just a few years later—rebelled and became Maroons. Note that the men are wearing breechcloths but no covering on the upper torso and that, aside from two long gathered (apparently European) skirts, the women are wearing knee-length wraparound skirts much like those in use by Maroons today. It also appears that the man in the left foreground is wearing a soft fancy hat at a rakish angle, that another has little braids protruding from his head, and that some of the men may be wearing earrings. The tied white head kerchiefs worn by several of the dancers are identical to those which Maroons of all regions now wear in countless ritual and performative settings. Finally, infants are tied onto the backs of women in just the same way as they are among present-day Maroons, and one baby is wearing a cap identical to those worn today.

21. A contemporary account by August Kappler, who served for many years as a government "postholder" among the Djuka, confirms this picture. It describes men's dress as consiting of a breechcloth and large amounts of jewelry; mentions the wearing of iron and copper anklets and bracelets and of many rings (see also Hostmann 1850, I:279); and enumerates some of the ingredients of ritual jewelry—glass beads, beetle antennae, jaguar teeth, parrot feathers, snails, and wooden "dolls" (Kappler 1854:124).

22. Saramaccan *baáka* and Ndjuka *baaka* designate both black and dark blues; when used for cloth, these terms almost always refer to a dark navy blue.

23. The sewing on these cloths was remarkably fine, often surpassing thirty-five stitches per inch. This may be compared, for example, to Amish patchwork quilts, on which the most highly skilled seamstresses "often 'put in' twenty stitches per inch" (Bishop and Safanda 1976:6).

24. See the end of this chapter for a description of the principles used in constructing these textiles.

25. Embroidery pattern books have come from a variety of sources; those we saw in Saramaka ranged from American publications showing Santa Clauses and angels to a French booklet illustrating seventeenth- and eighteenth-century Turkish saddlebag trimmings.

26. Saramakas remembered five named styles of women's tin lanterns, each of which was popular at a particular time. Tin lanterns in current use do not, as far as we know, have distinctive names, though their subtle differences in shape and surface texture are a common topic for aesthetic discussion. (See Figure 100 for four modern examples.)

27. Expectations concerning the quantity of cloth brought back from a coastal trip have varied dramatically over the past one hundred years, depending on wages and the price of cloth, as well as the length of time spent away. Saramakas claimed that around the turn of the century men sometimes brought as many as three hundred skirt-length cloths for each wife. During the 1920s and 1930s, twelve to twenty cloths was a more usual amount, and in the 1960s most men brought between fifty and one hundred, though some provided as many as one hundred fifty, for each wife. These figures account for only about 40% of the cloth bought on the coast; the rest is given to other kinsmen and affines, used for ritual purposes and kept in storage for future needs (e.g., gifts for new wives).

28. At that time, a Suriname guilder bought the amount of cloth needed for one skirt (2 ells). By 1970, skirts and guilders were no longer equivalent units; the 1978 price for a skirt was Sf. 3–5, and even women were by then discussing buying and selling in terms of guilders (Sar. *kólu*).

29. Named patterns refer to particular arrangements of stripes (and sometimes cross-stripes), and often to specific color combinations. Further details on cloth patterns and names are given in S. Price n.d., from which this discussion has been adapted.

30. Sixty-five names were originally elicited in 1967–68 in Pikilio villages and in Pokigoon, partly on the basis of eighty-nine sample swatches of cloth kindly provided by Ahmad El-Wanni—owner of the Jeruzalem Bazaar in Paramaribo and the largest supplier of cloth to all Maroons. Ms. (now Dr.) Leslie Haviland then showed the swatches to Saramakas living in the village of Brownsweg, who concurred on just over 50% of the names. In 1976 and 1978, women on the Pikilio expanded the sample to 121 names, including many for cloth patterns which had been introduced after 1968. Although all the names and etymologies that we use were confirmed by at least a second person, no one person knew them all, and disagreement on the name of a particular cloth was not rare.

31. Saramaka proverbs often assume the same only-partially-verbalized form. For example, an old man, referring to a conjugal feud of which he did not know the origin, once commented cryptically, "the person who sleeps in the house." His companion completed the proverb mentally ("...knows where the roof leaks") and nodded in agreement.

32. Although a woman may own more than one skirt of a particular pattern, differences in age, condition, kind of hem, and minor decorative embroidery allow her to distinguish those requiring specialized uses.

33. One man explained that although he chose never to wear calf-bands, because they became stained and unsightly whenever he underwent ritual washings for a sickness, his trunks were filled with those that his wives had, nevertheless, presented to him at various times.

34. Although the result is identical to a narrow strip of Euroamerican knitting, the Maroon method is quite different and utilizes two short reeds, slit to hold the thread, rather than long needles. For a description and diagram of the stitch, which is used also by some groups of Carib Indians in the Guianas, see Roth 1924:104 and Ahlbrinck 1931:119, 444–45.

35. Until the 1930s, men also wore these; see for example, Figure 69 and van Cappelle 1902:248. Note that Maroon anklets are individual rings rather than the single long coil often found in Africa (see Sieber 1972:150).

36. For a fuller discussion of Saramaka cicatrization, see R. and S. Price 1972a, from which much of this section is adapted.

37. A "wrestling belt" (Sar. *básua tatái*) is considered an intimate, personal, and private possession. Men other than the woman's husband or lover must not see it, and in Upper River Saramaka, a woman traditionally gave it to her husband when he left for an extended trip to the coast, as a token of her intended faithfulness. Very similar beaded belts, with similar functions and associations, have been made in West Africa (see, for example, Sieber 1972: 142–43), and beads possess more general erotic associations in some African societies (Warren and Andrews 1977:15–16).

38. As one late nineteenth-century observer remarked, their clothing "is always of a jumping-at-the-eye color" (van Coll 1903:538). However, Maroons view color contrast, like other aesthetic ideals, as a principle that can be overdone, and they are critical of what they consider excesses. An unusually colorful hammock, for example, may be criticized by Saramakas as "too patterned" (*pèndê pói*) and one of their terms for color contrast (*apísi ku wána*) is frequently used in a derogatory sense.

39. Eighteenth-century Moravian diaries make clear that the use of red, white, and "black" goes back to earliest Maroon history; see, for example, Staehelin 1913–19, III iii:131.

40. Such stools, among both Amerindians and Maroons, may or may not have carrying handles, sometimes elaborated into animal heads or tails (Roth 1924:275). There are possible African models for this stool-type as well (see, for example, Sieber 1979:30). It may well have been this type of simple stool that the European commander described during the final peacemaking ceremonies with the Saramakas in 1762. While wooden trumpets blared forth their messages, and muskets fired celebratory salutes, the most important dignitaries were seated on "little blocks of wood" (Dorig 1763a).

41. Wooden door locks with a mechanism similar to that found on Maroon examples are known from ancient Egypt (Oudschans-Dentz 1935/36). They had a broad distribution in pre-colonial Africa, apparently spreading from the Sudanic region to the Gold Coast and Slave Coast, and by 1000 A.D. they were found in parts of Europe as well (Joest 1893, Lindblom 1924, van Panhuys 1925). Apparently present among plantation slaves in eighteenth-century Suriname (Hartsinck 1770:17), they continued to be made by non-Maroon Afro-Surinamers well into the twentieth century (van Panhuys 1925:273). Whether knowledge of wooden door locks arrived in Suriname via Portuguese-Brazilian slave masters or with the African slaves themselves, the style of decoration on Maroon examples has always been closely related to current Maroon woodcarving fashions.

42. Our discussion of Saramaka woodcarving history is adapted from R. Price 1970b, which provides further information (e.g., on early tools, native terms, and types of wood used) not included in this book. The chronology used is based on a combination of oral history, Saramakas' age rankings of living and dead villagers, museum documentation, and records in the Landsarchief, Paramaribo of such events as the installations and deaths of village and tribal officials. While it should be apparent that we employ the idea of "style" merely as a classificatory convenience (cf. Thompson 1969:158), we want to emphasize that both the categories and the elements or traits which define these styles were identified in the process of examining objects in the field with Saramakas, and that the classification depends substantially on their own critical distinctions.

43. The stool in Figure 175 was collected in the late 1920s by Morton Kahn, who was told that it was carved by the great granduncle of the village headman who owned it. Kahn apparently inferred from this fact that the stool had been carved c. 1850; however, on stylistic grounds we would date its manufacture at about 1890–1900 (see, for example, the stool in Figure 176, which was made in a nearby village). We suspect that Kahn—who did not speak Saramaccan and had little familiarity with the ways that kinship terms are used—mistakenly reasoned that three generations must have represented about eighty years. In fact, a man whom a Saramaka would have called his "great granduncle" could easily have been only twenty years his senior, because of the use of classificatory kin terms.

44. Saramakas assert that this technique was invented not long after Djankuso became Tribal Chief (1898), and that knowledge of the technique (and the use of compasses with which it was always executed) soon spread from the Upper River region to the rest of the tribe and to the Djuka. Their date and location for this invention—probably the most revolutionary in the history of Maroon carving—is supported by the independent dating of objects in the field, examination of museum pieces collected in the late nineteenth and early twentieth centuries, and perusal of the literature (which illustrates a number of pieces from the 1890s).

45. The only possible exception is part of the change from Style I to Style II, when augers replaced knives for piercing.

46. We are not certain whether the lintel, carved with the wood-within-wood technique, was made at the same time as the vertical pieces or was substituted some years later for the Style II lintel which normally accompanied this standard design.

47. Carving in aluminum, using hacksaws, special files, drills, and so forth, was a new craft in the 1960s, and was learned only by a few young Saramakas. The aluminum was appropriated by men working for Suralco (an Alcoa subsidiary). Yarn tassels such as that on the aluminum comb in Figure 192b are currently fashionable among youths, who use them to decorate such things as lanterns, umbrellas, and even the protective rings worn by men on their biceps. (See Chapter 2 on the somewhat older art of decorative carving on aluminum eating spoons.)

48. This particular change is, to our knowledge, the most purely local described in this chapter. Today the "paddle" form is at least occasionally made in the Middle and Lower River villages of Saramaka, and is still very common in Djuka.

49. This tin was formerly taken from old cans (as on the canoe pictured in Figure 201b). More recently tin liners from empty import crates, bought in the city, have served the same purpose (as on the canoe in Figure 201c). Two variants of the 1960s involved heating corrugated roofing metal to fit the canoe tips or using thin sheet aluminum appropriated by men working for Suralco.

50. There is at least one rival story claiming that the current design was originated by a Dangogo man working in French Guiana and was carried back to Saramaka by men from the village of Pempe—which could in fact account for its name, Pempé bêtè (bête = "gouge" or "chisel" [work]). There is no disagreement, however, about the date or suddenness of this innovation.

51. See Figure 235 for a Paramaka adaptation of this practice to calabash carving.

52. We know little about the history and characteristics of woodcarving among the Kwinti, the smallest and westernmost group of Maroons. With the recent intensive development of west Suriname for mining and industrial purposes, Kwinti life has undergone sudden and wrenching change. By 1973, woodcarving was "no longer practiced" in Kwinti villages (van der Elst 1975:201), though slides kindly provided by Dirk van der Elst suggest that influences from eastern Maroon arts had been innovatively combined with features more characteristic of central Maroon carving in the recent past. One slide, for example, depicts a three-piece door frame, constructed like those in Saramaka with carved vertical pieces, but with a lintel that is painted in typically eastern Maroon colors in a design strongly reminiscent of Saramaka lintel carving.

53. For further details on calabashes and gourds in Maroon life, see S. Price n.d., on which this chapter is based.

54. Saramakas' word for compasses (pása) is also their verb for the carving of closed calabash containers. In spite of Dark's comment that these containers are incised "in a manner consistent with having been done with a fingernail" (1951:57–58), nineteenth-century examples in museums confirm Saramakas' assertions that chisels and compasses have long been used in this role. (See, for example, Figures 221, 222a, 223a, and 224a.)

55. Linguistic traces of the complex cultural history of calabashes may be seen in Maroon terminology. The Saramaka word for calabash bowls, kúya, apparently derives from Tupi, an Indian language of Brazil; it was either carried to Suriname by the Portuguese-Brazilian slave masters (or, possibly, their accompanying slaves) from whom the original Saramakas fled, or learned directly from Indians by the original Maroons (Schumann 1778:s.v. kuja). The Saramaka word for calabash spoon, kuyêè, apparently derives via these same slave masters from the Portuguese colher (Schumann 1778: s.v. kujeri). Their word for covered calabash containers, apaki, seems to derive (like the Jamaican packy) from Twi apákyi (Cassidy and Le Page 1967:s.v. packy).

56. Several calabashes from this collection include, in addition to these colors, a red brown dye; six others exhibit glossy solid black interiors and black exteriors into which geometric designs have been scraped. The calabash in Figure 216 is the only one in this entire set which museum records (made in the late nineteenth century) attribute to Maroons.

57. For further sources on these techniques of Amerindian calabash decoration, see Métraux 1928:108–09.

58. Peter Kloos, for example, reports that coastal Caribs do not decorate calabash utensils (personal communication, 1978), and Peter Rivière, who remembered having seen incised calabashes among the Trio in the early 1960s, was unsuccessful in a 1978 field search (kindly conducted on our behalf) for an example or an artist capable of carving one for us (personal communication, 1978).

59. What have often been referred to as "calabashes" in Africa were (and are) more frequently made from vine-grown gourds than from the fruit of the calabash tree. This means that seventeenth- and eighteenth-century African-born Surinamers would have been bringing together an established artistic style with a new technique for its production. Furthermore, differences in the physical features of gourds and calabashes may explain certain important stylistic differences between African gourd decoration and later Maroon calabash art. It is at least possible, for example, that the smoother, harder, and less porous interior surface of the calabash shell contributed importantly to the nineteenth-century creation, in the New World, of an art of interior carving which had never been developed on African gourds.

60. Although the donor listed this rattle as one of twelve objects collected "during an expedition to the Maroons," the description of its use by an Afro-Surinamese dance society suggests that it was actually acquired on the coast, since Maroons did not, to our knowledge, have such societies. For a discussion of the rest of this collection, which represents the earliest documented assemblage of Maroon artifacts extant today, see R. and S. Price 1979.

61. Such "bi-cultural" artistry is not limited to the interchange between Maroons and other Afro-Surinamers. There are several examples in this book of Maroons embellishing Western manufactured objects (such as carpentry planes and metal spoons). Such interchange has also been part of Maroon-Amerindian relations, and Amerindians have occasionally painted their own characteristic designs onto finely carved Maroon paddles which they obtained in trade; for one example, see Dark 1954: Plate 22C.

62. Matawais also sometimes incise linear designs, without scraping the adjacent surfaces (Figure 232 (2a)–(2c)).

63. Another aspect of regional variation involves the differential rates at which calabashes are being replaced by commercial utensils purchased in coastal society. The Kwinti, for example, use calabashes only rarely and incise them very crudely (Dirk van der Elst, personal communication, 1979) and Hurault states that in Aluku carved calabashes had, by the 1960s, "almost totally disappeared, replaced by imported utensils" (1970:116). In contrast, in Upper River Saramaka the only form to have dropped out of regular daily use is the "small spoon," which is now principally used for ritual occasions, particularly burial rites.

64. Similarly, Holm has demonstrated the sensitivity of Northwest Coast Indian artists to the contours of ground areas ("negative space") and has traced the origin of certain of their figures to the gradual standardization of these (back)ground areas. That is, particular shapes (in painted wood, weaving, appliqué, and silverwork) which began as carefully controlled backdrops to the design have evolved, over time, into elements of the design itself (1965:57, 80–82).

65. More generally, condensation is a common process in Maroon speech and performance. We have given several linguistic examples in our discussion of cloth names (see Chapter 3); highly condensed versions of a tale (often crystallized in a song) are used as "interruptions" in tale-telling sessions to stand for the full versions (see below); and we will see also that the most stylized dance performances involve the creative condensation of a wide range of everyday experience.

66. These play languages are structured by rules for the distortion of words from their own and other languages and are intensely enjoyed as a vehicle for the expression of peer group exclusivity (R. and S. Price 1976; Hurault 1970:19).

67. There is a striking similarity between many of these aesthetic principles of performance and those discussed for the British West Indies in Roger Abrahams' pioneering paper (1967). Were this a more extended presentation, we would discuss yet other important, if somewhat more limited, features of Maroon performance. For example, the stylistic device of "the intrusive I" (Abrahams 1967:472–74) is used in many verbal contexts. A man recounting a local scandal introduces the story by a detailed account of who told him and exactly what he was doing when he heard of it; a woman interrupting a folk tale with a condensed piece of another tale begins by stating that she was an actual eyewitness to the episode; and an older man transmitting historical knowledge to a younger kinsman always begins his account by specifying the circumstances in which he first heard of the events he is about to relate.

68. Multi-media "plays" are a widespread historical aspect of Afro-American life (see, for example, Szwed and Abrahams 1977). It is worth noting that the term "play," generally used by Euro-Americans with an implied contrast to "work" or seriousness, is widely used by Afro-Americans to refer to "*the* activity by which Afro-American individuality is asserted and maintained" (Szwed and Abrahams 1977:78, their italics).

69. We do not cite here the detailed documentary sources on which this paragraph is based. A fuller discussion of the early history of Maroon performance is included in R. Price n.d.1.

70. Many of these historically continuous features of Maroon performance are widespread elsewhere in Afro-America, and one could delineate such similarities between the uses of the body—posture, gesture, voice, and so on—among Maroons and many African peoples as well. In a still unpublished study, Thompson takes on this task in some detail, comparing, for example, the characteristic "stuttering" of people possessed by snake gods, "possession faces," and the "getting down" dance position on both sides of the Atlantic (Thompson 1980). Hoetink (following Herskovits, Brathwaite, and others) has recently argued more generally:

> If one were to denote the culture common to the Afro-American population group as a whole, in terms of unadulterated 'Africanisms,' the ego- and body-oriented elements (motoric and rhythmic behavior, facial and corporal gestures, the body as a vehicle of transportation and as an aesthetic object) should be considered its most important attributes [1979:30–31].

The complexities of tracing such continuities through time are discussed in Chapter 8.

71. Our knowledge of the Maroon arts of performance depends more heavily on our personal experiences in Saramaka than does our knowledge of the other arts. Unlike the plastic and graphic arts, which can be studied in part through museum collections, the arts of performance are impermanent, and aside from a phonograph record and an excellent film made in Aluku (Hurault 1968, n.d.), and a set of research recordings and a briefer film made in Djuka (Thoden van Velzen and van Wetering n.d., Thoden van Velzen 1965) there are very few materials available on performance among the eastern Maroons.

72. Among the Matawai, who have been strongly influenced by the Moravian church for the last century, the *apínti* drum (which missionaries associated with spirit possession) has long been forbidden. During the early 1970s, the major Matawai dance form (*bandja*) was performed to the accompaniment of drum substitutes—soap crates, enamel pots, and kerosene tins, all beaten with sticks. *Apínti* drums were reintroduced at the urging of Matawai Chief Abone following his eye-opening 1972 trip to Africa, but because local men no longer knew how to make them they had to be bought from Saramakas (Chris de Beet and Miriam Sterman, personal communication, 1980).

73. Similar singing is reported for the eighteenth-century slaves who rowed barges between the plantations: "it is to them peculiarly animating, and may, together with the sound of their oars, be heard at a considerable distance" (Stedman 1796, II:258). Such singing manifested the characteristic call-and-response structure, with "one person constantly pronouncing a sentence extempore, which he next hums or whistles, and then all the others repeat the same in chorus; another sentence is then spoken, and the chorus is a second time renewed, &c." (*Ibid.*)

74. The Surinamese ethno-musicologist Terry Agerkop is now conducting investigations which should greatly enrich our understanding of all aspects of Saramaka music.

75. There are significant regional differences in drum construction, as in other aspects of Maroon material life. For example, Saramaka *agidá* drums are normally pegged parallel to the body, like the one in Figure 247, while Djuka *agida* usually have nearly perpendicular pegs inserted through holes. (Some *agidá* drums in the Saramaka village of Dangogo have typically-Djuka pegging, because this technique was borrowed in the late nineteenth century by a Dangogo visitor to the Tapanahoni.)

76. The origins of the form of the *apínti*, once simply presumed to be Akan, now appear to be more complex. The most recent work on the subject suggests that in the seventeenth and eighteenth centuries peoples of both the Slave Coast and the Gold Coast had drums of this general type—Ewe *kagan*, Yoruba *apínti*, Akan *apentemma* (Thompson 1980). The drum's "praise name" for itself, played at the beginning of each Saramaka *apínti* performance, refers specifically to Asante.

77. The separate origins of these "gongs" in *komantí* (warrior god) and *papá* performances are reflected in their Saramaka names. In the former rites, which in Saramaka ideology are related to Asante, the instrument is known as *dáulo* (apparently from Twi *adawuru*), while in the latter—which preserves in the name *papá* the seventeenth/eighteenth-century Yoruba term for Coastal Ewe, "Popo"—the instrument is called *gan* (from the identical Ewe word).

78. Closely related Afro-American rasp instruments include the recently obsolete coastal Suriname *grumi* (Wooding 1972:530) and the eighteenth-century Jamaican *goombah* (Long 1774, II:423–24).

79. We believe that wooden horns were always closely associated with funerals. Today, in Saramaka, Western bugles are used extensively by the "gravediggers" association, as they travel the river from village to cemetery and back. African wooden signal trumpets, played like Maroon ones through a hole in the side, have a wide historical distribution on that continent (Lindblom 1924:68–70). Lindblom's attempt to pin down the African origins of the Maroon trumpet, however, pays too little attention to the variation evident among extant Maroon examples (*Ibid.*). The *abeng* of the Jamaican Maroons, though usually fashioned from cow-horn, is also blown through a hole in the side and used in very similar ways to the Suriname Maroon signal trumpet (see, for example, Cassidy and Le Page 1967:2).

80. For the fullest single study of the very widespread African instruments often called *mbira* or *sanzhi*, see Berliner 1978. The term *bèntá* derives from West African words for "musical bow," e.g. Twi *ɔ-bèntá* and Ewe *beta*. Afro-American musical bows are also reported for Jamaica (*benta* or *bender*) and Curaçao (*benta*) (Cassidy and Le Page 1967:38; van Meeteren 1947:39–40).

81. The fact that the preferred Maroon chordophone during the late eighteenth century was apparently the *gólu bèntá*, while plantation slaves of that era preferred the banjo (*banja*), may reflect the changing demography of slave importation through time. The Dutch slave trade began to draw on the "Windward Coast" area only toward the middle of the century (see Chapter 8), and the greatest formal parallels between African and Suriname "banjos" seem to stem from this region. By this time, Saramakas and Djukas were already many decades removed from the plantation world in terms of the development of their own cultural forms.

82. *Apúku-tôngò*, *Komantí*, *Púmbu*, and *Papá* are the esoteric languages most frequently used by Saramakas for proverbial allusion. These represent, respectively, the speech attributed to forest spirits, that used by warrior gods, and two languages which Saramakas associate closely with their early ancestors.

83. These associations are reflected in the special restrictions on telling both riddles and tales. Tales may never be told in Saramaka villages except at wakes, and riddling sessions occur only at night. Although tales may be told for evening entertainment in horticultural camps, the conventional introduction to each must then be changed to another form; Saramakas, for example, substitute the exchange used in riddling (*Híliti/Dáiti*) in place of the "heavier" form which must precede all tales told at wakes (*Mató/Tòngôni*).

84. The riddling session excerpted here was conducted at our request. In contrast, the two tales represent condensed paraphrases of performances which we recorded during actual wakes. The original field recordings of these tales, together with their full transcription in Saramaccan, form part of a large collection of verbal and musical materials that we have deposited in the Archives of Traditional Music, Indiana University.

85. We should emphasize that the relevant gap in this case is a cultural rather than a "racial" one. This in no way denies that the history and culture of the Maroons can hold very special meaning for other Afro-Americans; but the empathy based on a partially shared past does not carry with it cultural knowledge, and ideologically motivated attempts to equate the two (see, for example, Counter and Evans n.d.) do an injustice to the vitality, creativity, and originality of Afro-American peoples throughout the New World. Maroons themselves—whose current ideology may be more intensely focused on their historical struggles with whites than is that of any other Afro-American people—recognize this distinction clearly in classifying non-Maroon Afro-Americans, along with whites, as "outsiders" (Saramaccan *bakáa*, Ndjuka *bakaa*) both linguistically and in terms of the prohibitions which apply to their behavior in Maroon territories.

86. Several of the issues addressed in this chapter were first explored in R. Price 1972, though our understanding of meaning in the Maroon arts has evolved considerably since that time.

87. It is interesting that the Herskovitses' claims about the importance of iconography in Maroon art refer largely to the very villages where we conducted our fieldwork, and to a time (1928–29) which was well remembered by many Saramakas we know. (Indeed, we shared at least two "informants," who described the Herskovitses in some detail and reminisced about providing songs for their wax cylinder recording device.)

88. Commentators on eastern Maroon arts such as van Panhuys and Kahn, who have devoted great attention to their representational potential (see below), nevertheless make clear that "symbolism" is rare (see, for example, Kahn 1931:198–99 and van Panhuys 1928). Hurault has argued for the importance of a central and pervasive sexual symbolism in Aluku woodcarving, from its beginnings until well into the twentieth century (1970), but for methodological reasons, we do not find his case persuasive (see R. Price 1972).

89. The eastern Maroons may be more generally inclined to convey messages through conventionalized signs; women have sometimes braided messages into their husband's or lover's hair, and one famous pattern was specifically intended to "poke at" (insult) a co-wife without having to confront her directly.

90. A good deal of scholarly controversy surrounds the Afaka script. More than a dozen relevant references are listed in R. Price 1976:61, and Robert Farris Thompson is currently preparing an anthology of studies comparing various similar Afro-American and African scripts.

91. As we saw in Chapter 6, Maroon verbal arts are imbued with rich symbolism, with key words or images standing for whole complexes of philosophical ideas (and the same can be said of Maroon ritual). Although Maroons—for whatever reasons—do not generally use their graphic and plastic arts for this kind of developed symbolic communication, the existence of such types of communication in other areas of their lives may predispose them to consider more favorably outsiders' insistence on pervasive iconography.

92. When we reported the interpretations that the Herskovitses had assigned to woodcarving motifs, Saramakas were insistent that they were fanciful fabrications. Their claim (1934:280) that a crescential motif represented an erect penis was particularly perplexing to one man; the day after we discussed it, he came to visit us and, after apologizing for his ignorance on the matter, asked if perhaps *white* men's penises were curved like that.

93. It was the Dutch anthropologist André Köbben who first used the concept of "continuity in change" in considering a Maroon society through time (1968).

94. This several-page section on "The Early Years" draws extensively on ideas (and often on the actual prose) of two earlier publications which contain fuller expositions of the central argument as well as detailed supporting evidence (R. Price 1976:6–22 and Mintz and Price 1976:4–11, 22–26 *et passim*). In adapting these earlier statements to the needs of this section, we have found it more graceful, stylistically, not to separate quotations or paraphrases from the surrounding prose. We are grateful to Sidney W. Mintz for permission to use materials from the Mintz and Price study in this way.

95. In general, Amerindian influence has been far greater on technical than on conceptual aspects of Maroon life. Fish drugs, bows and arrows, and traps as well as a large variety of hunting techniques were learned from the Indians. A wide range of Indian basketry forms—including the manioc press and sieve, a variety of containers, and several kinds of fire fans—have always been an important part of Maroon daily subsistence (Color Plate IV, Figures 20, 257; see also Wilbert 1975:56–57, 76–77 and Yde 1965:255). The Amerindian techniques for constructing calf-bands and for split-reed "knitting" were taken over (see Roth 1924:104–05), and adolescent girls wear "aprons" which closely resemble those of Amerindian women, and are called by their Amerindian name (Figures 43, 52, 109).

96. In this regard, Herskovits argued that "cultural stability derives from the fact that so much of socially sanctioned behavior lodges on a psychological plane that lies *below the level of consciousness*" (1952b:147, his italics). His students Simpson and Hammond have pointed out that:

> Form is the most superficial level of cultural reality. Since it is consciously realised, it is often much quicker to change than the profounder philosophic principles and psychological attitudes which are frequently more persistent and tenacious because they exist beneath the level of consciousness [1957:50].

Likewise, our "deep-level cultural principles" (like the grammar of a language) may often exist on a non-conscious level (see Mintz and Price 1976:6).

97. See Chapter 5 for a discussion of the distinction between the creeping vine which has produced most of the shells used in African "calabash" art and the tree which has provided the fruit for all Maroon calabash decoration.

98. If our proposed beginning dates stand the test of time, there of course remains the question of why the first half of the nineteenth century witnessed this sudden artistic efflorescence. From a Western perspective about the "place" of the arts, it may not seem surprising that Maroons created new languages, political systems, and methods of horticulture before they elaborated their visual arts, but such a view holds little relevance for an understanding of Maroon life. Certainly, the answer to this puzzle must in some way relate to the more general processes of culture-building already discussed and to the overall role of these arts within the broader context of Maroon culture; but we do not yet feel in a position to propose a satisfactory solution.

99. More generally, it is worth noting that the Maroons who first developed and elaborated such arts as woodcarving, embroidery, or interior calabash decoration in the course of the nineteenth century were at least third- and fourth-generation Surinamers. The relative lateness of the development of these arts—compared, say, to language, ritual, or political organization—is undoubtedly related to the degree of their stylistic discontinuity with African models.

100. We are very grateful to William C. Sturtevant for bringing the Alsatian chair to our attention.

101. It was to explain such independent invention of similar cultural forms by widely separated peoples that early twentieth-century anthropologists coined the "Principle of Limited Possibilities" (see, for example, Goldenweiser 1913). More recently, Sturtevant has presented an excellent methodological critique of the reconstruction of culture history from the spatial distribution of cultural traits, and has gone on to argue that certain formal similarities between the aboriginal cultures of southeastern North America and the Antilles cannot be construed as proof of historical contact (1960). Caso, in reevaluating the case for cultural diffusion between the Old and New Worlds, has argued on the basis of a large number of fascinating examples that "resemblances of form have very little value as evidence [of historical connection] even when they are obvious" (1964:55). Long ago, Lowie stated the general case more boldly: "The sensible traits of an ethnographic object may determine its character from the standpoint of a curiosity dealer, but never from that of a scientific ethnologist" (1912:331).

102. William Fagg, the eminent Africanist, has come to similar conclusions based purely on the examination of museum collections of Maroon art:

> Some writers, like Kahn, have spoken in somewhat unspecific terms, of the markedly West African character of Bush Negro art forms, but most Africanists who have considered the matter have rather been struck by a conspicuous lack of similarity between them and the generality of West African sculpture. The parallels adduced have, to me at least, seemed unconvincing [Fagg 1952:121; see also Hurault 1970:80 for a similar assessment].

103. The meaning of Africa to Maroons is multifaceted as well as changing. To explore it would require a discussion of complex ideology, historical awareness, and ethnic identity not possible here. (A book on these issues is currently in preparation [R. Price n.d.2].) It would be a grave error, however, to assume that it simply conforms to current views of other descendants of Africans in the New World. In terms of art history, one of the weakest links in the focus on "Africanisms" is the common imputation to Maroons of a conscious awareness of the "Africanness" of particular forms, or an attempt to remain faithful to some notion of original African art styles. As we have tried to show, forms and styles such as the three cited above as "African-looking" are in no way viewed as such by Maroons, who see them rather as outgrowths of creative artistic innovations by particular Maroon individuals from known villages and time periods. (On the important distinction between "Africanisms" and *consciousness* of Africanisms, see Hoetink 1979:37.)

104. At certain times, especially in programmatic statements made in his later years, Herskovits himself recognized the need for such a re-orientation: "Culture contact," he wrote, "produces cultural change, and ... cultures of multiple origin do not represent a cultural mosaic, but rather become newly reintegrated" (1958:xxiii). Mintz and Price have stated the position more boldly: "The Africans in any New World colony in fact became a *community* and began to share a *culture* only insofar as, and as fast as, they themselves created them" (1976:7).

105. These transatlantic similarities are part of a more general African/Afro-American pattern of names, naming, and name use for persons, organizations, vehicles, manufactured domestic objects, and so on (see Dillard 1976).

106. Note that Maroon textiles have never been "edge-sewn" like African narrow-strip cloths, but are rather pieced together through a combination of seaming and hemming (see Chapter 3). This difference is directly related to the fact that Maroon strips are ripped or cut from larger pieces of cloth and therefore have no bound selvage that could hold stitching along the edge.

107. Because Saramakas did not comment on the slightly staggered alignment of stripes which often occurred in the middle section of such capes, we cannot say whether this contributed to their aesthetic appeal.

108. In a characteristically insightful suggestion, Herskovits—though he had little of the requisite historical or ethnographic data at hand—pointed to unspecified "aesthetic patterns [that] are ... found to lodge deep beneath the level of consciousness," and credited their "retention" with producing "the cloths of the Bush Negroes, which are made of strips cut from bolts of striped cloth, across the design, and similarly sewed edge to edge to make an African-like covering" (1952b:148). We might add that the dynamic Afro-American quilting tradition in the United States presents potential historical parallels to the Maroon case. We have seen photographs of a number of quilts that show a strong visual resemblance to Maroon bits-and-pieces and narrow-strip textiles (see, for example, Vlach 1978: Plates 67 and 50 *et passim*), but the historical research necessary to reconstruct this art in the United States is still in a very early stage.

REFERENCES CITED

Abrahams, Roger D.
1967 "The Shaping of folklore traditions in the British West Indies." *Journal of Inter-American Studies* 9:456–80.

Ahlbrinck, W.
1931 "Encyclopaedie der Karaïben." *Verhandelingen der Koninklijke Akademie van Wetenschappen te Amsterdam* Afdeeling Letterkunde, Nieuwe Reeks 27:1–555.

Armstrong, Robert Plant
1971 *The affecting presence.* Urbana: University of Illinois Press.

Barbot, John
1732 "A description of the coasts of North and South Guinea." In *A collection of voyages and travels,* Awnsham Churchill (ed.), London, vol. 5.

Bastide, Roger
1967 *Les Amériques noires.* Paris: Payot.

Bates, Henry Walter
1873 *The naturalist on the river Amazons.* Third edition. London: John Murray.

de Beet, Chris and H. U. E. Thoden van Velzen
1977 "Bush Negro prophetic movements: religions of despair?" *Bijdragen tot de Taal-, Land- en Volkenkunde* 133:100–35.

Behn, Aphra
1688 *Oroonoko or the royal slave: a true history.* London: W. Canning.

Benoit, P. J.
1839 *Voyage à Surinam: description des possessions néerlandaises dans la Guyane.* Bruxelles: Société des Beaux-Arts.

Berliner, Paul
1978 *The soul of mbira: music and traditions of the Shona People of Zimbabwe.* Berkeley: University of California Press.

Bishop, Robert and Elizabeth Safanda
1976 *A gallery of Amish quilts: design diversity from a plain people.* New York: Dutton.

Bonaparte, Prince Roland
1884 *Les habitants de Suriname, notes recueillies à l'exposition coloniale d'Amsterdam en 1883.* Paris: A. Quantin.

van Cappelle, H.
1902 "Bij de Indianen en Boschnegers van Suriname." *Elsevier's Geillustreerd Maandschrift* 23:240–51, 310–23, 370–83.

Carpenter, Edmund
1973 "You can't unring a bell." Talk presented May 12, 1973 at the Smithsonian Institution, Washington, D.C.

Caso, Alfonso
1964 "Relations between the Old and New Worlds: a note on methodology." *Proceedings of the 35th International Congress of Americanists,* vol. 1 (Mexico, 1962):55–71.

Cassidy, F. G. and R. B. Le Page
1967 *Dictionary of Jamaican English.* Cambridge: Cambridge University Press.

Cateau van Rosevelt, J. F. A. and J. F. A. E. van Lansberge
1873 "Verslag van de reis ter opname van de Rivier Suriname." In W. R. Menkman, "Uit de geschiedenis der opening van het Surinaamsche binnenland," *De West-Indische Gids* 27 (1946):182–92, 289–99, 321–43.

Chappel, T. J. H.
1977 *Decorated gourds in north-eastern Nigeria.* Lagos: Federal Department of Antiquities.

van Coll, C.
1903 "Gegevens over land en volk van Suriname." *Bijdragen tot de Taal-, Land- en Volkenkunde* 55:451–635.

Coster, A. M.
1866 "De Boschnegers in de kolonie Suriname, hun leven, zeden, en gewoonten." *Bijdragen tot de Taal-, Land- en Volkenkunde* 13:1–36.

Counter, S. Allen, Jr. and David L. Evans
n.d. *The Bush Afro-Americans of Surinam and French Guiana: The Connecting Link.* Pamphlet.

Crevaux, Jules
1879 "Voyage d'exploration dans l'intérieur des Guyanes, 1876–77." *Le Tour du Monde* 20:337–416.

1883 *Voyages dans l'Amérique du Sud, 1878–1881.* Paris: Hachette.

Crowley, Daniel J.
1956 "Bush Negro combs: a structural analysis." *Vox Guyanae* 2:145–61.

Curtin, Philip D.
1969 *The Atlantic slave trade: a census.* Madison: University of Wisconsin Press.

Dark, Philip J. C.
1951 "Some notes on the carving of calabashes by the Bush Negroes of Surinam." *Man* 51:57–61.
1954 *Bush Negro Art: an African art in the Americas.* London: Tiranti.

Dillard, J. L.
1976 *Black names.* The Hague: Mouton.

Dorig, J. C.
1763a "Journaal." Archives of the Societeit van Suriname 155, 20 April 1763. The Hague: Algemeen Rijksarchief. Unpublished document.
1763b "Journaal." Archives of the Societeit van Suriname 155, 15 November 1763. The Hague: Algemeen Rijksarchief. Unpublished document.

Eilerts de Haan, J. G. W. J.
1910 "Verslag van de expeditie naar de Suriname-Rivier." *Tijdschrift van het Koninklijk Nederlandsch Aardrijkskundig Genootschap (2e serie)* 27:403–68, 641–701.

Epstein, Dena J.
1977 *Sinful tunes and spirituals: Black folk music to the Civil War.* Urbana: University of Illinois Press.

van Eyck, J. W. S.
1830 "Beschouwing van den tegenwoordigen staat, zeden en gewoonten van de Saramaccaner bevredigde Boschnegers, in deze kolonie." In *Surinaamsche almanak voor het jaar 1830.* Amsterdam: C. G. Sulpke, pp. 260–77.

Fagg, William
1952 "Notes on some West African Americana." *Man* 52:119–22.

Fermin, Phillippe
1769 *Déscription générale, historique, géographique et physique de la colonie de Surinam.* Amsterdam: E. van Harrevelt.

Franssen Herderschee, A.
1905 "Verslag van de Gonini-expeditie." *Tijdschrift van het Koninklijk Nederlandsch Aardrijkskundig Genootschap* 22:1–174.

de Goeje, C. H.
1908 "Verslag der Toemoekhoemoek-expeditie." *Tijdschrift van het Koninklijk Nederlandsch Aardrijkskundig Genootschap* 25:943–1169.

Goldenweiser, A. A.
1913 "The principle of limited possibilities in the development of culture." *Journal of American Folklore* 26:259–90.

Griaule, Marcel and Germaine Dieterlen
1935 "Calebasses Dahoméennes." *Journal de la Société des Africanistes* 5:203–07.

Hartsinck, Jan Jacob
1770 *Beschrijving van Guyana of de Wilde Kust in Zuid-Amerika.* Amsterdam: Gerrit Tielenburg.

Herlein, J. D.
1718 *Beschryvinge van de Volk-plantinge Zuriname.* Leeuwarden: Meindert Injema.

Herskovits, Melville J.
1930 "Bush Negro art." Reprinted in *The New World Negro,* Frances S. Herskovits (ed.), Bloomington, Indiana University Press, 1966, pp. 157–67.
1952a "Note sur la divination judiciaire par le cadavre en Guyane Hollandaise." In *Les afro-américains. Mémoires de l'Institut Français d'Afrique Noire* 27:187–92.
1952b "Some psychological implications of Afro-American studies." Reprinted in *The New World Negro,* Frances S. Herskovits (ed.), Bloomington, Indiana University Press, 1966, pp. 145–55.
1958 "Preface to the Beacon Press edition." In *The myth of the Negro past,* Boston, Beacon, pp. xv–xxix.

Herskovits, Melville J. and Frances S. Herskovits
 1934 *Rebel destiny: among the Bush Negroes of Dutch Guiana.* New York: McGraw-Hill.
Hoetink, Harry
 1979 "The cultural links." In *Africa and the Caribbean: the legacies of a link,* Margaret E. Crahan and Franklin W. Knight (eds.), Baltimore and London, Johns Hopkins University Press, pp. 20–40.
Holm, Bill
 1965 *Northwest Coast Indian art: an analysis of form.* Seattle and London: University of Washington Press.
Hostmann, F. W.
 1850 *Over de beschaving van negers in Amerika door kolonisatie met Europeanen.* Amsterdam: J. C. A. Sulpke.
Hurault, Jean
 1961 *Les Noirs Réfugiés Boni de la Guyane Française.* Mémoires de l'Institut Français d'Afrique Noire (Dakar) 63.
 1968 *Musique Boni et Wayana de Guyane.* Phonograph record. Paris: Collection Musée de l'Homme.
 1970 *Africains de Guyane: la vie matérielle et l'art des Noirs Réfugiés de Guyane.* Paris—The Hague: Mouton.
 n.d. *Les funérailles de Kotoïda.* 16mm. color film with sound.
Inverarity, Robert Bruce
 1971 *Art of the Northwest Coast Indians.* Berkeley: University of California Press.
Joest, Wilhelm
 1893 "Ethnographisches und Verwandtes aus Guyana." *International Archives of Ethnography* 5, supplement.
Johnston, Harry H.
 1910 *The Negro in the New World.* London: Methuen.
Jones, LeRoi
 1967 *Black Music.* New York: William Morrow.
Kahn, Morton C.
 1931 *Djuka: the Bush Negroes of Dutch Guiana.* New York: The Viking Press.
 1939 "Africa's lost tribes in South America; an on-the-spot account of blood-chilling African rites of 200 years ago preserved intact in the jungles of South America by a tribe of runaway slaves." *Natural History* 43:209–15, 232.
 1954 "Little Africa in America: the Bush Negroes." *Américas* 6(10): 6–8, 41–43.
Kappler, August
 1854 *Zes jaren in Suriname.* Utrecht: W. F. Dannenfelser.
Köbben, A. J. F.
 1968 "Continuity in change: Cottica Djuka society as a changing system." *Bijdragen tot de Taal-, Land- en Volkenkunde* 124:56–90.
Koch-Grünberg, Theodor
 1910 *Zwei Jahre unter den Indianern. Reisen in Nordwest Brasilien, 1903–05.* Berlin.
Lamb, Venice
 1975 *West African weaving.* London: Gerald Duckworth.
van Lelyveld, Th.B.
 1919/20 "De kleeding der Surinaamsche bevolkingsgroepen in verband met aard en gewoonten." *De West-Indische Gids* 1:249–68, 458–70; 2: 20–34, 125–43.
Lindblom, Gerhard
 1924 *Afrikanische Relikte und Indianische Entlehnungen in der Kultur der Busch-Neger Surinams.* Gothenburg: Elanders Boktryckeri Aktiebolag.
 1927 *Fighting-bracelets and kindred weapons in Africa.* Stockholm: Riksmuseets Etnografiska Avdelning.
Lomax, Alan
 1970 "The homogeneity of African-Afro-American musical style." In *Afro-American anthropology,* N. Whitten and J. Szwed (eds.), New York, Free Press, pp. 181–201.
Long, Edward
 1774 *The history of Jamaica.* London: T. Lowndes.
Lowie, Robert H.
 1912 "On the principle of convergence in ethnology." Reprinted in *Lowie's selected papers in anthropology,* Cora Du Bois (ed.), Berkeley, University of California Press, 1960, pp. 312–35.
Martin, K.
 1886 "Bericht über eine Reise ins Gebiet des Oberen Surinam." *Bijdragen tot de Taal-, Land- en Volkenkunde* 35:1–76.
van Meeteren, Nicolaas
 1947 *Volkskunde van Curaçao.* Willemstad, Curaçao.
Métraux, Alfred
 1928 *La civilisation matérielle des tribus Tupi-Guarani.* Paris: Paul Geuthner.
Mintz, Sidney W.
 1974 "The Caribbean region." In *Slavery, colonialism, and racism,* Sidney W. Mintz (ed.), New York, Norton, pp. 45–71.
Mintz, Sidney W. and Richard Price
 1976 *An anthropological approach to the Afro-American past: a Caribbean perspective.* Philadelphia: I.S.H.I.
Muntslag, F. H. J.
 1966 *Tembe: Surinaamse houtsnijkunst.* Amsterdam: Prins Bernhard Fonds.
 1979 *Paw a paw dindoe: Surinaamse houtsnijkunst.* Paramaribo: VACO.
Nassy, David de Ishak Cohen, *et al.*
 1788 *Essai historique sur la colonie de Surinam.* Paramaribo.
Neumann, Peter
 1961 "Eine verzierte Kalebassenschüssel aus Suriname." *Veröffentlichungen des Städtischens Museums für Volkerkunde zu Leipzig* 11:481–98.
Newton, Douglas
 1978 "Primitive art: a perspective." In *Masterpieces of primitive art,* Lee Boltin and Douglas Newton, New York, Alfred A. Knopf, pp. 27–47.
Oudschans-Dentz, Fred.
 1935/36 "Het boschnegerdeurslot: zijn oorsprong en toepassing." *De West-Indische Gids* 17:228–30.
Oudschans-Dentz, Fred. and Herm. J. Jacobs
 1917 *Onze West in beeld en woord.* Amsterdam: J. H. de Bussy.
van Panhuys, L. C.
 1899 "Toelichting betreffende de voorwerpen verzameld bij de Aucaner Boschnegers." In *Catalogus der Nederlandsche West-Indische tentoonstelling te Haarlem,* pp. 74–82.
 1905a "Verslag omtrent de door de Gonini-expeditie medegebrachte afdrukken van ornamenten." *Tijdschrift van het Koninklijk Nederlandsch Aardrijkskundig Genootschap* 22:168–74.
 1905b "Verslag omtrent de door de Tapanahoni-expeditie medegebrachte afdrukken van ornamenten." *Tijdschrift van het Koninklijk Nederlandsch Aardrijkskundig Genootschap* 22:1022–32.
 1908 "Iets over de Marowijne rivier en hare geschiedenis." *Bulletin van het Koloniaal Museum te Haarlem* 12:15–66.
 1925 "Contribution à l'étude de la distribution de la serrure à chevilles." *Journal de la Société des Américanistes, Paris* 17:271–74.
 1928 "Quelques ornements des nègres des bois de la Guyane Néerlandaise." *Proceedings of the International Congress of Americanists* 22:231–74.
 1930 "Ornaments of the Bush-Negroes in Dutch Guiana: a further contribution to research in Bush-Negro art." *Proceedings of the International Congress of Americanists* 23:728–35.
 1934a "African customs and beliefs preserved for two centuries in the interior of Dutch Guiana." *Proceedings of the International Congress of Anthropological and Ethnological Sciences* 1:247–48.
 1934b "Die Bedeutung einiger ornamente der Buschneger von Niederländisch Guyana." *Proceedings of the International Congress of Americanists* 24:196–206.
van de Poll, Willem
 1951 *Suriname: een fotoreportage van land en volk.* The Hague: W. van Hoeve.
 1959 *Suriname.* Paramaribo: Varecamp; the Hague: W. van Hoeve.
Postma, Johannes
 1976 "The Dutch slave trade: a quantitative assessment." In *La

traite des noirs par l'Atlantique: nouvelles approches, Paris, Société Française d'Histoire d'Outre-Mer, pp. 232–44.

Price, Richard
 1970a "Saramaka emigration and marriage: a case study of social change." *Southwestern Journal of Anthropology* 26:157–89.
 1970b "Saramaka woodcarving: the development of an Afroamerican art." *Man* 5:363–78.
 1972 "The Guiana Maroons: changing perspectives in 'Bush Negro' studies." *Caribbean Studies* 11(4):82–105.
 1975a "KiKoongo and Saramaccan: a reappraisal." *Bijdragen tot de Taal-, Land- en Volkenkunde* 131:461–78.
 1975b *Saramaka social structure: analysis of a Maroon society in Surinam.* Caribbean Monograph Series 12. Rio Piedras: Institute of Caribbean Studies of the University of Puerto Rico.
 1976 *The Guiana Maroons: a historical and bibliographical introduction.* Baltimore and London: Johns Hopkins University Press.
 1979a "Kwasimukamba's gambit." *Bijdragen tot de Taal-, Land- en Volkenkunde* 135:151–69.
 1979b *Maroon societies: rebel slave communities in the Americas.* (Edited, with a new afterword, by Richard Price.) Baltimore and London: Johns Hopkins University Press.
 n.d.1 "The making of an Afro-American people: Saramaka culture and society in the eighteenth century." Book in preparation.
 n.d.2 "Those times shall come again: the Saramaka vision of their formative years." Book in preparation.

Price, Richard and Sally Price
 1972a "*Kammbá:* the ethnohistory of an Afro-American art." *Antropologica* 32:3–27.
 1972b "Saramaka onomastics: an Afro-American naming system." *Ethnology* 11:341–67.
 1976 "Secret play languages in Saramaka: linguistic disguise in a Caribbean creole." In *Speech play,* Barbara Kirshenblatt-Gimblett (ed.), Philadelphia, University of Pennsylvania Press, pp. 37–50.
 1977 *Music from Saramaka: a dynamic Afro-American tradition.* Phonograph record with ethnographic notes. New York: Folkways Records FE 4225.
 1979 "John Gabriel Stedman's collection of 18th-century artifacts from Suriname." *Nieuwe West-Indische Gids* 53:121–40.

Price, Sally
 1978 "Reciprocity and social distance: a reconsideration." *Ethnology* 17:339–50.
 n.d. "Saramaka artistry." Ph.D. dissertation in preparation, Johns Hopkins University.

Rattray, R. S.
 1927 *Religion and art in Ashanti.* Oxford: Oxford University Press.

Riemer, Johann Andreus
 1801 *Missions-Reise nach Suriname und Barbice zu einer am Surinamflusse im dritten Grad der Linie wohnenden Freinegernation.* Zittau und Leipzig.

Roth, Walter Edmund
 1924 "An introductory study of the arts, crafts, and customs of the Guiana Indians." *Thirty-eighth Annual Report of the Bureau of American Ethnology,* Washington, D.C.:25–745.

von Sack, Baron Albert
 1810 *A narrative of a voyage to Surinam.* London: W. Bulmer.

Schumann, C. L.
 1778 *Saramaccanisch Deutsches Wörter-Buch.* In "Die Sprache der Saramakkaneger in Surinam," Hugo Schuchardt. *Verhandelingen der Koninklijke Akademie van Wetenschappen te Amsterdam* 14(6), 1914. Amsterdam: Johannes Müller, pp. 46–116.

Sieber, Roy
 1972 *African textiles and decorative arts.* New York: The Museum of Modern Art.
 1979 "African furniture and household goods." *African Arts* 12(4):24–31, 90.

Simpson, George Eaton and Peter G. Hammond
 1957 "Discussion." In *Caribbean studies: a symposium,* Vera Rubin (ed.), Seattle, University of Washington Press, pp. 46–53.

Staehelin, F.
 1913–19 *Die Mission der Brüdergemeine in Suriname und Berbice im achtzehnten Jahrhundert.* Herrnhut: Vereins für Brüdergeschichte in Kommission der Unitätsbuchhandlung in Gnadau.

Stedman, Captn. J. G.
 1796 *Narrative, of a five-years' expedition, against the revolted Negroes of Surinam . . . from the year 1772, to 1777.* London: J. Johnson and J. Edwards.

Stedman, Susan
 1976 "The Peabody Museum of Salem." *African Arts* 10(1):42–47.

Sturtevant, William C.
 1960 *The significance of ethnological similarities between Southeastern North America and the Antilles.* Yale University Publications in Anthropology 64. New Haven: Department of Anthropology, Yale University.

Szwed, John F. and Roger D. Abrahams
 1977 "After the myth: studying Afro-American cultural patterns in the plantation literature." In *African folklore in the New World,* Daniel J. Crowley (ed.), Austin, University of Texas Press, pp. 65–86.

Teenstra, M. D.
 1842 *De negerslaven in de kolonie Suriname en de uitbreiding van het Christendom onder de heidensche bevolking.* Dordrecht: H. Lagerweij.

Thoden van Velzen, H. U. E.
 1965 *Visiting deities.* 16mm. black and white film with sound.
 1966 *Politieke beheersing in de Djuka maatschappij: een studie van een onvolledig machtsoverwicht.* Leiden: Afrika-Studiecentrum.

Thoden van Velzen, H. U. E. and Wilhelmina van Wetering
 n.d. Research recordings from the Tapanahoni Djuka, 1960s. On deposit, Tropenmuseum, Amsterdam.

Thompson, Robert Farris
 1966 "An aesthetic of the cool: West African dance." *African Forum* 2(2):85–102.
 1969 "Abatan: a master potter of the Egbado Yoruba." In *Tradition and creativity in tribal art,* Daniel Biebuyck (ed.), Los Angeles, University of California Press, pp. 120–82.
 1970 "From Africa." *Yale Alumni Magazine* 34(2):16–21.
 1973 "Yoruba artistic criticism." In *The traditional artist in African societies,* Warren L. D'Azevedo (ed.), Bloomington and London, Indiana University Press, pp. 19–61.
 1974 *African art in motion.* Los Angeles: University of California Press.
 1980 *The transatlantic tradition.* New York: Random House (In press).

Tripot, J.
 1910 *La Guyane: au pays de l'or, des forçats, et des peaux rouges.* Paris: Plon-Nourrit.

Vandercook, John Womack
 1926 "We find an African tribe in the South American jungle." *The Mentor* 14(3):19–22.

van der Elst, Dirk H.
 1975 "The Coppename Kwinti: notes on an Afro-American tribe in Surinam," *Nieuwe West-Indische Gids* 50:7–17, 107–122, 200–211.

Vlach, John Michael
 1978 *The Afro-American tradition in decorative arts.* Cleveland: Cleveland Museum of Art.

Volders, J. L.
 1966 *Bouwkunst in Suriname: driehonderd jaren nationale architectuur.* Hilversum: G. van Saane.

de Vries-Hamburger, L.
 1959 "Over volkskunst in het algemeen en die van Suriname in het bijzonder." *Kultuurpatronen* 1:106–10.

Walsh, John and Robert Gannon
 1967 *Time is short and the water rises.* New York: E. P. Dutton.

Warren, D. M. and J. Kweku Andrews

 1977 *An ethnoscientific approach to Akan arts and aesthetics.* Philadelphia: I.S.H.I.

van Westerloo, Gerard and Willem Diepraam

 1975 *Frimangron.* Amsterdam: Uitgeverij de Arbeiderspers.

Wilbert, Johannes

 1975 *Warao basketry: form and function.* Los Angeles: UCLA Museum of Cultural History.

Wooding, Charles J.

 1972 *Winti: een Afroamerikaanse godsdienst in Suriname.* Meppel, Netherlands: Krips Repro.

Yde, Jens

 1965 *Material culture of the Waiwái.* Copenhagen: Nationalmuseets, Etnografisk Roekke X.

CREDITS FOR ILLUSTRATIONS

All photos of exhibited objects (indicated by numbers in boldface type) were made by Antonia Graeber unless otherwise noted. Each object's largest dimension is given in centimeters unless otherwise noted. Order of objects (as indicated by a, b, c, etc.) is left to right or top to bottom. We have made a rigorous effort to secure all necessary permissions for previously-published photographs; in the rare case in which our repeated letters of request have been unanswered we have nevertheless published the photograph, with an acknowledgment of our source.

I. Photo by Richard Price (upper Pikilio, 1968).
II. Photo by Richard Price (upper Pikilio, 1968).
III. Photo by Richard Price (Dangogo, 1968).
IV. Photo by Wilhelmina van Wetering (Diitabiki, 1962).
V. Photo by Wilhelmina van Wetering (Diitabiki, 1962).
VI. Photo by Sally Price (Niukonde, 1968).
VII. Photo by Richard Price.
VIII. a) Rijksmuseum voor Volkenkunde, Leiden—2452–456 (99.0 cm.);
b,c) Private collection (99.1, 129.5 cm.);
d) UCLA Museum of Cultural History, Los Angeles—X72–118 (110.5 cm.);
e) Surinaams Museum, Paramaribo—T63 (113.0 cm.)
IX. Private collection (102.9 cm.)
X. Collection Tropenmuseum Amsterdam—3290–237 (107.9 cm.)
XI. Private collection (107.3 cm.)
XII. Private collection (185.3 cm.)
XIII. Photo by Christopher Healy (Djumu airstrip, 1976).
XIV. a,b) UCLA Museum of Cultural History, Los Angeles—X73–444, LX78–412;
c) American Museum of Natural History, New York—26.717;
d) Surinaams Museum, Paramaribo—H44;
e) UCLA Museum of Cultural History, Los Angeles—X73–443. Lengths vary from 44.5 to 167.6 cm.
XV. Private collection (26.1 cm.)
XVI. Surinaams Museum, Paramaribo, courtesy of Drs. Jan Michels (137.1 cm.)
XVII. a) Collection Tropenmuseum Amsterdam—798/2a,b (41.9 cm.);
b) Private collection (18.6 cm.)
XVIII. Photo by Richard Price (Dangogo, 1968).
XIX. Photo by Chris de Beet (Sukibaka, 1974).
XX. Photo by Wilhelmina van Wetering (Diitabiki, 1962).
XXI. Photo by Wilhelmina van Wetering (Diitabiki, 1962).

1. From Stedman 1796: Plate 11. Engraving by William Blake.
2. From Stedman 1796: Plate 71. Engraving attributed to William Blake.
3. Drawing by Margaret Falk.
4. Drawing by Margaret Falk.
5. UCLA Museum of Cultural History, Los Angeles—X79–495 (2.98 m.)
6. Algemeen Rijksarchief, The Hague: Societeit van Suriname 320, p. 333.
7. From van Westerloo and Diepraam 1975:158. Photo by Willem Diepraam (1973–75).
8. From van Westerloo and Diepraam 1975:148. Photo by Willem Diepraam (1973–75).
9. From van Westerloo and Diepraam 1975:66–67. Photo by Willem Diepraam (1973–75).
10. Photo by Richard Price (near Dangogo, 1968).
11. From van Westerloo and Diepraam 1975:122–23. Photo by Willem Diepraam (1973–75).
12. a) From Hurault 1970: Plate 30. Photo by Jean Hurault.
b) Photo courtesy of Stichting Surinaams Museum.
13. From Joest 1893: Plate VI(4).
14. Photo by Richard Price (Dangogo, 1968).
15. Photo by Wilhelmina van Wetering (Diitabiki, 1962).
16. Photo (1972) courtesy of Dr. J. B. Ch. Wekker, Central Bureau Luchtkartering, Paramaribo.
17. Photo by Richard Price (upper Pikilio, 1968).
18. Photo by Wilhelmina van Wetering (Diitabiki, 1970).
19. Photo by Richard Price (Dangogo, 1968).

20. Photo by Richard Price (Dangogo, 1968).
21. UCLA Museum of Cultural History, Los Angeles—X72–94. (85.0 cm.)
22. Drawing by Margaret Falk, after a field sketch by Sally Price (Dangogo, 1968).
23. Photos by Richard Price (Dangogo, 1968).
24. From van de Poll 1951: Plate 198.
25. Photo by Richard Price (Dangogo, 1968).
26. Photo by Richard Price (Niukonde, 1968).
27. Photo by Richard Price (Niukonde, 1978).
28. Photo by Wilhelmina van Wetering (Diitabiki, 1962).
29. From Hurault 1961: facing p. 76. Photo by Jean Hurault (Loabi).
30. From Hurault 1970: Plate 9. Photo by Jean Hurault (Tapanahoni, 1957).
31. Photos by Sally Price. These manioc cake patterns were made with fine white sand during a 1968 interview in Dangogo.
32. Photo by Richard Price (Dangogo, 1968).
33. Private collection (14.0 cm.)
34. Private collection (61.6 cm.)
35. Photo by Richard Price (Asindoopo, 1978).
36. Private collection (17.5 and 20.3 cm.)
37. Collection of Professor H. U. E. Thoden van Velzen and Dr. Wilhelmina van Wetering, Bosch en Duin (16.0 cm.)
38. Photo by Richard Price (Dangogo, 1968).
39. From Hurault 1970: Plate 41. Photo by Jean Hurault.
40. Museum of African Art/Smithsonian Institution, Melville J. Herskovits Collection—S 108 (64.5 cm.)
41. From Tripot 1910: facing p. 136.
42. From Kahn 1931: facing p. 162. Photo by Klein.
43. Photo courtesy of Surinaams Museum, Paramaribo.
44. Photo courtesy of the Koninklijk Instituut voor de Tropen, Amsterdam.
45. Photo by Wilhelmina van Wetering (Diitabiki, 1962).
46. Photo by Richard Price (Dangogo, 1968).
47. Drawing by Margaret Falk, after a field sketch by Sally Price (Dangogo, 1968).
48. Photo by Wilhelmina van Wetering (Diitabiki, 1962).
49. a) Rijksmuseum voor Volkenkunde, Leiden—2452–449 (5.6 cm. wide);
b) American Museum of Natural History, New York—26.72 (5.6 cm. wide);
c–g) UCLA Museum of Cultural History, Los Angeles—X72–111, X71–629, X72–112, X72–113, X71–630 (7.6–11 cm. wide);
h) Museum voor Land- end Volkenkunde, Rotterdam—9808 (2.3 cm. wide)
50. Photo by Richard Price (Dangogo, 1968).
51. Photo by Richard Price (Dangogo, 1968).
52. Photo by Richard Price (Dangogo, 1968).
53. Photo courtesy of Surinaams Museum, Paramaribo.
54. Private collection (96.5 cm.)
55. Surinaams Museum, Paramaribo—T27 (104.7 cm.)
56. Rijksmuseum voor Volkenkunde, Leiden—2452–441 (112.3 cm.)
57. Private collection (39.4 cm.)
58. Rijksmuseum voor Volkenkunde, Leiden—2452–431 (27.9 cm.)
59. Private collection (68.6 cm.)
60. Private collection (28.6 cm.)
61. Surinaams Museum, Paramaribo—94 (130.8 cm.)
62. Photo courtesy of Rijksmuseum voor Volkenkunde, Leiden.
63. From Riemer 1801: Plate 9.
64. From Coster 1866: frontispiece.
65. Photo by Richard Price (Asindoopo, 1978).
66. Photo courtesy of Photothèque, Musée de l'Homme, Paris (negative no. D.32.2022.53).
67. From Johnston 1910: Plate 102. Photo by H. van Cappelle.
68. From Johnston 1910: Plate 103. Photo by H. van Cappelle.
69. From Bonaparte 1884: title page (Amsterdam, 1883)
70. Drawn by Margaret Falk, after a sketch by Sally Price.
71. Collection Tropenmuseum Amsterdam—H2475 (115.5 cm.)
72. From Eilerts de Haan 1910: Figure 24.
73. Surinaams Museum, Paramaribo—T64 (109.2 cm.)

74. Surinaams Museum, Paramaribo—T81 (114.2 cm.)
75. Surinaams Museum, Paramaribo—T83 (115.5 cm.)
76. Photo courtesy of Surinaams Museum, Paramaribo.
77. UCLA Museum of Cultural History, Los Angeles—X71–627 (94.0 cm.)
78. Private collection (111.8 cm.)
79. Private collection (96.5 cm.)
80. Indiana University Museum, Bloomington—1732b1/26 (130.8 cm.)
81. Surinaams Museum, Paramaribo—T35 (93.3 cm.)
82. Photo by Sally Price (Asindoopo, 1976).
83. Hamburgisches Museum für Völkerkunde—30.51.66 (96.0 cm.)
84. Surinaams Museum, Paramaribo—T36 (90.1 cm.)
85. Private collection (88.9 cm.)
86. Musée de l'Homme, Paris—38.21.1. Photo by Photothèque, Musée de l'Homme (negative no. D.80.673–493).
87. UCLA Museum of Cultural History, Los Angeles—X72–116 (110.5 cm.)
88. UCLA Museum of Cultural History, Los Angeles—X72–119 (76.2 cm.)
89. UCLA Museum of Cultural History, Los Angeles—X72–125 (92.7 cm.)
90. UCLA Museum of Cultural History, Los Angeles—X72–117 (88.9 cm.)
91. UCLA Museum of Cultural History, Los Angeles—X72–122 (87.6 cm.)
92. Private collection (99.1 cm.)
93. Private collection (83.8 cm.)
94. Private collection (78.7 cm.)
95. Photo by Sally Price (Asindoopo, 1978).
96. Private collection (77.0 cm.). Photo by David Porter.
97. Private collection (87.6 cm.)
98. Photos by Richard Price (Asindoopo, 1976).
99. Collection of Robin "Dobru" Ravales, Paramaribo (92.0 cm.)
100. a) UCLA Museum of Cultural History, Los Angeles—X73–466 (14.0 cm.)
 b,c,d) Private collection (15.6–18.4 cm.)
101. Photo by Sally Price (Paramaribo, 1979).
102. Photo by Richard Price (Dangogo, 1968).
103. Photo by Sally Price (Dangogo, 1968).
104. Photo by Sally Price (Dangogo, 1968).
105. a) Collection Tropenmuseum Amsterdam—H 2433. Photo by the Tropenmuseum.
 b,c) Hamburgisches Museum für Völkerkunde—30.51.159 (12.0 cm. in diameter) and 30.51.160. Photos by the Hamburgisches Museum für Völkerkunde.
106. Drawings by Margaret Falk, after field sketches by Sally Price (Dangogo, 1968). Lengths of necklaces 49 and 79 cm.
107. From Hurault 1970: Plate 4. Photo by Jean Hurault.
108. Photo by Richard Price (Niukonde, 1978).
109. Photo by Professor C. F. A. Bruijning (Saje, 1952).
110. Photo by Sally Price (Dangogo, 1968).
111. a,b) From Stedman 1796: Plates 7, 68. Engravings by William Blake.
 c) From Benoit 1839: Figure 39
 d) From Teenstra 1842: frontispiece
112. Drawings by Margaret Falk, after field sketches by Sally Price (Dangogo, 1968).
113. Musée de l'Homme, Paris—38.21.1. Photo by Photothèque, Musée de l'Homme (negative no. D.80.674.493).
114. Drawing by Margaret Falk, after a sketch by Sally Price.
115. Drawing by Margaret Falk, after a sketch by Sally Price.
116. Private collection (81.3 cm.).
117. From Hurault 1970: Plate 26. Photo by Jean Hurault (1948).
118. Drawing by Margaret Falk:
 a) after a field sketch by Sally Price (Dangogo, 1968).
 b) after Roth 1924: Figure 81AA.
119. American Museum of Natural History, New York—26.204 (42.6 cm.).
120. Photo by Richard Price (Dangogo, 1968).

121. Museum of African Art/Smithsonian Institution, Melville J. Herskovits Collection—S102 (53.4 cm.).
122. a,b,e) Musée de l'Homme, Paris—32.96.6 (48.5 cm.), 32.96.9 (42.8 cm.); 47.14.19 (58.7 cm.)
 c,d) Hamburgisches Museum für Völkerkunde—30.51.168 (47.4 cm.), 30.51.169 (59.5 cm.);
 f,j) Surinaams Museum, Paramaribo—294 (43.3 cm.), 951 (41.9 cm.)
 g) Museum of African Art/Smithsonian Institution, Melville J. Herskovits Collection—S57 (47.6 cm.).
 h) American Museum of Natural History, New York—26.356 (45.7 cm.);
 i) Private collection (46.3 cm.)
123. American Museum of Natural History, New York—26.354 (54.6 cm.), 26.372 (53.3 cm.).
124. a) American Museum of Natural History, New York—26.713 (44.5 cm.)
 b) Musée de l'Homme, Paris—47.14.20 (40.0 cm.)
125. Musée de l'Homme, Paris—01.26.2 (65.3 cm.), 39.25.581 (40.7 cm.)
126. American Museum of Natural History, New York—26.810. Photo by American Museum of Natural History.
127. Museum of African Art/Smithsonian Institution, Melville J. Herskovits Collection—S106 (63.5 cm.)
128. Hamburgisches Museum für Völkerkunde—30.51.119 (64.0 cm.)
129. Musée de l'Homme, Paris—47.14.49 (59.6 cm.)
130. Private collection (each 51 cm.). Photo by David Porter.
131. Hamburgisches Museum für Völkerkunde—30.51.55 (65.0 cm.)
132. American Museum of Natural History, New York—26.588 (50.8 cm.)
133. Museum of African Art/Smithsonian Institution, Melville J. Herskovits Collection–S107 (64.1 cm.)
134. a,c) UCLA Museum of Cultural History, Los Angeles—X70–39 (44.5 cm.), X71–635 (50.8 cm.);
 b) Hamburgisches Museum für Völkerkunde—30.51.177 (60.0 cm.)
135. Musée de l'Homme, Paris—81.107.21 (66.6 cm.)
136. a) Surinaams Museum, Paramaribo—1042 (56.5 cm.)
 b,c,d) UCLA Museum of Cultural History, Los Angeles—X71–619 (41.9 cm.), LX78–408 (61.0 cm.), X79–497 (66.0 cm.)
137. a) American Museum of Natural History, New York—26.721
 b,c,d) UCLA Museum of Cultural History, Los Angeles—LX78–407, –413, –414. Lengths vary from 103.5 to 120.6 cm.
138. a) Private collection (141.0 cm.);
 b) Hamburgisches Museum für Völkerkunde—30.51.96 (130.5 cm.);
 c,d) Surinaams Museum, Paramaribo—H915 (152.4 cm.), H916 (234.9 cm.)
139. a) Photo by Augusta Curiel, courtesy of Surinaams Museum, Paramaribo;
 b) From Oudschans-Dentz and Jacobs 1917: Figure 120;
 c) Photo by Silvia W. de Groot (Kambaloa, 1961).
140. UCLA Museum of Cultural History, Los Angeles—X71–632 (101.6 cm.)
141. American Museum of Natural History, New York—26.847a,b (132.7 cm.)
142. Surinaams Museum, Paramaribo—H595. Photo by Richard Price.
143. Surinaams Museum, Paramaribo—H593. Photo by Sally Price.
144. Museum voor Land- en Volkenkunde, Rotterdam—25596 (28.5 cm.).
145. Collection Tropenmuseum Amsterdam—H2852 (50.0 cm.).
146. Rijksmuseum voor Volkenkunde, Leiden—370-424 (44.5 cm.).
147. Surinaams Museum, Paramaribo—H254, H255, H742, H1002 (29.7–57.1 cm.)
148. a) Private collection (24.1 cm.);
 b,c) Surinaams Museum, Paramaribo—H726 (30.4 cm.), T79 (29.8 cm.);
 d) Rijksmuseum voor Volkenkunde, Leiden—2452-466 (19.7 cm.)

149. American Museum of Natural History, New York—26.239. Photo by American Museum of Natural History.

150. a) Surinaams Museum, Paramaribo—H725 (25.4 cm.);
 b) UCLA Museum of Cultural History, Los Angeles—X70–42 (21.6 cm.);
 c) Musée de l'Homme, Paris—47.14.33 (25.4 cm.)

151. Hamburgisches Museum für Völkerkunde—30.51.59 (42.0 cm.)

152. a) Musée de l'Homme, Paris—39.25.625 (20.3 cm.)
 b) Surinaams Museum, Paramaribo—H393 (22.9 cm.)

153. American Museum of Natural History, New York—26.350 (83.8 cm.)

154. Surinaams Museum, Paramaribo—H478 (80.6 cm.)

155. Surinaams Museum, Paramaribo—H754 (34.9 cm.)

156. Museum voor Land- en Volkenkunde, Rotterdam—54444 (39.0 cm.)

157. Surinaams Museum, Paramaribo—H550 (38.7 cm.)

158. a) Surinaams Museum, Paramaribo—154 (34.3 cm.)
 b) Private collection (71.7 cm.)

159. a,b) Surinaams Museum, Paramaribo—H259, H247 (23.5, 41.3 cm.)
 c) Private collection (64.7 cm.)

160. interlocked) Surinaams Museum, Paramaribo—416 (25.4 cm.);
 with links) Museum voor Land- en Volkenkunde, Rotterdam—66364 (67.0 cm.)

161. Photo by Vaillant, courtesy of the Photothèque, Musée de l'Homme, Paris (negative no. D.61.1836.304).

162. a) Private collection (38.1 cm.)
 b) Musée de l'Homme, Paris—47.14.34 (43.2 cm.)

163. a) Rijksmuseum voor Volkenkunde, Leiden—2452–504 (26.3 cm.)
 b) UCLA Museum of Cultural History, Los Angeles—X71–615 (24.1 cm.)

164. Surinaams Museum, Paramaribo—H825 (34.2 cm.)

165. a) Royal Museum of Central Africa, Tervuren, Belgium—R.G. 48.42.4 (25.4 cm.)
 b) American Museum of Natural History, New York—26.703 (33.6 cm.)

166. Musée de l'Homme, Paris—01.26.4 (38.1 cm.)

167. Musée de l'Homme, Paris—47.14.10 (137.1 cm.)

168. Surinaams Museum, Paramaribo—H186 (63.5 cm.)

169. American Museum of Natural History, New York—26.203. Photo by American Museum of Natural History.

170. a) Collection Tropenmuseum Amsterdam—H2792 (38.0 cm.)
 b) Rijksmuseum voor Volkenkunde, Leiden—399–8 (50.8 cm.)

171. Collection Jean Hurault, Paris (151.1, 132.1, 124.4, 140.3, 160.6 cm.)

172. Drawn by Margaret Falk, after a sketch by Richard Price.

173. Museum of African Art/Smithsonian Institution, Melville J. Herskovits Collection—S110 (42.5 cm.)

174. American Museum of Natural History, New York—26.815 (52.1 cm.)

175. American Museum of Natural History, New York—26.154 (36.8 cm.)

176. Hamburgisches Museum für Völkerkunde—30.51.181 (50.5 cm.)

177. Collection of Dr. Silvia W. de Groot, Amsterdam (56.4 cm.)

178. Surinaams Museum, Paramaribo—H136 (52.7 cm.)

179. Photo by Richard Price (Dangogo, 1968).

180. Photo by Richard Price (Dangogo, 1968).

181. Private collection (26.1 cm.)

182. Photos by Richard Price (Dangogo, 1968).

183. Photos by Richard Price (Dangogo, 1968).

184. Photo by Richard Price (Dangogo, 1968).

185. Surinaams Museum, Paramaribo—H1079a,b (182.9 cm.)

186. Surinaams Museum, Paramaribo—H1080a,b (159.4 cm.)

187. Hamburgisches Museum für Völkerkunde—30.51.104 (190.5 cm.)

188. a) From van Panhuys 1928: Figure 1
 b,c) Photos by Richard Price (Dangogo, 1968).

189. a) American Museum of Natural History, New York—26.360 (29.2 cm.);
 b) Museum of African Art/Smithsonian Institution, Melville J. Herskovits Collection—S32 (40.0 cm.);
 c) Collection of Dr. Silvia W. de Groot, Amsterdam (26.1 cm.);
 d) Musée de l'Homme, Paris—99.43.1 (29.2 cm.)

190. Museum of African Art/Smithsonian Institution, Melville J. Herskovits Collection—S–144, S–142, S–2 (20.2–26.0 cm.). Photo by Museum of African Art.

191. Private collection (5.6–26.0 cm.)

192. Private collection (22.8–26.7 cm.)

193. Photo by Richard Price (Dangogo, 1968).

194. Private collection (53.3 cm., 17.3 cm.).

195. Collection of John C. Walsh, Boston (60.9 cm.)

196. Surinaams Museum, Paramaribo—H1078 (96.5 cm.)

197. American Museum of Natural History, New York—26.2 (43.2 cm.)

198. Rijksmuseum voor Volkenkunde, Leiden—399–1 (32.4 cm.)

199. Private collection (44.5 cm.)

200. Collection Tropenmuseum Amsterdam—H2509 (41.0 cm.)

201. a,b) Collection Tropenmuseum Amsterdam—H2780, 2307–1. Photos by Tropenmuseum.
 c) Photo by Richard Price (Dangogo, 1968).

202. a) UCLA Museum of Cultural History, Los Angeles—X79–495
 b,c) Photos by Richard Price (Pikiseei and Kambaloa, 1978).

203. Museum of African Art/Smithsonian Institution, Melville J. Herskovits Collection—S134 (27.9 cm.)

204. a,b) Surinaams Museum, Paramaribo—H155 (39.3 cm.), H331 (35.5 cm.);
 c,d) Musée de l'Homme, Paris—39.25.547 (29.9 cm.); 39.25.552 (29.2 cm.)
 e) Collection Tropenmuseum Amsterdam—2345–187 (36.0 cm.)

205. Surinaams Museum, Paramaribo—H649 (45.7 cm.)

206. Collection of Dr. Silvia W. de Groot, Amsterdam (70.4 cm.)

207. Photos by Wilhelmina van Wetering.

208. Musée de l'Homme, Paris—39.25.538 (31.4 cm.)

209. Collection of Dr. Silvia W. de Groot, Amsterdam (44.0–49.0 cm.)

210. University Museum of Archaeology and Anthropology, Cambridge, England—66.181A (25.2 cm.)

211. Photo by Sally Price (Dangogo, 1978).

212. a) Private collection (10.8 cm.)
 b) American Museum of Natural History, New York—26.273 (25.7 cm.)

213. Photos by Richard Price (Dangogo, 1968).

214. a-c) Private collection (12.8–14.8 cm.)
 d-e) Collection of Dr. John D. Lenoir, New York (4.7–22.2 cm.)

215. a,b,c) Collection Tropenmuseum Amsterdam—A6043 a,b,d (15.2, 17.1, 21.6 cm.)
 d,e) Musée de l'Homme, Paris—81.107.10 (25.4 cm.), 35.72.85 (12.7 cm.)

216. Musée de l'Homme, Paris—78.32.185. Photo by Photothèque, Musée de l'Homme (negative no. D.80.597.493).

217. Collection Tropenmuseum Amsterdam—3537/1 (18.4 cm.). Photo by the Tropenmuseum.

218. Rijksmuseum voor Volkenkunde, Leiden—1817–140. Photo by the Rijksmuseum.

219. Rijksmuseum voor Volkenkunde, Leiden—360–1602 (31.7 cm.)

220. Collection Tropenmuseum Amsterdam—A6113c (13.9 cm.), H2555 (11.4 cm.)

221. a) Rijksmuseum voor Volkenkunde, Leiden—1817–250 (21.5 cm.)
 b) Collection Tropenmuseum Amsterdam—1556/2 (15.2 cm.)

222. Musée de l'Homme, Paris—81.34.6. Photo by the Photothèque, Musée de l'Homme (negative no. D.80.596.493).

223. Rijksmuseum voor Volkenkunde, Leiden—399–44 (17.8 cm.)

224. Rijksmuseum voor Volkenkunde, Leiden—370–377 (14.0 cm.)

225. a) Museum voor Land- en Volkenkunde, Rotterdam—4807 (12.7 cm.)
b) Collection Tropenmuseum Amsterdam—1556/2 (15.2 cm.)
226. Private collection (17.8 cm.)
227. American Museum of Natural History, New York—26.237a,b (50.5 cm.)
228. Rijksmuseum voor Volkenkunde, Leiden—370–372 (11.5 cm.)
229. Surinaams Museum, Paramaribo—H685a,b (22.9 cm.)
230. Surinaams Museum, Paramaribo—H857–858 (17.2 cm.)
231. Collection Tropenmuseum Amsterdam—H2559 (19.7 cm.)
232. **1a,b)** Collection of Dr. John D. Lenoir, New York;
1d–f, 2a–c) Surinaams Museum, Paramaribo—H854, H1087, H1084, H1064, H1069, H1071;
1g) UCLA Museum of Cultural History, Los Angeles—X73–410d
2d) Musée de l'Homme, Paris—39.25.599. Photo by the Photothèque, Musée de l'Homme (negative no. D.80.598.493);
5g) Collection of John C. Walsh, Boston;
all others) Private collection
Diameters vary between 7.6 and 22.9 cm.
233. a) Musée de l'Homme, Paris—47.14.39 (20.9 cm.);
b) American Museum of Natural History, New York—26.83. Photo by American Museum of Natural History;
c) Surinaams Museum, Paramaribo—H1066 (17.8 cm.)
234. Private collection (6.0–14.3 cm.)
235. Collection of Dr. John D. Lenoir, New York (16.5 cm.)
236. American Museum of Natural History, New York—26.380. Photo by American Museum of Natural History.
237. Musée de l'Homme, Paris—35.72.74 (20.4 cm.)
238. Surinaams Museum, Paramaribo—T82 (111.8 cm.)
239. Danish Royal Museum of Fine Arts, Copenhagen—Oil on canvas (58 × 46 cm.). Photo by Danish Royal Museum of Fine Arts.
240. Private collection (33.0 cm.). Photo by David Porter.
241. Photos by Silvia W. de Groot (Godo, 1961).
242. a) Photo by Richard Price (Dangogo, 1968).
b) Photo by Terry Agerkop (1970s).
243. UCLA Museum of Cultural History, Los Angeles—X79–496 (76.2 cm. in circumference).
244. From van de Poll 1959: 83.
245. From Stedman 1796: Plate 69.
246. American Museum of Natural History, New York—26.544 (44.4 cm.)
247. Drawing by Margaret Falk, after a sketch by Sally Price.
248. From Hurault 1970: Plate 42. Photo by Jean Hurault.
249. Hamburgisches Museum für Völkerkunde—30.51.60 (49.5 cm.)
250. Photo by Richard Price (Dangogo, 1968).
251. Photo by Richard Price (Dangogo, 1968).
252. Rijksmuseum voor Volkenkunde, Leiden—360–5696 (80.6 cm.)
253. Drawings by Margaret Falk, after field sketches by Sally Price (Dangogo, 1968).
254. Private collection (22.2 cm.)
255. a) Photo by Sally Price.
b) Private collection.
256. Musée de l'Homme, Paris—81.107.13 (25.4 cm.)
257. a,c) Private collection (21.0–33.0 cm.)
b) UCLA Museum of Cultural History, Los Angeles—X73–447 (38.1 cm.)
258. Collection of Robin ("Dobru") Ravales, Paramaribo. Photo by Richard Price (Paramaribo, 1979).
259. Drawing by Margaret Falk, after a field sketch by Sally Price (1968).
260. **a)** Private collection (17.5 cm.)
b) Photo by Richard Price (Dangogo, 1968).
261. a) Drawing by Margaret Falk, after photo and sketch by Richard and Sally Price (Dangogo, 1968)
b) Private collection (25.4 cm.)
262. **a)** Private collection (13.9 cm.);
b) Surinaams Museum, Paramaribo T63 (113.0 cm.);
c) Photo by Richard Price (Asindoopo, 1978).
263. a) Collection Tropenmuseum Amsterdam—722/1c (15.2 cm.)
b) Collection of John C. Walsh, Boston

264. **a)** Collected 1968, Pikilio. Private collection (16.9 cm.)
b) Photo by Sally Price (Dangogo, 1968).
c) Photo by Sally Price. This manioc-cake pattern, like those in Figure 31, was made with fine white sand during a 1968 interview in Dangogo.
265. From Thompson 1970: 18.
266. From Fagg 1952: Figure 7 (after W. D. Webster, Ethnographical Catalogue No. 31, Item No. 167).
267. Hamburgisches Museum für Völkerkunde—30.51.141. (101.0 cm.). Destroyed during World War II. Photo by Hamburgisches Museum für Völkerkunde.
268. a) From Stedman 1976:44
b) Private collection.
269. a) Musée des Arts et Traditions Populaires, Paris—70.97.1. Photo by Richard Price.
b) Collection of John C. Walsh, Boston (60.9 cm.)
270. a) Musée de l'Homme, Paris—14.5.103. Photo by Photothèque, Musée de l'Homme (negative no. E.79.1451.493).
b) Private collection. Photo by David Porter.
271. Collection of John C. Walsh, Boston (74.2 cm.)
272. Drawing by Margaret Falk, after Roth 1924: 275Q and V, and Stedman 1796: Plate 40.
273. Drawings by Margaret Falk, after
a) Stedman 1796: Plate 39;
b) Barbot 1732: 237;
c) Stedman 1796: Plate 22;
d) Coster 1866: frontispiece (see also Figure 64, above)
274. Drawing by Margaret Falk, after a sketch by Sally Price.

ADDENDUM

The following objects appeared in the exhibition with which this book was associated but are not illustrated here.

Textiles

Museum of Cultural History, University of California, Los Angeles
- **275.** Breechcloth with appliqué decoration (X71–628)
- **276.** Crocheted calfbands with decorative stripes and yarn tassels (X72–114a,b)
- **277.** Crocheted calfbands with decorative stripes (X72–115a,b)
- **278.** Man's narrow-strip shoulder cape (X72–120)
- **279.** Man's narrow-strip shoulder cape (X72–121)
- **280.** Breechcloth with appliqué decoration (X72–123)
- **281.** Breechcloth with appliqué decoration (X72–124)
- **282.** Breechcloth with appliqué decoration (X72–168)

Rijksmuseum voor Volkenkunde, Leiden
- **283.** Apron with appliqué, embroidery, and fringe on the lower edge, collected 1932–38 (2452.432)
- **284.** Crocheted calfband, white with red stripes, collected 1932–38 (2452.450)

Surinaams Museum, Paramaribo
- **285.** Man's shoulder cape, openwork narrow-strip construction (T15)
- **286.** White knitted belt for use with a breechcloth (T57)
- **287.** Man's "bonnet-style" cap with fringe (T88)
- **288.** Man's drawstring cap with fringe (T89)
- **289.** Man's drawstring cap (T323)
- **290.** Red, white, and black crocheted calfband (T325)
- **291.** Man's drawstring cap (93)

Private collections
- **292.** Saramaka embroidered neckerchief, sewn 1955–65
- **293.** Man's shoulder cape with appliqué decoration, sewn 1920–40 by Peepina, Totikampu
- **294.** Saramaka man's shoulder cape with three panels of narrow-strip patchwork, sewn 1950s in Ganzee
- **295.** Saramaka man's shoulder cape, patchwork composition utilizing short narrow strips of cloth placed both vertically and horizontally, sewn 1950s in the Lower River region
- **296.** Saramaka breechcloth with appliqué and embroidered decoration, sewn 1930s by Adjaba, Gaanseei
- **297.** Saramaka breechcloth with appliqué decoration, sewn in Masiakiiki

Wood

Musée de l'Homme, Paris
- **298.** Djuka comb, collected before 1932 (47.14.26)

Museum of Cultural History, University of California, Los Angeles
- **299.** Saramaka comb, collected in Pokigoon (X70–41)
- **300.** Saramaka food stirrer, collected in Tutubuka (X71–616)
- **301.** Saramaka peanut-grinding board, collected in Semoisi (X71–621)
- **302.** Saramaka round-top stool, collected in Guyaba (X71–623)
- **303.** Saramaka door lintel, collected in Pokigoon (X71–633)
- **304.** Djuka comb, collected 1971 on the Tapanahoni River (X73–431)
- **305.** Djuka comb, collected 1971 on the Tapanahoni River (X73–433)
- **306.** Djuka comb, collected 1971 on the Tapanahoni River (X73–434)
- **307.** Djuka hammock tool, collected 1971 on the Tapanahoni River (X73–436)
- **308.** Djuka hammock tool, collected 1971 on the Tapanahoni River (X73–437)
- **309.** Djuka hammock tool, collected 1971 on the Tapanahoni River (X73–438)
- **310.** Djuka paddle, collected 1971 on the Tapanahoni River (X73–441)

Rijksmuseum voor Volkenkunde, Leiden
- **311.** Comb with openwork carving and decorative tacks, collected before 1883 (399.2)
- **312.** Laundry beater, collected before 1886 (581.17)

Surinaams Museum, Paramaribo
- **313.** Djuka paddle, collected 1962 on the Commewyne River (H11)
- **314.** Saramaka comb, collected in Pikiseei (H329)
- **315.** Djuka comb, collected in Diitabiki (H334)
- **316.** Matawai comb, collected 1958 in Posugunu (H447)
- **317.** Djuka comb, collected 1966 on the Tapanahoni River (H975)

John C. Walsh, International Society for the Protection of Animals, Boston
- **318.** Saramaka drum, collected 1966 in Adawai

Private collections
- **319.** Saramaka doorframe, carved 1978 by Akudjuno, Asindoopo
- **320.** Saramaka finger piano, made 1968 in Dangogo. Wood, string, and split reeds

Calabashes

Museum of Cultural History, University of California, Los Angeles
- **321.** Djuka ladles, collected 1971 on the Tapanahoni River (X73–409a,b)

Rijksmuseum voor Volkenkunde, Leiden
- **322.** Ladle, collected before 1893 (951.27)
- **323.** Ladle, collected 1885 in Ganzee (2777.20)

Private collections
- **324.** Saramaka hand-washing bowl, carved 1960s by Keekete, Asindoopo
- **325.** Saramaka drinking bowl, carved ca. 1960 in Asindoopo
- **326.** Saramaka ladle, carved 1950s on the Pikilio
- **327.** Saramaka drinking bowl, carved ca. 1970 in Tutubuka
- **328.** Saramaka drinking bowl, carved ca. 1970 in Tutubuka
- **329.** Drinking bowl carved 1960s on the interior by a Saramaka woman and painted 1975 on the exterior by a coastal Afro-Surinamer, probably a man

Other

Rijksmuseum voor Volkenkunde, Leiden
- **330.** Maroon stringed instrument with gourd sounding box, collected 1932–38 (2452–723)

Private collections
- **331.** Set of commercial metal spoons, decoratively carved on bowls and handles in 1978 by Afelanti, Asindoopo
- **332.** Red, white, and blue commercial yarn on holder made from split reeds, collected 1968 on the Pikilio

INDEX

Note: References to consecutive pages, indicated by a hyphen, may include pages with illustrations that are not germane to the indexed category.

Abrahams, Roger D., 169n, 197
Accessories, 50, 56, 85–87; Fig. 64; *See also* Calfbands; Jewelry
Aesthetics in Maroon life
 history of, 93, 140–142, 197–198, 213, 214–215
 pervasiveness of, 35–42, 81n, 167–170, 214–215
 principles of, 85–86, 89, 92–95, 167–170, 193, 197–198, 213, 214; Fig. 113
 terminology of, 60n, 92–95, 170, 193
African and Maroon arts, relationship between, 47, 170n, 194–215
 in calabash arts, 154n, 155
 in cicatrization, 89–91; Fig. 111
 in jewelry, 86–87, 89n
 in musical instruments, 179n, 182n, 183
 in textiles, 72–76; Figs. 268, 273
 in woodcarving, 99n, 100n; Figs. 265, 266
African origins of Maroons, 89–90, 194; Table, 195
Agerkop, Terry, 178
Ahlbrinck, W., 86n, 207
Amerindian and Maroon arts, relationship between, 156n, 165, 196n; Figs. 243, 257
 in calabash arts, 154, 155; Figs. 216–218
 in textiles, 86n, 210–211; Figs. 49, 273
 in woodcarving, 97–99, 207; Figs. 118, 272
Andrews, J. Kweku, 89n, 212
Apinti ("talking drum"), 100, 172n, 179–181, 185–186; Figs. 173, 246–248
Appliqué, 64; Color Plates VIII, X
Aprons, 48, 52, 172; Figs. 43, 52, 57, 58, 62
Armstrong, Robert Plant, 197
Artistry in social life, 42–43, 85–86, 88n, 89n, 95, 99, 175–177, 193, 211, 214; Table, 82–83; Fig. 130

Banjo, slave 183; Figs. 245, 252
Basketry, 196n; Figs. 20, 159, 257
Bastide, Roger, 209
Bates, Henry Walter, 154
de Beet, Chris, 30n, 50n, 54n, 172n
Behn, Aphra, 194
Berliner, Paul, 183n
Bishop, Robert, 64n
Bits-and-Pieces textiles, 60–64, 93, 212, 214; Figs. 55, 62, 65, 70, 72, 76–82; Color Plates VIII–XI, XIX
Bonaparte, Prince Roland, 91
Brathwaite, Edward Kamau, 170n
Breechcloths, 48, 50, 52, 56n; Figs. 43, 48, 56; Color Plate VIII

Calabash arts, 35, 150–165, 191; Figs. 22–25, 33, 36, 163, 210, 212, 216–237, 254, 259–264, 270; Color Plate XVII
 history of, 153–160, 198–199
 men's and women's, 150, 151, 152–153, 155–156, 156–160
 regional differences in, 160, 189
 techniques in, 152–164
Calabashes, uses of, 30, 33n, 150–152, 165; Figs. 17, 211, 213–215
Calfbands, 35, 50–51, 52, 85–86, 210–211; Figs. 13, 38, 49, 50, 52, 67, 68, 103, 148, 150, 273
Canoes, 18, 99, 142–143; Figs. 5, 10–13, 201, 202, 207; Color Plate III
Capes, 51, 52, 76–80, 93–95, 213; Figs. 19, 54, 55, 76–99, 116, 274; Color Plates VII, IX–XI
van Cappelle, H., 86n
Caps, 52, 56, 172; Figs. 65, 66, 256
Carpenter, Edmund, 8
Caso, Alfonso, 206n
Cassidy, F. G., 182n, 183n
Cateau van Rosevelt, J. F. A., 100, 178
Chappel, T. J. H., 155

Cicatrization, 88–92, 199; Figs. 42–44, 107–112
Cloth names. *See* Names and naming
Cloth supplies, 54n, 60, 64, 84, 95, 201, 214; Table, 82–83; Fig. 101
Clothing
 history of, 47–80; Figs. 41–48, 52, 53, 62–65, 67–69, 72, 76, 77, 273; Color Plate XIII
 regional and tribal differences in, 48, 50, 54, 56, 73–76, 77–78, 92; Fig. 66
 of officials, 54, 56–60; Figs. 52, 53
van Coll, C., 92n
Color, uses of, 33, 60n, 64, 92, 93, 94, 199–200, 211, 213–214
Combs, 87, 99, 136–137, 140, 142, 143–145; Figs. 160, 165, 166, 189–192, 203, 204, 258
Commercialization, 19–20, 44–46, 97, 99, 139, 188, 190; Fig. 196
Cooking, diet, and meals, 19, 23, 27, 30–33, 99; Fig. 19
Coster, A. M., 56, 91
Cotton yarn, uses of, 86, 99, 137n; Figs. 103, 104, 110, 192, 243
Counter, S. Allen, 188n, 208
Creole and Maroon arts, relationship between, 33, 52–54, 100n, 156, 201–202; Figs. 221, 223, 225, 226
Crevaux, Jules, 51, 91
Crowley, Daniel J., 99
Cultural change, mechanics of, 40–42, 165, 177, 195–198, 199–202, 209–215
 in textile arts, 51n, 76–80
 in woodcarving, 129, 137–139, 139–146
Curtin, Philip D., Table, 195

Dance, 171–174; Figs. 38, 39, 242, 243; Color Plates XVIII–XXI
Dark, Philip J. C., 97, 100, 101, 136, 137, 153n, 156n, 204
Dieterlen, Germaine, 155
Dillard, J. L., 212n
Door frames, 100, 131–136; Figs. 184–188
Door locks, 100; Figs. 144, 145
Doors, 100; Figs. 24, 140–143; Color Plate XVI
Dorig, J. C., 99n, 182; Fig. 6
Drum and horn languages, 179–181, 182
Drumming, 172n, 178–181; Fig. 248
Drums, 100, 172n, 178–181; Figs. 173, 245–247. *See also Apinti*

Embroidery, 60, 76–80, 92, 198; Figs. 34, 35, 54, 56–60, 70–75, 83, 94, 96–99, 113, 238, 256, 261, 262; Color Plates VII, VIII
Emigration from Maroon territories, 19–20, 202; Table, 82–83: nos. 25, 26; Figs. 7–9
Esoteric languages, 177, 179–181, 183, 185, 186
Ethnoaesthetic/ethnographic approach to the arts, 8–9, 40, 93–95, 129n, 188, 193
El-Wanni, Ahmad, 84n
Epstein, Dena J., 183
Evans, David L., 188n, 208
van Eyck, J. W. S., 60

Fads and fashions, 50, 86, 91, 200
Fagg, William, 204, 206n, 207
Female/male differences. *See* Male/female differences
Fermin, Phillippe, 154, 155
Field methods, 40, 129n, 190–193
Finger piano. *See* Musical instruments
Food stirrers, 99, 140; Figs. 122–125, 170, 209
Formative period of Maroon societies, 14–15, 90–91, 194–198, 210; Figs. 6, 63
Franssen Herderschee, A., 30n
Funerals, 85, 86, 170, 174, 177, 184; Figs. 240, 241; Color Plate XVIII

de Goeje, C. H., 48
Goldenweiser, A.A., 206n
Gourds, 99, 150, 155n, 164–165; Fig. 194
Griaule, Marcel, 155

Design: Larry duPont
Drawings and Production: Margaret Falk
Studio Photographs: Antonia Graeber
Publication Direction: Robert Woolard
Display Type: Franklin Gothic by Burns Typesetting Service
Text Type: ITC Garamond Light by Graphic Typesetting Service
Cover Stock: Cameo Dull
Text Stock: Cameo Dull
Color Separations: Ultra Color
Printing: Alan Lithograph, Inc.
12,000 copies printed in duotone.
Production consultation by UCLA Publication Services Department